OPERATION
COLUMBA—
THE SECRET PIGEON SERVICE

OPERATION COLUMBA—

THE SECRET PIGEON SERVICE

The Untold Story of World War II
Resistance in Europe

GORDON CORERA

wm

WILLIAM MORROW
An Imprint of HarperCollinsPublishers

HarperCollins books may be purchased for educational, business, or sales promotional use. For information, please email the Special Markets Department at SPsales@harpercollins.com.

Originally published as *Secret Pigeon Service* in Great Britain in 2018 by William Collins.

A hardcover edition of this book was published in 2018 by William Morrow, an imprint of HarperCollins Publishers.

FIRST WILLIAM MORROW PAPERBACK EDITION PUBLISHED 2019.

Designed by Fritz Metsch

Map © Martin Brown

The Library of Congress has catalogued a previous edition as follows:

Names: Corera, Gordon, author.
Title: Operation Columba : the Secret Pigeon Service : the untold story of World War II resistance in Europe / Gordon Corera.
Other titles: Secret Pigeon Service.
Description: New York, NY : William Morrow, [2018] | Includes bibliographical references and index. | Description based on print version record and CIP data provided by publisher; resource not viewed.
Identifiers: LCCN 2018017421 (print) | LCCN 2018039485 (ebook) | ISBN 9780062667090 (ebook) | ISBN 9780062667090 (ebook) | ISBN 9780062667076 (hardcover)
Subjects: LCSH: Great Britain. MI6—History—20th century. | Homing pigeons—War use—Great Britain. | World War, 1939–1945—Military intelligence—Great Britain. | World War, 1939–1945—Communications. | World War, 1939–1945—Underground movements—Belgium.
Classification: LCC D810.S7 (ebook) | LCC D810.S7 C635 2018b (print) | DDC 940.54/8641—dc23
LC record available at https://lccn.loc.gov/2018017421

ISBN: 978-0-06-266708-3 (pbk.)

19 20 21 22 23 RS/LSC 10 9 8 7 6 5 4 3 2 1

In memory of Leopold Vindictive
and others who made their choice

CONTENTS

Map . ix

Prologue . 1

Introduction . 5

1: Birth . 13

2: The Special Pigeon Service 27

3: Leopold Vindictive 49

4: Arrival . 67

5: Listening 81

6: Battle of the Skies 93

7: Reaching Out 107

8: Resistance 119

9: Secret Agents 133

10: Undercover 155

11: Battle of the Skies II 169

12: Capture . 181

13: Interrogation and Infiltration 191

14: The Viscount 211

15: Trials and Tribulations 233

16: Deception 247

17: The Americans Are Coming 259

18: Fates 283

Acknowledgments 301

Notes 303

Index 323

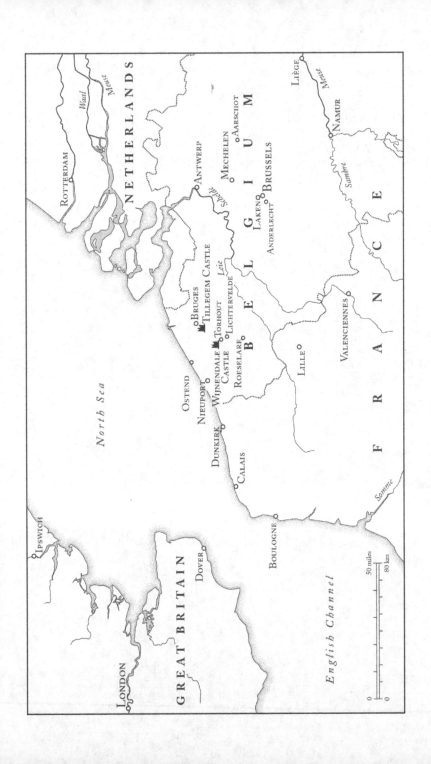

OPERATION

COLUMBA—

THE SECRET PIGEON SERVICE

Prologue

THE BELGIAN FARMER could see there was something odd in his field, something that did not belong there. It was early on a July morning in 1941, just over a year after Nazi tanks had swept through the country. As he stepped closer the farmer could make out that the unfamiliar object was a small container with a length of white material attached. Picking it up, he realized the material was a parachute—but one too small for a man. Inside the box he could see something moving and a pair of eyes that peeped out at him through a small opening. Next came the unmistakable sound of a pigeon cooing. Attached to the side of the container was a message—a request for help. The farmer decided this was something that he needed to consult his wife about.

It was a moment of peril—one that many a British pigeon did not survive. The message made clear that this was no innocent pigeon but a very dangerous bird. It was a spy pigeon that could get the farmer and his wife killed. At this crossroads in the war, many faced with the same discovery across northwestern Europe would decide it was better that the pigeon died than they did. Often villagers would make the choice more palatable by roasting and eating the bird. Others went straight to the local police station or to their Nazi occupiers and took the reward on offer

for surrendering one of these pigeons. That July morning, half a dozen other birds dropped in nearby Belgian fields would be handed over to the authorities out of fear or greed.

But this farmer and his wife were not like the others. And so the first in a series of small choices was made. The wife set off by bicycle, hiding the container in a sack of potatoes. She had an idea where to go. The small local town of Lichtervelde was, like Belgium as a whole, divided by Nazi occupation. The split was delineated by alcohol. Those who frequented a local pub called De Keizer were known as whites—they thought of themselves as "patriots," meaning they were against the occupation. Meanwhile, those who frequented De Zwaan were blacks—nationalists who often wore black shirts and sympathized with the Nazis. Everyone knew who was who and what side they were on.

The farmer's wife parked her cycle by a grocery shop on a corner a few streets from the center of town. She carried in the sack of potatoes—nothing suspicious, since it was part of the regular drop-off of supplies for the shop's owners. But she also handed over the spy pigeon to the family who ran the store. Why them? For two reasons. Everyone knew the Debaillie family were patriots—three brothers and two sisters, plus assorted relatives sent to them for safety during the war. But there was another reason. One of the brothers, Michel, was a pigeon fancier.

The brothers and sisters gathered around as Michel—gangly, with a mop of unruly curly hair—carefully took the bird out. Like any pigeon fancier, he knew how to hold it tenderly but firmly. With the bird were a small sack of feed, two sheets of fine rice paper, a pencil, a resistance newspaper and a questionnaire. The questionnaire, like the pigeon, was from England. It asked for help—specific and dangerous help.

It was time for another decision, one that would shape the course of lives for this family and others: To help or not to help?

To spy or not to spy? To resist or not to resist? Not all were sure. Michel's younger brother wanted to act. The elder thought it was dangerous. But collectively, they made their choice. If they were patriots, they were patriots.

What did they know about spying? Nothing, really. But they had some friends who might be able to help. One was a former soldier from the First World War who had a fascination with military maps. The other, more surprisingly, was a priest. By the next day, these two had arrived in the corner shop and were inducted into the secret of the pigeon. An amateur spy network, consisting of a band of friends, had been born, driven by a desire to do something about the Nazi occupation that blighted their homeland. For the first friend, the former soldier, the bird was a thing of beauty at which he marveled, reminding him of the pheasants he kept at home. For the priest, the rice paper was what lured him in. It was like the type of paper on which he had learned to write characters in China a decade and a half earlier. And it was like the paper he had used to draw maps of German positions in the last war. And so, he knew, the paper and the pigeon were drawing him into the world of espionage—to make him once again priest, patriot and spy.

Introduction

Like the farmer in the field, I stumbled across the oddities of Operation Columba by chance one morning. I was covering a quirky news story about the leg of a dead pigeon found in a chimney in Surrey. Attached to the bony leg was a message that had stumped top code breakers for Britain's Government Communications Headquarters (GCHQ). They had been unable to decipher what the seemingly random series of letters meant. No one was even sure who the pigeon had been sent by, and everyone seemed quite surprised to find that pigeons had been used in the Second World War.

Perhaps there was some clue in the British National Archives in Kew that could unlock this pigeon's secrets. I spent a morning pulling up any and every file that looked as if it might relate to pigeon messages in the Second World War. There were more than I thought, and it was a bewildering introduction into a world I had never even known existed. But among the interminable accounts of which department should pay for pigeon feed, or what rank of personnel was required for a particular RAF loft, one file that landed on my desk immediately stood out.

Apart from the dates, the front cover bore only two words. One was "Secret"; the other, in elegant handwriting, was "Columba."

At the top was a photo of a pigeon someone had cut out. Just below the pigeon was a cartoon—also cut out, this time from a newspaper—of Hitler lying prostrate on the floor. This gave the impression that the pigeon had done on Der Führer what pigeons do, leading him to fall over. At the bottom of the cover was another cartoon, this one of an RAF plane flown by Winston Churchill with a familiar cigar in his mouth and his fingers held up in his V for Victory sign. The file clearly contained details of a secret operation. But it looked utterly unlike any I had seen before. What kind of people would, in the middle of a war, encase the contents of their clandestine work in such colorful—even playful—packaging?

Loosening the ribbon that bound the file, I uncovered riches inside. The file had nothing to do with the secret message found in the chimney. But it was far more interesting. The riches came in the form of tiny pink slips of paper. These were messages from ordinary people living under Nazi rule in occupied Europe that had been brought back by pigeon. They were filled with the day-to-day realities of wartime and offered a remarkable insight into the small frustrations and dark tragedies of life under occupation. And then I came across Message 37. It was unlike anything else. All the other messages had been written up into formal notes, but in this case a copy of the original message had been included in the archive, clearly because it was something special. It looked more like a work of art than an official document. There was tiny, beautiful inky writing, too small to read with the naked eye and densely packed into an unimaginably small space. A swirling symbol as a signature. And maps, detailed colorful maps. Most of the other messages produced intelligence reports that were half a page or perhaps a page long. Message 37—rolled up tightly into the size of a postage stamp so it could fit into a cylinder attached to a pigeon's leg—produced an astonishing twelve pages of raw intelligence. And it had clearly

had a profound impact on the team running Columba. The intelligence must have left an impression on everyone who saw it—and many did, as it was passed around the highest levels of government, many referring to it in almost reverential terms.

But there was a mystery: Who had written it? And what had happened to them? The files had no answer. There was only a code name—Leopold Vindictive—on the message. Other documents contained confusing references to attempts to contact the writer after the message had been received. In none of them could I find a name. Nor was there any reference to the author in the history books I consulted. I knew I had to find out. The quest became something of an obsession. Who or what was Leopold Vindictive? And what was his—or her—fate?

Three years after first opening that file, I found my answer in Belgium. The answers lay partly with the families of those who had been members of Leopold Vindictive and who had preserved their story. In one house in a small town, a family opened up a metal keepsake box. Inside was a treasure trove of photos, maps and—most startlingly—the raw intelligence that had been collected to send back to Britain. Some of it had formed the basis for my Message 37, but even more surprisingly, there was much more that had never made it over the Channel. Alongside those artifacts, I found a human story more dramatic and more powerful than I imagined. It is a story that has not been told before and that has had to be pieced together from personal accounts and archives in Britain and Belgium. It is the story that forms the centerpiece of this book, around which the wider story of the operation called Columba is told.

The pigeon is not the most obvious subject about which to write for someone interested in intelligence. It is fair to say that the birds had not exactly stirred my interest before. Pigeons have a bad name. Quite literally, since if we preferred to call them by

their proper name—doves, or, to be more precise, rock doves (or, most formally, *Columba livia*)—they might be seen in a less negative light. Our perception of the pigeon is colored by the times we have chased them as children or have evaded their droppings as adults. But our experience of "feral" pigeons has obscured from us the truth that some pigeons are a form of superhero. Imagine being blindfolded and then taken hundreds of miles from home—perhaps even to another country across the sea. And then suddenly having the blindfold removed and, despite not having the slightest idea where you are, racing home at top speed. Even if home is six hundred miles away. That is not normal. Just like the superpowers of comicbook heroes, the homing instinct of pigeons is something that scientists cannot explain. They have tried over the years, with theories about magnetic fields and the sun, but no one has satisfactorily managed it.

It is a strangely comfy superpower though. The pigeon is not on a mission to save the world. It just wants to go home. From the age of six weeks, pigeons can be taught to "home" to the loft from which they make their first flight because they understand that is where they will find food, water and company. Pigeons can be picky in their journey—they do not like to fly at night or to cross water, often flying along the coast to find the shortest point at which to cross a body like the English Channel. But they are ultimately single-minded in simply wanting to get back to where they belong. Amid the horrors of wartime, this longing has a particular resonance.

Over the course of human history, this superpower has been recognized by people who have learned to employ it for communication by releasing pigeons to send messages home. Noah released a dove from the Ark to bring back reports of whether the floodwaters had receded. In ancient Greece, the names of winners in the original Olympic Games were sent to distant

towns by pigeon. Julius Caesar used birds during the conquest of Gaul (the Romans had, at various times, a fad for breeding pigeons, but that seems largely to have been in order to eat them). The sultan of Baghdad used a pigeon post around 1150. In the nineteenth century, Julius Reuter began a news service using pigeons to send messages between Brussels and Germany. In Paris, pigeons were the only form of contact with the outside world during its siege in 1870–71. A manned hot-air balloon flew out of the city under fire carrying pigeons. Friends and family (including those in Britain) could post their letters to the city of Tours, where they would be photographed and then reduced to the point where one of the pigeons could be loaded with a film containing 2,500 messages before it flew home to Paris. A magic lantern would project the messages onto a screen so they could be copied out and sent to the recipients.

The modern sport of pigeon racing began at the start of the nineteenth century in Belgium. Clubs were formed as pigeons were carefully selected and bred to improve their abilities. The breeding extended their range from 40 miles to 200 miles and then upwards to 600 miles or more. The peak popularity of the sport came in the years before and after the Second World War; at least a quarter of a million Belgians were involved, and one in nine families had a pigeon. Lofts were present in almost every small town and village in northern France and the Low Countries, across much of Britain and in the United States.

Breeding pigeons to improve their ability (or their looks) was honed to a fine art by pigeon fanciers, or—to give them their proper name—the *fancy*. Pigeon keeping has come to be seen as a working-class preserve, the "poor man's racehorse," a sport offering the chance to train an animal, enjoy a social life around meetings and even perhaps win a bit of money on the side. Historically, it was also a sport for the well-off, which is why so many country houses

had dovecotes and pigeon lofts. The Queen still has her own pigeon loft at her estate in Sandringham, the first pigeons a gift from the Belgian king. At the start of the Second World War, these pigeon owners—rich and poor alike—were called on to play their part in a remarkable and little-known volunteer effort. Total war demanded sacrifice, and pigeons and their owners played their part.

Pigeons did not win the war. People did. And this story is not so much about the birds as about the people who sent and received the pigeons of Columba. Yet, in a war that began with Blitzkrieg and ended with the atomic bomb, pigeons had a unique place when it came to intelligence gathering. Intelligence involves understanding your enemy—the disposition and composition of their forces, the lie of the land and the mood of the people. There are many ways of finding this out, the oldest being to use human spies who can see what is happening. But in this war there was a crucial challenge: How did your agents get the information back from behind enemy lines? Long before modern communications tecÿology, the near miraculous ability of trained pigeons to return to their home lofts offered an unusual but highly effective way of receiving news and communicating.

Columba ran from April 1941 until September 1944. A total of 16,554 pigeons would be dropped in an arc from Copenhagen in Denmark to Bordeaux in the south of France. Casualties were heavy. Some were lost on planes shot down before they had a chance to be released. Some lay unfound in a field. Others fell into enemy hands. Some were eaten by hungry locals. Others were released but never made it back. The pigeons had to race through storms and battle against their nemesis—the hawk—to come home with their precious cargo. They returned with their messages to a quirky and quarrelsome band of British spymasters-cum-pigeon fanciers who did their best to prove the worth of their special operation against bureaucratic hindrances, institutional

skepticism and bitter personal rivalries. The story of Columba—
and particularly that of its most important message—does not
always shine a particularly happy light on the inner workings of
British intelligence, revealing divisions often overlooked in rose-
tinted accounts of the war. The harsh reality is that brave men
and women in the field were sometimes let down by London.

The messages Columba's pigeons carried, though, would
prove their worth. Messages like Number 37 provided vital intel-
ligence on Nazi plans to invade England during its darkest hour.
Others brought news of the latest German weapons and paved
the way for D-Day and victory in May 1945. Still other messages
were more personal, like the letter from a crashed RAF airman
to his mother.

Who were the people who provided this rich seam of intel-
ligence? Some were trained agents. But most were simply local
villagers who made a choice to undertake their own small acts
of resistance. As a result, their messages—sometimes tragic,
sometimes comic—provide a unique and untapped insight into
the realities of daily life under Nazi occupation, from the struggles
over food to the attitude toward collaborators, and even the of-
ten terrible impact of Allied bombing on those living under oc-
cupation. They offer the authentic voice of the villagers of rural
France, Belgium and the Netherlands and their calls to Britain
for help.

The pigeon was simply doing what it did by its nature. It
knew nothing of the war that raged around it. But for those in-
volved in Columba, the values of sacrifice, duty and a love of
home all came to be embodied in the humble pigeon's flight.
The living creatures offered a unique bond. For the British com-
mando dropped with a pigeon behind enemy lines and in fear
for his life, the sight of the bird flying off to a suburban garden
with a message that he was safe offered a connection to home

from a dangerous foreign field. And for a Frenchman or -woman or a Belgian living under occupation, there was the knowledge that the pigeon they released up into the sky was racing back to its home, bearing their message, to a land still free. This was the secret of Columba.

1

Birth

THE PIGEON THAT fell in the farmer's field near Lichtervelde in July 1941 had begun its journey a day and a half earlier. Home was a loft in a large garden on Lattice Avenue, a quiet suburban street in Ipswich full of recently built houses. The bird had been plucked from its loft and handed over by its owner. Owners were told nothing of where a bird was going or what it would be doing. All they knew was that it was something secret for the war effort.

Soon the bird had company. Our pigeon and its fellow birds were driven in a van about forty miles to Newmarket racecourse. There, each pigeon was placed in its own special box with a parachute attached. A tiny green Bakelite cylinder—about the size of a pen cap—was placed around its leg.

Newmarket was home to a top secret RAF squadron whose job was to carry out "Special Duties" for British intelligence. In the summer of 1940, MI6 had approached the Air Ministry to ask if it could help drop agents behind enemy lines. The first attempt to land an agent in Belgium using a small Lysander plane ended in disaster on August 18, 1940. The plane was unable to touch down and was lost on its return flight, killing both pilot and agent. But the RAF persisted and began to use a mix of Lysander landings and parachute drops to deliver agents. The crews were trained

in the dangerous task of night flying over enemy territory using moonlight. The hours before takeoff would be spent memorizing the locations of rivers, lakes, railway lines and forests. The moonlight allowed crewmen to read their maps and guide themselves by the landmarks they could see below.

The drop of our pigeon on that July night was a minor add-on to the primary secret mission of parachuting two agents into Belgium. The pilots, Ron Hockey and Ashley Jackson, took off in their Whitley from the racecourse and headed over the Channel into Nazi-occupied Europe. Enemy searchlights lit up the plane as it reached Nieuport on the Belgian coast—not far from Dunkirk, where the previous year small boats had played a vital part in rescuing the British Expeditionary Force from destruction. Anti-aircraft fire opened up from the ground, but the pilots pressed on. They headed inland toward Charleroi, south of Brussels. As they did, they passed over a field in Ardoye, near Lichtervelde. This was our pigeon's moment.

The flaps of the aircraft were lowered and one of the team grabbed the container. The best height from which to drop was between 600 and 1,000 feet, at a speed of about 180 miles an hour. The pigeon was rudely ejected. "We tried to be very humane and give them a good drop," an RAF pilot remembered of the process.

The plane went on to Namur and Saint Hubert but the crew realized they were lost and had to abandon the agent drop, returning home after a five-hour trip. The next night they tried again but the mission went disastrously wrong. The parachute of one of the agents caught in the plane as he leapt out over Belgium. He was left twirling out of the back like a puppet on a string. The crew were unable to reach him as his body repeatedly slammed against the side of the aircraft. By the time they returned to Britain, he was dead and his battered body was dropped into the sea the next night.

Crews, as well as agents, took enormous risks—their life expectancy was lower even than that of those who flew bombing missions over Germany—and with their gallows humor they enjoyed regaling each other with stories of derring-do. They found Columba a rather amusing and odd little sideshow. "Pigeons were dropped in a small parachute container, their heads just visible through the top of it," one pilot recalled. An agent might sometimes have second thoughts about parachuting into some dark, snowy wilderness, but the pigeons were given no choice. "I doubt if any of them survived," the pilot reflected.

But the bird dropped near Lichtervelde did make it. The primary mission of that flight to drop agents might have failed, but the pilots would not have known that the train of events set in motion by the pigeon they had pushed out would end up with intelligence landing on Churchill's desk. The parachute deployed and the pigeon fell gently into the dark field, ready to be discovered by a farmer the next morning.

This was Columba—the Secret Pigeon Service.

THE DRIVING FORCE behind the use of pigeons in the Second World War were two men with experience of the previous war. One was a leading member of the fancy—the community of pigeon fanciers in the country—whose ambition would drive deep fissures within the pigeon world. The other was a washed-up spy looking for one more chance to make a difference.

The name of Osman is to pigeon racing the equivalent of Kennedy in American politics: a family dynasty stretching back for decades. The founder of that dynasty was Lieutenant Colonel Alfred Henry Osman. Stout, with a proud mustache, Osman had abandoned a career as a lawyer to found the publication the *Racing Pigeon* in 1898. In the First World War, he brought his personal passion to bear as the leading light in all matters pigeon.

A hundred thousand pigeons were bred for use in the war. First deployed on trawlers commandeered to carry out minesweeping in the North Sea, one brought news of a Zeppelin heading toward Britain. Another was released by a skipper who lay mortally wounded on deck after a U-boat attack, which led to his crew being rescued.

Pigeon use quickly expanded across all the services. The army used them for communicating short distances from the front line, especially when cables had been cut or visual signaling was impossible owing to smoke or when a runner carrying a message had been shot. "If it became necessary immediately to discard every line and method of communications used on the front, except one, and it were left to me to select that one method, I should unhesitatingly choose the pigeons," wrote Major General Fowler, chief of signals and communications of the British Army, after the war. "When the battle rages and everything gives way to barrage and machine gun fire, to say nothing of gas attacks and bombings, it is to the pigeon that we go for succor."

Belgium had the best pigeon service but had destroyed many of its birds at the start of the war to prevent them falling into German hands. The French released five thousand birds during the Battle of the Somme. The Americans took home and eventually preserved one bird that had arrived badly wounded with a message that saved a battalion trapped behind enemy lines.

The British Army Pigeon Service was disbanded not long after the war. But as the 1930s turned darker and the threat of another war loomed, there were those from the fancy who saw themselves as voices in the wilderness, just like those calling for rearmament with tanks and airplanes. They urgently pressed the authorities to prepare to make use of pigeons once again. The leading advocate was Alfred Osman's son William. His poor eyesight meant he had been rejected from regular service in the First

World War, but he had worked with his father. On Alfred's death in 1930, William inherited his father's mantle as editor of the *Racing Pigeon* and leading proponent of the birds' value in times of war. In 1937, he wrote to the Secretary of the Committee on Imperial Defence saying it was a mistake to not prepare pigeon plans. The army said it saw little need, apart perhaps from their use for contact with isolated garrisons. The RAF thought they might need a hundred or so birds as an alternative means of communication— for instance, if a plane crashed or a radio was jammed. But that could be organized when war began.

Osman kept pressing. At over six foot, he had the bearing of an old-fashioned military officer and the manner to go with it— abrupt in a way that could easily be interpreted as rude. He did not suffer fools gladly. The next year he attended a meeting of the Committee on Imperial Defence and explained that it was a blunder not to have maintained a compulsory register of pigeon owners. His profound knowledge of pigeons was clear, but there was also an element of self-interest, as he proposed that an appeal for volunteers could be made through the *Racing Pigeon*, the newspaper he edited. It was agreed that a committee of four—including Osman—should start a National Pigeon Service, the NPS. It was to be riven by bitter infighting.

An immense voluntary effort was at the heart of Britain's wartime pigeon operations. It is hard to appreciate just how popular a sport pigeon fancying was at the time. There were a quarter of a million people involved, with at least 70,000 lofts, mainly concentrated in working-class areas. At the outbreak of war, all pigeons had to be registered. In Plymouth, Bert Woodman went to the city police to collect his permit to keep his pigeons. A middle-aged local food factory manager, he was typical of the working men who would play their part. The regimen was strict: All foreign birds and those without a ring to identify their owner were

destroyed. "There was a terrible slaughter," Woodman remembered. Registration was about control, but it also offered a route for those like Bert Woodman to volunteer for the new NPS. Two thousand signed up at first, but the membership would grow to include eighteen thousand lofts. NPS members agreed to offer at least twenty birds a month for national service, and membership was the only way a fancier could legally obtain food for his pigeons. Members were organized into local pigeon supply groups led by a pigeon supply officer—Bert Woodman would take on the role in Plymouth, where he also acted as adviser to the police. Membership offered a way to make a difference and was one of the many ways in which the Second World War became "the people's war" in which so many contributed. For one man, who had lost his brother in the last war but was now too old to fight, handing over his pigeons meant he could feel he was doing something for his brother's memory. Meanwhile, the children of a Nottinghamshire miner remember always being late for school on Tuesdays, as this was the day their dad was down the pit early and they had to excitedly wait for someone to come and pick up his pigeons for some kind of secret work. Pigeon keeping had been a largely male pastime, but many women also took over a husband's or son's loft as their loved ones served far away.

The Air Ministry was given the overall coordinating role for all matters pigeon, including the supervision of the NPS. Its pigeon section was run by the influential but insecure William Dex Lea Rayner, who was maneuvered into the job by Osman. Another veteran pigeoneer of the First World War, Rayner had gone on to run military pigeon operations in Ireland (soldiers battling against Irish Republicans would sometimes send news by pigeon that they were under attack). He then operated his own pigeon stud list in Norwich before becoming a somewhat hard-up dance band manager. Balding, with an oval face and sharp nose, he was birdlike

in looks and was determined to maintain his position as pigeon supremo. He would be at the center of "pigeon politics" and some monumental feuds. This was especially the case once the army—rather than Rayner's own RAF—moved into the pigeon business when it saw the particular value of the birds in intelligence work. The army, not the RAF, would be Columba's master.

Osman had ensured that the humble pigeon had its place in the machinery of war. But he was not inside the spy world. And the pigeon's specific role in Columba—as a tool to get intelligence back from ordinary people behind enemy lines—was established thanks to the vision of Rex Pearson, a veteran of military intelligence in the previous war. But as the Second World War began, Pearson was a spy without a mission or role.

In the interwar years, Pearson had—to all appearances—left the intelligence game for a career in business. In Switzerland he had become the representative for the British firm Unilever. But that was not the full picture. In the mid-1930s, he had resumed his clandestine life. He was recruited into the Z organization. Z was the brainchild and code name of Claude Dansey, a powerful figure within MI6. Some called him "Uncle Claude" because, at first sight, Dansey looked like an elderly uncle, white-haired and with a general air of benevolence. That impression never lasted for those who got to know him. Dansey was an acerbic, sharp operator whose penchant for secrecy and intrigue made him as many enemies as admirers and left junior officers terrified of him. He had achieved his lofty position by trusting nobody. In the 1930s, he had realized that the Germans had worked out MI6's use of the Passport Control Office in British embassies to hide its undercover officers. That made MI6 officers easy to identify. So Dansey set about building his own network across the continent, using businessmen.

The Z organization was a parallel intelligence network, and

Pearson—a colleague of Dansey's from military intelligence in the First World War—was Z's man in Zurich. Dansey himself moved to Switzerland to run the network late in the decade. But in November 1939 he returned to London to supervise all MI6's European operations, leaving Pearson in charge in Switzerland. The results were disastrous. Chaos ensued as Pearson proved to be not up to the job. At one point he managed to send two different officers to the same rendezvous with a contact. His catastrophic performance may also have stemmed from the fact that he had a drinking problem. Heavy drinking was common at the time, but Pearson's intake seems to have been bad enough to have an adverse impact on his work. In February 1940, another MI6 officer was sent out to Switzerland to replace him.

Pearson returned to London, his intelligence career in apparent ruins just as the war was beginning. But in November 1940, he approached Military Intelligence with an idea. In the last two years of the First World War, he had been involved in a clever intelligence operation that he wanted to reprise. It involved pigeons. He was met, perhaps unsurprisingly, with a degree of bewilderment bordering on annoyance from the higher-ups. Pigeons were an "outmoded" weapon in Britain's armory, he was told. But Pearson persisted, and he explained to his superiors what he had gotten up to in the last war.

The first lesson from that war was that pigeons could be used for the core business of intelligence gathering. The intelligence the military wanted included things like the disposition and movement of enemy forces. If trainloads of soldiers were seen heading to a particular station, for instance, that might mean the Germans were about to make a push on the front at that point. Networks of agents had emerged, especially in Belgium, to collect this information in the previous war, but the biggest challenge had been getting their information back from the other side. MI6

had employed couriers and specialist *passeurs* ("line crossers"), whose hazardous work involved cutting and crawling through barbed wire, wearing rubber boots to avoid being electrocuted, while carrying details of German forces.

Inventiveness was at a premium. A colleague of Pearson had developed a system in which messages were written in invisible ink on banknotes and dropped in offertory boxes in Catholic churches, which were allowed to be taken across the front lines. Another officer was convinced that by standing in front of an oven and moving back and forth he could send "infra-red rays" to signal in Morse code. Animals were another possibility. The pigeon with its homing instinct seemed an attractive option, and it was soon employed to carry intelligence back from agents.

But Pearson explained that he had been involved in a further innovation. What about not only using pigeons to send back intelligence from existing agents, but to actually recruit people to gather intelligence in the first place? There were sympathetic people on the other side who wanted to help. The challenge was finding them and then getting their intelligence back. In the First World War, small hydrogen balloons had been sent out downwind from the British side of the front lines to any district where it was thought German forces were concentrated. Normally seven balloons were released in a night, each holding four carrier pigeons in their own basket with a parachute. At first, the baskets were attached to a cross-shaped device with an alarm clock in the middle. When it reached the right hour and rang, it would release the parachutes. Later, a slow-burning fuse was employed.

Attached to the pigeons was an envelope containing a patriotic appeal and a questionnaire asking whether the Germans were present and in what numbers. This could be filled in by locals and then clipped back onto the pigeon's leg. By breakfast time, a quarter of the pigeons released at night had normally returned, half

with messages. It bothered the Germans enormously. The chief of the German intelligence service had complained about their use, and fourteen days' leave was promised to any German soldier who shot a pigeon down. At least eleven were shot and found to be carrying important military information.

Pearson had been in charge of all balloon operations in France by the end of the First World War. Now he wanted to do it again. And better.

What Pearson had in mind this time was much more ambitious. In the previous war, the pigeons had typically flown only fifteen or twenty miles across the front lines. Balloons dependent on the wind might be fine for delivering pigeons over enemy lines that were sometimes close enough to observe. But in this new war, the challenge was much greater. Pearson wanted to see if pigeons could make it all the way from occupied Europe, over the Channel or North Sea and back home to England. The challenge of getting the pigeons to the target zone in the first place could be solved by dropping them from planes rather than balloons. The chances of their return home would depend entirely on the skill of the birds.

Pearson pressed his case, against considerable resistance. His old service, MI6 (officially designated the Secret Intelligence Service, or SIS), which recruited agents to provide information abroad, was dismissive. It thought so little of the prospects that it said it wanted absolutely nothing to do with the idea and refused to cooperate. But Military Intelligence—based at the War Office and reporting to the army and separate from MI6, which reported to the Foreign Office—eventually relented. It was a long shot but Columba, as the service was christened, offered the tantalizing chance to establish contact with untapped sources that Britain could reach by no other means. Pearson was appointed officer in charge of the Special Continental Section of the Army

Pigeon Service, and soon a grandly titled Special Section (Carrier Pigeon) team was set up in the Royal Corps of Signals. Pearson would organize the logistics. Any messages that arrived back were to be forwarded to a Military Intelligence team at the War Office. This meant Columba was rooted in the army and not in the RAF—a source of abiding tension.

The first experimental pigeon drops took place at the end of 1940. Pigeon owners were told as little as possible about why their birds were needed. Early trials focused on how to transport the pigeons—and whether "head down" or "tail down" was better to avoid tail feathers being frayed. By January, a new container made their journey somewhat more comfortable as six birds were dropped from a Lysander plane at 130 feet. The parachute opened perfectly and the landing was gentle, but the container rolled over two or three times after reaching the ground. The pigeons did not appear "unduly frightened," it was noted. They were given two minutes to recover before being liberated. Visibility was poor, so the birds circled for nine minutes or so trying to get their bearings before heading off to Aldershot. They covered ten miles in about fifteen minutes.

By April 1941, Columba was ready. Each pigeon container would be attached to a three-and-a-half-foot parachute. On the outside of the container was an envelope with a questionnaire, some rice paper for the return message and—thoughtfully—a pencil, as well as a bag containing half a pound of pigeon food. Instructions explained that the parachute must be disposed of and that the pigeon should be fed an eggcupfull of corn a day and allowed to stretch its wings a little.

The questionnaire would be in French or Dutch, depending on the drop site. It included a rundown of the information Britain sought, compiled by the organizations that were customers of Columba's information—Military Intelligence, the Air Ministry, the

Admiralty and the BBC. Top priority was anything on a planned invasion of England, followed by details of any troops in the area, enemy morale, significant addresses the Germans were using, the locations of airfields, the effect of any recent bombs dropped by the Allies and finally—in an example of early audience research— the extent to which people could hear BBC radio clearly and their views of the service it provided. It ended with the words: "Thank you. Take courage. We will not forget you."

Instructions showed how to properly clip the small green cylinder onto the pigeon's leg again once the questionnaire had been filled in. Also enclosed was a copy of the latest edition of either a French, Belgian or Dutch resistance newspaper printed in London (or in some cases the *Daily Mail*). The idea was that this would provide assurance to the recipient that the bird had come from England and would return there when released.

No one was quite sure it would work. One official reckoned there were four options for a pigeon. It might not be found and simply die. It might be picked up by a local, as hoped, and a message sent back. It could be picked up by the Germans and dispatched back with a fake message. And there was a final option: "They may be picked up by a hungry patriot and find themselves in a pigeon pie." The skepticism was shared by the RAF pilots who were asked to drop the birds. Perhaps reflecting their own sense of humor, they were convinced that any questionnaires that did come back would be filled with obscene messages from the Germans. But most, they thought, would not even get that far. "In our jaundiced opinion most of them ended up on the dining table!" a pilot reckoned. That may have been true for many of the birds. But not all.

On the night of April 8, an RAF Whitley took off from Newmarket making for Belgium on Columba's first run. The plane was attacked by anti-aircraft fire near Zeebrugge, but the Germans on

the ground were wide of the mark. The rear gunner on the RAF flight even managed to take out one of the searchlights. The plane headed for the Franco-Belgian border and the dispatcher was told to "commence operations." The pigeons in their containers were pushed out.

At Columba's HQ in the War Office, they sat and waited.

2

The Special Pigeon Service

I N THE BOWELS of the War Office, two men waited anxiously for the first signs that Columba would work. Everyone has heard of MI5 and MI6, the domestic and foreign intelligence services that survive to this day. Some may even have heard of MI9—the wartime department that helped Allied servicemen escape from behind enemy lines. But few will have heard of MI14—let alone its subsection MI14(d) and its "Special Continental Pigeon Service." Perhaps that subsection's lack of fame is understandable, given that in 1941 it comprised a crack team of just two. But the little-known MI14 department to which those men belonged had arguably one of the most important tasks of the war. Its mission was the first priority of intelligence—to know the enemy.

When the war began in 1939, the entire staff devoted to evaluating information about the Nazi war effort and its day-to-day battle strategy amounted to a grand total of five officers across MI14. The initial estimates of German military strength were way off the mark: Britain thought the Germans had fourteen hundred medium tanks, for example, when there were only three hundred. That kind of knowledge had serious repercussions when it came to understanding the fight that lay ahead, and whether and how it might be won.

Initially operational intelligence on the enemy sat within the department known as MI3, which was broken down into different departments. MI3(b) looked at Italy, while MI3(c) looked after the Soviet Union and was staffed by two Russian-speaking former brewers who despised the USSR more than they did the Germans and who were consistently wrong on every issue. Intelligence on Germany became so important that it merited its own separate team, so it was hived off to become MI14. Initially the small team consisted of a rich array of old-timers from the First World War who were not quite up to it, alongside a new batch of often eccentric but more talented younger men.

MI14 was itself broken up into smaller units populated by an array of oddballs and professors who had come into the military from civilian, often academic, life. One section investigated German strategy and intentions. Another, led by a former English team cricket captain, looked at German anti-aircraft positions. A professor who had studied the Roman army's order of battle two thousand years ago now did the same for the Wehrmacht, the German army. As seems customary in British intelligence, MI14 even had its own Soviet mole in Leo Long. He had been recruited at Cambridge and was, unbeknownst to his colleagues, passing on their secrets to Moscow via Anthony Blunt. The teams worked all hours dealing with a constant stream of queries and requests from different parts of the armed services. Which were the best targets to attack in Germany by air? Where was this or that Panzer division? How was the German army reacting to British propaganda?

The specific task of MI14(d) was to understand the German occupation of western Europe, including the deployment of its forces and the work of its secret services. And it was in this team that Columba found its home.

Brian Melland was the man in MI14(d) who oversaw Columba

for much of its life. Melland was described by a colleague as a "theatrical character." He was a convivial figure, a brilliant comic and mimic around the dinner table, who could quickly go from fooling around to focusing on the most serious matters with a fiery moral indignation. The theatrical description, moreover, was literally rather than just figuratively true. He had been born in 1904 in Paris, where his father had fallen in love with a French pianist. After studying French and German at Cambridge, he had begun a rather conventional career with Shell Oil. But after five years he realized he was bored and gave it up for his first love, acting. He spent eight years before the war treading the boards as a professional actor in repertory theaters in Manchester. He was married in 1938 and his son was born just as the war was beginning. Melland had hoped to join the navy, but when that did not work out he walked across the road to the War Office; thanks to his language skills, they put him straight into Military Intelligence. With his dark hair parted on the side, he was handsome but also smart and diligent. He would become the leading British expert on the German military and the go-to man on German documents. This meant he became involved in interrogating captured Germans. In the summer of 1941, just as Columba was starting up, a secretary came into his office. In her strong cockney accent, she said there was a "Mr. S." whom Melland needed to go and see urgently. It turned out she meant Rudolf Hess—the deputy Führer, who had just landed in Britain.

The second member of MI14(d)'s double act was L. H. F. "Sandy" Sanderson. He had joined MI14 in January 1940, after being told he was too old to return to the Highland Division, in which he had served in the First World War. The fact that he spoke excellent German would be put to good use. Lean and mustachioed, Sanderson had served as a business executive between the wars. "He looked like a friendly, alert terrier," recalled Noel

Annan, who had been recruited into MI14 as a twenty-four-year-old on New Year's Day in 1941. It can be surprising to realize the inexperience of the quickly expanding British intelligence world in the early years of the war. But in some cases, it drew in people who brought their own skills and experience. That was true of Melland and Sanderson.

The MI14 team, whose initial five officers would grow to more than fifty, lived what Sanderson called a "troglodyte existence" in the bowels of the War Office. This created something of a bunker mentality, especially as their job was to immerse themselves in their enemy's thinking. They sometimes feared that their combination of dedication and humor might lead to confusion and even suspicion among those not part of the team. "We had in this large basement a great picture on the wall of Hitler with the inscription 'Heil dem Führer,'" Sanderson later recalled. "We often spoke German among ourselves for fun or practice and I wondered what a British passerby in Whitehall would have thought, had he witnessed the scene."

Amidst the humor and camaraderie, MI14's work could not have been more serious. In six weeks during May and June 1940, France, Belgium and the Netherlands had all collapsed. There was now one crucial question to which everyone from Churchill down to the man on the street wanted the answer: Was Britain next? Were the Germans about to invade? This became the overriding mission for MI14 in its early days. Few tasks could have been more important. The fear was that the Germans would simply follow through and head over the Channel. At the end of May 1940, an urgent telegram went to coastal stations saying all defenses had to be manned through the night since an invasion was considered imminent.

From June 1940, Sanderson was made responsible for all army intelligence relating to the invasion of the UK. He was the only

officer on the Invasion Warning Committee who worked full time looking for "indicators"—warning signs that meant the worst was about to begin. The committee met every day at noon at the Admiralty and at one o'clock would issue a single sheet of paper that summarized all the intelligence that had come in over the last twenty-four hours. It aimed to answer three simple questions: Where, when and how would an invasion take place? That piece of paper would go up to the chiefs of staff and to the prime minister himself. The team would hold their breath for any outbursts from Churchill. Normally, by three o'clock they knew they could breathe out if nothing had been heard.

In June 1940, Churchill had prepared the public for the possibility that German troops might arrive over the Channel. "We shall fight on the beaches, we shall fight on the landing grounds," he had promised a nervous but resolute nation. The message is now remembered as one of defiance, but it was also designed to prepare the public for what many then thought inevitable. Posters were put up for public consumption titled "If the Invader comes— what to do and how to do it." The advice was simply to stay put.

The last invasion of the country had been in 1066, and Sanderson felt the public had no idea what total war would be like as ravaging armies moved across the British countryside. "Confusion and bewilderment might have led to disaster," he believed. "We felt that if we held out for a week we should do well." For all Churchill's talk, the secret British assessment was that if the Germans did manage to gain a foothold in Britain, there would be no chance of driving them back into the sea. The country would be lost. The army was short of equipment and the Home Guard was not far off its depiction in the BBC series *Dad's Army*, relying on pitchforks and golf clubs as weapons. Sanderson compiled a top secret handbook to help defending British forces know what to expect. (Although it did not remain so very secret, since someone

managed to leave a copy in a public lavatory in Dublin, and an Irishman handed it to the German embassy.) The army prepared an emergency pigeon service that would provide communications for defensive lines if all other links between HQ and forward units were cut.

There were also farcical attempts to undermine German morale. English phrase books were dropped by air upon German troops in France containing what seem comical phrases, such as "We are seasick—where is the basin?" "See how briskly our captain burns!" and "Why is the Führer not coming with us?" But there was little hiding the fact that the situation was desperate. If the Germans seized the moment, it might all be over.

On July 16, 1940, Hitler issued Directive No. 16, ordering his armed forces to prepare plans for Operation Sea Lion—the invasion. The German navy had been considering the challenge for close to a year. They reckoned if they could get an initial ten divisions, or about 110,000 men, over a bridgehead they could drive west of London to cut off the capital, forcing its surrender. German spies reported back to the high command details of coastal defenses between Dover and Brighton. The Germans also planned their own deception operation—as the British would later manage—in which they fed false radio traffic and intelligence to make it look as if a landing was about to take place in the northeast of England, reports meant to send defending forces the wrong way. The German D-Day was initially planned for September 1940.

The job of Sanderson and the MI14 team was to provide an early warning. Intelligence experts had said an attack on the Low Countries was probable—but they had never spotted any signs that it was actually beginning. Britain had been completely blind to the attack on Norway as well. The fear that there would be no warning when it was Britain's turn haunted the team at the War

Office. They were convinced Germany had completed all the necessary arrangements.

The British had no spy inside Berlin who could tell them when the order was given, so Sanderson's job was to scour whatever scraps of intelligence he could get his hands on to find any so-called indicators. For instance, the Germans would need barges and other vessels to carry troops across the Channel, so any sign of increased activity at ports in Belgium and France might be a giveaway (there were plans to bomb the ports if sufficient warning was received). Every moment mattered and might make the difference between the country's survival and its capitulation.

The sources Sanderson and MI14 could turn to for insights into German plans were scant. The intelligence picture was parlous. The pickings were so slim that at one point MI14 was instructed to see if an astrologer and water diviner, "Smokey Joe" from Yorkshire, might be able to help. The Enigma decrypts from Bletchley Park would eventually transform understanding of Germany's actions, but at the start of the war that effort was only just beginning and was yet to bear much fruit. In the dark early days there were only two real sources.

The first was age-old—human intelligence, courtesy of MI6. But their networks were an absolute mess at the start of the war. In November 1939, two MI6 officers had fallen into a Nazi trap and been captured at Venlo on the Dutch border. They were interrogated, with the result that much of the secret service's work in western Europe was compromised. The Nazi thrust through Belgium, the Netherlands and then France had compounded the disaster for MI6. No one had expected that those countries would collapse so quickly, so no one had prepared for the gathering of intelligence through underground networks under occupation. Almost all of MI6's existing networks had been rolled up, and the unit had to start virtually from scratch. Dansey and MI6 were all

too aware of the pressure they were under to deliver—especially since they now had competition from the newly formed Special Operations Executive (SOE), which was making a lot of noise carrying out orders to "set Europe ablaze."

The reputation of MI6—fueled by thriller writers even then—might have been fearsome, but the reality did not always match up. Brainpower was often lacking, as the emphasis was on a kind of schoolboy cunning. Hundreds of reports from MI6 regularly passed through Sanderson's tray in a single week, but many were likely to be rubbish. Some of the reporting Sanderson saw from MI6 was "quite ludicrous," he thought. One report in 1940 suggested German troops in Norway were training to swim ashore wearing green watertight suits and had been heard practicing on Scottish bagpipes. There was absolutely no reliable source in France reporting anything to MI6 until late November 1940.

Belgium, with its busy ports, was always likely to be a key staging post for an invasion of Britain. But MI14 was unconvinced by the reports that came in during the early months of the war. "Unfortunately, neither the agent in Belgium nor the agent in France inspire full confidence," the team noted of MI6's offerings. "The agent in Belgium may be described as enthusiastic, as well as painstaking; his frequent reports are alarmist in tone (some of his prophecies have already been disproved), and he has provided very few identifications." Along with the French agent, the two "can only be classed as among the least reliable of our whole body of sources."

A second source of intelligence for MI14 was new. Aerial reconnaissance was just emerging. From photographs taken at a height of 30,000 feet, Sanderson recalled, an interpreter in one case was able to not only see a football stadium on the ground but also provide a useful match commentary, reporting that during the interval of nine seconds between three photos, the team at the

end closest to a gasworks was being severely pressed by the other side as the opposition moved the ball a good twenty-five yards forward. An MI14 specialist could use photos to count the number of barges at Channel ports and look for changes. But there were limits to what could be seen from the skies. Interpretation by analysts was often tricky and filled with ambiguity. Bad weather sometimes meant there were many days when no flights could be made. The irregular timing of reconnaissance missions also made it hard sometimes to know from the pictures obtained what was changing and why. Movements on land were harder to spot than those of ships, since they often took place at night. There was also the risk of reconnaissance planes being shot down.

Air reconnaissance and "special methods"—a code for intercepts—might provide indications, but agents were the best means of reporting German intentions and identifying what the signs meant. There were at least fourteen ports that the Germans might use. Since August 1940, MI14 had been pressing MI6 forcibly to try and have agents placed in these ports with some means of communication, but so far it had failed to deliver. There were people in occupied Europe willing to help, and Dansey and MI6 were trying to drop or land agents into Europe to contact them, but the going was slow.

The biggest problem with human intelligence sources (other than the reliability of the source itself) was the delay before the information arrived in London. Getting agents in and out at the start of the war was difficult and dangerous. Radios were in their infancy, so intelligence often had to be smuggled out by hand, passing from courier to courier. This meant it could take months, and by the time it arrived an item of intelligence that might have once been valuable could be out of date. One MI6 officer complained that although he was receiving lots of reports from Belgium, the information "has been so old that they have become valueless." The

average time it took in the middle of the war for an agent's report to reach MI6 was nearly a third of a year. This was frustrating to analysts in London hungry for intelligence to help inform their decisions and improve their understanding of the enemy's capabilities.

IN THE SUMMER of 1940, the Luftwaffe had begun its campaign to destroy Britain's defenses—first targeting the RAF itself and then, in what became known as the Blitz, the capital city and other targets. In Plymouth, Bert Woodman watched as incendiaries rained down on the city, anti-aircraft guns roared in response and tracers lit up the sky. As local pigeon supply officer and also an Air Raid Precautions (ARP) warden, he found his pigeons in high demand, as police needed them in order to communicate when the telephone lines went down. The damage was fearful. "The bomber will always get through," prewar prime minister Stanley Baldwin had warned, and for a while it was feared he might be right. As war approached in the 1930s, desperate ideas had been thrown around to stop raids at night, when it was much harder to spot incoming bombers; one idea that was taken seriously was to floodlight the whole of southern England. Tecÿical intelligence on Germany's weapons—especially in the air—was vital.

MI6 as a whole was skeptical about pigeons as a method of gathering intelligence, but one person who worked at its headquarters would become Columba's greatest champion as he struggled to combat Germany's aerial power. He was not a spy but a scientist. When the war began, Reginald Jones—usually known as R. V. Jones—was one of those impatient new men who would rise fast because he understood how much warfare had changed. Jones, from a middle-class background in South London, had by the age of seventeen built a radio set that could pick up transmissions from Australia. He was ambitious and difficult to work with, but he knew what he was doing.

As fears of invasion gripped the country, Jones was sent from the Air Ministry to MI6 as a scientific adviser in its air branch. His mission was to detect as early as possible any new German weapon that might change the course of the war. Panic had gripped the intelligence community when Hitler made a speech claiming he had a secret weapon against which no defense could stand. Jones was ordered to find out what this mysterious weapon might be. MI6 files were crammed with wild rumors of "death rays." One inventor had been paid by MI6 to see if he could live up to his promise of developing such a ray, but his invention proved useful only for preserving fruit. Eventually, Jones asked for a new translation of Hitler's speech that had started all the fuss. He discovered that the context of the word for weapon (*Waffe*) had been mistranslated; what Hitler was referring to was his Luftwaffe, or air force, against which no one could prevail. Jones's inquiries, though, had taught him two lessons. First, the spies barely understood science. And second, the Germans knew the war in the air would be pivotal and were far ahead in utilizing the latest tecYology.

Jones found the old hands at Bomber Command complacently arguing that the use of their standard flying instruments along with a quick glance at the sky was enough to find targets. Jones did not make himself popular when he asked why, if this was the case, so many British bombers flew into hills during practice flights. And when German bombers began their onslaught, they seemed uncannily accurate—at least compared to the British—in finding their targets. What followed became known as "the Battle of the Beams." Through a series of clues and intelligence leads, Jones was able to work out that the Germans had discovered a successful way of guiding their bombers by means of radio beams, which the planes were able to follow. Aged just twenty-eight, Jones found himself briefing Churchill in the Cabinet Room, rebutting hostile

questioning from those around the table who doubted his ideas (including his former tutor, who was the prime minister's scientific adviser). But he won the argument, and British scientists began developing countermeasures, which included broadcasting their own beams to confuse the Germans' navigation. At the same time, the development of radar helped the RAF scramble to meet the German threat as the Luftwaffe began its campaign against Britain. It was the start of a scientific cat-and-mouse game that would last throughout the war.

Jones's forte was solving intelligence puzzles. In his hand would be a jigsaw piece that looked curious—say, a report of some kind of unusual German activity. First he had to find other pieces that might fit alongside it. Jones described an intelligence analyst as being a human with various senses—eyes in the sky in the form of aerial reconnaissance, ears listening at Bletchley, hands that could reach out from the Secret Intelligence Service. When the ears heard an unusual noise, then the eyes would turn toward the sound to find out more. Jones was hungry for every snippet of intelligence that might help him understand German technology, but, as with MI14, the sources were few. Pigeons would play their part.

The RAF's victory in the Battle of Britain meant the summer of 1940 passed without invasion. The Luftwaffe had proved a fearsome weapon but not, as Hitler had claimed, one against which it was impossible to prevail. The German navy had insisted that air superiority was a vital prerequisite for invasion. Nor had there been enough time to prepare the right type of craft to transport the Wehrmacht over the Channel. But the leadership of MI14 remained convinced that invasion was likely in 1941.

The job of detecting preparations was complicated by a German decision to keep up the constant menace of the possibility of invasion, so as to maintain pressure on Britain. This meant

Germany was ensuring that activity was visible and that fake intelligence was passed to Britain through military attachés and other channels. As the spring of 1941 began, the fear that German landing craft would soon be arriving on the British coast was still real. Sources reported details of such preparations as the training of parachutists and even the intensive manufacture of gas. By May 1941, MI14 was still seeing reports of a possible invasion, with June to August appearing to be the most likely time. Reports from Belgium talked of the training of troops wearing British uniforms and the possible construction of barges.

The reality was that Germany had backed away—but no one in London knew that for sure, partly because the intelligence picture remained so poor. Details of the German military position in Belgium and the Netherlands remained "very unsatisfactory," the director of Military Intelligence told MI6 in February. "We have no confirmed evidence of the number of divisions located at any time in these countries . . . With invasion more than likely at any time after a month from now this is a most serious situation."

Beginning in the spring of 1941, there was a new source for the analysts in London—Columba. For Brian Melland and Sandy Sanderson at MI14, Columba was not a source whose reports were passed on to them like the human intelligence of MI6. It was their own source. Rex Pearson looked after the logistics, but Melland and Sanderson were given the job of overseeing the operation. They were the ones who decided what questions would be asked in the questionnaire; in what areas the pigeons would be dropped; and who evaluated the material when it came back. They were able to handle the resulting intelligence directly. And—most remarkably—it was intelligence so fresh one could almost smell it. It would be in their hands within hours or days of someone observing something.

Two days after the initial drop in April, the phone rang at the

War Office. On April 10 the first bird had made its way home to Kent. Columba Message 1 was phoned back to Melland and Sanderson at the War Office at ten thirty that morning.

The message was from a small village called Le Briel in the commune of Herzeele in northern France, not far from the Belgian border. It might have been short but it contained real information. "Pigeon found Wednesday 9th at 8am," it began. "The German troop movements are always at night. There are 50 Germans in every Commune. There is a large munitions dump at Herzeele 200 meters from the Railway station. Yesterday, a convoy of Horse Artillery passed towards Dunkirk via Bambecque and another to Hazebrouck. The Bosches do not mention an invasion of England. Their morale is not too good. The RAF have never bombed these parts. They should come to bomb the brick works as the proprietor is a . . ." The next word is written up as "illegible" by the translator, but one wonders if that was actually to avoid the blushes caused by a cruder word the source might have used about a collaborator.

And then the message ended with one of those phrases that spoke of something in the spirit during those dark days in France: "I await your return, I am and remain a Frenchman." It was signed "ABCD34." This was precisely the type of intelligence the team had been after. It was a good start, a relief for the team that had backed Columba.

That same day at three o'clock came Message 2, this time unsigned, from Flanders. "There are only a few troops here and no petrol dumps, but yesterday some artillery arrived and the men say they are going to Yugoslavia where other troops and wagons are also moving." Columba was working, although it took another nine days for the next message to arrive.

The next drop took place on May 6 and was less successful. One message simply brought greetings from West Flanders. Below it was the slightly forlorn comment: "Through a mishap this bird

lost the questionnaire en route as did a number of others which have returned empty." Another from the same batch mentioned some airfields but, as would often be the case, provided too little detail to locate them.

Resistance is often portrayed as a stark choice: a choice between a life of danger on the run or one of collaboration. But in reality, it was a much broader spectrum. People could and did resist in small ways and large. That was evident from those who chose to take the risk to send a message back via Columba. Some of those early messages were short: "No troops here" was all one said, without indicating even roughly where "here" was. Others wrote just a few lines with a plea for help, while making clear the individual understood the risks involved. "Although this may cost me my head if one of the damned Boches saw me take the bird to my house, I will release the pigeon again with information for you," one wrote.

Most pigeons were found early in the morning by farmers tending their land. The messages sometimes showed daily rural life continuing as if war had barely intruded. "I found this pigeon on the 6th early in the morning while I was cutting clover for the animals and I have looked after it well and given it food and drink and am now anxious to know if the little animal reaches its loft . . . Hoping that I have possibly rendered you some service." Often the finders were illiterate or unsure of what to do and would confide in a local priest, schoolmaster or someone else whom they trusted. That was often when the best intelligence came.

In some cases the pigeons found their way to people already trying to organize some kind of resistance. In July 1941, a writer said he was part of a group of eleven patriots in a position to give important information. A parachutist who had recently been dropped above Carpiquet in Caen was safe and sound, but the person who had sheltered him had been denounced and was going

to be shot. "From now onward we will take direct action against such person in striking down anyone who betrays," the source wrote. Columba was revealing that there were many in Europe who wanted to do something—that some were willing to send a short message back, while others were already looking for ways to do more. There was potential there to be tapped.

Food was one recurring theme. The Germans requisitioned the majority of the food produced, and the results were severe. Messages spoke of hunger and starvation. One writer in May said the pork butchers had all been closed because the pigs had been sent to Germany and there was precious little other meat. "If it lasts much longer we must starve," one Belgian wrote, "try to free us as quickly as possible." In Brussels a writer said that the rations for the previous month had been 5 kilos of potatoes plus 225 grams of bread per day: "too much to starve but not enough to live." Potatoes were requisitioned to be sent to Germany, so people would dig them up and eat them before they were ripe. There were complaints of some French peasants profiteering and selling butter and eggs to the Germans at high prices. Also evident were signs of small acts of resistance. One writer in Flanders recorded that a local farmer had hung a dead hen outside with a written note on it saying he would rather his hens were dead than lay eggs for the Germans. (The same author ended his message: "I do hope this is not a German pigeon.")

A few weeks after Columba began, a message recorded that everyone had heard the "startling news about Hess"—the deputy Führer who had landed in England on some kind of bizarre mission in May and was now in custody. The Columba message noted it had made a "big impression on the Boches." Another said that the German soldiers had tried to listen to the English wireless to hear what had happened, as they did not believe the claims on German radio about the deputy Führer's mental illness. The

morale of the Germans was not always good. One message that summer reported that sixteen pilots near Passchendaele being trained at an airfield were imprisoned for not flying, while one had actually taken off with his airplane and fled. Another writer talked of his conversations with the German soldiers: "When we talk to a soldier he dares to give his view they are all tired [of the situation]—but then he keeps looking around to see if another soldier is not approaching for they have no confidence in each other."

One pigeon from Folkestone was found by a fellow pigeon lover in northern France. The English pigeon "could hardly have come into better hands," he wrote in a detailed message tinged with sadness. He provided a long note full of details of life and of whatever movements he had seen, including the location of German telephone exchanges. He suggested that the Germans were convinced the British would not dare try a landing and could easily be defeated if the British did come. He did not want compensation for his efforts—he was just serving his country. But there was another reason: "This is a means for me to avenge myself for my son, whom they have killed." His son could not be replaced, but he did say that after the war he would like to replace all his own pigeons, which had also been killed.

Each pigeon was an act of resistance, however small—the risk of a life for the chance of contact with distant Britain. A bond was being created between the sender of a message in a small rural village and the official reading it in London's War Office. But could Columba provide real, hard intelligence, more than just scraps and color? The first signs that it might arrived in June.

Top of the list of questions to which Melland and Sanderson wanted answers was whether the finder of a pigeon knew anything of possible plans for the invasion of England. The seventh Columba message pointed to just that. "The attack on England will occur very soon, unforeseen and terrible," it warned in spring

1941 and went on to report that ships were being prepared in the Grand Canal in Belgium and four new airfields would be completed in the next few days. Docks that had been bombed were being repaired. Sanderson would find pigeons among the best sources for invasion intelligence; he noted when they corroborated other sources or failed to back up reports from MI6 agents about whom he was not sure. "Valuable reports continue to arrive by pigeon," the official indicator's summary noted. In May and June 1941 sources were still suggesting that an invasion was possible, as large-scale exercises were occurring and requirements like barges were being put in place—though the German troops did not hold out much enthusiasm for the project.

A pigeon from Cambridge was dropped over Huisnes-sur-Mer near the Channel coast on June 14, 1941, and was liberated from Pontorson three days later. It had an unusual journey home and was found in Penzance on June 20. A military officer opened the message and "with great zeal" translated it himself. It took a further three days for it to be transmitted by a wireless officer to the War Office, leading to an angry letter explaining that in future any pigeon container found with a colored disk was to be sent immediately by dispatch rider.

The annoyance arose because that message from Pontorson—Columba Message 19—was one of the first to show what the operation might be capable of achieving, especially when it came to the challenge of warning about a possible invasion. It contained rich details of troop movements out of Brittany and the use of nine motor barges near Mont Saint-Michel for embarkation practice. It pointed to an airfield at Caen where the planes were housed in specially camouflaged hangars. Details of anti-aircraft positions were given, and the writer offered specific suggestions of where to bomb. The source also warned of fifth columns in

England, having heard a drunken officer say that they were dropping parachutists in English uniforms who spoke the language; there was even a special instruction center in Brest to train these infiltrators. He also wrote that a letter the previous day from a German officer to a female collaborator had indicated that an invasion was to come about next week. This was precisely the kind of information for which Sanderson was looking.

The author was highly motivated. "The population here is 95% with you and hopes for deliverance. They vomit Darlan [the French admiral who collaborated in the Vichy regime] and his clique of traitors; we are ashamed to be represented in the eyes of the world by such a band of bastards. There are some 'swine' here too, as everywhere, but I've got them listed." The author went on to name the specific hotelkeepers at Mont Saint-Michel who "fight each other as to who shall make the most fuss of the Boches." This scandal should be broadcast, he suggested, on the BBC, which he said he could hear very well. He reported that there had been violent riots in Rennes on June 15 when the people tried to commemorate those who died in the fall of France. The Germans and the police drove the crowd back to the Place du Palais where "La Marseillaise" was sung "with great fervor" and accompanied by cries of "Death to Ripert!"—the prefect nominated by the Vichy government to the area. Reprisals had come thick and fast afterward, but the plan was to repeat the demonstrations on the night of June 17—the very night the individual was writing the message. He ended with "Vive La France, Vive L'Angleterre and Vive de Gaulle." The writer, who signed himself Arvor 114, asked for more pigeons and gave a specific location in a marsh near a railway line.

The Columba team analyzed the message carefully and found it unusually detailed. How, when travel restrictions were in place,

could someone living in Pontorson be in a position to report on events as distant as Caen in one direction and Beaumont-Hague in the other? Could it be a plant? The analysts went through the details paragraph by paragraph. The troop movements, they judged, matched those of Message 18 and the train movements also seemed about right. The claim of poor morale in the area was supported by an MI6 source. Other information was considered fairly likely to be true or "sensible." They carefully examined the request to name certain collaborators on air. Could this be an attempt to implicate genuine members of the resistance? "On the whole, we think not," was the verdict.

One or two points were considered unlikely to be true, but the writer's wide-ranging knowledge could be explained by travel entailed in his job or by information being passed on from others. That would be similar to the way MI6 sources often reported, and "the information he has supplied us is certainly well up to their standard," the Columba team noted. The decision was made to consider the message valid and drop more pigeons in the marsh where they had been requested.

On July 2, 1941, the results from Columba's initial foray were written up. Over three months, 221 birds had been released over Flanders, Normandy and Brittany. Forty-six returned, 19 with messages, 17 of which contained information. And this information had already shown its value. The six messages from Normandy and Brittany helped identify two German infantry regiments as well as the movement of troops away from Cherbourg and Brittany. This was especially interesting since there had been few such indications from MI6 sources. What was particularly special about Columba was that intelligence would be in the hands of those hungry for information within hours of a message being written. This was unique among sources of intelligence, and the fresẎess of the information was something at which London would frequently

marvel. "I think this form of intelligence is most valuable and has great possibility and should be encouraged," the deputy director of Military Intelligence wrote. It was an economical operation as well. The RAF planes were going across the Channel anyway, and the main contribution was that of the pigeon owners themselves, who gave of their time and their birds freely. Columba was up and running. And within days of that first summary of its efforts, its most important message would arrive.

3

Leopold Vindictive

T HE DEBAILLIE FAMILY gathered in the large building in
Lichtervelde that doubled as a grocery store and a family
house. A local farmer had found the pigeon in the field that July
morning in 1941 and his wife had brought it to them hidden in a
sack of potatoes. It was just over a year since the Nazi war machine
had swept through Belgium, and the farmer had taken the bird to
the Debaillies because he knew they were patriots. But now the
family had to decide what being a patriot really meant.

Their task was initially to decide the pigeon's fate—and per-
haps, with it, their own. The decision was far from easy. The three
brothers—Gabriel, Arseen and Michel—and two sisters—Marie
and Margaret—deliberated over what to do with the bird. Two of
the brothers differed. Gabriel thought it best to not get involved.
It was true the family were "patriots" who hated the Germans,
rather than "blacks," but they had never engaged in any overt act
of resistance. The risk was too great. They had too much to lose.
But Arseen felt the need to act. He was the most ambitious of the
brothers and the keenest to take risks. The pigeon had come to
them with a call for help and they should not turn it away—it was
their duty. Even though he was the youngest brother, he got his

way. Margaret, the younger of the sisters, backed him, while her elder sister, Marie, was more cautious.

Once the decision had been made, there was no reluctance or dissent on the part of the other members of the family. They were and remained united. Their father, the founder of the business, had died a few years earlier, and the close-knit siblings ran the concern together and knew they could trust each other. Spying would be a family affair. But what were they actually going to do? They knew that to make the most of the opportunity that the pigeon had brought their way, they needed help. And so they turned to two friends. One was Hector Joye from Bruges, who spoke English and loved military maps. The other was a Catholic priest, Father Joseph Raskin. The Debaillies knew Raskin through another brother of theirs who was a missionary in China. He had been taught by Raskin and had invited the older priest to stay with the family before the war. The priest had become a frequent overnight houseguest, with his own regular room. The two sisters—Marie, aged forty-eight, and Margaret, nearly forty—were particularly devoted to Raskin. In turn, Raskin was a friend of Hector Joye, having presided over his wedding. So the circle of trust among the friends was complete. This was the way many early resistance groups were born—not as soldiers or spies but as groups of friends who felt such deep anger at the occupation of their homeland that they were willing to accept the risk of trying to do something about it. The bonds of friendship offered trust and some degree of protection, but this often had to compensate for a lack of experience in the world of espionage against a formidable enemy.

Within a day of the pigeon's arrival, the budding spy ring had gathered in Lichtervelde. Joseph Raskin would be the central figure. For all his outward trappings of a priest, it was as if everything in his life up to this point had prepared him for his career as a spy.

Raskin had been born in 1892 in a comfortable, detached house

in Stevoort, a village of a few hundred families who all knew each other. His father had become a teacher and then principal of a local primary school. Joseph was the eldest of eleven siblings—the one they all looked up to and idolized. Culture and Catholicism were the defining characteristics of a family that would pray, sing, draw and read poetry together. From the time he was a small child and grabbed a rattle or moved to the piano, it was clear Joseph had a love of and gift for music. But the Church came first. The headmaster of Joseph's school had a brother who was a missionary, and his letters from far-off lands would be read aloud to the pupils. That inspired Joseph to follow in his footsteps, and in 1909 he left home and joined a Belgian missionary organization called CICM—known as the missionaries of Scheut or Scheutists, after the neighborhood of Anderlecht in Brussels where they were based. It was a strict regimen: up at five, asleep at nine, the hours between filled with prayer, study and communal living. Family visits were limited, but when Joseph returned for a few days' holiday in 1912, his siblings found he had grown up. He hadn't grown much in height, and he continued to walk with a slight stoop that had been there from childhood, but now he proudly sported a short beard, much to their amusement. Joseph and his youngest brother would become missionaries and another brother a priest. Two of the sisters would become nuns.

When Germany invaded Belgium on August 4, 1914, at the start of the First World War, Raskin had just been ordained a subdeacon, but he was not immune from the patriotic fervor sweeping Europe: God and country were intertwined for many at that time. But Raskin's family were about to see up close what war really meant.

The family had moved to the town of Aarschot a few years earlier, when Raskin's father became a school inspector. It was a small town but would become famous both in Belgium and Britain for

the events of August 1914. As the Belgian army retreated, two Belgian regiments acted as a rear guard in the town and held up the enemy advance, much to the anger of German commanders. In their house, Raskin's younger siblings hid in the basement and sat fearfully around a single lamp, occasionally going upstairs to peek at events from behind the curtains. When the town fell, twenty captured Belgian soldiers were shot and thrown into the river. That evening a German brigade commander was shot while standing on a balcony on the square—perhaps killed by the ricochet of a bullet fired by his own soldiers. But the Germans treated the death as an assassination and began heavy reprisals aimed at what they saw as resistance from the local population. Men were rounded up in the marketplace and then taken to a field, where they were executed. In all, 156 civilians were killed over the following days. Women were said to have been victimized. The events in Aarschot were pivotal in what came to be known in Britain as "the rape of Belgium," an episode ably exploited by British propagandists as their country responded to the attack on neutral Belgium by joining the war. The British spy and author William Le Queux wrote graphically of babies being bayoneted and women savaged by the German army in the town. British newspapers were filled with lurid, exaggerated accounts, which in turn helped galvanize support for war among the British public. And so Belgium's war quickly became Britain's.

The first time Joseph Raskin was arrested as a spy by the Germans he was entirely innocent. Priests and primary school teachers had been mobilized as stretcher bearers and ambulance men for the Belgian army. Raskin was put to work at Beverlo ferrying wounded soldiers around. As word reached him of events in Aarschot, he became desperate for news of his family. At six o'clock one Sunday morning, he put on civilian clothes and got on

his bike. A German patrol stopped him. A young man cycling in civilian clothes was highly suspicious at a time when the Germans thought every Belgian was a spy. Worse, Raskin did not have his Red Cross papers. The case seemed open and shut: He must be a spy. The sentence was death.

Raskin was taken to a fort that was being used as a prison. In a car on the way he noticed that the papers regarding his case were lying on the seat next to him. He slowly edged them underneath him and then to the other side. As the car hit a particularly violent bump, he pushed them out of the side without the Germans noticing. Upon his arrival at the fort, the authorities were lost without the paperwork. In the chaos of the early days of the war, there was nothing that could be done. He would just have to be kept there.

In December 1914, he made his escape from the fort. The family story was that he hid under the hay in a wagon on the return journey of a farmer who had come to deliver food. The reality may have been somewhat more prosaic. German papers indicate that they had been unsure what to do with him, and because he had made himself useful as a cook he was allowed to travel to Stevoort in early December. It was from there that he may then have made his escape, perhaps indeed in a hay cart. Whatever the real story, he was out. He then went to the front lines, again as a stretcher bearer. This was dangerous work, which sometimes involved making one's way right to the front lines to load up the battered and broken bodies of soldiers and then suddenly dropping into the mud as German bullets whistled overhead.

He enjoyed a ten-day break in London—not knowing that a quarter of a century later the course of his life would be shaped by his attempts to reach out to that city once again. During that brief visit, there were visits to churches and museums, but Raskin had one problem: With his lively blue-gray eyes, rippled dark hair

and infectious laugh, he was handsome, and he wondered how to explain to the local girls who seemed interested in him that he was actually a chaste priest.

When he returned to the front, Raskin's peculiar skills opened the way for him to become something else—an artist-spy. Since his youth, he had been good with his hands as well as his head. He could repair clocks and generally tinker with things. He was particularly talented as an artist. So now he began to go to the front lines, initially of his own volition, to draw what he saw before him. The results were beautiful drawings of the trenches and German positions.

When his superiors in the army saw the drawings, they immediately recognized their military value and they were passed up the chain of command to the highest levels. Raskin was dismissed as a stretcher bearer and turned into an *observateur*—a kind of intelligence gatherer. He worked across the Belgian front, just north of Ypres where the British were fighting. It was a bleak, apocalyptic landscape. The Germans had initially advanced over the Yser River but the Belgians flooded the area to halt their advance. The Germans then partially retreated back over to one bank. The land between the two armies was laid waste by a mix of water and war. Sometimes the two sides were close—at a place called the "trenches of the dead" they were little more than twenty meters apart. But in other places, no-man's-land was far wider and less clear-cut. Shredded trees stood among pools of muddy water with the remnants of farm life surrounding them. The Germans had established advanced observation points and positioned snipers in farmhouses across the desolate flooded plain.

Raskin would travel at night. He would give a password to a sentry and then sleep for a while in a shell hole. At first light, as the birdsongs began, he would observe and sketch. Two men would accompany him and provide covering fire if needed. At night,

when he had seen enough, he would return. Back in his room he would take the rough drawings he had made and turn them into something approaching art. There are beautiful pencil drawings and watercolors of the view from the Belgian side facing the Germans, with each German position carefully marked out. The largest, most dramatic panoramas he made are two feet long, works of art crafted from the chaos of warfare.

It could be dangerous. In mid-May 1916, he spent three days and nights without food or water, trapped in an abandoned flour mill that was full of rats and surrounded by Germans. Another time, a bullet shattered the lens of the periscope he was using.

Sometimes the picture will reveal what appears to be an abandoned building. But look closely and you can just see the eyes of a German soldier hiding in a gap, ready to shoot. A caption may note this as a permanent German observation point. There are also bird's-eye views of the same front lines, marked out in precise detail with map coordinates and distances. One map has arrows indicating not just the direction in which the Germans shoot from each trench but how regularly they fire: for instance, whether they fire only in response to Belgian fire or just at night. At one farmhouse, it is noted that every time the Belgian artillery begins firing, a German periscope pops up. At another point it is remarked that the Germans send out patrols at night to throw grenades into Belgian trenches.

Senior officers were impressed. One went so far as to put his signature on one of Raskin's pictures, which led the priest to realize he needed to sign them himself to prevent others taking credit. In spare moments, the priest's humanity would shine through: He would make small pencil drawings of an exhausted fellow soldier having a cigarette or devouring a chunk of bread. And so, without knowing it, the first stage of his preparation for the English pigeon scheme was complete. Raskin had learned the

fine art of military intelligence: which information was of value, and how to present it.

When the war ended, Raskin became, as he had always intended, a missionary-priest. After celebrating his first Mass, he boarded a white steamboat for the long journey to China. Pictures show the young man lounging on a bunk with fellow priests in second class and out on deck with a mixed group of priests and nuns, all smiling as they head out on their adventure. During the long voyage, Raskin would play the piano in the evenings or draw pictures of fellow passengers. They made their way via Port Said and the Suez Canal, Singapore and Hong Kong before finally reaching China. A photograph shows Raskin in Shanghai, dressed in local clothes, learning how to write the local language. And here was mastered the second phase of his preparation for the pigeon operation: the ability to write beautifully and precisely as he learned how to trace Chinese characters. The quality of his handwriting would win him a prize in Shanghai and would later be useful in condensing information into a tiny space.

His training complete, Raskin made his way to the heights of Mongolia. There he worked at a school training Chinese priests. He became the closest thing to a local doctor, dealing with ulcers in particular. "I have more consultations than confessions. That is not good," he joked. The part of Mongolia he lived in was the Chinese equivalent of the Wild West. Local warlords would rampage from village to village, looting and killing. Raskin organized the villagers so that a signal fire could be lit on a hilltop, which could be seen by watchers in other villages to warn them of attack.

After the best part of a decade in China, he was summoned back to Brussels by the chief of the Scheut mission house. His varied skills meant he was needed as what was called a "propagandist"—a traveling preacher who would go from town to town spreading

the word about the missions to raise funds and persuade people to support the organization or become missionaries themselves. In his diary in Mongolia, he wrote of his disappointment at the order to return. "My soul is sad as if it has died." But then, in Latin, he added: "Your will be done." Back in Belgium, he would crisscross the country giving talks about China. Here was another stage in his preparation, as he built up a wide-ranging network of friends, supporters and contacts.

As the years passed, Raskin became rounder and seemingly smaller, the lines on his face deeper. But still he could attract people around him with his laugh and his storytelling.

And then war came again: another invasion of neutral Belgium. But this war was not like the one before. This time there were no trenches or static front lines. German tanks, accompanied by the terrifying air power of the Luftwaffe, ripped through Belgium in a matter of days. Raskin acted as a chaplain to soldiers in Torhout during the dark days of May 1940, visiting the nearby Debaillie family in Lichtervelde wearing the uniform of a captain. Within eighteen days, all of Belgium was occupied by the Nazis. Initially, the Germans promised that if there was compliance there would be no need for brutality. But for many Belgians that did not quell the desire to do something. Unlike France, it was a country that had been occupied and invaded many times before. There was almost an ingrained sense in many Belgians for finding ways to live under occupation while also getting the better of the occupying power. For some that meant small acts of defiance; for others it was something more risky. Resistance would emerge faster and with greater strength in Belgium than in many other countries, including France. But it would still take time to recover from the shock of defeat and for the resistance to become organized. For the first few months, the urge lay largely dormant and barely visible, like a flower bulb beneath the hard

earth. By the summer of 1941, it was ready to push through into the open.

This was how resistance often emerged in occupied Europe. It was not the result of activity from London on the part of British spies or exiles; it was groups of friends spontaneously coming together because they hated the German occupation and were desperate to do something about it. People would hang out in cafés, conspiring, starting to collect what they knew might be useful information about the enemy they could see around them, though often with no way of transmitting it to Britain. Now, suddenly, Columba presented some people with an opportunity. Could it act as a link to the nascent resistance?

And so, after a year of occupation, Raskin received the phone call from Arseen Debaillie. The next day he was there in the corner shop, with the pigeon and the two sheets of rice paper in front of him, along with a patriotic appeal from Britain for help. He never had any doubts about what to do. Raskin, Hector Joye and the Debaillies made their decision. They would answer the call. They agreed among themselves that they would split up over the coming days to maximize the amount of information they could collect.

Arseen, the youngest of the brothers at age twenty-seven, nevertheless looked the oldest, with his broad chubby face and glasses. He was the chief enthusiast and spy among the three brothers, although the family would work together as a team, its members supporting each other. Arseen spent the next few days driving along the coast and through the neighborhoods around Bruges taking notes. Gabriel, thirty years old and the most anxious of the three brothers, would maintain the cover of working the family's growing business—supplying animal feed at Roeselare. But he also went with his brother on a trip by car to the coast, ostensibly for business but also to see what information they could gather.

Michel, the gangly pigeon fancier, tended to stay at home. The pigeon had arrived just a fortnight before his thirty-second birthday. As a child he had suffered from rheumatic heart fever, a condition that had left his heart damaged, and he was required to see a doctor every few weeks. His comfort, like those in Britain who had supported Columba, were his pigeons. Sundays were the days he liked to spend with his birds, often racing them at Lille. He kept them in a large, closet-sized coop on the ground floor of the building.

Hiding the British bird carried risks. Immediately after occupying Denmark, Norway, the Netherlands, Belgium and France, the Germans imposed controls on pigeon owners that were progressively tightened. In Belgium, the country's Fédération des Colombophiles had to keep a register of every pigeon, and the Germans checked this regularly. Pigeon keeping would later be forbidden entirely in a number of districts in Belgium and northern France, matching closely the places where the Columba birds were dropped. Sometimes messages brought back by Columba pigeons revealed the pain this brought to those who loved their birds. One message reported a plea to British owners: "Rear a couple of young pigeons for me. I have to kill all mine." But Michel and the family were willing to take the risk. It was not too hard for him to hide one special bird that was different from the others.

Marie and Margaret, the two sisters, had their role. They would maintain the appearance that everything was normal at the shop, chatting away with customers while looking out for any signs of trouble. Raskin would go back to Brussels and gather material from there. He would also ask friends whom he trusted for any information they had.

Hector Joye had the time—and the cover—to travel. He had been a soldier in the First World War, but while in the trenches he

had been gassed by the Germans and was now invalided. During that war he had met Louise Legros, who worked for the Red Cross. Her well-to-do family had been opposed to their relationship, but one person who had encouraged them was Raskin. Theirs had been the first marriage he had conducted as a priest. Louise's career had taken off and she had been appointed the director of a girls' school in Bruges. The family lived in comfort in a house that was part of the grand, Gothic school complex. A family picture shows Raskin enjoying a lunch in comfortable surroundings with the Joye family all around—his visits were always the occasion for a party, events that the Joye children enjoyed.

Handsome, with swept-back fine dark hair, round glasses and a trim mustache, Joye was another tinkerer with similar hobbies to Raskin's. He had once been a carpenter; he had designed a heating system for some nuns and had built incubators for the eggs of the pheasants he kept. His finest invention, his son would remember, was a special Christmas tree mobile containing a mechanism that enabled the angels to fly around. As a former military engineer, he was fascinated by maps and fortifications. Like the others, he was a devout Catholic for whom serving God, king and country were as one. Because of his health, Joye had permission to travel up to the coast to get fresh air. With little to do (not least in comparison to his wife), Joye was enthusiastic about the opportunity to turn his hand to espionage.

The amateur spies needed to work fast. The pigeon could not be kept too long. But they were determined to make the most of their opportunity. The amount of information they collected was astonishing. They fanned out to discover what they could on their travels. Joye was the busiest. He knew there was a particularly interesting chateau near Bruges occupied by German troops, as well as airports, ammunition warehouses and factories producing material for the Wehrmacht. He would see what he could find.

Arseen knew about the Bruges–Ghent railway line and a local airfield near their house, and he could give details about the local population. Marie and Gabriel provided specific information about a nearby chateau. Raskin, meanwhile, seemed to have a stack of information ready to go. Some of this came from the network of contacts he had built up in Brussels, many of whom were women he knew through the church who were beginning, if haphazardly, to gather details of what they observed. Raskin tapped these friends for information. One letter to "my good Father" from those days provides information about a German storage building in Brussels and includes a drawing as well as details of munitions.

After days of frantic gathering, all the precious intelligence had to be squeezed into the two tiny sheets of rice paper the British had supplied with the pigeon. Raskin's experience as a cartographer in the First World War and as a calligrapher in China meant he would be the one to write it all up. The Debaillies had just the place for him to work. Their corner shop was the public face of the business, where customers could come in and out. But the building was more of a minicomplex. There was an adjoining house where the family lived. And then, around the back of the shop, past a small, closed interior courtyard, was a structure used as a warehouse to store all the goods. At the beginning of the war, fearing German bombs, the family had built a windowless concrete room toward the back. Relatives would send their children out to Lichtervelde because it was thought less dangerous, and this room was their hiding place. The room had a bed in it, where the children could sleep at times of danger, and a strong lock. It was what you might today call a safe room. It was perfect for spy work.

A niece called Rosa, the daughter of another sister and eleven years old, was staying with the family. She was fond of Raskin.

He wrote a rhyme, *"Doosje van Roosje"* ("little Rosa's little box"), on her sewing box and taught her to play the accordion the family had given him as a gift. She remembers Raskin was there more than usual during those days of July 1941. Something different was happening, she knew, but no one told her what it was. That would be too risky, in case she talked. She does remember one of her aunts—Marie, she thinks—heading into the safe room more often than she normally did.

At a table underneath a light in the safe room, Raskin pored over the drawings and details that came in, the spider at the center of a web of espionage. The drafts of the maps and notes have miraculously survived, pages and pages of them, different types of notepaper and different handwriting reflecting the many hands that contributed to the work. Space was tight. Everything had to fit on two pages, and that meant decisions. Like a ruthless subeditor at a newspaper, Raskin scribbled out lines with black pen where he thought the detail was superfluous. A line about the Germans taking too many potatoes from people is crossed out, as are general complaints about poverty and life being expensive. That was not hard intelligence, he knew. The next line of a draft, though, stayed in for the moment—how the Germans went from carriage to carriage on trains taking food from people, sometimes even slurping raw eggs. Also retained is a line about how people were taking the copper from phone cables between Bruges and Ghent. A line about how people longed for the English and would point out the blackshirts is scribbled out. Raskin was careful to stick to the exam question—answering the specific queries that the pigeon had carried to them and not inserting extraneous information.

The pigeon sat just around the corner, at the ready. For Raskin, it may have represented something more than just a messenger. The pigeon—referred to by its proper name, the dove—has a

powerful symbolic role in Christianity. When Jesus was baptized by Joy the Baptist, "the Holy Spirit descended on him in bodily form like a dove. And a voice came from heaven: 'You are my Son, whom I love; with you I am well pleased.'" This dove had come to Belgium from Britain; but perhaps for Raskin it had come spiritually as well as literally from above. Faith, duty and spying were all intertwined in the priest's mind.

Material was still coming in as he wrote. The Germans were strengthening their positions on the coast, fearing an English attack. A new division had been installed, and there was extensive activity from planes as well as trucks bringing in fuel. Advice was offered as well: If the British were planning to invade then they should avoid delay in moving through the country or the Germans would take all the able-bodied men to Germany. No one had any idea that it would take three long years for the British to arrive.

Finally, he was ready. Raskin took his pen and began the final draft, working through the night of July 11. He sat at the desk with a magnifying glass to ensure he could cram in as much detail as possible on the tiny sheets of paper. The quill of his pen was precise. Every space would be put to use. A last-minute item of intelligence came in on the morning of July 12 at 7:55. Joye had come through the Bruges railway station and seen a ground air defense post being moved. That detail was added in the corner.

Raskin finished with a flourish and a special touch. "Our seal!" he wrote in the bottom corner, adding a symbol that he intended to be a unique identifier of the group and its future messages. It was a circle with a curly L sitting in a V, one side of the V becoming either a cross or a sword, depending on how you interpreted it. Their name was Leopold Vindictive.

There was no more space. The message was ready to fly. The two pieces of rice paper were carefully folded up and placed inside

the green cylinder that had come with the pigeon. The cylinder was slotted into the ring around the pigeon's feet and twisted to secure it.

The group then did something extraordinary, an act contrary to every rule of spycraft. They picked up their family camera and took pictures of the pigeon and then of the message being pushed into the green cylinder. But then, even more extraordinarily, the three brothers and two sisters stood for a family portrait in the inner courtyard. Marie and Margaret are in their aprons, Michel and Gabriel in working shirts with braces. Arseen looks somewhat smarter. At first sight, it could be any other family picture, but look more closely and you can see that Marie, the elder sister, is holding a resistance newspaper, while Margaret is holding what looks like a white sheet—the parachute. Arseen holds a pencil, Gabriel the British intelligence questionnaire, and Michel proudly clutches the pigeon. And in front of them, propped against a table with a white tablecloth, is a chalkboard—probably the board that they would normally use to display the latest fruit and vegetable prices for shoppers. But this time, on the board are written the dates of the bird's arrival and departure, its ring number and the phrase "*Via Engeland*" to mark its destination. And at the top are three capital Vs—the symbol of Victory, which earlier that year the BBC had called on people to daub on walls as a symbol of defiance.

Taking the photos was a mad, risky and amateurish thing to do, and yet it spoke of something that is impossible to criticize: a deep pride in their work of resistance. Raskin is not in the picture, most likely because he was on the other side of the camera taking it.

There was one final picture to be taken. Michel climbed up onto the roof, where there was an oat attic. This was the place from which he normally released his pigeons, and so it may have looked less suspicious than it sounds to anyone watching him. Up there he opened his cupped hands and released the bird; a picture

captures the precise moment. At 8:15 a.m. the bird rose high into the sky and circled for a few moments to get its bearings. Then it made for the Channel and for England. In seven hours' time it would have escaped Nazi-occupied Europe and be home in suburban Ipswich.

4

Arrival

FROM MICHEL'S RELEASE of the pigeon on the roof in Lichter-velde, it took thirty-six hours for Raskin's elegant message to reach the hands of British intelligence. The pigeon, which had left Britain on July 5 and was released from Belgium at 8:15 a.m. on July 12, flew over the English Channel and was back at its loft in suburban Ipswich—about ten miles from the coast—by three thirty that afternoon. All it knew was that it was home.

Loft owners had been ordered to keep a sharp eye out for the return of a bird, even though they were told nothing of its mission. As soon as a pigeon arrived, they were to take off the small Bakelite cylinder attached to its leg. Well-to-do owners with their own phone might be able to call the special number. But otherwise a child might be sent on a bike with the cylinder to the local pigeon supply officer, who would call in the delivery. Then they would wait. In some cases the roar of a motorcycle dispatch rider could be heard outside in just twenty minutes. The cylinder would be handed over and rushed to London. The orders were strict: Cylinders were never to be opened by anyone until they arrived at the War Office. This was partly because the contents were secret, but more so because they were often written in pencil and folded up so tight that they had to be carefully extracted without being

ripped or smudged. If that happened, someone would have risked his or her life for nothing.

On the morning of July 13, the message arrived in London at Room 25 of the War Office. Sanderson and Melland were both on duty that day, and early in the war they opened the messages themselves. "I well remember the fascination of opening these little tubes and unwinding the thin slips of paper which they contained," Melland later said. When the pigeon service first began, it was feared that the tiny cylinders might be booby-trapped. So Melland and Sanderson would open them with a sheet of protective glass in front of their faces in order to guard against any "tricks." Fortunately, they never had a cylinder explode in their faces (although Bert Woodman in Plymouth said he heard that at least one cylinder had been found with explosives). Once a cylinder was open, they would translate the message into English, enter its details in a logbook and then distribute the information to other departments.

Both men would always remember that day in July. There was nothing to suggest that Message 37 would be anything different from the other thirty-six they had opened in the previous three months. Melland pulled the first thin sheet of paper, nine inches square, out of the canister. The writing on it was tiny. But the closer he looked, the more astonished he became. Decades later, when Sanderson reflected on the intelligence that he had seen, he would remember this as the "most exciting and romantic" of all the reports that passed through his hands.

Melland and Sanderson realized instantly that this was something different, something special. The writing spread across the two pages was small but perfectly formed, the accompanying maps expertly drawn. It felt as if every single millimeter of the two sheets had been used to cram in as many words as possible.

The author of the message had helpfully recommended placing

the sheets against a dark paper and using a magnifying glass af-
ter cutting it up and reassembling it so that it was all in the right
order. As the team set about typing up a report, they found that
the transcription came to five thousand words and took up twelve
pages. And what was in those pages was gold dust.

"This message is from Leopold Vindictive 200," it began in
English, although the bulk of the message was in French. It was
the specificity that was so remarkable, comprising precisely the
type of intelligence the team had dreamed of when they started
Columba. The text referred to maps and specific symbols em-
ployed to indicate hidden German emplacements and munitions
depots. An old submarine base was now being used to repair boats
and was carefully concealed by shrubs and buildings. Bombs would
need to fall over an area of 200 by 300 meters to destroy it, Leopold
Vindictive noted, and explained when to attack to avoid civilian
casualties. The Shell depot near Neder-over-Heembeek should be
bombed "without delay"—and a map indicated exactly where the
key parts of the oil facility lay. Another important fuel dump was
protected by concrete and so would need larger bombs. "At any
price spare the town of Bruges," the writer pleaded, expressing
care for the architectural beauty of the city.

There were also precise battle damage assessments of recent
British raids in Brussels. "Our congratulations to the airmen who
carried out the bombardment in the Rue de Birmingham on
Thursday 26th June and the Rue de l'Intendant on Thursday 10th
July. They were marvelous hits which filled the whole city with
admiration." The first bomb had wiped out a building where para-
chutes were made while hardly damaging neighboring houses.
Nine Germans were killed, while fifteen civilians had been only
slightly wounded. The second had taken out a crucial German
factory. More targets were suggested—a palace inhabited by
hundreds of Germans, the location of an officers' club, another

building "swarming" with Germans day and night, a garage that only worked on German vehicles, other barracks. The location of a wireless jammer opposite a hotel was also given. The Brussels airfield should be targeted, but the writer warned that most of the structures around it were actually dummies. Nearly a dozen other factories in the region were also named as playing a role in the German war effort.

In the case of one telephone exchange, the writer revealed it was guarded night and day with a machine gun for fear of a British attack by parachutists. The Germans were supposed to call the local civil guard for help in the event of an attack, but Leopold Vindictive revealed that the guards were in fact quite hostile, suggesting they might take their time to arrive. "I have this from a man on the spot," he added.

There were also assorted items of intelligence about daily life. Dropping propaganda leaflets was fine, but it was recommended that little packets of chocolate be dropped with them to show there was no lack of food in England. The impact of British bombers and the recent German attack on Russia had worried many of the local "blackshirt nationalists" who supported the Nazis, and many had begun deserting. The blackshirts trained every Sunday morning between ten and twelve at one set of barracks. Bombing them, it was suggested, would discourage any more would-be recruits, and there was no anti-aircraft gun for several kilometers around the site. The Germans had been trying to recruit locals to fight the Russians, claiming it was a crusade of Christianity; leaflets should be dropped to say that those who joined would be held accountable.

Sanderson in particular found Message 37 invaluable. The most significant part of the message answered the question that haunted his waking hours: What were the invasion plans? Belgium was seen as a launching point, with barges potentially

heading out from Ostend, Antwerp and other ports. Britain had its own plan to carry out a sabotage mission (code-named Claribel) to sink barges, damage rail lines and cut power and communications once the first signs of invasion were spotted, although the department tasked with carrying this out had to acknowledge in the spring of 1941 that it had no contact with or knowledge of any Belgian resistance organization and that its attempts to send in a radio operator to make contact had failed.

Leopold Vindictive had real information. A map showed the chateau of Tillegem near Bruges and revealed that it was the central communications installation for German high command in the whole sector. The picturesque medieval chateau, surrounded by a moat, had been undergoing work for four months, and Leopold Vindictive was sure it was to be used by an admiral as a base for the invasion of England. It was nearly—but not quite—ready, he reported. One hundred and fifty special technical staff used the latest radio apparatus from Siemens. *Nobody* (the word was underlined by the writer) was admitted to the chateau except for the chiefs and the specialists. Anybody approaching would be shot without warning.

The site's true purpose and importance had been unknown to anyone in Britain. If an invasion appeared imminent, it could now be targeted by bombers or even by commandos; it would also need to be dealt with if Britain wanted to launch its own attack on the Belgian coast. With that in mind, Leopold Vindictive described how the crucial junction for the communication cables was outside the building encased in concrete nine meters underground, protected with reinforced steel bars. An 11,000-volt current was provided by a cable lying along the road. Further specific details were supplied of the cables and of the antennae, which sat fifty meters back. In order to identify this from the air, the writer explained, a photograph could be taken between eight

and ten in the morning from a particular direction marked on the map. This would make the complex easier to spot. Usefully, it was pointed out which anti-aircraft positions had not yet had their guns installed. In all, fifty separate locations used by the Nazis were detailed; in some cases the paper gave more than a dozen items of note about an individual position.

The professionalism of whoever sent the message was obvious. It asked for a response that would indicate, by referring to letters ascribed to different sections, what in the enclosed information was unknown to the British and in which areas more information was still wanted. The information, the author promised, was "thoroughly reliable."

But who could have produced such treasures? And could they really be trusted? There was no name other than the code name, and nothing else was known except that the team consisted of a staff of three principals and several secondary agents. But to establish his bona fides, the author did offer an unusual means of verification. "Identify me as follows—I am the bearded military chaplain who shook hands with Admiral Keyes on the morning of May 27, 1940, at 7:30 a.m. Ask the admiral please where he was exactly at that moment with my most respectful greetings."

Admiral Roger Keyes was quickly approached by Military Intelligence. He would have remembered the meeting with the chaplain well. It was a day he would never forget. Keyes was close to King Leopold of Belgium, a friendship forged in the First World War when the sailor had led the Dover Patrol and the Belgian royal family frequently crossed the Channel. Leopold, then a boy, had attended Eton during term time, occasionally lunching with Britain's royal family but returning to serve on the front line during vacations. His father had stayed in Belgium as king during the war, a decision popular in the country.

Leopold had come to the throne in 1934 when his father died

in a mountaineering accident. His reign started darkly and would prove troubled. A year after coming to the throne, Leopold was driving in Switzerland when he lost control of his car and it crashed, killing his wife, Queen Astrid. By that time, his old friend Keyes had retired as an admiral and been elected to Parliament in Britain. A buccaneering character, although not necessarily of the highest intellect, Keyes had long been a close friend of Churchill, one of his allies who warned of the dangers of appeasing Nazi Germany.

On May 7, 1940, Keyes played a leading role in the unseating of Neville Chamberlain as prime minister when he stood up in the House of Commons, wearing his uniform with six rows of medals, and launched a passionate denunciation of the government's ineptitude. Three days later, on May 10, Belgium was attacked without warning at dawn. The country had desperately clung to its neutrality in the hope it might offer protection. But this proved a false hope. Its armies were poorly prepared for the onslaught of the formidable German war machine. That morning Keyes received a telephone message summoning him to see Churchill. At that moment Churchill was still First Lord of the Admiralty, but by the end of the day, with Neville Chamberlain ousted from Downing Street, he would be prime minister.

Churchill told Keyes to put on his uniform and fly to Belgium to act as his special representative to the king. Keyes had already made a number of visits in recent months on behalf of the government to take advantage of his friendship with Leopold (who was also commander in chief of the Belgian army). By three thirty that afternoon Keyes was flying out of Hendon to Amiens, escorted by three RAF Hurricanes. That night he drove to a blacked-out Brussels, passing trucks and buses full of troops from the British Expeditionary Force, which was suddenly in a precarious position as the German military tore through the country at frightening speed.

Keyes saw the king the next morning at an old moated fort twenty miles outside the capital. Leopold was not yet forty, with a gentle face and curly hair. Nothing had prepared him for what his country was now going through, and his ability to lead his nation would be sorely tested. The shell-shocked king told Keyes that when the invasion began a hundred German troops had landed atop a fort and dropped bombs down ventilators, putting it out of action, while all but seven Belgian aircraft had been destroyed by German attacks on the country's airfields. Much to Britain's annoyance, the king had clung too long to the false hope of neutrality; now he pleaded for British air support to avoid what he called "an absolute debacle." But Britain's military leadership was also in chaos, and coordination with the French and Belgian armies was abysmal.

Initially, the British Expeditionary Force advanced. The *Times* correspondent in Belgium traveling with the BEF (a certain Kim Philby) told a colleague that "it went too damn well." The reason was that Hitler was trying to draw the British army into a trap.

Over the next two weeks, Keyes's telegrams back to Churchill carried increasingly dire news. The Germans were moving fast—so fast that the MI6 station in Brussels lurched from complacency to panic and had to burn its papers in a furnace and hurl its teleprinter out of the window to ensure nothing was captured, while MI6 officers took turns guarding the office with a long-barreled Luger pistol. The Germans strafed military personnel and civilians alike as they fled the cities by road and rail. Suddenly the British commanders realized they risked being trapped and began to make a desperate retreat under pressure; London was initially less than honest with the Belgians after the decision was made for the BEF to abandon the country, using the Belgian army as cover while they headed toward the coast. They made their way, amidst scenes of chaos and confusion, for Dunkirk, where hundreds of

boats, including the "little ships"—a flotilla of fishing vessels, pleasure craft and lifeboats—waited to ferry them back over the Channel.

But where did the mysterious chaplain come in? Raskin's royal connection dated back to the First World War. He had played music in a convent whose services were attended by Queen Elizabeth and had been introduced to her. After the queen's husband, King Albert, died in 1934, she became queen mother to King Leopold. She had arrived with the king at the castle of Wijnendale on May 24, 1940. She asked her chamberlain, the comte de Grunne, to organize Mass to be celebrated in the private chapel.

Raskin was acting as chaplain to soldiers in nearby Torhout and was asked to come to the royal court as personal chaplain to the royal family. For the next few days, he would be picked up by car and taken to see them. The journey for Raskin on Sunday, May 26, had been perilous, as the Germans bombed the roads from the air, leaving craters and burning vehicles. Raskin took Confession from the royal family and held a heavy, solemn Mass at ten o'clock at the baroque altar under the domed vault of the chapel, which was located in the castle's highest tower. His words and the singing of the congregation must have been spirited to overcome the sound of enemy aircraft flying overhead. Afterward, Raskin spoke to the king at length, one to one. Leopold looked and sounded like a man not quite able to cope with the huge burden that lay upon his shoulders. He asked for the priest's prayers as he agonized over the decision of whether to stay in a country that was collapsing or flee to Britain.

Raskin was a decade older than the monarch, and sought to stiffen the resolve of a man who seemed to struggle with the burden of kingship. He stressed to Leopold the tight bond between faith, the nation and the monarchy, in which the priest himself fervently believed. Raskin said he was sure the nation would

support the king. The monarch should face the plans God had for him with patience and confidence. When he finished speaking, the king, trembling slightly, clasped Raskin's two hands. "Chaplain, I understand. I understand," he said.

The day Admiral Keyes met Raskin was the darkest. Everyone knew the end for Belgium was near. Churchill was desperate for the king to flee to Britain and not make any kind of deal with Hitler. The question for Leopold was whether he should lead an army in exile or stay with his people. He wanted to emulate his father, who had won support by remaining with his soldiers during the First World War. But he did not understand this was a different war. His ministers either fled or wanted to leave, and they were angry when he indicated he would stay. They would arrive in London in dribs and drabs, but the bad blood from those days in May and the legacy of the choices each individual made would bedevil Belgium for years to come.

At six o'clock on the morning of May 27, Keyes received a telegram from King George VI of England to pass on to his fellow monarch, asking him to reconsider his plans to stay. "I do not feel that Your Majesty is called upon to make the sacrifice which you contemplate," one king wrote to another. He went on to argue that the risk of being taken prisoner by the Germans and depriving his people of a leader was too great. Keyes gave the message to Leopold, who took it to his bedroom to read with Elizabeth. Leopold's view was that he had no choice. "I feel my duty impels me to share the fate of my army and to remain with my people. To act otherwise would amount to desertion," he replied.

A photograph—taken by the comte de Grunne—shows the scene on the morning of May 27. Outside the castle among the trees stand four figures in military uniforms, talking in two pairs. On one side is Keyes, standing with the king's aide-de-camp. On the other side, King Leopold is talking to his chaplain, Joseph Raskin.

The dark looks on all their faces make clear that they know the end is at hand. This was the moment referred to by Raskin in the Leopold Vindictive message. He knew Keyes would remember it.

Keyes telephoned Churchill that day to give him the news of the king's decision, adding that the Belgians would not last much longer. At five that afternoon, the king told Keyes his army had collapsed and he was surrendering. Churchill made clear that a new Belgian government would be formed in exile to disassociate itself from the king and his decision to make peace.

By eight that evening Keyes knew he had to move fast to avoid his own capture. As his convoy crossed the country, German parachutists landed around them and opened fire. Keyes made one last plea for the king to leave with him. His decision to stay would prove to be a fateful one for the monarch and for his country. Leopold would never again be a unifying figure. At ten o'clock Keyes left on a road crowded with refugees. By one o'clock the next morning he was at the coast and found a fishing boat with two sleeping men on board. With some persuasion (which involved rifles and the promise of money on arrival) he was soon sailing back to England, where by the following morning he was at 10 Downing Street to report the king's decision to an "indignant" Churchill.

Churchill later claimed wrongly in Parliament that the surrender had exposed the British flank, when in fact the Belgian army's resistance had protected the British Expeditionary Force as it was evacuated from Dunkirk. But the public needed a scapegoat for the disaster, and the Belgian king served the purpose. The British press poured vitriol on the king for what the newspapers said was a surrender without warning. Keyes himself sued the *Daily Mirror* for saying he had been "bowing on Brussels carpets in a rat king's palace."

The day Keyes had met the chaplain was the day Belgium was

lost. In their short time together, a bond may have been forged between the Belgian priest and the British admiral—perhaps over the fact that both had spent time in China before war. Raskin the following day had taken a bike from Lichtervelde to Torhout and then to Bruges. In Bruges he went to the schoolhouse of Hector Joye's wife, which had become a field hospital, and met with the wounded. "German troops in the city, sad rainy day," he wrote.

The link to Keyes also explains the mystery of the code name taken by the spy network. *Leopold* was clearly a reference to King Leopold of Belgium. But *Vindictive*? It was a tribute to Keyes himself. In 1918, as commander of the Dover Patrol, Keyes had been given the mission of blocking the ports of Zeebrugge and Ostend. Ostend proved a challenge until Keyes sent an aging cruiser with orders for its crew to sink the ship in the harbor entrance. That ship was the *Vindictive*. Raskin had named his spy network in honor of his own king and a British admiral.

For MI14(d), the link to Keyes served to emphasize their new-found source's credibility. "Confirmation of the value and accuracy of message No 37 has been obtained from the GOC [General Officer Commanding] Belgian Army in the UK and Admiral Keyes has assisted in assessing the sender's bona fides," the team recorded.

There is one odd fact, though. Nowhere is the name Joseph Raskin recorded. Had Keyes recalled meeting the chaplain but not remembered his name? Or did MI14 want to keep the name of their new agent secret? Either way, it was by the name Leopold Vindictive that the spy network would be known in London.

WHEN REX PEARSON saw the original Message 37, he marveled at the way in which the author had crammed so much into such a small space. For a man who had fought to create Columba, it must have been a moment of validation against all those who had

been skeptical of using pigeons. The intelligence from Leopold Vindictive rapidly made its way around Whitehall. In July, 174 pigeons had been released in five operations, but the information they gathered had revealed only limited details of troop movements and concentrations and confirmed one or two weapons dumps previously reported by human sources. Without Leopold Vindictive it would have been a pretty poor return. But Leopold's report was of a different class, as was clear even to the skeptics of Columba.

Naval Intelligence had been pretty dismissive of Columba until it saw Leopold Vindictive's message. The Admiralty said it was a "particularly good report" for its "wealth of detail." Two MI6 reports had suggested the possibility that the Germans might have a naval headquarters, but there had been no confirmation until Leopold Vindictive drew attention to the chateau near Bruges and for the first time revealed its role in invasion plans. "Having seen such a detailed report as No. 37 it is clear that action should be taken" in the event of an invasion, Naval Intelligence noted. Further photographic reconnaissance was ordered on the sites mentioned in the report.

There had been questions about Columba and its value. Was the bizarre scheme really going to work? Message 37 put those concerns to bed. Keep it going, but under regular review, was the order from the top of Military Intelligence. Columba offered speed and relevance. It is not hard to imagine that for Claude Dansey at MI6, who had been one of the skeptics, there was a touch of jealousy that this strange sideshow had suddenly delivered results that gained the appreciation of the rest of Whitehall while he still struggled to rebuild his European networks. One of the many secrets that Dansey was keeping was just how little real intelligence his own agents had so far delivered.

Something else happened to Message 37: It was shown to

Churchill himself. Why? Churchill loved intelligence and asked to see fresh Enigma decrypts from Bletchley every day to help him guide the war. Significant as the specific details of the intelligence in Message 37 were, though, there was no reason he needed to know the exact location of a particular ammunition dump or even a naval headquarters. The real reason was different. The message from Leopold Vindictive represented much more than just a collection of useful facts. It represented the spirit of resistance, confirming to Britain's spies and leaders in that troubled hour, when they still feared invasion and when defeat seemed possible—perhaps even likely—that some of those living under the tyranny of Nazi occupation in Europe were willing to risk their lives to help. It was a sign of a spirit that Churchill hoped to inspire in the British people should the disaster of invasion ever befall them: a sign that out there in Europe were people who wanted to work with Britain and who stood ready should Britain be able to return to the continent to drive the Nazis back. All that was required now was for the two sides who needed each other so much to be able to communicate. A humble Ipswich pigeon had made that possible. Both sides were determined that this should be just the beginning. So now the question was: Could they manage to get back in touch with the bearded chaplain?

5

Listening

AFTER THE PIGEON was released, Margaret and Marie sat by the radio in Lichtervelde listening intently. Every night at the assigned time they clutched pencil and paper, determined not to miss a word as they tuned their radio trying to pick up the erratic crackle of a signal. The elder sister, Marie, may have been more cautious, but both were now committed. Their father, who had passed away, had been ambitious for all his children, including his daughters, and had ensured they had private lessons in French in addition to their native Flemish. That meant they could scan broadcasts in different languages for some sign that distant London knew they were there.

That the two sisters pressed their ears to the radio to make out the words was itself an act of resistance. The BBC's broadcasts provided a reassurance to those living in occupied Europe that they were not alone. The broadcasts encouraged them to defy the invaders and parodied the propaganda spouted by the Germans. For that reason, the Nazis hated the BBC for its subversive influence. Almost every member of the population listened. A German officer given the accurate time by a little girl on the street asked how it was possible she knew it was a quarter past seven when she had no watch. She replied, "Don't you see?

There is no one on the street. They are all listening to the English radio."

When the Nazis raided a house in Belgium, one of the first things they did was check what frequency the radio was tuned to. The penalties for being caught were severe, especially if the Germans wanted to make an example of someone. The headmistress of an Antwerp girls' school was sentenced to five and a half years for permitting her pupils to listen to the BBC.

The Germans also did their best to jam the signal, which was why one of the items in the Columba questionnaire was about audibility. Responses saying which wavelength provided the best listening quality were hugely useful for the BBC's tecȲical staff. The broadcaster's European intelligence director told MI14 that Columba was of "the utmost value" thanks to the immediacy of its messages—often they provided feedback within a day or two of a program's broadcast, faster than a letter might arrive today. "Everything interests us but speak clearly and loud," wrote one person in a Columba message, echoing the kind of encouragement BBC broadcasters continue to receive.

There was audience feedback not just in terms of reception but also editorial content. "My wife would like to kiss the well-known speakers, as they are so patriotic," one writer from Pas-de-Calais, in France, said enthusiastically. A pigeon message from Brittany said a wife was cheered up by hearing her husband speaking from London, and they wanted him to know. Sometimes there was frustration married with the enthusiasm. The V for Victory campaign started by the BBC in its broadcasts to Belgium caught on like wildfire. It led to the daubing on walls of a flurry of signs in what seemed like every village, as well as on the chalkboard held up by the Debaillie family in their picture with the pigeon. Churchill himself joined the act with his trademark two-finger

V for Victory sign. The campaign encouraged ordinary people to feel they could resist, even if only in a small way.

The downside was that it created an expectation among many that victory and a British return to Europe must be imminent. "You have announced you're coming too long now. It would have been better to have done it and said nothing," one person wrote in frustration. But the BBC did not only support the war effort by broadcasting news and information. It had a direct operational role in the clandestine world of espionage.

The greatest prize for those brave enough to send a message via Columba was the possibility that for a brief few seconds they would become the stars of the BBC broadcast by receiving an acknowledgment on the *messages personnels*. When this was required, a British intelligence officer would ring up the BBC and identify himself with a code name—rather bizarrely, for Belgium this was Napoleon Bonaparte and for the Netherlands Bing Crosby. He would then ask for a specific phrase to be broadcast, such as "Here is a message for Adolphe: The wine is warm"—which was meaningless to everyone else but acted as a coded signal for a particular group. The messages could be used to signal an upcoming drop by parachute, to establish the bona fides of an agent by proving they were in contact with London or to signal that a person—or information—had arrived in London. It was the last function that Columba used—the acknowledgment of a pigeon's arrival was broadcast in a code provided by the writer.

For all those listening, the messages were a sign that somewhere out there were people taking risks who were in touch with Britain. For Columba message writers there would have been a real but clandestine thrill in knowing that a code phrase they had scrawled on rice paper and attached to a pigeon was suddenly being read out loud from London.

Leopold Vindictive's message had asked for a response on the Dutch and Belgian BBC radio news as soon as possible. They did not have to wait long. The stunning intelligence haul had left the Columba team in London knowing they had something special on their hands. On July 15—only three days after Michel had set the bird free—Marie and Margaret heard the answer to their prayer.

"Leopold Vindictive 200, the key fits the lock and the bird is in the lion's cage." The acknowledgment was sent that day on the Dutch, Belgian and French BBC news services—all three to make sure. In Lichtervelde, the band of friends now knew that the crazy plan had worked. The pigeon tended by Michel had successfully crossed the Channel with their treasure.

The relief, joy and excitement were overwhelming. But the family may also have understood there was a cost. Their code name had just been broadcast across northern Europe. Thousands in Belgium would have heard it, and among the listeners would be the German secret police, hunting for resisters. The chase to identify a new band of spies had begun.

There was, though, another sign that their pigeon had gotten through. Toward the end of the message, they had mentioned a German radio station at Ichtegem, near Wijnendale, which consisted of a camouflaged wooden shed and two aerials. This was bombed by the British, creating what was described as a magnificent fireworks display. Not only had the intelligence gotten through but it was making a difference. From being powerless, it must have seemed almost as if the RAF were at the Belgians' beck and call, and that the Belgians were forward air controllers calling in air strikes to the targets they selected.

The BBC acknowledgment raised hopes that a fresh consignment of pigeons might already be on its way. The first part of the BBC message had consisted not of intelligence but of details for the next drop. That was because the group of friends were

convinced that this bird had just been the start. They had so much more to offer, and all they needed was the means to communicate it back to London. The instructions to British intelligence were clear and precise: Leopold Vindictive needed more pigeons.

Raskin had written that he heard that up to ten other pigeons, in addition to the one they were setting free, had landed in the area on the same July morning. But all the rest had been handed in. Not because people disliked England, he explained, but because they feared Germany. So future birds would need to be dropped carefully. He was reluctant to put the exact location of the drop in the text in case the pigeon was captured and the Germans used it to trap him. So he told British intelligence to get a 1:40,000 military map of Belgium and find the point where Keyes would say he had met the bearded chaplain. They were then to place a ruler southeast from there along the axis of the main road. At the extreme east the ruler would meet the letter E on the map, which was the last letter of the name of a village. The second letter of the name on the map lay over a field 300 yards by 300 yards square which was full of crops. That was where the new supply of pigeons was to be dropped. Planes were to avoid spending too much time in the air or else they would wake people, who would get out of bed to see what was happening. Nor should the birds be dropped on a Saturday night or Sunday morning, as people would be heading to church and it would be harder to hide them. The men had asked for a drop of three birds on July 15, 16 or 17. "We will do our best but failure is not impossible," Raskin had written. "We suppose also that you know that such relations are rewarded by death."

Raskin had stayed in the Debaillie house in Lichtervelde the night after the pigeon's release and had taken the train the next morning. The pages of his small pocket diary from July 7 to 13 are all cut out, as he tried to cover his tracks (he would also

sometimes write in Chinese for the same reason). It was left to the Debaillie family to wait for the birds.

From sunrise on the first of the designated days, the Debaillies awaited the hoped-for delivery. Arseen had originally thought about using lamps to highlight the drop zone from the air, but Gabriel and Michel talked him out of it. It was too risky. But when the brothers went for a walk in the early morning, doing their best to look natural, as if they were just ambling around, there was no sign of another container anywhere in the field. Their message had specified a three-day window, and they waited nervously and walked the fields on each of the three days. But each time there was nothing. A disappointment. The first, but not the last.

The friends were moving too fast for Columba. Raskin had no idea about the logistics required in organizing a pigeon drop— why should he? The message had only arrived in Ipswich on July 12. For MI14(d) to analyze it, verify it with Keyes and others and decide to respond by radio in two days was extraordinarily fast—a tribute to the importance of the message. But dropping fresh pigeons in a hurry required a level of coordination and cooperation that was a challenge for Columba. The delivery of pigeons was far less flexible than the Belgians imagined. They were dropped incidentally, as an adjunct to existing RAF Special Duties missions for the intelligence services, rather than on commission. Pigeons were low down the pecking order of intelligence requirements, way behind MI6. A flight needed to be carrying an agent over the right part of Belgium to allow for a drop of pigeons in Lichtervelde. That would be at best perhaps one in every half dozen flights of those that made it over the Channel. And the planes only flew during the full-moon period. In July, the last successful flight had been on the 12th, the day the message arrived in London. A flight on July 15 crashed, with eight of those on board ending up in the hospital. After that, the moon promised no light until August.

Here was Columba's weakness: Columba excelled at gathering ad hoc intelligence from villagers in Europe. But it was harder to use as a reliable, regular tool of communication in the way Raskin imagined.

MI14(d) was nevertheless determined to contact their new prize asset. One item of evidence in Sanderson's personal papers reveals the effort that went into following up on Message 37. A photograph dated July 21, taken by an RAF plane, shows an aerial view of a patchwork of fields of different colors intersected by paths and roads. A scattering of fluffy clouds hang lazily above the fields. Sanderson's notes indicate that the RAF aerial reconnaissance team had been tasked to photograph the exact location suggested by Leopold Vindictive for the second drop of pigeons. They had found the field. The message from Leopold Vindictive said that if weather made the first drop time impossible, then the next occasion should be July 30 or 31, or August 1.

Raskin and his friends were not going to wait passively for the next pigeon, whose arrival they were sure was imminent. And so they simply got on with the business of spying. Drafts and notes of their work survive in a box kept by the Debaillie family: handwritten notes, maps and coordinates, details of factories in Brussels, of movements on the Belgian railways. In addition to the information the group collected themselves, Raskin's many contacts in Brussels and elsewhere had been picking up more. All of it would be ready to go.

Raskin also needed to pass on an important item of news. He wanted to do away with Leopold Vindictive—not the group but the name. Raskin had gone to the royal court at Laken to speak to his friend and contact there, the comte de Grunne, the queen's chamberlain. De Grunne knew about the espionage network and perhaps may even have aided it quietly. The name *Leopold* had been intended as a tribute to the king, but when Raskin told the

count he was horrified. Having stayed in his own country, the king was in a precarious position—a virtual prisoner under house arrest—and the use of his name for the purposes of espionage by a person associated with the court risked the assumption that this was a spy network with—quite literally—a royal seal of approval. "It is as if the king himself is now a spy!" exclaimed the count.

And so a chastened Raskin decided he should change the name of his group. He wanted to call it *JoŸ Victoire*. Raskin wrote out a message, saying that they were waiting for the next pigeons as stated in the original message and requesting that, in future, the BBC acknowledge its response to JoŸ Victoire. But how was he to get this urgent message back to London?

Raskin had always been a man in a hurry, and his impatience grew after the first window for a pigeon drop closed in mid-July. He needed to send the news about the name change to London. Pigeons were the best way of passing on maps and long, detailed intelligence reports, but radio was better for short, urgent messages. He was now desperate to find a working clandestine radio transmitter, both to announce the new name and also to try to hasten the arrival of the next pigeon. But radio sets were rare and dangerous. They got you killed. If the Nazis came through your door, you might be able to explain away a pigeon but not a radio transmitter. The Germans were on the hunt for those using them. Especially in the early months of the war, a reliable, trusted radio transmitter was almost a mythical creature for those involved in espionage; to find such a rare prize would require a long tortuous path of whispered conversations and dangerous meetings, always with the risk of being betrayed by a double agent. But Raskin thought he knew someone. So he passed his message of the name change through his Brussels contacts to try to ensure it reached London.

Raskin's circle of contacts in Brussels, largely female, had been

involved in sheltering airmen and had also supplied intelligence to the priest. The central figure was a woman known to everyone as Madame Roberts. She had been born Anna de Bruycker but had married a British man called Jesse Roberts from Blackpool. When the occupation began, Madame Roberts had involved herself in helping Belgians who wanted to go to England. She helped hide two British servicemen for months, providing them with lodging, food, clothes and money. Raskin himself, it seems, was involved in helping hide people from the Nazis; these were often British servicemen who had not made it out at Dunkirk or Belgian servicemen who wanted to leave for Britain. The details of Raskin's work on escape and evasion are hazy, although one note in the Belgian Security Service Archives from a woman says she and Raskin took food and clothes to a forest near Soignies for refugees who were hiding there and that four refugees were tended for three months by "Père Raskin and his group" in the forest and in cellars.

Madame Roberts was a friend of Raskin's through his Catholic missionary network (which would increasingly become a spy network). When the war began Raskin had confessed to her that he had an ardent desire to help his country but was not sure how to do so. To think of Madame Roberts and her friends as a formal resistance network would be a mistake. They were less organized than that name implies. By the middle of 1941, resistance was just beginning to build and establish itself in Belgium. Britain had not yet been defeated, as some had expected. There was still hope. Food shortages and the conscription of workers were taking their toll. There were occasional strikes and small acts of sabotage. People who wanted to resist were starting to work together, but they were not yet organized into coherent networks. Rather, they consisted of overlapping groups of friends and contacts, who often lacked much understanding of the kind of security they needed to protect themselves.

As the second drop period approached at the end of July, Raskin, Joye and the Debaillie family waited anxiously, their prized notes ready to be transferred onto rice paper, the priest ready with his calligrapher's pen and magnifying glass. But on the morning of July 31 the field again failed to yield a pigeon. Marie and Margaret listened anxiously for an update on the BBC.

The sisters heard what they were listening for on two consecutive nights, July 31 and August 1. The message was relayed again on the French, Dutch and Flemish news services. That was the good news. The bad news was that it still began with the old call sign and not the new name—confirmation that the radio message Raskin had passed on had not gone through. "Leopold Vindictive 200 Allo Allo," it began. It said there was much appreciation for the bravery and magnitude of their efforts. But there was news of a delay, given in a coded phrase: "The key is turning in the lock." But when it came to the field indicated by Raskin they would have to wait some days. Regarding the information, the details marked A—in other words, information from the original message relating to the invasion plans and the chateau—were of the greatest importance. It also asked what was happening south-southeast of location B2. But there was a strange ending: "Long live the courageous V of Lille and Nieuport." This was a riddle to Leopold Vindictive. They were not in Lille or Nieuport. Was there some kind of confusion as to who they were? Had another group somehow adopted their name or their pigeons? Or were the British trying to divert any listening Germans from the group's identity?

In London, they were finally ready. "With the help of photographic recce, it is hoped to check the information still further; in the meantime it has been possible to locate the exact site recommended by source for a further release of birds and this operation is taking place tonight weather permitting," a note from Columba dated August 3 reads.

At 3:35 a.m. the following day, August 4, Ron Hockey took off with the RAF for Belgium as part of Operation Periwig. His flight plan took him on a path over the field mapped out by MI14(d). Searchlights lit up the plane and heavy flak headed his way as he reached the coast. The pigeons were released, and he flew back above the clouds. But when they looked the next morning, the friends in Belgium could find no sign of a pigeon.

Battle of the Skies

IN THE OCCUPIED Channel Islands a poster went up on August 3, 1941. It announced that a Frenchman, Louis Berrier, from the town of Ernes just south of Caen, had been shot by a firing squad the previous day. The poster stated that the punishment had been for a crime the Germans were already starting to worry about— the sending of intelligence by pigeon.

Above the skies, in the fields of France, the Netherlands and Belgium, and even on the cliff-tops of Britain, a battle was being fought that might be deadly both for Columba's pigeons and for those who tried to use them. Only one in ten of the birds sent on Columba missions made it back alive. The frustration experienced by Leopold Vindictive in trying to obtain fresh pigeons was a mark not only of the inherent challenges of Columba but also of how much effort the Germans put into stopping it. Even though the operation had just started that summer, the Germans were already working to counter it. The challenges to ensure that the British birds first reached the hands of sympathizers and then found their way home with a message were immense.

Just one month after the beginning of Columba in 1941, reports had come from Courtrai, close to Lichtervelde, of birds falling into the hands of Germans rather than local sympathizers. Columba

was in many ways an oddly un-secret operation. It was designed to elicit sensitive information, yet its workings were anything but clandestine. From the start, the Germans could see the pigeons with their parachutes and questionnaires. The team at MI14(d) had a phrase for this level of awareness on the part of the enemy: "The Germans are fully pigeon-minded and our continued activities can hardly make them more so." It did not take long for Germany to develop counter-Columba tactics and become still more "pigeon-minded."

As they did against British bombers, the Germans developed a multilayered defense against pigeons in this battle of the skies. "Our defense against the carrier pigeons was vast," one German expert boasted. Rewards were offered. An MI6 agent reported that a notice displayed in one Belgian town offered 625 francs to anyone who delivered to the authorities any pigeon dropped by the enemy; in other places, a sliding scale of rewards was offered, the largest sums being available for a pigeon carrying a message.

As well as the carrot, there was also the stick. The point of the Channel Islands poster was to issue a warning. Others too paid the price, and the penalties were always made public. A Belgian called Julien Ferrant was executed for trying to send messages by pigeon, while in Antwerp two Frenchmen were shot for the same reason. "In future, the Courts-Martial will impose the death penalty inexorably in all cases of this nature," a local newspaper reported. Fear had its effect on the local population. "An Italian found one of your pigeons and killed it. The coward!" a message from Florennes in Belgium read. The Germans sometimes planted a parachute and watched it from a hiding place nearby, waiting to arrest those who picked it up; occasionally they even placed a booby trap underneath. Rumors began to emerge that the Germans were planting false pigeons to trap people. "I do not sign because the Germans also drop carrier pigeons, which you

must understand, take the messages to the kommandatur. Various patriots who wrote their names and addresses have been arrested," read another Columba message.

The Germans actively hunted the birds. A Columba report from Loudun in France's Loire Valley said that many pigeons had fallen into enemy hands after a German observation post spotted the RAF passing overhead. An hour later a hundred and fifty Germans arrived in motor cars, searched gardens, paddocks and roofs and went door-to-door asking for pigeons. Arrests were made and four birds were found. This news was brought back by one of the pigeons they did not catch.

The Germans targeted the birds directly in flight. A Columba message from northern France reported that there were "marksmen on the coast endeavoring to shoot down pigeons from time to time." The Germans had used snipers during both the siege of Paris in 1870–71 and the First World War to try and take down birds in flight suspected of carrying messages, and similar orders were given again.

Just as in the past, the sight of a pigeon and the knowledge that it might be carrying messages seems to have rattled the Germans. "Considering the wide area covered, the dropping of our pigeons may contribute in a small way to a kind of a German-invented nerve war," it was noted in London. A seed had been planted, whereby the British began thinking about what could be done to make use of this German fear of the pigeon. It would bear fruit later in the war, thanks to British specialists in deception.

The pigeons had many enemies, German snipers and hungry locals among them. But their most deadly foe was natural. The Battle of Britain saw the use of radar and British Spitfires fighting Luftwaffe Messerschmitts. But in the Battle of the Birds it was the pigeon against the hawk. Hawks—and especially the peregrine falcon, with its wingspan of three feet—were the pigeon's nemesis.

In action the falcon is a fast, vicious, carnivorous predator of the skies—part Spitfire, part dive bomber. If a pigeon crosses its path, the falcon can swoop down vertically at a staggering two hundred miles per hour and then, at the last moment, pull up to strike with its rear talons, sometimes with such force it can take the pigeon's head clean off. If it misses, the avian equivalent of an aerial dogfight would still take place between the two. In this engagement, the poor pigeon usually comes off worse.

The Germans were quick to weaponize the hawk. Before the war, a British falconer on holiday in Germany had come across what he described as a set of "princely mews"—the buildings used to house hawks—which was controlled by the state. The countless birds were, he said, looked after by a team of uniformed men who were exempted from regular military service. Hermann Goering, the man in charge of the German air force, was also the guiding hand of its hawks. An amateur falconer, he adored the imagery of being seen with the powerful predator on his wrist more than the actual work of training one. German hawks were specially bred and flown along the coast from Belgium, France and the Netherlands to catch and kill Columba birds as they headed for Britain.

British agents undercover in Europe sometimes even witnessed firsthand the power of the hawk. One British officer took two pigeons with him on a commando raid upon the coast of France. Radio silence was required for the operation, so the pigeons would be used to signal his arrival. He released them at six thirty in the morning, but as he watched them swirl above him in order to orient themselves, he saw a terrible sight. Hawks descended from the cliffs and swooped on his only means of communication with home. Both pigeons were dead within seconds. How many pigeons perished this way, and how many valuable messages were lost, is unknown.

A few brave pigeons did escape the talons of the falcon. Fanciers

supplying Columba complained that their birds were returning with gashes. But the dangers from hawks sometimes lay closer to home, on British shores. One pigeon carrying a message from Pontivy with useful details of troops in the area was found by Pembrokeshire police after having been killed by a local falcon. A messenger pigeon named Mary, released with a message for the army, came back after four days, ripped open on her neck and on the right of her breast by a British hawk. Her owner cleaned her up and tenderly put seven stitches in her. All this meant that Columba offered a new card for pigeon owners to play in their long-standing war on British hawks.

Pigeon owners had been complaining for years about the carnage wreaked by falcons. The falcons enjoyed protected status, but pigeon owners were desperate to persuade the government to license their destruction in order to protect their precious pigeons. With its newfound role as part of the war effort, the fancy seized its chance. In February 1940, a Plymouth fancier wrote to officials that one of his pigeons on NPS duty in a training flight along the English coast had returned "distressed and scared" after an encounter with a hawk. The local pigeon officer confirmed that there were peregrine falcons in the hills surrounding Plymouth and that losses during training flights were running at 40 percent. That month the secretary of the NPS forwarded to the Air Ministry a grisly package of five pairs of feet and rings collected from a nest of hawks on the Cumbrian coast to make his point. Stories even surfaced of mysterious hawks spotted in Dorset, owned by suspicious characters who had links to Germany before the war. MI5, perhaps knowing pigeon owners were on the warpath and might be behind such tales, decided it was probably not worth an exhaustive investigation.

A very British civil war broke out, one that pitted two sets of bird lovers against each other. Pigeon lovers wanted the peregrines

dead. But there were those who preferred the elegant hawk to the humble pigeon. The Scottish Society for the Protection of Wild Birds complained about the way in which "the homing pigeon fraternity in the past have indulged in the wildest and most extravagant assertions," blaming falcons for every failure of a pigeon to return. Some suggested that the number of pigeons lost to falcons was small compared to fog and ice. This might be true, an official replied, but there was not much that could be done about such impediments. "We find it difficult to deal with ice and fog unless the Treasury means to suggest that we fit de-icing apparatus to pigeons," he wrote sarcastically.

The fancy won an early victory. In order to avoid fortune-seekers there would be no "price on the head" of falcons, but Defence Regulation 9, issued in July 1940, designated a series of counties where a strip ten miles deep would be purged of falcons. About a hundred people, usually ornithologists but sometimes gamekeepers, were given permits to destroy them. One individual covered over two thousand miles and killed seventeen peregrines in one month, but the process was haphazard and there were questions as to whether some were taking advantage of the petrol allowance. So instead a mobile unit was established to replace the ornithologists. This special crack team was called the Falcon Destruction Unit, and it could be sent to a particular area at the request of any government service. The 007 of the bird world, it had a license to kill. It also had the wheels to go with the mission. The group of five men drove around in an open touring car, an American Packard generally agreed to be an absolute beauty by those who saw it—including Bert Woodman of the Plymouth Group of fanciers—as the unit worked along the north Devon cliffs. Attached to the car was a caravan in which the men could sleep. Around a fire in the evening, the oldest of the group, a retired Irish colonel and champion shot, would regale the others

with stories of his freebooter and marauder ancestors. By day, the men would scour the cliff-tops for a nest, using ropes to climb down to it. Then they would lay spring traps among the debris at the bottom. When a falcon landed, its talons would become trapped. The men, wearing thick leather gauntlets, would then go down in a sling to retrieve it. The Irish colonel would be ready with a shotgun if it escaped. Tragically, one of the men fell off a two-hundred-foot cliff and was killed during their work.

The unit was soon in heavy demand as requests flooded in from a variety of sources, including the Army Pigeon Service as it tried to protect the Columba birds. For Columba's team—and especially the volunteer pigeon fanciers who supplied the birds—it was clear the hawks were a menace that had to be dealt with. But in the battle of the skies between hawk and dove, the worlds of intelligence and counterintelligence would collide. Columba's work gathering intelligence was not the only pigeon game in town.

Using pigeons as spies cut both ways. If Britain and Columba could use pigeons to communicate with agents undercover and gather intelligence, could the Nazis do the same? Were Nazi pigeons stealing British secrets? Enter MI5, Britain's spy—and pigeon—catching service.

Spy fever gripped Britain when the war began, and pigeons inhabited the nightmares of some MI5 officers. In the First World War, even regular everyday pigeons on the streets of British cities had been eyed with suspicion. "It was positively dangerous to be seen in conversation with a pigeon; it was not always safe to be seen in its vicinity," wrote one official. One foreigner was even arrested after a pigeon was seen flying from where he had been standing in a park; it was assumed he had liberated it. The same spy hysteria, whipped up by the media but also based on a sliver of truth, resurfaced at the beginning of the Second World War. This was one reason for the registration of all pigeons at the start

of the war and the wholesale slaughter of any foreign birds whose background could not be accounted for. Pigeons were under "very strict surveillance, and a deadly weapon of espionage was rendered useless from the start," Bert Woodman claimed. But the anxieties persisted despite the strict controls.

On August 29, 1940, Guy Liddell, head of counterespionage at MI5, received a phone call from the Admiralty. Invasion fears were still at fever pitch and there was concern that German spies were either already in Britain or on their way. The Admiralty said a carrier pigeon had been captured by the Portland signal office. It carried a message: "Beach Hotel. The barmaid's drawers are pink. Sutton on Sea from Rogues Roost Louth." Was this evidence of German espionage, preparing for invasion using some bizarre code? "There was no other means of identification on the bird," Liddell noted in his diary. Two days later the mystery was solved when Liddell had dinner with David Boyle, a senior MI6 officer. "He has, I think, solved the mystery of the message about the barmaid's drawers. The pigeon was probably one of his, as he has communication not only by wireless but by pigeon to a loft at Willesden." Quite what the code about the barmaid's drawers actually meant was not revealed.

Not all the fears were misguided. Germany had launched Operation Lena to penetrate Britain by sending in undercover agents—sometimes by parachute, sometimes hiding among refugees from the continent. Most were of low quality and were relatively easy to find, especially after Bletchley Park broke the codes of German intelligence. But there were signs that someone in Britain was secretly using pigeons. A cylinder was found with a message in numerical code with a preamble in German. It was suspected that the pigeon had arrived via a German U-boat and a neutral freighter. It referred to army, naval and air matters and had apparently become detached from a bird in flight

that had been released from London. This was not the only time during the war that fears of Nazi pigeon spies would surface.

In October and November 1941, a loftman in the army pigeon loft on the Scilly Isles saw something suspicious. Pigeons were flying low from the northwest and heading south toward the French coast. A number of pigeoneers made eleven sightings in all in the following months. These were men who prided themselves on being able to tell the difference between a wild and a homing pigeon. They were sure the birds they saw were homing pigeons, and they were not from the local army or RAF lofts. Each time they crossed between midday and two o'clock.

MI5 sprang into action with its counter-pigeon team—Section B3c—led by the dedicated Richard Melville Walker, the security service's counter-pigeon expert. His job was to be "pigeon-minded" when it came to Germany's activities.

A special pigeon security meeting was called. Major Frost from MI5 said that it had previously been thought that the danger of the enemy using pigeons in the UK was remote. But now there had been a change of opinion. The danger of the enemy dropping pigeons by parachute with sufficient accuracy to be used by agents hiding in Britain had to be "seriously considered," he told the assembled group. The director of signals for the army suggested that all pigeons not used for national service could be banned, something MI5 also favored. But the civilian representative of the NPS explained to him that there were fifty thousand fanciers outside the NPS and only eleven thousand inside. In the event of invasion, the police would be responsible for the dramatic move of destroying all pigeons so that they would not fall into German hands. Bert Woodman and other NPS officers would receive a coded instruction requiring them to go about the task. But it was considered too disruptive to destroy all non-NPS birds at the present time.

THE GERMANS WERE better prepared than the British for the use of pigeons in war. They had seen the French use pigeons in the 1870 siege of Paris and had begun their own military research soon after—and, unlike the British, they had not abandoned it after the First World War. At the beginning of the Second World War, they quickly conscripted birds, as well as some of the fifty-seven thousand fanciers who were too old to fight. Where Britain had to scramble to create the NPS, the Germans already had tight control of their birds under the state-run German Pigeon Union. To own pigeons one needed a certificate of morality and good political behavior. This meant being "100 percent German"—Jews and foreigners were banned. Heinrich Himmler himself was a keen fancier, and both the army and the SS had their own birds. A secret pigeon base operated out of Spandau, where over two thousand birds were being bred and trained at any one time. At the peak of activity there were at least fifty thousand birds in German service, with six hundred to eight hundred men looking after them.

A pigeon section was attached to most Abwehr military intelligence units across Europe, but they were used most frequently in the west and the Balkans rather than on the Eastern Front. Before the war, the Germans had also organized races from England back to Germany—one such, including fourteen hundred birds, went from Lympne in Kent in 1937 and another from Croydon—and MI5 realized only later that this was highly suspicious.

The occupation of Belgium had allowed the Germans to requisition the best pigeons and lofts. Pigeons were one of the spoils of war. The German in charge of Belgian lofts, Hauptman Zimmerman, may even have flown over England in 1940 or 1941 to release pigeons on practice flights. One German pigeoneer later claimed that a bird had been flown from Harwich and another

from Dover all the way back to their home in Freilassing, a trip that took twelve or thirteen hours.

One advantage Britain did have in the pigeon wars was that the Germans could not copy Columba. If they had dropped pigeons into England, it is hard to believe many people would have chosen to fill out questionnaires. (If they had, one can begin to imagine the choice phrases and epithets that might have been used.)

In response to the spy-pigeon fears, MI5 instigated a watch by all coast guard and Observer Corps posts on the southern and southeastern coasts to spot any birds flying out to sea. Richard Walker worried that messages could be concealed on the birds. Small holes could be burned in the feathers with a fine nail, a trick he was shown by a retired British intelligence officer who had studied the use of this method by the Germans in the First World War. Another method was to insert a small roll of rice paper into the hollow part of a feather after it was cut in two. Few would notice anything suspicious about such a bird.

A series of mysterious finds on the east coast in 1942–43 would heighten pigeon-spy fears. Two birds were found on a British vessel seven miles off Orford Ness, not far from Ipswich. One carried a message in German. A bird whose wings were stamped "Wehrmacht" came aboard a motor launch off Lowestoft in early December. More birds with German army stamps were found in the following days. It seemed to Guy Liddell at MI5 as if the enemy were experimenting to find out if they could train birds to fly across the North Sea for German agents. Indeed, at the end of the war, a captured German who worked at a Dutch loft confirmed he had taken pigeons out onto the North Sea to train them on that line of flight for agents who were to be dropped to spot invasion preparations. One bird with a German practice message that had landed exhausted on a British ship was nursed back to full strength and dropped over the Netherlands with a "plant," or fake

message. "Reaction, if any, will be awaited," it was noted. Two others were adopted and given homes in an English loft. "Both birds are now prisoners of war working hard breeding English pigeons," Walker reported.

Britain did have one possible defense against German birds. But it was the same one that threatened Columba. The Columba team and the fancy had been worried about wild hawks killing British pigeons. But what about the growing risk of German pigeons flying out of Britain with secrets? Having created a Falcon Destruction Unit, MI5 decided that it now also needed its own hawks and falcons in order to intercept and kill German pigeons. In a strange reverse, that meant creating its own elite, trained unit of killer falcons.

Falcons have been trained to hunt for sport for thousands of years in the Middle East and China. In England the sport was introduced before the Norman Conquest but had almost died out by the end of the seventeenth century and was kept alive by just a few enthusiasts. These were the small band that MI5 now needed. The director general of MI5 approved the creation of a falconry unit at what some thought the rather high cost of £200.

The Army Pigeon Service said they had a hawk expert who could trap the wild hawks that were playing havoc with Columba. MI5 approached him and asked if he would like instead to help use hawks to hunt enemy pigeons. He was enthusiastic. In June 1942, he headed out to the scenic coast of Pembrokeshire to find some young hawks. A picture in the MI5 archives shows him in a rather dashing tweed jacket retrieving a wild hawk that had been trapped in a net after it had pursued a decoy pigeon. In all he caught half a dozen on that trip.

The best method of training was to take young falcons, feed them pigeon meat and then fly them out toward live pigeons; they learned to recognize that the pigeons represented food.

(The Americans even tried training hawks to associate parachutes with food, to see if they could be used to take out enemy parachutists.) A falconer could carry on his wrist a falcon with a leather hood, which would be whipped off when a suspicious pigeon was seen. More effectively, the birds could be trained over a period of three weeks to remain in the air and patrol a certain spot employing their remarkable vision. Ideally, hawks could learn to bring a dead pigeon back rather than eat it, so that any message it was carrying could be examined.

After five weeks' training in Pembrokeshire, the hawks were ready for aerial combat, and the falconry expert and his two assistants went down to the Scilly Isles in late August. By then, reports of enemy birds had died down and the spy scare was already passing, but the team still took their task seriously. They were based at the local golf club. One would stand at the highest point of the course, while another was posted across the island, on the coast—hardly the worst job in summer—looking out for enemy pigeons, their falcons ready on their wrists to let slip. The Air Ministry supplied them with some pigeons for practice. Some hawks patrolled quite well, but one preferred to perch on a mast in the middle of the golf course. Soon the trainers let them fly out on patrol for a couple of hours on beautiful summer days to watch over the whole group of islands. The diary of MI5's head of counterespionage records the results. "The ones in the Scilly Isles caught several pigeons but they were found to be our own," Guy Liddell wrote. Hawks knew no nationality. No "Friend or Foe" identification system had been invented, as would be done for aircraft. The only pigeons killed were seven British birds, two of whom were carrying messages. Two of the hawks were also shot by local children. "Some boys will be little devils," one of the trainers commented. But despite the lack of any evidence of Nazi pigeons, the case of the suspicious Scilly

birds remained open and "unproved," the ever-watchful Walker declared.

By the end of October 1942, the weather was turning and there were new reports of suspicious pigeons, this time near Swanage on the southern coast. The falconry unit had its next mission. The three-man team kept surveillance along the cliffs, falcons at the ready. Unlike their time on the Scilly Isles, now it was cold. On December 15 came a sighting—a pigeon flying fast overhead. But the trainer was caught off guard. His hand was so frozen by the cold that he fumbled and released his falcon too late. The pigeon disappeared south over the sea.

Next they let loose the falcons on patrol where they would circle an area hunting anything that came in their path. Three pigeons were brought down in the following months. A lighthouse keeper called to explain that a hawk was eating a pigeon in her garden, but this turned out to be a British rather than a Nazi pigeon. Soon after that, two of the falcons simply gave up—perhaps annoyed at the lack of food—and flew off on their own. The teams were left convinced there had been some kind of suspicious activity—the pigeons that had been spotted flew straight as if they were homing to a possible German loft in Cherbourg. The unit was then dispatched to Wales by the Air Ministry to catch some peregrines that were disrupting their pigeons.

Overall the results were not exactly an overwhelming success. "We were sent out to catch pigeons," said one member of the team. "If they were not 'spy' pigeons it was not our fault." An MI5 report at the end of the war notes that the hawks never actually brought down a single enemy bird—"probably because there never were any."

7

Reaching Out

WITH SO MANY enemies, it may seem a miracle that any pigeon dropped as part of Columba survived to reach home. But in Belgium, all Leopold Vindictive knew was that Britain had managed to drop the birds once and that the one they found had then made it back home. The communications channel had worked, so why should it not work again? As the days passed, however, the frustration began to grow. The birds dropped on a flight on August 3 were never found. There was an attempt to drop more birds from another RAF flight in early September, but as a result of bad weather the planes returned to base with the pigeons still in their containers.

On September 27, 1941, Marie and Margaret heard a deeply discouraging message on the BBC: "Here is a special message for our correspondent Leopold Vindictive. We regret the absence of anything new from you, despite our best efforts. But—as before— have courage." Did the reference to "our best efforts" mean another pigeon had been dropped? If so, it had not been received. Nor had the message yet reached London about the change of name, since they still used the original designation (no doubt annoying the royal court). The two sides were like star-crossed lovers whose messages constantly missed each other. Sitting on a huge stash of intelligence was both frustrating and dangerous.

On the night of October 3, a few days after the BBC message was broadcast, pigeons were dropped again. Another RAF Special Duties flight crossed the Channel with specific coordinates to drop pigeons near Lichtervelde. It was again a secondary mission to an agent drop. Britain was still struggling to work out how to make contact with nascent intelligence networks. Belgium might have been small, but it was strategically important and a vital target for British intelligence services. It was littered with airfields and ports that might be used to attack Britain, and crisscrossed with main railway lines that ferried material from Germany into France. But how could a link be established to the people there? Sending agents in and out to contact the networks was the ideal, but Belgium posed unique challenges. The coast was too well guarded for agents to be landed by sea. It was also the most densely populated country in western Europe, which meant that—unlike France—it was nearly impossible to land agents or pick them up by aircraft without being spotted.

That night saw a rare success. Jean Cassart—a captain in the Belgian army code-named Hireling—floated to earth by parachute southeast of Liège along with his radio operator. It was the third attempt to get them into the country, a sign of just how difficult these drops were. The two men hid in the woods until morning and then headed to a hotel to meet their contact. Cassart was there to coordinate sabotage. "He will organize small groups to kidnap and kill individual Germans," read his instructions.

The agent made it in, but what was the fate of the pigeons designated for Leopold Vindictive? Pilots were improving their dropping skills, and on one occasion, the containers were dropped with neat precision in a row of back gardens from a height of fifty feet, almost as if Santa Claus on his sleigh were dropping off presents house by house. But this time the pilots seem to have dropped the birds five to seven miles to the west

of their target. Navigating at night was a challenge. Columba worked if the intention was to hit a general area but was less effective when a specific spot was aimed for. Another opportunity had been missed.

Raskin continued to travel across the country, giving religious talks. In his letters to his brother Albert he made no mention of his clandestine work. He stayed regularly at Lichtervelde with the Debaillie family. While there he heard a rumor that pigeons had been dropped somewhere nearby but they had fallen into German hands.

With no pigeons, the hunt for a radio transmitter or some other way of getting a message to London gathered intensity as every day passed. Hector Joye had an idea. He would talk to his friend Clément Macq in Brussels. Macq had built his first radio in 1923 and had set up a business to sell wireless sets. Joye had been one of his clients and he knew he was a patriot, having worked out Macq's sympathies when they had a coded discussion about whether a new radio might be good enough to receive the BBC; discussing such a possibility was a signal of where one's allegiances lay.

Joye first paid Macq a visit in July and asked if there was a way to construct a radio to send a message to England. Macq, a thin, angular middle-aged man, said he was unable to do so. That was not true: Macq was already secretly involved in a resistance network. But you had to be careful what you told people.

Joye was persistent. On a second visit, he went further in his pleas for help, asking Macq if he had heard the name Leopold Vindictive on the radio. Of course he had, Macq said, an interesting sign of how the fame of the group was beginning to spread. Joye confessed—perhaps with a touch of pride—that he was one of its members. "We had a pigeon," he explained, "the English received the information and want more."

Joye showed Macq some of the information they were now

collecting, and Macq was astonished at the level of detail. Joye explained that they had no means of getting it to London, since they had not received any more pigeons. Could Macq help establish a line to London in order to ask for more pigeons? Perhaps there was a way. Macq relented, realizing that this was a serious, if not necessarily experienced, group of amateur spies. He knew a man in Brussels who might be able to get a message through. He would speak to him.

Joye introduced Raskin to Macq, who would say that Father Raskin was *"toujours bouillant"*—always on the boil, eager for action. But such enthusiasm was also a risk. Raskin said he wanted a radio transmitter to be ready the next day. Macq had to explain it was impossible. Could Macq perhaps build some kind of short-range transmitter that could send a message to a passing RAF plane, Raskin asked. Not possible, Macq explained. He could sense Raskin's impatience.

Macq did say he might have one way to get a message to England. But it would not provide direct contact; rather, it would be transmitted via a route using couriers carrying messages by hand. Nevertheless Joye gave him the message. "Leopold Vindictive 200 requests a bird without delay," read the text. "A message of the highest importance is ready to be sent. In the first message give instructions for dropping of the pigeons (i.e., 300 is ok). If you cannot, please give us a different route for sending maps. For information: our key position is in the castle of Wijnendale. We change our name to A.M.20. Use this for radio communication."

As this note makes clear, there had already been another name change, this time to Ave Maria, a short prayer for help. Raskin told Macq during their meetings that the plan for his network had been submitted to someone close to King Leopold, who had approved. That was the reason that they now needed the change of name—in order to protect any link. The urgency of their requests for pigeons

also reflected the men's knowledge that they had achieved something special.

When Macq paid a visit to Raskin at the missionary house of Scheut in Brussels in order to discuss installing film projection machinery, the priest showed him something that left him speechless. The frustration for Leopold Vindictive was that their efforts had now far eclipsed the work on the original message that had so stunned the British. The group's appetite for espionage had been whetted. The first pigeon might have been the appetizer; now they were ready to deliver the main course.

After the fall of Belgium, the Nazis had begun building a network of defenses along the Channel, including the coast of Belgium. This was initially to protect their forces as they were marshalled for a potential invasion of Britain. But from March 1941 the emphasis shifted to protecting the continent from British commando raids. A directive that month established a new unified command and ordered an increased pace of construction. In 1942 Hitler would order the extension of the coastal defenses all the way from Norway through to the border with Spain; it would become known as the Atlantic Wall, designed to ward off an Allied attack or invasion. Belgium, along with Norway, was the forerunner in 1941 because it was considered the most likely target for enemy action. In May 1941, there had been two attempts to make some kind of landing on the coast but they had been unsuccessful. Belgium had the most heavily defended coastline in the world.

These defenses were the grand project the three friends had been working on—an astonishing feat of intelligence gathering. They had traveled along the coast and mapped out the entire Belgian coastal defense system from De Panne near Dunkirk on the French border to Knokke on the Dutch border—a distance of sixty-seven kilometers, precisely drawn out in the same meticulous manner displayed in the first message.

Raskin traveled to give religious lectures on China, often appearing at schools where he would write out the children's names in Chinese characters. He had permission from the Germans to travel, and there were bicycles he could use littered across the country. On the trips he would also scan for birds through a pair of binoculars, while at the same time noting down the defenses he observed. He would also talk to his extensive network of contacts.

Arseen, meanwhile, did his spying while going about his business, the buying and selling of animal feed (which also bankrolled the operation). He drove a large American 1939 Pontiac and owned a set of binoculars and a Leica camera—all the tools needed for spying.

Hector Joye was free to make the most of his spare time, and he seems to have carried out the bulk of the reconnaissance work. The permission he had been given to visit the coast because of his need for fresh sea air gave him the perfect excuse to head out in his large Minerva car, touring Bruges, Ostend, Zeebrugge and other coastal spots. His two teenage sons came along on some of the trips and perhaps may even have been directly involved in the espionage work themselves.

The men first used a military map, on which they would add the information they discovered. Next they made their own detailed, colored drawings. Slowly, visit by visit, they updated these and added specifics. Barbed wire here. German emplacements behind some dunes. Roads to barracks and airfields. Munitions depots. A detailed legend was included to help the reader interpret all the details. German military buildings were depicted from different vantage points and angles. Arseen Debaillie traveled along the coast in August and September to spot machine gun installations. His brother Michel told him about the existence of an ammunition depot in a forest. Sometimes the brothers traveled together, sometimes with Joye.

The Joye family still possess drafts of their coastal defense and Atlantic Wall map. The plans are breathtakingly beautiful and delicate, written out on near translucent tracing paper, which could be folded tight to fit into a pigeon cylinder. Each consecutive draft from the early summer of 1941 onward reveals more detail and—strikingly—more color. By the end there are reds, yellows, greens, blues, oranges and browns. Red ink for bunkers, military installations, machine gun posts, airports; black ink for railway lines; green ink for forests and woodlands; brown ink for roads and paths. The drafts were put together over months and were far more detailed than the message they had already sent by pigeon to London. Later versions are packed with tiny writing, noting updates such as when German troops took part in maritime exercises and at what time guards were on duty on the coast and which places were mined. Huge amounts of tiny text accompany the maps. The places where bombs might do most damage are marked out. The writing is illegible without a magnifying glass.

Across each significant section is drawn the symbol for Leopold Vindictive—a curly L in a sharp V. The final versions have the group's seal. The result was Joye and Raskin's masterpiece—as much a work of art as the watercolors and panoramas Raskin had drawn in the First World War.

If Belgium and the continent were ever to be liberated, everyone knew that there would have to be a landing on the coast, and for it to work it would have to penetrate layer after layer of bunkers and hidden firing positions, barbed wire and large guns installed by the Germans. But it was not just for the longer-term eventuality of a full invasion that details of the defenses were invaluable. Churchill was determined in the meantime not to adopt a passive mentality. "The completely defensive habit of mind, which has ruined the French, must not be allowed to ruin all our initiative," he wrote just after Dunkirk. "We should immediately set to work

to organizing raiding forces on these coasts." This would be a task for newly created commando units. Churchill was keen to target the coast, and Leopold Vindictive was collecting precisely the information needed to do so successfully. If the British wanted to launch a raid (as they did in Dieppe in August 1942, although with serious losses), let alone a full invasion, few things could have been of greater use than the maps that showed where each camouflaged *Blockhaus* lay, with German guns in wait.

The maps were so detailed that when they were shown to Clément Macq he initially thought he was looking at the original German defense plans, and he wondered how the priest had managed to steal them. The amount of work involved in both collecting the intelligence for the maps and then drawing them is astonishing. Only by understanding that can one appreciate the frustration of those who had produced such masterpieces but had no way to ensure they were seen by their intended audience in London.

The maps had to be carefully hidden. Joye concealed his own set of drawings in his house, placing them in the frame of the kitchen door. Inside the large complex of the Scheutist missionaries where Raskin lived, there were plenty of rooms, basements and gardens that offered hiding places. Raskin took his set of maps and drawings and placed them in a stainless steel briefcase, which he buried in the peaceful gardens. He told one person what he had done—Father Remi Verhaeghe, an assistant to the head of the organization and the one person there to whom he entrusted the secret of his resistance work. Raskin had made color microfilms of the maps, and it was these that he hoped to send to Britain on the next pigeon. On the first floor of the mission house Raskin had his own room, hung with ornaments from China and containing his own books, papers and drawings. A two-foot plaster statue of the Virgin Mary stood on his writing table. The statue was hollow; inside he hid the films.

The plans were incredibly precious, their possession dangerous. How to get them to London remained the challenge. Raskin did not want to risk passing them through networks of couriers—the chance that they would be intercepted or lost on the long, tortuous journey, which could take months, was too great given the work that had been put into them. There was still no doubt that the safest and fastest way to get them to London was by pigeon. They just needed to get a message to London to ask for pigeons. Macq said he would try his contacts.

Macq's initial contact in Brussels was a former gendarmerie commandant, René Dufrasne, who had asked Macq for help with radios for resistance work in 1940. Dufrasne passed Raskin's message on to the next link in the chain, an engineer who lived a couple of streets away named Maurice Muylaert. But then something odd happened. Muylaert surprised Dufrasne by telling him that he already knew all about Leopold Vindictive. More than that, Muylaert boasted that he played a key role in the team.

The news went back through Macq to Joye, who then spoke to Raskin. It was time for the priest to make his own confession. Raskin sheepishly explained that he had been trying so many routes to send messages to London that he'd passed a radio message to Muylaert, which he would try and get out to London. Muylaert had first met Raskin in February 1941, after being introduced by Madame Roberts. Muylaert had not, as he boasted, helped found the group, but he had known about it. He was part of Raskin's circle of Brussels contacts, the secondary agents who supplied the priest with material.

Hector Joye was only now realizing that the pigeon that had landed was not, after all, the beginning of his friend's espionage work. Rather, it had been a gift from above, providing a route out for information collected by someone who had already been trying to spy for some time. Even before the arrival of the first

pigeon, Raskin seemed to have been stockpiling intelligence from his contacts.

Raskin's restless determination was both his strength and his flaw. It led him to try every avenue, and that was dangerous. Muylaert had been showing off by claiming to have founded the group. He had a reputation for boasting about his intelligence work, especially to his numerous girlfriends—in one case telling a woman in a cinema that he had a secret message in his pocket. He was proud of what he was doing. But pride could be dangerous if it was not tightly contained. Word about Leopold Vindictive was spreading. Radio broadcasts from the BBC—the only means of contact—did not help, nor did the ever broader circles in which the group was moving as it tried to find a way to reach London.

The Germans were already on the hunt for Allied airmen and those sheltering them. Now, as resistance began slowly to organize, it found itself facing a formidable adversary. Belgium was effectively under military administration, and Section IIIF of the Abwehr, the German military intelligence unit, had the task of hunting for spies and disrupting enemy intelligence activity both in Germany and in the territories it occupied. In Brussels the work was led by Major Mohring. But the key investigator was Georg Bodicker (also spelled Boedecker), originally from Hamburg. Bodicker was in his late thirties, slim, with blond hair and glasses, his teeth artificial after his real ones had been knocked out in a car accident. He had the scholarly appearance of a teacher and spoke both English and French.

Bodicker was no thug. He understood that rooting out spy networks required running one's own spies. That was Abwehr IIIF's speciality. It realized that the challenge of occupation required the active penetration of resistance cells and escape networks, after which as much intelligence as possible should be carefully gathered. Playing a long game in this way allowed one to understand every

contact and connection before pouncing, which usually meant the arrest of a wider network rather than simply the first people spotted. Abwehr IIIF was characterized by an effective combination of patience and boldness, MI5 in London reckoned.

Muylaert had passed Raskin's messages to a police inspector named Joseph Dehennin. At the start of the war, Dehennin had fled to France and developed contacts with French intelligence. He returned to Brussels and promised to work loyally with the Germans, but instead he sought to use his contacts to work against them. Dehennin and his group were in the early stages of building a network, passing political information to a French officer who would visit Brussels throughout 1941 and using a courier who could move across the border carrying material about German military movements and facilities.

Dehennin in turn had passed Raskin's messages to try to get them to London through one of the various routes his network employed, but this relied primarily on trusting the French to carry them out by hand through the Iberian peninsula. Documents—and eventually people, whether airmen or resistance fighters whose identity had been blown to the Nazis—would slowly follow the network's path of contacts, first into France, then down to Spain and usually to Lisbon, from where they could eventually make it to Britain. Every step carried risk, and there was never a guarantee a person or a message would get through.

In April 1941, Bodicker had begun an investigation into Dehennin. His great success came from inserting an agent into Dehennin's network itself. The Germans often did not speak the local language and so delegated much power to local agents, tasking them with the infiltration of enemy networks. Bodicker was careful to keep the identity of this new informer secret. In a cruel twist, the culprit was Dehennin's own brother-in-law—a portly, thirty-five-year-old fellow policeman named Eric Pieren who was being used as

a courier for the messages. No one had any suspicions about him. But somehow this man, who had been seen as a patriot, was quite the opposite. By the summer, he was passing all the messages he received from Dehennin to Bodicker, who would copy them before allowing them to move on so he could trace the network.

In early October, Dehennin passed to Pieren a long letter for the Belgian government-in-exile in London, who had also established contact, asking for a link to be set up to a group codenamed Zero, which could supply regular intelligence. Bodicker decided it was time to swoop. The next morning, Dehennin was picked up. In quick succession, Muylaert and two other members of his group were arrested by the Germans.

The Germans were careful to protect Pieren's identity as the source of the intelligence. No one knew he had betrayed the group, and he continued to inform for the Abwehr, collecting four thousand Belgian francs a month for much of the war.

Everyone who knew the arrested men held their breath. Would they be next? Some of Raskin's contacts in Brussels who helped with escape routes had already been arrested. How close were the Germans? Had the message that Raskin passed to Muylaert given him away? And would the prisoners talk about their contacts once they were interrogated? Raskin and his friends held their breath and waited. At any moment, the door might be kicked in. But slowly, they were able to exhale. It seemed, after a while, as if they may have survived.

But there were still no pigeons for Raskin and his friends. Their first alternative route to London had been cut off, and the Germans were now on their trail. Raskin did not know it, but the traitor Pieren had heard something in August to pique Bodicker's interest: He had heard there was a priest in Brussels who was sending messages to England via pigeons dropped by parachute. But Pieren did not know his name.

Resistance

B Y OCTOBER 1941, Raskin and his friends were becoming increasingly desperate for a means of contact. The hunt for a way of getting in touch with London became more desperate and dangerous by the day. But Arseen Debaillie now had another potential route. He was in touch with an insurance agent named Fritz Devos, who lived in Roeselare, whom he knew through business. Devos was a patriot who might know a way to get a letter to England. It had to be worth a try. With no sign of a pigeon, they were forced to reach out ever farther to try to find some route to Britain. But each new contact exponentially increased the risk, as the circle of knowledge widened beyond a small group of friends. All it took was for one part to be penetrated and the whole web could be rolled up. That was why small, self-contained groups were often the best. If Leopold Vindictive had received its pigeons it might just have stayed that way. But that was not to be.

The other option would have been to simply give up—to decide it was too difficult and too risky to try to get the intelligence material back to London and instead to go back to ordinary life as a priest, a farmer or a pigeon keeper. But that was not the nature of these men and women.

On October 9, Raskin and the Debaillies gave Devos a message

to get to England. A draft the priest wrote the previous day survives. "To the Commander in Chief of all British Forces," it begins grandly. "We have important information." It asks for multiple pigeons to be dropped in the hope that at least one would get through. Raskin believed that pigeons had been dropped on the right day for him but at the wrong place and had fallen into German hands. He also explained that his group had tried to send a message by radio but assumed that this had not worked. New pigeons were needed and could be dropped at the same place on a date London should indicate. He asked for acknowledgment that the letter had been received through a reference to AM 20 on the BBC. Never use Leopold Vindictive, he stressed.

"We are neither from Nieuport nor Lille, but a self-built self-standing group of just three men," he added, still trying to correct the confusing British message of a few months earlier. They had heard that pigeons had been dropped near Nieuport but explained they were not able to get hold of them. They thought the British had wrongly dropped them there for them, although it may have been that they were just another regular Columba drop.

"Some try to steal our name and reputation," Raskin wrote, offering a fascinating insight into how jealously he guarded that reputation. "Never believe messages that do not bear our seal," he continued, explaining that this seal consisted of the curly initials used in the first July message. No one else would know what that looked like or be able to copy it. He said nothing would be spared to help—including their lives. The message promised that the group had new information "of the utmost importance," referring to plans of the Belgian coastal defenses. After an Allied victory, his group would reveal their identity and congratulate the British, he went on. But before that, they wanted it to be impossible for the Germans to discover them. The message ended: "Long live England! God save the King and us with Him! Leopold Vindictive 200."

The message was given to Devos to pass along to his network during a visit to Lichtervelde on Raskin's travels between two lectures. But would it reach London?

In London, the Columba team was itself becoming increasingly desperate at the lack of news from Leopold Vindictive. In December 1941, Rex Pearson, running the drop operations from army signals, wrote to a commander in Naval Intelligence who received the material from the Columba team, saying that they had repeatedly tried to get in touch with Leopold Vindictive but with no response. "Whether it is the fault of the RAF or just bad luck, I cannot say," Pearson wrote. "The matter is of such extraordinary importance however that I am wondering whether you could consider inspanning the Fleet Air Arm," he pleaded. It is clear from this note that the team was sufficiently worried about their failure to reach the Belgians that they were casting around desperately for help. Pearson seems to have feared that the pigeons were just too low a priority for the RAF team and that other departments might be enlisted to drop birds especially for them.

"If you would consider this, I would be glad to meet you and talk things over," Pearson ended his plea. But in the files of Naval Intelligence, those sentences are met with a large black cross, and "NO" is written in the margin. There would be no help from the Admiralty. Columba was simply not a priority for the military, and MI14(d) lacked the heft of other intelligence agencies to demand resources.

The winter of 1941 was a low moment for the Columba team. The performance of the pigeons had begun to dip through the autumn. In September, ninety-nine birds had been sent but only seven returned—just three of those bearing a message. The team was sufficiently worried that Brian Melland suggested keeping back the figures until they could be combined with those of October to improve their appearance. But October produced a

mere six reports. It was a bleak winter for those sending and receiving the pigeons alike. "One hears many people say 'What are the English waiting for before they come?'" a Frenchman wrote. "We Frenchmen wait impatiently for your help to get us out of this misery," said another.

Pearson wrote to Brian Melland of MI14(d) in mid-January 1942 proposing a pause in operations. The awful winter meant that the pigeons' white parachutes would be difficult to spot. Few people were likely to be in the fields anyway. Most of the birds would freeze to death if they were not discovered quickly enough. The aim was to go slow and build up a stock of good birds to be used in spring when, as the team put it, the "invasion season" started and they needed to watch for signs of renewed German activity.

The subsequent three-month break was the only time during the war when Columba would halt its operations. These were precisely the three months when Raskin and Leopold Vindictive continued to wait, hoping for a delivery.

The planes dropping Columba pigeons and secret agents, like those of RAF Bomber Command, traveled a perilous path. As they crossed the Channel, German anti-aircraft guns and the Luftwaffe's night fighters lay in wait. Belgium—lying on the main air route to Germany—was the location of some of the most concentrated defenses. Searchlights were controlled by radar, and when they found a plane, it was lit up so brightly that the crewmen were near blinded. "When they got a fix on the aircraft you immediately became illuminated, isolated and vulnerable—and by God, do you feel naked," one pilot recalled. "You are up there weaving about trying to get out before you are spotted by the night fighters."

As pigeons and agents were dropped, German searchlights and night fighters picked out British planes with uncanny accuracy. The initial Battle of the Beams had been a response to German

bombers' success in striking Britain. Next, R. V. Jones wanted to know why German defenses were so good at spotting British planes heading over Europe, whether on bombing missions or to drop agents and pigeons.

Germany had been shocked when the bombing of London was reciprocated by RAF strikes on Berlin, and it invested hugely in defending its homeland with the most advanced technology. From the autumn of 1940, Jones had begun glimpsing a new set of advanced defenses—a belt of searchlights that sought out British bombers as they flew over France and the Low Countries heading for Germany. Using the searchlights, the German night fighters seemed inexplicably accurate in finding British planes. At the lowest point, the RAF was losing two hundred bombers a month, 80 percent of these due to night fighters. Why were the German defenses so effective, asked Jones. The answer had to be that they were guided by some kind of radar. But where were the stations, and what did they look like? And how did they work?

Mysterious pictures taken by Americans in Berlin pointed to some kind of new tower, while Enigma decrypts talked of something called Freya. The problem for Jones was how to get intelligence from the ground, especially in places where MI6 had no coverage.

Jones realized that Columba offered something new. Columba was already helping to find targets for the RAF. A message signed "Bernard Franklin" from Courtrai provided a readout on recent bombings and specific map coordinates for ammo dumps and airfields, including the location of dummy wooden installations and airplanes installed by the Germans in the hope they would be hit. The difference between these and real airfields could not be discerned from aerial reconnaissance. This was one of many ways in which Columba could offer something inaccessible to eyes in the sky. (Sometimes Columba provided glimpses of the

dark events that were unfolding. One message in Dutch from Assen in the Netherlands on September 24, 1942, ended not with a signature but a single plea: "Help our Jews.")

Jones was now realizing the operation could be used for something more than random drops; it could be more closely targeted in its intelligence collection. He asked the Columba team to drop pigeon containers with questionnaires in precisely the spots where he suspected radar stations might be, and where there was limited agent or aerial reconnaissance coverage. "As with every other kind of source, it was essential to ask questions that the finder could answer. The chances were that the finder would be an agricultural laborer; so the questions had to be such that this kind of man could usefully answer them," Jones wrote. So the questionnaires were deliberately written in a way that required no tecÿical knowledge. "Are there any German radio stations in your neighborhood with aerials which rotate?" the questionnaire asked, since this was something so distinctive and unusual that people could not but be curious. "Even unskilled observers could hardly fail to identify these, and to give fairly accurate pinpoints," Jones said. "So we had the pigeons dropped in areas where agent cover was bad, near where we thought radar stations ought to be." The birds were dropped. Now he just had to wait and see what came back.

AS THE YEAR ended, Raskin kept himself busy giving lectures, carrying two heavy suitcases as he tried to travel around the country, the trains now irregular thanks to the occupation. His only relief, he wrote to his brother, was being able to play the accordion for half an hour on the one or two nights a week when he was at home in Brussels.

Following the arrests of the Dehennin group in October, the channel via Devos was now Leopold Vindictive's best—perhaps

their only—hope of establishing contact with London. And eventually, this channel would offer Raskin the first chance since the pigeon to make some such contact. The channel relied on a growing network engaged in smuggling people over the border.

After the arrests in October, Madame Roberts introduced Raskin to the man at the center of the group. Henri Michelli was emerging as a major player in resistance work in Brussels and was Devos's key contact, the man behind the much-hoped-for link to London. Michelli looked like the forty-something accountant he had been, rather boring, old fashioned and upright. Like many other patriots, he was a middle-aged man who had fought in the First World War but had been denied—either by age or by the sheer speed of Belgium's collapse—the opportunity to fight a second time around, so he sought to express his patriotism by getting involved in resistance work. By September of 1940, he was helping stranded British servicemen and Belgian pilots escape to London and distributing clandestine literature; the following year he would become involved in sabotage. He had his finger in many pies. One of those was the most important escape network of the war, which offered a way to get people and information through France, into Spain and out of occupied Europe.

In August 1941, the strikingly elegant twenty-four-year-old Andrée ("Dedee") de Jonge turned up unannounced at the British consulate in Bilbao in neutral Spain. She explained to officials that she had single-handedly smuggled a group of escaped Belgian prisoners and British servicemen through France and over the Pyrenees.

At first, British officials were incredulous that this well-spoken young woman could have achieved such a feat. Was it a Gestapo plot? Back in London, the organization tasked with helping Britons escape was MI9. But Claude Dansey at MI6—as ever—pulled the strings. He was interested in escape and evasion work largely

as a source of intelligence, but he kept a close watch on it since he disliked the idea of anything happening without his knowledge. "My job, and that of my agents, is to collect information about the Germans' intentions and activities, not to act as nursemaids to people who seem totally incapable of doing much to get back on their own," he explained to Jimmy Langley, the man he installed at MI9 as his liaison. Dansey told Langley he was to keep him informed about everything that went on at MI9, even above his own nominal boss inside the organization. Dansey, never a great believer in the ability of women to take part in clandestine work, was suspicious about de Jonge's feat. But despite his skepticism, after ten days officials on the ground were won over and realized de Jonge was something special. She would become known as "Little Cyclone," and the evasion network that grew out of her visit would be code-named Comet. The network passed escapees from safe house to safe house while false papers were prepared, then from guide to guide along the route, with schoolchildren often acting as couriers. By the end of the war, Comet would become a legend, having helped eight hundred Allied airmen and seventy-five intelligence agents escape from under the noses of the Nazis. It sacrificed the lives of more than a hundred and fifty of its own members in the process.

The network was initially run by Andrée's father, and Henri Michelli had become his trusted lieutenant after they had met earlier in 1941. Like other Belgian intelligence and escape networks in the early years of the war, the people involved in Comet overlapped and interconnected with other intelligence networks like Marc, Luc and Zero, as well as with the smaller Leopold Vindictive. It was inevitable that the networks' personnel should intersect in the early stages of occupation, but it took time and hard lessons for those involved to understand just how dangerous this was.

Raskin's message "for the Commander of British forces" in

early October 1941 had been passed from Devos through to a man whom Michelli was sending out of the country on the Comet line. This was a Belgian aviator in his late thirties named Jean Vandael. Michelli was helping Vandael move in and out of the country as the airman tried to establish his own intelligence network in Brussels, Antwerp and Liège. He had made at least three journeys between Vichy France and Belgium that year, and every time he had taken messages with him that he would pass on to people in the hope they would make their way to England. It was a slow, difficult process, with many possible points of risk and failure.

Raskin's message slowly made its way out with Vandael in October. It eventually found its way to the crossroads of Lisbon. The capital of neutral Portugal was a place where people trying to get in and out of occupied Europe congregated—some trying to reach Britain, others South America. It was also crawling with German spies. People frequently turned up at the British embassy claiming to be secret agents or escapees. Sometimes it was true, and they were just trying to get out. Sometimes, though, they were working for the Gestapo.

The British presence was a mess, replicating the rivalries that soured relations in London. As well as the regular embassy staff, there were representatives of three separate British intelligence teams—MI6, the Special Operations Executive and the escape and evasion service, MI9. If there was any cooperation it was on a personal level because two people got on with each other, and despite—not because of—orders from London. MI6 in particular looked down on SOE. "Our recently constituted junior half-sister was rash and untrustworthy, lacking in security," was how one MI6 officer in Lisbon had been taught to see his partner agency.

After his October trip, Vandael returned to Belgium, but now the Germans were on his trail. He was "burned" and realized he needed to leave. Jean Cassart, the agent who had been dropped in

October, knew Vandael, as they were both air force officers, and he gave Vandael ten thousand francs to pay Michelli to take him out again through the Comet line.

But Cassart himself now needed to flee, and his story reveals just how difficult it was for London to maintain contacts and get people in and out. His life was in danger and London was desperate to extract him, both for his own sake and in case he was caught and compromised their networks. In early December, Flight Lieutenant Alan Murphy (known as "Sticky") flew out to pick up Cassart on an RAF Special Duties mission. It was a snowy night and Sticky arrived after midnight, looking as he approached the field for the reception committee to flash the letter L, for Leopold, in Morse code as a recognition signal. But he saw the wrong letter.

Sticky was supposed to head home if that happened, but he circled while deciding what to do. Could they have simply made a mistake? He decided to land a short distance from the flares. When the aircraft landed, he pulled out his revolver and flashed a light toward the flares. Then he heard a bang.

On the ground, Cassart and his wireless operator had been delayed by ice on the roads and arrived just before the pickup time. As they went to lay out the torches, Cassart heard voices. Were they locals or Germans? The five dark shapes were wearing helmets. Cassart cocked his revolver. At that moment a bullet hit him in the arm and he fell down a slope. He jumped over a stream and lost his gun as he slipped on the ice and raced into the woods. Two more rifle shots followed him, and there were five soldiers on his tail. At this moment, Cassart was watching as Sticky's Lysander flew overhead. He prayed it would not land but watched in horror as it did. The Germans came out firing, and he watched the Lysander plane turn and take off again. One German bullet went through Sticky's neck. Fortunately, he carried one of his wife's

silk stockings as a lucky charm and wound it around to reduce his bleeding. By the time he made it back to Britain he was barely conscious from the loss of blood. Colleagues at the RAF base told him dirty limericks over the radio to keep him awake as he approached. When he landed, they found thirty bullet holes in his Lysander.

Cassart himself was captured within a few days. One of his contacts on the ground had been a double agent. After this mission, British intelligence and the RAF decided that it was simply too dangerous to land in Belgium to pick people up or drop them off.

Over Christmas, Andrée de Jonge took Vandael on a week-long trek over the Pyrenees. On January 19, 1942, he arrived in Lisbon. Here he was questioned by British intelligence, keen to talk to him because something strange had happened. Officials in London had begun an investigation to find out what had happened to the October message from Leopold Vindictive brought by Vandael to Lisbon. He was questioned as to what it contained and what he had done with it. He recounted the details as best he could—for instance, Leopold Vindictive's desire to change their name and to be sent more pigeons—although he also got some details wrong. He explained that he had given the message to a man called Harper in Lisbon, although there was another intermediary called Eric.

The investigation suggests London had never received the message from Raskin and Leopold Vindictive and that it was now trying to work out why and reconstruct its contents. A note from February 1942 details the report of an agent investigating the message's route in Lisbon, explaining that it was proving very difficult to talk to people. At the passport control office (which was cover for the MI6 station), someone said they thought Vandael had sent a message from Leopold Vindictive about pigeons, but they also

said that there seemed to be a lot of boasting and that there was some kind of confusion—probably between different Belgian and British intelligence services, which proliferated in the city and did not always talk to each other—as to whom the message had been delivered to. It may simply have fallen into the hands of someone who did not understand its significance. Lisbon was yet another place where the attempt to reach out had failed.

After five days of debriefing by a Belgian intelligence officer, including investigation of the route of the Raskin message, Vandael went to Gibraltar, and on March 11 he reached Scotland. He carried with him another message for British Military Intelligence, this time hidden in the epaulets of his jacket. The message consisted of one sentence and three words in code, so that if he had been caught it would not have made sense. He told British intelligence that Michelli had offered his services to help any agents they could drop into Belgium. When an agent was dropped, a message was to be broadcast with the code words "Expect a visit." The agent was then to make contact using a recognition phrase that included the words *Michelli*, *Marcel* and *Malaga*. Michelli's message also said he was in touch with a resistance network that urgently needed a radio set—Leopold Vindictive.

The arrival of Vandael in person with this new message had immediate effects. Events were gathering pace. British intelligence now realized that Leopold Vindictive was still in existence and eager to cooperate. The pigeons had not gotten through, but there might be a way after all to reach the team. Urgent action was needed. This time the contact would be more direct: As soon as possible they would parachute in an agent who could act as a radio operator.

But who in British intelligence had received the message and was now running the show? This was not MI14 and Columba— they dealt with pigeons and German military intelligence, not

with people coming through escape lines or agents being parachuted in. Intelligence from that route went straight to Claude Dansey and MI6. Dansey would have known who Leopold Vindictive was after its startling intelligence had been circulated around London, and even to Churchill himself, the previous summer. Now there was a chance for MI6 to muscle in on the group that, in his mind, the amateurs at MI14(d) had stumbled across. This would now be an MI6 operation, a chance for his service to deliver the goods. And that would prove to be a problem.

What no one knew was that Bodicker in the Brussels office of Abwehr IIIF had begun a number of parallel investigations. One was into reports of British airmen being sheltered in Brussels. Another was into the mysterious priest who had been using pigeons. A third was into the group calling itself Leopold Vindictive, to which the BBC had been broadcasting messages. Bodicker wanted to know the identity of this mysterious group. King Leopold himself had at some point been questioned as to whether there was any royal link to this apparent new intelligence network, since it at least partly bore his name. Bodicker and the Abwehr pressed on with their investigations. They had no idea that all three lines of investigation were leading them toward the same place.

Secret Agents

JEF VAN HOOFF was afraid. Even his MI6 minder looked tear-
ful, he thought. He and Marcel Thonus climbed aboard Whitley
aircraft B-4166 and the engines started up noisily. It was a cold night,
but their flying suits kept the two Belgians warm as they set off on
their mission.

The pilots did not know the real names of those they were tak-
ing to Europe. But they knew this was an MI6 job. Those were
even more secret than the missions organized by SOE. MI6 usually
insisted that its agents must never share an aircraft with agents of
any other service and that nothing be put in writing about them
in operational logbooks. MI6 liked to keep things tight. That was
going to be a problem for Raskin and Leopold Vindictive—that,
and the petty rivalries among spy services in London, in which
men like Jef Van Hooff were pawns. MI6 had decided that Van
Hooff and his companion Thonus would be dropped with instruc-
tions to establish contact with a number of groups and individu-
als. Among those groups—added late, after Vandael's arrival just
a few weeks earlier—would be Leopold Vindictive.

Van Hooff looked down at the floor of the cabin, where he saw
two containers and two small baskets of pigeons. They were for
the resistance, it was explained. But not for Leopold Vindictive.

Van Hooff and Thonus swigged rum to keep warm as the plane made its way toward the Channel just after ten at night. Thonus seemed a world away. Van Hooff was having dark visions of what might lie ahead. After a while he drifted into a deep sleep.

He was awoken with a start. The sound was different. Enemy fire? The jump door was opened—just in case they needed to make a sharp exit, the sergeant flying with them explained. Thonus and Van Hooff sat with their legs dangling. Suddenly there were bright streaks across the aircraft. "What's that?" Van Hooff asked the sergeant. "It's the engine," the sergeant replied, not very reassuringly. Van Hooff was convinced it was tracer fire coming from all sides. The men pulled their legs back in quickly. But it was just the port engine causing problems. Sitting in the containers, the pigeons seemed as scared as he did, thought Van Hooff.

After an hour or two, they approached the drop point in a wood near Valenciennes. It was just after midnight.

They looked at the light that would tell them the correct moment to jump. A red light meant get ready; green meant go. Red came on. The men tensed, and the plane began to descend. But the light did not change. Van Hooff's eyes began to hurt as he stared at the light without blinking, desperate not to mistime his jump and miss the right landing spot. But it stayed red.

The seconds ticked by. The sergeant emerged from the cockpit to explain that the pilot could not locate the right point for the drop. There was too much ground haze.

"What now?" Van Hooff asked.

"Back to England," he said.

Van Hooff tried to quell his anger by gulping the last swig of his rum, and he sat behind a container, cursing. The pigeons sat next to him in their baskets, oblivious.

Just after half past three in the morning, the plane was home. Exhausted, Van Hooff fell into a sleep so deep there were no

dreams or nightmares. For Jef Van Hooff, the irony was that after the crazy things he had done to get out of Belgium, the planned parachute jump to go back in as an undercover agent working with the resistance seemed almost straightforward.

THE THIRTY-YEAR-OLD HAD left Belgium nearly a year earlier. He had been a sports journalist. A picture of him in his soccer uniform before the war shows him as an apparently carefree, well-built young man with a broad, easy smile and dark hair. After the occupation, he first made his way into France and then hid on a boat from Marseilles that crossed the Mediterranean to Algiers. From Algiers he headed to the border with Morocco. Then he clung for twelve hours to the underside of a wagon crossing the hot desert. From there he made it—perhaps inevitably—to the crossroads for those trying to hide or escape: Casablanca. On a dark night, Van Hooff stripped off and swam naked with thirty others to clamber aboard a boat that would take them to the British outpost of Gibraltar. The boat had not gone far when the motor gave out.

After six days and nights packed in like sardines, they landed in Algeciras. Eventually a British destroyer picked them up and took them to Gibraltar. A month later Van Hooff made the dangerous crossing on a transport ship and eventually arrived in Liverpool.

For Van Hooff, like all the other refugees arriving from Europe, his first experience of Britain was not dissimilar to that meted out to their children by the British elite. He found himself cooped up in a place that was ostensibly a school but actually more like a prison. The Royal Victoria Patriotic School in Wandsworth, in south London, is a vast neo-Gothic castle that at the time acted as the processing center for arrivals from Nazi-occupied Europe. Beneath its battlements laced with barbed wire, the guards were

ready to shoot. The security was tight thanks to the fear that the Nazis were sending in agents posing as refugees.

After a cup of soup and a tiny scrap of meat, arrivals were interviewed carefully about the smallest details of their previous lives and their journeys to Britain. Interrogators were looking for inconsistencies. Not only the answers they gave, but the clothes they wore and the documents they carried were scrutinized for evidence of deception. The discovery of some sticks, cotton wool and white powder in a wallet of one Belgian who arrived in the spring of 1942 was the beginning of the end for him, since they were telltale signs that he had been trained to use invisible ink. For him and other spies who were discovered, the hangman's noose lay ready at Wandsworth prison across the road.

But as well as looking for enemy spies, the sifting was also a means whereby British intelligence could find their own recruits. Van Hooff told people he had left Belgium pretending he was going on holiday to France but instead had come to the UK to join the Belgian section of the RAF. But in October 1941, he was marked out as a man with the independence of spirit and will to survive that would make for a good secret agent. The job of a recruiter was to understand the character of the man in front of him. Over whiskey and cigarettes, one recruiter regaled Van Hooff with the risks as well as the romance of clandestine work. By the end of the conversation, Van Hooff was intoxicated with the idea of parachuting back into his homeland. He saw himself arriving as a hero to rescue his friends and family.

Two different British intelligence services were sending in agents undercover into occupied Europe. There was MI6, the well-established and rather sniffily superior Secret Intelligence Service, which gathered intelligence; and then the noisy new kid on the block, the Special Operations Executive, or SOE, tasked by Churchill with setting Europe ablaze with acts of sabotage. It

was the latter service that reached Van Hooff first. On October 21, 1941, SO2—a unit of SOE involved in using agents to spread black propaganda and stir up resistance—sent a request to MI5 for a trace on Van Hooff because the unit was considering employing him as an agent. On November 14, an MI5 officer wrote back saying "Nothing Recording Against," meaning there was no indication of anything negative about the man, adding that "he made a good impression at his interrogation."

The leading figure in the SOE section dealing with Belgium for much of the war was a colorful character even by the eccentric standards of the secret world. Hardy Amies joined the beehive-busy SOE HQ at Baker Street in 1941, aged thirty-two, and the Belgian section that November. A fresh-faced, good-looking young man, his civilian occupation was noted as "dress designer"; after the war, he would gain renown as the queen's dressmaker, and a fashion label still bears his name. His colleagues in British intelligence soon realized that the fact he was gay (in both senses of the word) did not disqualify him from work specializing in violence. "He is far tougher both physically and mentally than his rather precious appearance would suggest," noted one instructor. Amies played by his own rules and could be ruthless. During the war he planned the Belgian end of "Rat Week," in which collaborators who had sold out members of the resistance were shot or beaten to death.

Amies's willingness to undertake such actions likely reflected his frustration at the failures SOE had experienced in Belgium and the heavy losses it had suffered. The year 1941 had been bad for the team he joined. "None of the officers on the staff of the Belgian section had any practical previous knowledge of clandestine work. They gained it by experience, which can only be described as bitter," read an official evaluation.

Recruits were often of poor quality. A mechanic they trained

was deemed "absolutely appalling" by the security team thanks to his fondness for drink and for picking up "the most awful women." Amies overruled the warnings and sent him into the field, where he picked up a peroxide blonde and took her to the Palace Hotel in Brussels, which was packed full of Gestapo agents. He was arrested and eighteen people were shot as a result. Amies was the man who had to identify the mutilated body of the agent whose parachute caught when he jumped over Belgium in July 1941, at the time Leopold Vindictive's pigeon was dropped. It was a sight he never forgot.

Belgium suffered in comparison to the resources devoted to France. "We were very much the poor child of northern Europe," Amies reflected. "We had low priority. If there was a moonlit night—weather-wise correct for parachuting—and there was only a certain number of planes that were available for taking off agents and parachutes, France got priority over us. There would be a lot of frustration. A great deal of my energy was taken up in assuaging the distress and the anger and the nerves of the parachutists that were delayed. There's nothing like getting teed up for going off and then it is delayed."

SOE needed unsentimental agents, hard men with little to lose, willing to obey orders to carry out sometimes morally as well as practically challenging tasks. At his interview, it was decided to see what Van Hooff was made of. "A train is occupied by hundreds of Germans and war material of the highest importance," an SOE recruiter asked him. "But it also carries a member of your family. Could you blow it up?" Van Hooff's answer was honest: No. Then he was not right for them, it was explained. SOE only wanted those who would answer yes to that question.

The next afternoon someone else came to interview Van Hooff. The Royal Victoria Patriotic School was the site of fierce competition between spy services. This time, the man said he was called

Page. He was in his midforties and English in character but Latin in look, Van Hooff thought, with his olive complexion and curly jet-black hair. He could also speak French like a native. The interview this time was more like a conversation than an interrogation, cordial, as if the two men were exchanging pleasantries in a park.

As he spoke of the work of his agents, Van Hooff thought the mysterious Page talked with respect and affection, almost paternally, of his charges. He did not gloss over the hard truth of the torture they had endured after their capture by the Gestapo. By the end of the long conversation, Van Hooff was sold. Page had worked his magic and reeled him in with care rather than by bludgeon. The Belgian wanted to be worthy of Page's respect—even if that meant taking a gamble with his life. Page had just recruited Van Hooff for MI6.

The Belgians knew the man as Major Page but his real name was Frederick Joÿ Jempson (after the war he changed his name to Page-Jempson). He joined the police in 1914 and then the Special Branch, but after twenty-five years he left when war began and joined first the military and then MI6. He would be the officer in charge of Belgium at MI6 HQ for much of the war. He had a sometimes flamboyant manner but was an effective operator, and he was spoken of with high regard by those who worked with him—apart from SOE, whom he fought to keep off his turf.

Page served directly under Claude Dansey, the all-powerful, almost spectral presence whose hidden hand guided MI6 operations all over Europe. Dansey's job title was assistant chief, but many thought him the real power behind C, the Chief. Dansey was battling to rebuild the work of MI6 in Europe, and his wily character meant no one was to stand in his way and no one else was to know what he was doing. SOE was supposed to stir up resistance through sabotage and by setting up secret armies. In contrast, the task of MI6 was to gather intelligence. There was an inherent

tension between the two types of work. Sabotage was loud and noisy and drew attention. Espionage was designed to be stealthy, to keep a low profile so that it could endure.

Dansey did his best to control SOE in the early days—insisting that all SOE radio traffic from the field went through his hands at MI6—but control was wrested from him. The month that Van Hooff and Thonus were to be sent was the lowest point of relations between SOE and MI6 during the whole war. Dansey thought SOE men were amateurs, crashing around, but he also recognized that what Churchill wanted was someone to make a lot of noise and carry forward the spirit of subversion and resistance, as much to boost morale at home and in occupied Europe as for the actual impact of its activities. The perception was that at least SOE was doing something, which was not always the view of MI6's work. MI6 even feared being swallowed up if a new figure was appointed to run both organizations. At one point, SOE paraded a letter from the air staff saying it had carried out the finest piece of intelligence gathering during the war. R. V. Jones was summoned to a meeting with Dansey, who wanted to find out who had written the letter. Jones was forced to reveal that he had written it himself. He explained that SOE had produced a report from one of their agents—a member of the French resistance—who had infiltrated a German control station that operated its latest navigational beam for night fighters and whose report of his findings showed remarkable bravery combined with techni-cal understanding. When Jones finished, Dansey began walking around the room, shouting "The cheats, the cheats, the cheats!" before claiming that the agent was actually from MI6.

There was competition to recruit the best agents, for RAF slots to drop their men into enemy territory, even to prioritize which messages were sent out on the BBC. The Royal Victoria Patriotic School was itself a flashpoint. Amies had furious rows because

he believed that the best men were always being funneled to MI6 and not to him. In the case of Van Hooff, SOE let him slip through their hands and into those of MI6.

Van Hooff was next introduced to the Belgian intelligence service in London. This drew him into a vicious, murky realm of refugees and spies. British intelligence operations in Belgium involved a poisonous brew of vitriolic rivalries, and in the spring of 1942 they too had reached their lowest point. MI6 and SOE were not just feuding with each other but also with the Belgians in exile. London was home to a myriad of exiles from each country, all maneuvering for influence in the hope of perhaps running their country if the Nazis were ever driven out (as de Gaulle managed on the French side). The Belgians were no exception. Layered on top of political ideology and personal ambition were the linguistic divides that addled the country, as well as the question of whether to be loyal to a king who had remained under occupation. There were two intelligence outfits linked to the exiled government. The Sûreté (tasked with protecting the state) was focused, like MI6, on intelligence gathering. Around the corner in Belgravia was the Deuxième Bureau, which, like SOE, was more interested in military intelligence and sabotage. The resultant infighting was savage and spilled over into relations with the two British services, each of the four trying to play off the other side against their competition. "It is many years ago since I first had to deal with the Belgians and their intrigues. They have not altered one bit in twenty-five years," Dansey noted bitterly. He was a man who distrusted the security of exiles, while understating his own role in fueling the various intrigues and the fact that his service drew much of the intelligence it presented as its own in London from the Belgians and other foreign services.

The Sûreté was led by Fernand Lepage, a thirty-five-year-old magistrate who had escaped to London and started to set up the

intelligence agency virtually from scratch. As a child, Lepage spent the First World War in Britain after his family had fled the conflict, and he had been educated at English schools. That meant he could speak the language fluently as well as navigate its politics. Within a few weeks of returning to London in 1940, he had been contacted by a mysterious Englishman—Page again. The MI6 officer took Lepage to a flat in St. James's Street where he was confronted by Dansey, who gave him a lecture on starting a freelance spy service. "Do you realize, Lepage, that you are endangering the security of the realm?" he was told.

Lepage confessed that he knew little about intelligence work but wanted to learn. Dansey softened, and eventually the two men concluded a written agreement that would be the basis of close cooperation. Lepage preferred MI6's intelligence work to SOE's sabotage, which led to bitter, vicious rows. He did not want to blow up his own country's factories and potentially kill civilians, even if the Nazis might be using them. Lepage feared that the SOE's supply of weapons to militia groups risked arming groups who would fight each other to take over the state after the war. That was the kind of thing the rival Deuxième Bureau wanted to do, but Lepage warned MI6 that they wanted to build a "crypto-fascist regime around the monarch." The Deuxième Bureau meanwhile said it would cooperate with SOE only if it promised to have nothing to do with the Sûreté. It was an unholy mess, which had real consequences for the lives of agents operating in Belgium.

On March 11, 1942, just before Van Hooff made his flight back to Belgium, Lepage and Amies's boss at SOE had a screaming match in which each called the other a "bloody liar." Lepage was convinced SOE had been sending agents into Belgium without telling him. He was right. SOE had not told the Belgians, as they believed their own sabotage operations were being sabotaged. They thought the Sûreté was carrying out surveillance at SOE training

schools and then getting hold of any SOE agents before they left for Belgium and warning them not to engage in sabotage. One of Lepage's aides had been caught by Hardy Amies frightening off nine potential recruits for SOE who withdrew at the last moment. Each side withheld messages they were supposed to pass on, and Lepage was left "hopping mad" when he discovered that SOE had sent a message to an agent in Belgium asking for details about his own background.

SOE thought the problem stemmed in part from Lepage's personal ambition. "To achieve his ends and safeguard his own position he can be proved to 'double-cross' to an unlimited extent," went one SOE memo, highlighting the personal vitriol that bled into relations and even led to the darkest possible accusation as part of an attempt to oust him. "This 'double-crossing' gives rise to the strongest suspicions of treachery." Another SOE official said the leader of the Belgian government-in-exile was using Lepage "as a head of a Gestapo service to browbeat and terrorize all Belgians in this country and watch their every movement to prevent by all means in his power anything which might jeopardize his apparently dominating position."

But Lepage had the full backing of the Belgian government-in-exile—and of MI6, who saw him as their man. Lepage was particularly close to Page (leading Lepage's own staff to mutter occasionally that he was in the pay of England rather than Belgium). SOE considered Page a "very cagey individual" who might even be happy to see the rift grow deeper. The mansions of Belgravia made for a bitter, distrustful backdrop for the agents who risked their lives. This could have real consequences for resistance networks like Leopold Vindictive operating on the ground.

FOR VAN HOOFF, after his recruitment by MI6, the following months were a mix of hard training and hard carousing. Soho and

Piccadilly were the playgrounds for men preparing to risk their lives and desperate for one more night on the town. Londoners carrying their gas masks often looked on disapprovingly, unaware of why he and others were drinking and dining at the best restaurants. Agents wanted to party; but this meant word often got around the small exile communities about who was about to head back home.

Van Hooff's training took place in a large house in Hans Place, just south of Harrods department store in Knightsbridge. There were no uniforms, no names for the recruits—just a serial number and nickname. Guards watched them during the day. The fear was that German spies might identify or turn agents before they even landed back in their own country. They were also tested. Could a recruit's tongue be loosened by too many drinks? Or by a conversation with a pretty girl (who was, unknown to the agents, working for British intelligence)? Many failed the tests. By the end of two months, half the original entrants had been weeded out. Van Hooff learned to look on everyone with suspicion. He would need to do so when he got back to Belgium.

The school for spies included training on radio sets—how to transmit and receive, how to take a set apart and put it together again, how to encode a message. There were also lessons on enemy weapons and uniforms. Van Hooff paid attention. He knew his life might depend on his ability to remember each answer. He was quickly singled out and promoted to lieutenant.

After classroom education, there was physical education in Manchester with a former officer of the Lancers of Bengal and finally parachute training. What would you do if your parachute did not open? Put on another, the instructor joked to a group of Poles, Czechs and Belgians. When it was Van Hooff's turn to do his first training jump, he preferred to close his eyes.

Finally, Van Hooff was given his instructions, stamped TOP

SECRET—details of his cover and his mission, his codes and contacts. There was a week in a fancy hotel to read and learn his file by heart, with orders to make no contact with anyone except Page and a man assigned to mind him. But on the fourth day, something strange happened. Van Hooff's minder had gone off for a chat with some women when the hotel front desk called up on the internal phone and said there was a guest to see him—a captain. This did not sound right, thought Van Hooff. He knew he was not supposed to have visitors. He said the man should wait a few minutes before coming up. Van Hooff called Page, who said he had not sent anyone and told Van Hooff to hold the man there for ten minutes if at all possible while Page tried to organize a response.

The visitor made his way up to Van Hooff's room a few minutes later. He was dressed in a British uniform. He knew Van Hooff's code name—Lieutenant Press. Without any niceties but in a well-spoken accent, he asked the Belgian how he was getting on with his instructions and his codes. He said he wanted to see them. Van Hooff's suspicions—already strong—were now sky-high as the man became more insistent.

"Who sent you?" Van Hooff asked.

"Major Page," he replied.

Van Hooff knew this was a lie since he had spoken to Page. He tried to play for time—talking about this and that but handing nothing over. Eventually, after a final refusal to show him the file, the man left.

Outside the hotel was a parked car. As the mysterious captain walked past, he was pushed inside the car. Later, when Van Hooff tried to ask Page about what had happened, he just smiled. "Lieutenant Press, you have done a good job," was all the MI6 officer said. "Don't worry."

Don't worry? thought Van Hooff. It seemed to him that a German spy might have tracked him down, which meant he was

not safe in London, let alone Belgium. Was that really what happened? A strange reference in an SOE file a few months later refers to Page having a "stooge," who had now been removed to a "cooler." "This man, you may know, has been a source of great trouble to us and to the Belgians themselves," SOE wrote. Was this stooge linked to the hotel incident? Page was a man who liked to play games. It is possible the hotel guest had been sent by Page as one final test for recruits; perhaps it was the same person as this stooge, perhaps not. But there is no record of a German spy infiltrating British intelligence in this way, or of any investigation by MI5.

BY MARCH, VAN Hooff was ready to go. When he arrived at the airfield, he met his partner for the mission, Marcel Thonus. The two men knew each other from training school, but it would be going too far to say they were friends. Van Hooff was the smarter and more professional of the two. He knew Thonus was a hard-boiled veteran of the Foreign Legion, and he was not entirely sure about him, not least because of his fondness for a drink.

Thonus had been recruited by MI6 in September 1941, aged thirty-two. "Was recruited at a time when agents were extremely scarce," reads the opening line of his MI6 service file, almost apologetically, perhaps aware that he was not one of the best. He had a square chin and short, slicked-back hair. No father was named on his birth certificate from Liège, and he had taken the name of his mother. At the end of 1941, MI6 had informed the Belgian intelligence service in exile that they wanted to employ Thonus. One of Lepage's aides had met Thonus, who told MI6 that he had been with the Foreign Legion and participated in various operations before coming to Britain to join the Belgian forces. But the man from the Sûreté discovered from the records that Thonus had actually deserted from the Belgian army. He explained to MI6

that it was impossible to use a deserter as an agent. The British were insistent and eventually Lepage gave in, agreeing he could be sent on a mission "so that he could redeem himself." "The Belgians were good enough to arrange this matter for us. He was sent as a mutual agent," his MI6 file notes.

That last line was telling. These agents did not owe their loyalty of service to MI6 alone but also to the Belgian Sûreté. That was what was meant by "mutual agents." Thonus's MI6 service record notes that financial responsibility for him—in other words his salary and costs—was undertaken by the Belgian government. One thing the Belgians in exile did have was money, thanks to a steady income from their colony in the Congo.

With their training over, the only thing left for the Belgians to do was to take the leap into the unknown. On March 25, Van Hooff's MI6-assigned bodyguard-cum-watcher, already edgy after previous events at the hotel, took a phone call. They were told to head for Tempsford airfield. Their flight was to be one of the first since the RAF Special Duties squadron had moved there a few days earlier. Tempsford, in Bedfordshire, was built on a swamp and said to be foggy and boggy, especially if you were a pilot and veered off the runway.

After the disaster of Cassart's pickup in December 1941, landings in Belgium had been ruled out. Parachuting agents in was the only option. Dropping agents from planes had been tried in the First World War but was hampered by the agents' regular failure to jump at the right moment over the targeted drop zone. A cruel solution to this had been found. The poor agent would sit in the passenger seat of the RAF plane, which had been modified so that at the right moment the pilot could pull a lever (probably shouting "Tally-ho!") and the passenger's seat would give way— just like one of those movie scenes in which the archvillain disposes of a poorly performing subordinate. The agent would be

dropped into the sky below and, it was hoped, would gracefully parachute to the ground.

By the Second World War, things had moved on. When a mission was to be run the RAF team would get a call from SOE or MI6. That evening the BBC might broadcast a *message personnel*, including a phrase meaningless to everyone except the reception committee, which would now know a landing was coming. They would wait at the designated field for the sound of an engine. With torches at the ready, they would flash in Morse code the right letter for that day and then light up an L shape for the plane to land on, guns at the ready in case of ambush. Sometimes agents would be dropped "blind," with no one waiting for them, and have to make their own way to a rendezvous point with contacts.

Pigeons were a part of life at the RAF Special Duties airfield. Four mobile pigeon lofts were looked after by a staff of three who lived onsite, always on standby to pack and dispatch birds for a flight. As well as Columba, pigeons were given personally to some agents sent behind enemy lines. When the war started, portable radio transmitters were in their infancy, unreliable and dangerous to be caught with. Sending an "innocent letter" using an agreed code took its time. But a pigeon could fly back immediately and inform London of a safe arrival or of any problems. The first success had come in early October 1940 when Philip Scÿeidau— Agent Felix—was parachuted into France carrying with him a pair of pigeons supplied by a fancier vetted by MI5. William Dex Lea Rayner of the Air Ministry advised Scÿeidau to cut off the toes of a pair of socks and stuff the pigeons into them so that their heads peeped out. On the sixth attempt, Scÿeidau finally parachuted into France. But ten days later the Lysander that was supposed to pick him up did not appear. He was unaware of it, but the weather had been too bad back in Britain. Scÿeidau encoded a message and attached it to the leg of one of the pigeons, releasing the bird

from Fontainebleau after eight o'clock one Sunday morning. By three o'clock that afternoon, the pigeon had arrived in Kenley, just south of London. Fifteen minutes later a dispatch rider arrived and raced the cylinder to the Air Ministry. But in true bureaucratic style, it took another thirteen hours before anyone with the right authority actually read the message. A Lysander had already been dispatched. As ScŸeidau climbed into the plane, a bullet shattered its compass. The pilot became lost en route home and ScŸeidau was still trying to change into civilian clothes in case they were over enemy territory when they eventually ran out of fuel and crashed. Jumping naked out of the wreck, he and the pilot were relieved to find they were in Scotland.

This use of pigeons to acknowledge the arrival of agents and send brief messages soon found favor primarily not in MI6 but in SOE. The leadership of SOE first heard reports of Columba and of MI14(d)'s successful pigeon service in November 1941. It was keen to get hold of the intelligence it had gleaned, while agents with the French and Belgian sections were also using pigeons. Much to the annoyance of Rayner, who felt cut out, SOE ran some tests and decided it preferred MI14's civilian birds to those of the Air Ministry. In November 1941, Rex Pearson told SOE they were welcome to use Columba birds. Radio transmitters might be the future, but SOE found pigeons had some advantages. Many agents preferred pigeons because once released they left behind nothing incriminating and required little specialist training, although there was the disadvantage that pigeons were a means of one-way communication only and a message might not get through. If they were to be released immediately on arrival simply to tell London that the agent had landed successfully, pigeons were sometimes carried around the neck of parachuting agents. They could also be carried in a rucksack (although there was the danger of an agent falling back and crushing them) or strapped to the stomach.

SOE agents were soon given up to six pigeons from the Columba lofts selected for their stamina and experience. Agents were given written instructions on how to look after their pigeons. They should never hold on to a pigeon for too long—after a day or two in a confined space the birds would get wing stiffness, but a bird could be kept for up to ten days if there was somewhere it could exercise, like a shed, attic or outbuilding (but one had to beware of cats and rats). The agent had to be careful because if a pigeon could see out of the shed or attic it might get used to its surroundings and refuse to leave. The birds should be given thirty to thirty-five grams of food a day—not more, or they might prove unwilling to leave their comfortable surroundings. Agents were also told to check the birds' droppings. "Color provides guidance. If showing Green and Watery pigeon is out of sorts and not reliable for flying. Cause of above generally flight or rough handling on the journey. Remedy—quiet and normal feeding." Light brown poo tinged with white meant they were ready to fly.

Agents were advised to liberate pigeons clear of buildings, high trees and wires. Fog meant they might lose their way, headwinds would slow them down. In darkness they would stop flying, which meant they traveled farther in summer. The best time to liberate them was early morning, so they could home the same day.

One place to which agent messages returned was Bletchley Park, home of the code breakers. Thirty to forty pigeons lived in a loft around the back of the main mansion house above a garage. A landing board with an electric bell would alert staff if a pigeon returned in the night. Messages would then be taken to the local police station, where a dispatch rider would pick them up. SOE's messages were delivered to Room 055a at the War Office and then to HQ at Baker Street.

Columba itself could be used to drop pigeons for agents who

were waiting at specific points, rather than, as more usual, dropping them over a wider area for whoever found them. Often the pigeons were dropped at the same time as arms, ammunition and other equipment. In these cases, four or six pigeons were dropped in a special container on one parachute. One RAF team was shot down on the way home, killing all on board. The return of a pigeon from the reception committee with valuable intelligence was the only way the RAF knew the plane had arrived at the drop site. But among British intelligence services, there was a sharp division over the use of pigeons—and it would be one that cost Leopold Vindictive dear.

Van Hooff himself, ironically, was a fan of using pigeons to send messages back from the field, preferring them to radio. At the same time the Belgian Sûreté was beginning to examine their use (contacting some fanciers in Folkestone). But the Belgians only started properly in May 1943 and the problem was that MI6—which had sent Van Hooff and was now trying to reach out to Leopold Vindictive—was never as keen. Rex Pearson's concern, when SOE started using his birds, was that MI6, having previously cold-shouldered the idea, might wake up and try to take over pigeon operations now that they were producing results. He did not need to worry. The intelligence they brought back made R. V. Jones pretty much the only backer of pigeons within MI6. At one point, he persuaded an air commodore posted to MI6 that the pigeons on the windowsill at the service's Broadway HQ were the primary means of communication with the French resistance. "For days, at our instigation he solicitously provided them with saucers of water!"

MI6 was suspicious of the whole Columba "racket," SOE noted, and "have got no belief in it." MI6 seems to have initially been dismissive of both Columba and the use of pigeons by its own agents. The use of birds was "spasmodic and only ancillary

to our normal communications with agents in the Field," a report noted.

Pigeons were perhaps not what the macho spies at MI6 thought should be at the heart of the spying game. This perhaps explains why Thonus and Van Hooff—agents of MI6 rather than SOE—were sent in with radios but no pigeons for Leopold Vindictive when they left in March 1942. The tragedy was that there were pigeons next to them in the planes as part of a regular Columba drop. But they were not intended for Raskin and Leopold Vindictive. It seems a terrible oversight on the part of MI6, which would have known that Raskin and his collaborators had originally used pigeons. But why did Melland and Sanderson in MI14 not ensure the pigeons were sent with the agents?

The reason was that MI14 itself was in the dark about the whole mission. This was down to MI6 and secrecy. Melland, Sanderson and the team at MI14(d) may have been the first to contact Leopold Vindictive through Columba. But the subsequent messages from Leopold Vindictive—like that given to Vandael—had been delivered through evasion and intelligence networks, which belonged to Dansey and MI6. And MI6 kept to itself. In its mind, this was all about the problem that other agencies were "leaky" and amateurish. It was an analysis that had some truth: "The gossip tends to swell," Amies conceded. But this could also be used as an excuse when secrets meant power. MI6 had seen the intelligence from Columba and knew how good Leopold Vindictive's network was. But now MI6 wanted to contact Leopold Vindictive itself. It had not told MI14 about the message received from the network. Nor had it told MI14 it was now dropping in agents to make contact. And it did not want to use pigeons, even though these were precisely what Raskin had asked for. The rivalries and secrecy of British intelligence came at a terrible price.

THONUS AND VAN Hooff were primed to go in March. The full-moon period had started on the 23rd, two nights before Van Hooff's first flight ended in an anticlimactic return to base following sparks and engine failure. It was to be a bad patch. Seventeen operations were attempted but only four completed. Drops into Belgium had failed to find any reception committees. But the following night, March 26, Van Hooff and Thonus were ready to try again. Agents—known as Joes—were normally driven to Tempsford at the last minute from a country house nearby that acted as a holding place.

Thonus and Van Hooff were first taken to a building known as the barn, where they were prepared. Then the two men had their pockets inspected carefully. Their clothes had been made in Belgium so as not to arouse suspicion. They had to be sure there were no receipts or items that might give away the fact they had spent time in London. They were given false papers in their cover names. In one room, their parachutes were prepared and fitted by a dispatcher. In another, the radio sets were handed over. Then on went the flying suits, and each took a weapon, and finally a shovel to bury their parachutes, a bottle of rum and enough food to last them a day. Now they were ready.

They flew with other planes and other agents in a larger operation. Their plane crossed the coast at the Pas-de-Calais. Encountering haze, the pilot dropped altitude and set a course for Cambrai. This time the light went green. The containers of pigeons were dropped on the same flight—but not at the same place as the men—before the plane made its way home just after midnight. The agents were in.

10

Undercover

Over Valenciennes, the red light had come on. The sergeant gave the parachutes one last check and opened the door. A blast of cold air hit the two Belgians. Jef Van Hooff's heart was thumping. This time the light switched to green, and he jumped out into the dark night.

In training there had been a long drop—a chance to close his eyes and feel the sensation of falling for a few moments. But when it happened for real, everything seemed to take place much faster. After fifty meters of free fall, he felt a jolt. In what seemed no time at all, branches struck his face. He tensed for impact on the ground. But it did not come. He had fallen into a forest and was suspended from a tree like a scarecrow, twenty meters in the air. His radio had fallen next to him. He could just about see the RAF plane still circling above him, a small sliver of light visible from the open hatch door from which he had jumped. Then it was gone. The last few months of freedom were over. Now he was heading back home to fulfill his own romantic ideal of helping free his country. But in reality he was a spy on the run, hanging like a puppet from a tree.

A feeling of abandonment and helplessness washed over him, but survival instincts quickly kicked in. The Germans might have

heard the plane and would come looking. By wriggling back and forth, he was able to break a few branches, although with a painfully loud crack that reverberated through the quiet forest. It took him nearly an hour in all to extricate himself from his parachute, an effort that left him sweating from head to toe despite the cold of a March night. He then began to dig with his shovel to bury his parachute and flying suit in the temporary hiding place of a pit. In another hole, he hid his radio. It was too risky to carry everything around.

But what about his partner? Thonus should have fallen less than one hundred meters away. They had agreed on the rather unusual signal of making the sound of a cat in heat to try to find each other, and so Van Hooff started imitating an amorous feline. There was no response to his cries. Van Hooff began to explore the woods, gun in hand. Eventually he found a clearing. There, to his horror, was what looked like a man swinging in the tree, as if hanged. As he came closer, Van Hooff saw with relief that it was just the parachute and flying suit, with no trace of Thonus inside. Thonus had already disobeyed orders by abandoning rather than burying the incriminating items. There was no sign of him. Van Hooff was slowly learning what others would realize: that Thonus was sloppy.

Van Hooff headed off through a field of cows. He glanced at his watch. It was five in the morning. As he came to a farm, a dog began barking. Weapon in hand, he approached the door of the farmhouse. "What have I done wrong?" the farmer asked when he saw a stranger bearing a gun.

"You haven't done anything wrong, but do what I say," said Van Hooff gruffly. He ordered the farmer to help retrieve Thonus's parachute. The farmer at first refused. Van Hooff threatened to burn his farm down, at which he complied.

The two parachutists had agreed that if they lost each other

they would meet at the Valenciennes railway station. When Van
Hooff arrived later in the day, the station was packed with Ger-
man soldiers. One of them asked Van Hooff for a cigarette. "I
don't smoke," the undercover agent replied, his voice shaking.
Around a corner he spotted Thonus reading a newspaper. Despite
the seriousness of the situation, Van Hooff crept up and surprised
Thonus, making him jump out of his chair.

Thonus apologized for the previous night's carelessness. He
said he had been overcome with panic and abandoned his para-
chute. That night they traveled over the border to Brussels. They
were carrying tens of thousands of francs, which Van Hooff hid
down his trousers. Thonus was so relieved to make it that he
knocked back whiskey after whiskey in a bar on arrival.

At dawn, having had just a couple of hours' sleep in a hotel,
Van Hooff and Thonus were up. The two were embarking on a
life in which survival depended on acting normally, even though
your nerves were shredded daily. Every time you approached a
German control point where soldiers asked for your papers, you
feared they might notice something odd, some incongruous de-
tail. Or would reference be made to an event that you had missed
while you were away in London? Survival depended not just on
your own wits but also on the network of helpers who would
shelter and move you from place to place. All it took was for
someone who knew you to be captured and talk—or for there
already to be a traitor among your ranks. The longer you lived
undercover, the more—rather than less—paranoid you became.
Capture was not the exception for agents like these. It was the
norm. You were living on borrowed time.

On a train journey, one person recognized Van Hooff and said,
"Everyone thought you had gone to England." It was a reminder
that Belgium was a hard country in which to be a secret agent. It
was small, and people always wanted to know who someone was

or where they were from. Friends and family talked. Sometimes the agents themselves boasted. If a member of the Belgian army disappeared for a few months and then came back, gossip quickly spread that he had probably been to Britain and was back on a "special mission." Even when agents were dropped at different locations with instructions not to contact each other, they would end up meeting—sometimes by chance, sometimes by choice. Networks that should have been separate became intertwined and compromised.

Van Hooff and Thonus plunged straight into their work. Like many agents, they had been given multiple tasks by Page and MI6. One of Van Hooff's jobs was to liaise with a network code-named Beaver. But this network had already begun to collapse following German arrests. He was also supposed to go to Liège and build a network of contacts that connected to Brussels and Mechelen. Thonus would stay in Brussels and act as the radio operator based in the capital.

Among their assigned missions was one that had been added at the last minute. Vandael had arrived in Britain two weeks before the departure of Thonus and Van Hooff, and MI6 had decided that the two parachutists should be given the task of establishing contact and supporting Leopold Vindictive. The primary role was given to Thonus, since he would be based in Brussels.

The pair had been told that their contact with Leopold Vindictive was Fritz Devos. Vandael had reported that he seemed to be competent and had money. They arrived at his house in Roeselare on March 29 and gave him the password: Madeleine.

The next day, March 30, Devos and Thonus went to the Debaillie house in Lichtervelde, the home of the pigeon nine long months earlier. Raskin and Joye had been phoned, so the band of friends was together once more. It was a moment that filled them with hope. At last, Britain had received their messages reaching

out for further contact. And London had judged them important enough to parachute in agents to help. This was surely the beginning of a new chapter in their work. MI6 with its radio sets had arrived.

Thonus handed over thirty thousand francs to the men. In return, the parachutist was passed a message to send back to the British. A surviving typed note from Raskin dated April 7, 1942, begins: "Leopold Vindictive demand a pigeon with great urgency to send back important information." It asks for an acknowledgment on the BBC of receipt of the message and requests a drop around midnight; it gives precise coordinates, saying that the site, near a forest in Uccle near Brussels, will be marked out with two white lights and one red light. Three pigeons are to be dropped. It is suggested that other pigeons be dropped at locations ten kilometers away to try to divert the German search parties.

Behind the instructions lies a deep sense of frustration—and of hope. Why had the pigeon route begun so successfully last July proved so difficult to maintain? Pigeons were the best way of getting the detailed maps of the coastal defenses they had carefully drawn back to London. Van Hooff was impressed at the quality of the map when Raskin showed it to him at their meeting. A map could not be sent by radio. But the pigeons had still not come, even though Van Hooff himself was a fan of the method and they had sat on the plane next to the men as they parachuted in. And every moment that passed increased the danger of the net closing. Raskin said that Michelli's friends would look after the agents in Brussels. And he introduced them to Madame Roberts, whose network of friends and helpers would aid them.

Thonus got to work. Being a radio operator (or "pianist," as they were sometimes called) involved moving from house to house for security. It took time for an operator to convey a message. First, you had to painstakingly encode it. Next you had to

wait for one of the moments agreed with the British to transmit. You then had to hope they could hear you and that atmospheric interference or a fault on one side or the other did not get in the way. All the time, you would have half an eye on your protection team in case they gave you a warning signal that someone was coming. In his rather vague handwritten testimony, Thonus says he began trying to send messages but there was no contact. When he had landed in the tree, his radio set had taken a battering. Something was not working.

Devos initially set Thonus up and provided him with a new identity card. The first priority was a new transmitter. They began to ask around, hearing that perhaps there was a working set in Tournai. In the time they worked together, Thonus and Devos did not get along. Thonus described Devos as "very imprudent" and said he had to change safe houses because the people he met spoke too freely about who he was and why he was there. One helper demanded a hundred francs a day and insisted Thonus should pay at every café. Devos, meanwhile, blamed Thonus for lax security. He was "superficial," he said, and "frequented bars and dangerous women. I warned him that he would expose us all." Word eventually got back to London that Thonus was "constantly drunk." Devos claimed that Thonus ran out of money, so he had to give back the money the parachutist had brought for him. Michelli eventually intervened to place him with another helper. Thonus was moved around from safe house to safe house in the suburbs of Brussels through the network of contacts that Raskin had used to gather intelligence in the city. But wherever they tried, the transmitter would not work.

Meanwhile, Marie and Margaret listened to the radio in Lichtervelde, hoping that the message given to Thonus would get through and the BBC would respond, confirming a pigeon drop. But by the end of April, they had heard nothing.

In London, too, there was frustration. The agents had gone in, but now there was silence. Leopold Vindictive was still out of reach. Had the agents been captured? A note from Page at MI6 says that even though a wireless operator was sent with money and instructions, "He did not establish wireless communication with us and we do not know what happened to him."

The Germans were beginning to close in. Bodicker in the Abwehr's IIIF turned to his best man, Willy Plate (also known as Peeters), as his investigations gathered pace. Now in his early fifties, Plate had originally been a civilian German secret policeman in Düsseldorf, and he had been attached to the Abwehr's IIIF in Cologne before being sent to work out of its office on Place Rogier in Brussels. He was red-faced, fat and bald with glasses, but he was always well dressed and chasing after women. Plate was involved in the Abwehr's *Hauskapelle* network, a small team designed to be kept secret from everyone else, tasked partly with spotting enemy agents and also with undertaking possible work if the Allies ever invaded. Colleagues noted that he hoarded his archives of papers and never let colleagues see what he was up to (perhaps because he had a sideline in buying and selling paintings). He was given the most difficult and complex cases.

Plate was running multiple agents. One of these, Augustin Leduc (code-named Laurent, but he had so many aliases that one file just ends with "etc.," as the list goes on), was given the task of finding the priest and the pigeon about whom Bodicker had been tipped off. Leduc, in his late thirties, worked only for Plate—no one else either wanted or was able to deal with him. Plate disliked Leduc but also rated his abilities. He was a Belgian who betrayed his compatriots for hard cash—ten thousand francs a month, sometimes more—and even Plate would call him a *"grand bandit,"* later saying he had to send him off to France because he was so difficult.

Van Hooff went to Liège to set up his network, having first

paid a visit to an old friend. Before he even had a chance to say anything, he could tell from the friend's eyes that something was wrong. Van Hooff's mother had passed away, the friend explained. Anger welled up against the Germans. If it had not been for their occupation, he would have been there to see her. Van Hooff's response was to throw himself into his work, trying to find people who might know about the movements of military convoys around Belgium.

On his fourth day in Liège, he tried to radio London for the first time. He found himself wishing he could use a pigeon instead to communicate—not just because it would be easier but because he was jealous of the idea of the pigeon being able to fly away from the danger that encircled him at every moment. But, like Raskin, he was to suffer from MI6's prejudice against the use of birds and their preference for radio. He waited in his room at the Star Hotel for the assigned moment and then went up. Van Hooff was always nervous when he used his transmitter, knowing he had maybe ten minutes at most before the risk of being found began to grow exponentially. German direction-finding teams (known as the *Funkabwehr*) were becoming increasingly efficient at locating agents by triangulating signals with detectors. Sending a message was a race against time. Every extra second that an operator spent tapping out his message increased the chances of the Germans crashing through the door. Being a fast operator was not only efficient; it was the difference between life and death. Van Hooff was particularly nervous, since staying in the room next door was a German officer. Then, with his headphones on, he heard the code letters EFD—his call sign. He almost cried with joy, but his nerves got the better of him. Clumsily and hesitantly, he tried to answer, but he could not get his response right and made mistake after mistake. Eventually the depressing response came back from London, "Repeat tomorrow."

The next time he was steadier, and over the coming days he began collecting information and meeting contacts, often transmitting from a cemetery at night.

Van Hooff had another, even more clandestine mission, one that remains shrouded in secrecy. Making contact with Raskin was not merely about securing a route for the intelligence whose value had been shown by the original Columba message. Thonus had been assigned to work with Leopold Vindictive, but Van Hooff was given a specific mission that required Raskin's help. What he describes as his "political mission" was to find out as much as possible about the inclinations of key political and religious figures. The well-connected Raskin would be his liaison in finding some of these people. It may have helped that Van Hooff's own brother was a Scheutist missionary, so he was welcomed with open arms.

The most delicate aspect of the mission was the attempt to establish a secret back-channel contact to the king of Belgium. The government-in-exile had a difficult relationship with the monarch, each side being angry with the other for their decisions in those chaotic days of May 1940. In his mind, the king had decided to stay with his people rather than flee, but in many people's minds he had effectively lent his legitimacy and support to Hitler. Could relations be repaired between the two sides? And what were the monarch's real views toward the Nazis now, after nearly two years of virtual house arrest?

Just before Van Hooff arrived, the king's position had taken a turn for the worse, with many of his compatriots seeing further signs of faulty judgment. In late 1941, Leopold had remarried. For many Belgians, it seemed odd that a man who was supposed to be a prisoner should be in a position to marry. An intelligence report from MI14 noted that some wags had chalked a message on the walls of his palace at Laken: saying *Des poules pour nos prisonniers"* ("Tarts for our prisoners"). The refrain was frequently

heard that "King Albert [Leopold's father] would not have done that."

The British government wanted to know what the king's disposition was now. But he lived in the palace at Laken under the watch of a German colonel. He could not communicate with outsiders or travel without German permission, and he was never seen in Brussels. There had been an attempt to drop an agent to make contact with the king in May 1941 but the agent had been arrested hours after arriving in Belgium. Now Leopold Vindictive offered a new opportunity.

The testimony of Roger Keyes from the turbulent days of May 1940 would have made British intelligence realize how close "the bearded chaplain" was to the royal family and that he might offer a way of establishing a clandestine contact. Raskin would regularly visit the comte de Grunne, chamberlain to the queen mother, and even keep him informed about his espionage work. Raskin also knew the secretary to the king well. Early in 1942, through the comte de Grunne, the king and queen mother had both passed on their greetings to Raskin personally in an exchange of messages. Raskin was an occasional visitor to the palace, and it is even possible the king himself knew about Raskin's espionage. But for a man already carrying many secrets, Raskin himself knew this was the most sensitive of his roles, and his relationship with the royal court was close but discreet. It was not something to be talked about. This was especially the case since he took Confession from the king; few things could require greater discretion. But one of the Belgians who worked with Van Hooff, moving him from one safe house to another, would later confirm that it was thanks to Raskin that a link was established with the king. This, he said, allowed information of great importance to be sent to London. The precise details of those contacts remain in files still classified on both the Belgian side and the British.

Van Hooff's work was complicated by his partner's misfortunes. He received a message from Thonus to say that his radio set was still not working. Thonus explained that he had dismantled it and was trying to put it back together again, but he could not work out where all the pieces were supposed to go. Van Hooff headed to Brussels by train to meet him. The two agents went to the house of Madame Roberts, where many meetings would take place in the coming days. Here Thonus tried again to transmit, but the fuses in the transformer blew. They seemed cursed. Raskin told them Henri Michelli might be able to help. The two agents were now becoming increasingly enmeshed in the Brussels network featuring Madame Roberts with Michelli at its head.

Thonus was beginning to panic. He was frustrated that his radio was not working and was also hearing of more German arrests. He was sure they were on to him. "I felt burned," he later said. Undercover agents who lost their nerve like this were almost always useless. Agents often had a short shelf life and were extracted when they were in trouble. Overconfidence got one caught, but so did excessive fear. Thonus made clear he wanted to go back to London (in order to be sent on another mission, he said). It was time to get him out. The Comet line was the obvious way to do so. The plan was for Thonus to make his way to Michelli's house on May 6 to organize his departure.

Henri Michelli was a busy man and was moving to the forefront of operations in Brussels. At the end of April, the Abwehr was getting too close for comfort in its hunt for Frederick de Jonge, the leader of the Comet line and Andrée's father. With a price of one million francs on his head, de Jonge fled (growing huge sideburns to disguise himself). He ate with Madame Roberts the night before he left, telling her Henri Michelli was now to be in charge of Comet. Michelli's office in Brussels had become a central meeting place for an array of networks. A well-meaning

man whose ambition for his clandestine work exceeded his ability and experience, he wanted to be almost a chairman of the board for the underground resistance—the big chief. As well as playing a key role in Comet's work, he was carrying out his own intelligence gathering and trying to set up a sabotage network. He was also in touch with groups like Leopold Vindictive—by some accounts a total of seven or eight different networks. His work overlapped between SOE and MI6. This was too much. His time in charge of Comet would be counted in days.

German police files indicate that at Abwehr IIIF's headquarters, word had reached the Nazis that someone was hiding British soldiers and airmen in Brussels. Bodicker and Plate turned to another agent in the search for them—a man who was just beginning a career that would haunt Britain and Comet through the war. This agent's name was Prosper de Zitter, described as possibly the single most important traitor in Europe. At the age of twenty-two, de Zitter had fled Belgium for Canada in 1915 to escape a charge of rape. He returned when, thanks to the statute of limitations, he could no longer be prosecuted and became involved in fraud and other crimes. The arrival of the Nazis offered a man like him an opportunity, and soon after May 1940 he offered his services to German intelligence, penetrating escape lines. His time in Canada meant he could speak French and English and pose as a Canadian helper using one of at least thirty-one different false identities (although the fact he was missing part of his right little finger was one potential giveaway). His great skill was his ability to engender trust in people, and this was exactly what Abwehr IIIF was after.

From Plate, the orders came to trace the network that would become known as Comet. As early as June 1941, de Zitter had started to work his way around the edges of the early Comet line, doing what he did best—infiltrating, watching and reporting

back. Later he would form his own fake escape network to trap servicemen. Many hundreds were caught and died because of the actions of this one individual, who took millions of francs in payment (and also abused some of the women who were captured). Stories and wild rumors about him spread (including one that he slept in a coffin), to the point that some wondered if he was a fictional bogeyman. But he was real, and he was to be the Comet line's nemesis through much of the war. British agents would be given instructions that, if he was ever spotted, he was to be killed instantly.

On April 22, a message had been sent to another Belgian agent and radio operator, Jacques Van Horen—code-named Terrier by SOE—a handsome, square-jawed former member of the Belgian army. The message told him to send someone to Michelli saying he was from "Marcel" and was interested in "Malaga." This was the code Vandael had told London could be used to contact Michelli if they needed something—in this case, the evacuation of agents via Comet. The message came back to London saying that Michelli had agreed but needed more guidance. At the end of April London kept up the contact, sending a message on the BBC that another agent was arriving who would come to see Michelli. What few knew was that this was part of the Abwehr operation and the net was closing in. Michelli—without being aware of it—was a dangerous man to know.

The early resistance networks had always been messy, overlapping and intertwining. In London each network might have a separate code name, but on the ground they consisted of people who knew each other and who met and talked and helped each other. It was further complicated because the two British agencies sending people over—SOE and MI6—were feuding at home in London and failing to share information. Yet in Brussels, their respective agents on the ground were intermingling. This was a recipe for disaster.

One of the reasons for the intermingling was the very unreliability of many early radio sets, which meant that when word went around of anyone who might have a working set, everyone wanted to use it. As a result, MI6's intelligence networks would often end up using the same sets as Belgians parachuted in by SOE for sabotage. At times London had no real idea from whom a message was coming, and there was confusion in Brussels as well. London was realizing it needed to "compartmentalize" the networks with much higher walls, so that if one person or group were discovered, the Germans would not be able to roll up many others. SOE had contacted Page at MI6 on April 28 regarding the overlaps. Page had understood things were going wrong. But it was already too late.

The plan was to hold a meeting on May 6 at Michelli's house. Thonus and Van Hooff would be there and could discuss Thonus's departure with the guides for the Comet line. There was also a British airman named Larry Carr, whom they were due to take out. It would be a chance to work out what messages from the various networks also needed carrying to London. Many paths led to Michelli's door, and on May 6 that would prove a disaster.

Battle of the Skies II

LARRY CARR'S PARACHUTE had taken him down into Belgium just after midnight on April 28. But he was no secret agent. Before the war he had been a surveyor from Kent. That night he was part of the crew of an RAF Halifax bomber that had set out from Yorkshire on a bombing raid destined for Cologne. But as it flew over Belgium, the Halifax was attacked by a German night fighter flown by Reinhold Eckardt, one of the Luftwaffe's top pilots and a veteran of the Battle of Britain. Carr bailed out over Hamois and came down about a kilometer from the wreckage of his aircraft. He hid his parachute and headed south using a collar-stud compass.

Half an hour later, as he was crossing a track, two Belgians approached him. One was a commandant of the gendarmerie. It was a moment of tension. Would he be arrested? They asked if he wanted to get back to England. Fortunately, it was no trap. He was taken to a house and given a meal and some civilian clothes. The commandant called the local German HQ and told them that there had been no survivors of the crash.

The next day Carr had been taken by train—changing a few times to be careful—to meet a representative of the Comet line. He would now be moved from house to house around the Brussels suburbs by Michelli's network, learning along the way that

the gunner on his plane had been betrayed by a Belgian to whom he had called out in a forest.

For those RAF men who crashed in Europe and were lucky enough to find their way to sympathizers, Columba pigeons offered a way to send news back home. One message from Le Neubourg in northern France came from a "patriotic organization" formed in 1940 that explained how a local anti-aircraft gun had shot down four bombers. After that came a message in English:

> Dear Mum, I am glad to be able to relieve your minds on my whereabouts, and to tell you I am in good hands. It shouldn't be long before I'll be back in good old England. Already, I know of two other members of my crew being safe, Wally Jones and George Henton. They are a few miles from here and are much the same as me. I haven't seen them yet but have received a note from each. There isn't much else to say, only that I am in good health and happy. The chatter of an unfamiliar language gets a bit monotonous. There isn't any more to say, so will stop. Your loving son, Stan
>
> R.197072 Sgt Jinks, S.B.

Next comes a series of one-line messages from allied airmen hiding with Stan. Each just gives their number rather than their name. "Good luck, feeling pretty cheesed," says the first RAF man. "Always smiling. Also cheesed," writes the second. "Keep up the good work," says the third. Then follows a characteristically American-sounding line from a US Air Force officer: "Doing what we can. God's speed." Then another RAF man: "Am okay now injuries healed up. Okay." And finally one more RAF line: "Feeling fine, but as the rest, cheesed." They might have been cheesed but, thanks to Columba, at least their families knew they were safe.

One Columba message had a particularly personal connection

for an RAF pilot dropping the pigeons. Guy Lockhart's Spitfire took off from Biggin Hill just after lunchtime on July 6, 1941, to escort six Stirling aircraft to Lille. But less than an hour into the flight, enemy fire shredded one of the wings, and he crashed not far from Calais. Lockhart parachuted out but was knocked unconscious when he hit the ground. Fortunately for him, he, like Carr, found help. The twenty-five-year-old was hidden for three weeks before making his way back to Britain. He was then talent-spotted by the RAF Special Duties team responsible for dropping agents and pigeons. Columba Message 214 came from a pigeon dropped in preparation for the Dieppe raid in August 1942. It was from Pas-de-Calais and a group calling itself LMN Kommando 6, a pair of brothers who had sheltered Lockhart. "He will remember the two brothers," they wrote, providing the pilot's home address as verification of their bona fides. They offered allegiance to de Gaulle and said they wanted to fight, offering extensive information on local German movements. The authors asked for greetings to be sent to Lockhart and two other aviators. Lockhart would have their address, they explained, so that would allow more pigeons to be sent to them. Unfortunately, by the time the pigeon made it back home on September 3, Lockhart was in no position to receive the greetings. Three nights earlier he had flown his Lysander to France to collect an agent. The pickup proved disastrous because the agent (who appeared to be drunk) had laid a flare path across a ditch, with the result that the plane sustained damage as it landed. Lockhart was forced to make a second escape from behind enemy lines through Gibraltar. He then joined Bomber Command. On his forms he had to enter the countries he had visited and for what purpose; his answer was "France. Twice. Escaping." The third time was not lucky for Lockhart, though. In April 1944, he was shot down and killed by a German night fighter.

IN THE BATTLE of the skies, pigeons saved the lives of some RAF airmen out on their mission. Just before noon on October 10, 1940, a pigeon arrived back at the royal family's loft in Sandringham, having been released in the Netherlands four hours earlier. It was the first to carry details of a crew that had made a forced landing on the continent.

Down in Plymouth, Bert Woodman and his group would deliver birds by van to the local RAF station every Wednesday and Saturday to be taken out on flights. Two baskets of pigeons were given to many RAF planes in case their radio failed and they had to make a forced landing. The birds would be carried in the upper half of the plane to reduce the risk of drowning if the plane ditched in water. Inside the lid of a box were instructions on how to use a special indelible pencil to write on the container and then release the birds. The lofts of fanciers in the Plymouth group were fitted with alarm bell traps; when the bell rang they would call Bert's wife, who would then contact the RAF signals officer.

Despite its early royal success, the RAF scheme nearly did not survive. In May 1941, there were complaints that no message had led to a crew's rescue. Often the planes were sinking too fast and the crew, perhaps understandably, had other things to worry about than following the proper pigeon release procedure. The director of signals thought that it was time to consider discontinuing the service.

But Bomber Command came out strongly in favor of keeping the pigeons. It was not just about the number of times they had actually saved lives. It was warned that morale would be affected by the pigeons' removal. Officers realized that crews found the pigeons a genuine comfort. In the event of the horror of being ditched at sea, why would a crew not want one more possible means of rescue, however slight? There was also something in the warmth of another creature and the knowledge that it was

heading off home; its value was intrinsically more reassuring than the valves and wires of a radio set, whose message—like the bird—disappeared into the vast sky above the sea. Bomber Command had recognized that there was an emotional comfort to carrying the pigeons that exceeded their practical value. Often birds would become mascots. One air gunner would only fly with a black and white checkered bird because the first time he carried one on board he had not been fired upon once. The only crew Bert Woodman and the Plymouth fanciers were not so keen on was a group of Australians, since there had been mysterious losses of pigeons liberated on their training flights. An inquiry found the crew had developed a taste for pigeon pie.

The RAF rescue pigeons received a stay of execution in the middle of the war and were provided with a new watertight container that could be sealed in four seconds. This could be thrown from the aircraft into the water and picked up by the crew once they were in their dinghy (the container could even be used by the crew for buoyancy if the dinghy was too far away). Soon afterward, the pigeons began to show their worth. A bomber crew crash-landed in the Netherlands on the morning of February 21, 1942, and eleven-month-old Billy delivered his message the following day a little after noon "in a state of complete collapse" after having flown through a gale-driven snowstorm, making a journey of two hundred and fifty miles back to the RAF station at Waddington.

The real star was a bird called Winkie. That same month a Beaufort ditched into the sea on short notice owing to engine failure. The crew managed an SOS but the aircraft broke up on impact. An open pigeon container fell into the sea. The crew— now in a dinghy—tried to recover the container, but in doing so, the door was broken open. The pigeon became wet (which hindered its ability to fly), and it escaped before the crew could

get hold of it and attach a message. A second pigeon was recovered but it was too wet to fly, so the crew carefully massaged the bird to dry it by hand and then attached their SOS message before releasing it at midafternoon. This second pigeon never made it home, but the first pigeon arrived the following morning. A radio SOS signal had been received, but it was so weak that the resultant fix was extremely vague and the ensuing air search was attempting to cover an area of seventy square miles. On the arrival of the pigeon, an NCO linked it to the missing aircraft; seeing that the bird was wet and smeared with oil, he was able to assess the pigeon's condition, the time of the aircraft's ditching (as established by the faint radio signal) and the weather, and work out that the bird had flown 120–140 miles. He suggested that the search should operate within a much more specific area. The search parties changed their bearings and the aircraft and dinghy were spotted fifteen minutes later, 129 miles from base. Four lives were saved. It was at a subsequent dinner in the pigeon's honor that the name Winkie was bestowed, since in her pen she "winked" by drooping an eyelid at one of the men she had rescued—although in truth, the slow action of her eyelids was almost certainly a sign she had not recovered from the exhaustion of the flight. Only a handful of pigeons were, like Winkie, responsible for the saving of lives, mainly at sea, but many other RAF men found them a comfort in dangerous times.

FOR R. V. Jones, the struggle to stop the German night fighters that were inflicting such a terrible cost on Bomber Command was a top priority. His task was to try to understand the nature and location of German defenses against the RAF so that they could be countered and men like Larry Carr might avoid being shot down. Jones went to see Page, head of the Belgian section at MI6. "Tell me what you want," Page said with a wave of his hand,

"I will get you anything." Jones suspected it was an idle boast, but Page began to deliver. In February 1942, his Belgian agents produced a report about an object thirty-five kilometers east of Brussels. Using the information, Jones sent in aerial reconnaissance to get pictures. It was a radar installation code-named Freya, and there was also in the vicinity a large paraboloid about twenty feet in diameter with other structures around it. This was what would be called a "Giant Wurzburg." A combination of sources led Jones to understand that the Germans had constructed a vast ground-based interception system. Freyas and Wurzburgs allowed the Germans to fix the position of both enemy aircraft and their own at long and short range. They could help target gunfire and guide a night fighter directly onto the tail of a British bomber.

Mapping these defenses was vital. Scattered as they were across northwestern Europe, however, finding the sites was a challenge. The one advantage was that the installations looked very unusual if you got close enough. A Giant Wurzburg or a Freya looked distinctive because no one had ever seen a radar dish before. Locals struggled to describe them, often calling them "inverted umbrellas." Jones asked resistance agents to pass on information if they saw any buildings that might be searchlight or radar stations so they could be photographed from the air. One Belgian agent managed to steal a map of searchlight locations. But getting agents' reports out remained problematic. They were sometimes smuggled out on the express train that ran from Lille to Lyon, the fireman hiding them under the coal so that they could be shoveled into the fire and burned if a search began. But the final leg back to Britain proved harder. Page told Jones that at one point there were fifteen hundredweight of reports waiting in Lisbon to be taken by plane back to England. They needed to get the reports back faster. The answer was pigeons.

Columba would provide Jones with some of the vital intelli-

gence he craved. He had asked locals to spot any large structures with rotating aerials that looked unusual, and soon replies to his questions were starting to arrive at MI14(d). On June 5, 1942, a Columba message came back. The writer said he thought the bird had been meant for Belgium rather than the Netherlands but decided to provide some details anyway, and he reported news of a camp at Opperdoes with a great many "tecYical installations, listening-in-apparatus, jammers . . . From this camp, the night fighters get their instructions," the author wrote, helpfully providing a map that showed the precise location. "Do come over this way and do not fly so high so we can see that you are British." Jones and the Air Ministry considered this message "first class." It was just the start. "Pigeons drew first blood on three night fighter control stations," Jones recalled.

One of the Columba messages Jones valued came via a strange route. An English racing pigeon bred in Barrow-in-Furness was blown over to the Netherlands in July. It was taken to two Dutch patriots on July 21. They could see it was a British pigeon and so named it Tommy. It was exhausted, so they tended it carefully until it was ready to return to its home in Lancashire, where it arrived on August 9. A message was attached in which the authors said friends wanted to send their greetings to Winston Churchill as well as to the queen of the Netherlands, who was in exile in Britain. She should be told the opposition in the country was "at the highest grade it has ever been owing to the latest German measures against the hostages and the Jews." But after the salutations came hard military information. The authors explained that near the village of Sondel in Friesland was an enormous installation designed to hear approaching British aircraft. It had a diameter of ten meters and they had learned that it could hear British planes when they approached the coast. There were enormous cables to carry information from this facility to an airfield

where German fighters could be launched in response. A British plane had been shot down on the night of July 25 after dealing with two German planes, but the crew had since been arrested. If Tommy the pigeon was found, they asked for a message to be broadcast on the Dutch bulletin of the BBC. "Long live Great Britain. Long live the Allies. Long live the queen," they ended, before a special greeting to some friends, which was followed by the rather wonderful signoff: "Cheerio!!!!! Twee Geuzen" (Two Pirates).

The bird had brought details of one of the main radar posts in the Netherlands, one that Jones and London had not been aware of before. And more information was soon to follow. Message 235 came from a pigeon found at five o'clock on the afternoon of September 27, 1942, on an island south of the Hook of Holland, which made its way back to the Isle of Wight three days later. The author gave his name as Smuggler. Perhaps that was why he was so observant about details of coastal defenses. The crucial point for Jones came with one line: "At Oostvorne there are wireless masts made to rotate, situated in the dunes."

Jones found this detail invaluable. And Britain made use of it. A month later, Rex Pearson at the War Office wrote to Commander Cyril Tower at the Admiralty saying that he understood that the location station "has since been quite satisfactorily dealt with." The Admiralty said it wanted the locations of more radar stations on the coast.

By January 1943, Jones said that Columba had located three stations in the Netherlands "which could not be fixed by any other means." He specifically asked for the Columba team to be thanked on his behalf. More were found by pigeon that year. It had taken a combination of intelligence sources to understand the German night fighter system—from captured maps to RAF combat reports, radio intercepts to aerial reconnaissance. But Jones

specifically cited pigeons alongside these better known tools in his reports.

Columba also brought Jones news of the success of the counter-measures he was working on. Jones and others in scientific intelligence had developed a way of confusing German radar by dropping thousands of strips of aluminum foil from a plane. The strips—code-named Window—reflected back the radio waves and made it impossible to pinpoint a British plane. Jones had to push hard to deploy the tecȲique against resistance from those who feared the Germans might develop their own version against British radar. But finally in the summer of 1943 they received the go-ahead. Columba brought a stunning insight into its effect.

On August 13, 1943, a Frenchman in Ville de Landrecies in northern France shoved a message into one of Columba's green cylinders. Two days later the bird was back at its loft in Mitcham and the message had reached Brian Melland and the Columba team. From there it went straight to R. V. Jones. Message 486 was a cracker, second only to Leopold Vindictive's Message 37. Extensive details of infantry movements were given, not at the level of Leopold Vindictive but still among the best that would be seen. There were precise coordinates of munitions depots and detailed assessments of recent RAF bombing raids—how two factories and a railway repair shop that had been targeted were now back up and running and needed to be struck again.

The author reported that a German ship had apparently received six hundred tons of a gas, and that French prisoners at a particular base had been provided with gas masks to work with it. There were calls for the BBC to name collaborators and warn them of their fate. Columba writers frequently asked for such broadcasts, for the BBC offered one of the few ways of exerting any power over those who betrayed their communities. A tutor at Prisches worked for the Gestapo. An insurance agent, a fruit

merchant and a collector's clerk were also named. Then there was the husband of a teacher who was a "keen collaborator" and a police spy. The writer warned that the Germans dropped their own agents disguised as British airmen to trap potential helpers. He suggested providing passwords and recognition signals that could change every fortnight or every month, and which only the chiefs of the French resistance organization would know, in order to vouch for airmen's identity. This would "also enable us to do away with a few agents of the Gestapo," noted the writer.

But then came the real prize. There were details of what the author called a "Radio listening-in and guiding post for night fighters." It was located at Croix-Caluyau, and the author provided a precise description and location for the two hemispheric and one rectangular apparatus. Twenty English bombers had been shot down in a radius of around twenty-five kilometers from it, the author noted.

And finally came the detail that made Jones fall in love with the message. There was a remarkable description of events a few days earlier, on the night of August 9–10. The writer described how the British aircraft had dropped "a multitude of black bits of paper metallized by contact with a piece of tin." The writer would not have known that this was the British Window countermeasure. But the writer managed to describe the reaction it inspired among the Germans at the base. A German operator said he detected seven hundred signals in the sky but could not localize a single one to which to respond. "The officer commanding the post was mad with rage and declared that he would prefer to be bombed by a hundred aircraft rather than submit to that flood of papers." The writer added that a fairly large number of the bundles of paper did not scatter properly during the descent. The message ended with a request for a signal on the BBC to acknowledge receipt with the words *"deux pigeons s'aimaient d'amour tendre."*

"I have never seen a pigeon carrying such a profuse message," said Jones.

Who had sent the message on what Jones called a "heavily laden and very gallant pigeon"? Whoever it was, they must have been inside the control room of the night fighter station to hear the exact words spoken by the German, Jones thought. He believed at one point it may have been a janitor, although he also wondered if it was an agent, since the message as a whole read as if its originator was someone who knew about resistance work.

Within two days of the message's arrival by pigeon, Jones had shown it to the secretary of state for air, the deputy chief of the air staff and the chief of Bomber Command. The revelation of the frustrations that their German opponents were facing was an enormous morale boost (and of course a vindication for the scientists who had developed Window). There was another advantage to the message. It was considered less secret than the Enigma decrypts and so could be shared more widely. "This information coming so soon after the raid was of extreme value in that it could be told at once to all our bomber crews, to their satisfaction, whereas information arriving through more secret channels could not have received so wide a distribution," Jones said.

Columba was proving its worth. "From my point of view, the Pigeon Service produces occasional extremely valuable reports and this is one of them," Jones wrote to the Columba team. The combination of the mapping of night fighter defenses and the use of Window proved a turning point in the air war. From that summer, RAF losses began to decrease. This battle of the skies was being won thanks in part to the pigeons of Columba. But for MI14's most important agent on the ground, the net had closed.

12

Capture

T HE MORNING OF May 6, 1942, in Brussels promised a beautiful spring day, one which Henri Michelli expected to prove busy. He had three meetings. In the morning, Michelli took Van Hooff to see the president of the local football club, FC Mechelen. For Van Hooff, this was not a chance for a kick-around. The president was a well-connected clergyman named Dessain. He and Van Hooff had clashed before the war over the journalist's criticism of his leadership of the club, but now Van Hooff was welcomed and they began to chat eagerly, Van Hooff about England and Dessain about the club. Van Hooff gave Dessain a long questionnaire about relationships between the Church and the Nazi occupiers that had been drawn up by British intelligence. Dessain took the list and said he would fill it in later. He also promised to lay flowers on Van Hooff's mother's grave and say a Mass in her memory. If things went wrong, Van Hooff asked Dessain to ask for forgiveness from his father for abandoning his family for his mission.

The next day in Mechelen Van Hooff was due to see Cardinal van Roey, a strong royalist, in the hope of forging a link to the government-in-exile. Raskin had arranged the meeting. A crazy plan was hatched in which Van Hooff was to go to the cardinal's palace in disguise, dressed as a priest wearing a cassock. It was an

absurd disguise. He was well known in the town from his foot-balling days. But before that meeting could take place, events took a dramatic turn.

At four o'clock in the afternoon, Madame Roberts came to see Michelli at his office. She brought along a dark-haired woman in her thirties whom she had only recently gotten to know. The new friend had won Madame Roberts's trust thanks to the help she had provided in supplying clothing, papers and coupons for the resistance. The two women and Michelli talked. Michelli mentioned that there was going to be something of a party later that evening. Madame Roberts's friend left just after half past six.

Van Hooff and Marcel Thonus arrived at Michelli's soon after-ward in order to discuss their route back to England. The meeting was also a social get-together. That evening Michelli's place would be filled with members of the secret world. Also present was another agent, Gérard Wauquez, along with Charles Morelle, who acted as a guide on the Comet line. Michelli's secretary and girl-friend were there too. Members of a handful of networks were gathering to meet. The plan they discussed was for Morelle to meet Thonus and two English airmen—Larry Carr and Ron Shoebridge—the next day at a square in Brussels. He would then take them out on the Comet line along with messages from the various networks.

The gathering was unusually—dangerously—large, something of a farewell party for those planning to depart. The food spread out on the table was mouth-wateringly extravagant for people who were used to rations. Each person was to get two boiled eggs, and there was asparagus and bottles of fine wine brought up from the cellar. For those living under the heavy burden of resistance, this was a moment to relax and be with those you trusted and who shared the secrets for which you risked your life. The pace was wonderfully slow as they talked before sitting down to eat.

Sitting by an open window, Van Hooff heard the sound of children playing. As he closed the window, he saw a large gray car on the other side of the street. He caught a glimpse of a woman tipping her hat. Next he heard the bell ring. Then everything became a blur. Five, then ten members of the Geheime Feldpolizei (GFP)—the foot soldiers of the Abwehr—smashed their way into the dining room. All Van Hooff could see was the grimace of bloated German faces. He felt something hard strike his neck. Then the barrel of a gun was pushed into him. Next he was staring straight into the eyes of a thuggish German. The man had the appearance of a wild boar: a huge face, no chin, a snout and two prominent teeth. His arms seemed to end with huge paws. He was Walter Brodmeier, leader of Section 530 of the GFP and an officer with a reputation for brutality.

Van Hooff saw the others being stripped naked to check for weapons. He knew he had one last line of defense. MI6 had given him a cyanide pill, which he had hidden behind his ear. One bite and there would be no torture and no revelations from him. But he could not do it. The self-preservation instinct, the hope that there might be some chance of escape or a way out, was too strong. Instead, he tried to make a bolt for a flight of stairs that led out the back, but he fell right into the arms of a German soldier waiting for just such a runner. A whole battalion had been mobilized that evening. The Germans were taking no chances. Van Hooff was met with a volley of kicks and punches. Within a few minutes, he and the others were being bundled out of the house and ferried to the city's Saint-Gilles prison. The Germans found forged papers and other information, including sketches of military facilities, letters and the false documents to be used on the escape line. The extravagant feast lay on the table uneaten.

For Michelli, meeting with so many people on the night of May 6 was dangerous. To have such a large group linger for a dinner

party increased the risks. But people like Michelli and his friends were not professional agents. They were patriots who had become spies to help save their country. They were not suspicious enough. The idea of having to worry about infiltrators among their own had not yet sunk in. They had not quite gotten the measure of the Nazi threat. The resistance would have to learn the painful way to fear traitors within.

On the other side of the street, watching the arrests from the café, was the dark-haired woman Madame Roberts had brought with her that afternoon to Michelli's office. She was the mistress of a dangerous man but also a danger in her own right. Her name was Florentine Giralt (also known as Flore Dings), and she was the mistress of Prosper de Zitter, the man tasked by the Abwehr with infiltrating Comet and hunting down those helping the escapees. De Zitter himself was street-smart but something of a thug. However, his dark-haired, Spanish-born mistress was better educated and better spoken. The thirty-seven-year-old Giralt had met de Zitter before the war, when she was married to another man. She played the final role in the entrapment of Michelli, Van Hooff and the others. When she had confirmed that they were all in the building, she tipped her hat. That had been the signal for the Germans to move in.

What had gone wrong? Madame Roberts—who lived two blocks from Michelli—may have been too trusting. She was proud of her role in the clandestine world and had boasted that she had two agents sent from England try to signal from her own house. One of those she told was Florentine Giralt, who had then managed to work her way into Michelli's office that day. Michelli and Roberts must have talked about the dinner that evening, and the opportunity was too good for the Germans to miss. Madame Roberts had been guilty of naiveté in her choice of friends. She later defended herself by saying she had been introduced to Giralt

by another man she trusted. There were few more important at-tributes needed to stay alive than being a good judge of character.

But in truth, her slip had provided only the final tip to create the most opportune moment for an arrest. The investigation into Michelli had been running for weeks, if not months, after news had come in that someone was sheltering British airmen. The Germans had Michelli under surveillance well before May 6. A few days before the raid they told people in a neighboring apart-ment to move out and installed their own counterespionage offi-cers to watch. No doubt Florentine Giralt's report that a party was planned for the evening of May 6 provided them with the perfect opportunity to wrap everything up at once, but the operation and surveillance had been in existence well before that.

The rot went deep. The British intelligence networks put to-gether in Belgium by both MI6 and SOE were starting to collapse like a house of cards. Worse, they had been rotten for some time, yet no one in London had realized how badly compromised they were. One aspect of the problem were the messages contacting Michelli that had been passed through Jacques Van Horen, SOE's agent Terrier, just before the arrests.

Van Horen had been dropped "blind"—with no reception committee—over Rochefort in Belgium just before midnight on March 2. He had two pigeons in a container around his neck, but during the drop the cord had become detached and the container dropped to the hard, snow-covered ground. The pigeons were dead on arrival. It was perhaps an omen of what lay ahead. The snow made it hard to hide his parachute and his radio set, but he made his way to Brussels. He arrived the next day at the Café de la Paix and looked for a waitress who was the daughter of the owner and who was supposed to put him in touch with another agent. When the contact arrived in the evening he gave her the password, but she either did not understand or would not accept it. So instead he

went to his parents. He retrieved his radio set and tried to contact London to explain what had happened. Word soon reached him about another agent who had been betrayed, and he wanted to tell London. His parents acted as his protection team to keep watch as he transmitted late at night in early April. But he stayed on the air for an hour, which was far too long.

Van Horen's father burst in and said there was movement in the street. Van Horen sent off the last two groups of letters that London had asked him to repeat. While he was transmitting, the doorbell rang. He told his parents to go to bed immediately, turned the light out and listened. Through a window he saw that a house-to-house search was in progress. He took everything that was on the table and shoved it into the suitcase that normally held the radio, put on his coat, drew his weapon and waited. After a while, hearing nothing, he gently opened the back door and looked out. The coast seemed clear. He slipped out, hoping to hide his set. But as soon as he stepped outside, the yard was filled with men. He dropped his suitcase next to a stairway in the yard and tried to make a run for it but was caught. His wrists were handcuffed behind his back and his ankles tied. The Germans searched him and found a pistol. They struck him in the face. When they found the radio, they struck him in the face again. His parents were arrested, while he was taken away for interrogation.

They asked how he knew certain named individuals from SOE and Belgian intelligence, and whether he had enjoyed a stay in London hotels. He was told several agents were already working for the Germans. When he did not answer their questions, a rope was slung over the door and he was hung by his handcuffs for between fifteen and twenty minutes, he later said. The Germans then brought in the text of messages sent to him from London. They had been recorded, and now that they had his codes, they were able to decipher them. Next, he said, he was

forced to watch as another man was tortured in front of him. The man had open sores on his feet, on which the Germans painted some kind of liquid that foamed on contact—probably acid. The man was told to walk. He fell and was then beaten and told to stand. The process was repeated. Van Horen was asked if he understood the lesson.

A few days later, Van Horen was blindfolded and taken to another house. An elevator carried him up to the top floor, where there were three or four radio sets. Van Horen's own set was placed on the table and he was told he had to send a message, which they handed to him. Van Horen claimed after the war that he had refused and that a highly proficient German operator started transmitting, using his set and imitating his style.

London certainly assumed that the messages were from Van Horen himself, and both SOE and—it seems—MI6 continued contact over the coming months, sending among others the message for Michelli at the end of April. London even dropped containers of material as Van Horen apparently reported successful sabotage attacks on generators and bridges. Van Horen's story after the war was that he had never cooperated with the sending of such messages. But he may have been forced to send and receive messages using his own codes on behalf of the Germans in order to save his parents.

British intelligence is frequently given credit for its work on deception. Among the schemes it employed was Double-Cross, which involved turning German agents dropped in the UK and then using them to feed false information by radio. But the Germans could play that game too. The messages London had been sending to Van Horen asking him to contact Michelli and to work on getting Van Hooff and Thonus out had been received by German intelligence. The Abwehr had realized Michelli was a key contact. Van Horen's radio set had been used for sending

messages back to London asking for more guidance, and it had also sent collaborators to Michelli using the agreed code names.

These were not the only compromises. Another agent—code-named Intersection—dropped in Belgium in January 1942 was arrested on March 27 while transmitting as a result of German direction finding; he'd had no one watching his back. Intersection agreed to work for the Germans. Within days everyone he had talked to was arrested. London, even though it could see that his signals were not up to his previous standard, continued to use him as a contact for further agents who were to be parachuted in. Those agents literally fell into the hands of the Germans as they arrived. British intelligence did not know it, but its Belgian operations were largely run by the Germans as 1942 progressed.

In a square in central Brussels on May 7, the British airman Larry Carr waited nervously with his Belgian helper. He was expecting to meet a guide who would take him out of the country on the Comet line and back to Britain. He was due to meet another pilot, and, although Carr did not know it, Marcel Thonus was also supposed to accompany them on the journey out. But after an hour no one had turned up.

The only person who arrived was Ron Shoebridge, another member of his flight crew shot down the week before. It was the first time they had met since the crash. But they soon realized there was no sign of the guide. Word reached them that the men who were due to get them out—led by Michelli—had been arrested.

The Germans' search of Michelli's house had uncovered false papers, including passports that had been made up for the pilots. Now new plans had to be made to help them make their way out; Carr eventually crossed the mountains that bordered France and Spain with Andrée de Jonge, both wearing berets and disguised as Basques. Two others from his crew, Shoebridge and Bill Ralston, were captured by the Gestapo.

The Germans had been watching Michelli, but they had no idea about the identity of the others whom they had picked up in the raid. It was only after combing through the documents that they realized they had found two agents—Thonus and Van Hooff. They did not know about the link to Raskin. But Bodicker and Plate already had another team on him.

Jean Starck was one of those helping to move Thonus around Brussels. When he felt the hand of the Germans approaching, he decided he too had to get out. He was told Raskin would help and would provide false documents. He had not met the priest and was told to present himself to Raskin with some Chinese money, which would act as a token of recognition that he was legitimate (no doubt Raskin had brought it back from China, and no one else could get hold of something similar). Starck was told the priest would help put him on a route to Gibraltar. But then he heard something had gone wrong.

13

Interrogation and Infiltration

O N FRIDAY, MAY I, Joseph Raskin was at the Scheut mission headquarters. He celebrated an early Mass and had breakfast before going to work in his room in the large brick complex. Around nine in the morning, the doorman knocked on his door to say he had a visitor. In the reception parlor was a local man named Laurent. He asked if Raskin was the priest who had been to China. Raskin said he was. The man said he was a stamp collector and wondered if Raskin would be interested in seeing some of the Chinese stamps from his collection. Raskin said he would be interested and that his visitor should come again. He walked the man to the door of the reception building. As the visitor stepped outside, he gave a signal. Two Germans walked in and grabbed Raskin by the arm.

They ordered the stamp man to tell Raskin in French that he had to take them to his room. By now, it was clear to Raskin that the stamp man was working for the Germans. He was Augustin Leduc, Bodicker's and Plate's best agent, sent to track down the priest who was using pigeons. Bodicker himself had been deeply involved in the case. Leduc's orders were to confirm the identity of Raskin as the priest who had been to China. They knew for some reason that this was the key to identifying him as the priest who had been making use of pigeons. Leduc had been given orders

to identify if the priest was there and to give a signal to the Germans waiting outside if he was.

Others in the building realized something was going on. A milkman had just left after making his delivery to the basement, but walked straight back in again to say the Germans were outside and they had guns. In just a few minutes, the building had been cordoned off. A car entered the grounds. Raskin was ushered into the back, and before anyone else had the chance to say or do anything, it drove off. Raskin was unable to utter a word. Their catch secured, the soldiers melted away and the priests and students began to emerge. Upstairs, the entrance to Raskin's room was sealed. Printed on the seal were the words *Sicherheit Polizei*. The Germans conducted a thorough search after the arrest, taking away two suitcases full of evidence. They discovered a lab for making microfilms and canisters ready for the pigeons. But the statue of the Virgin Mary lay untouched in his rooms. Inside were the microfilms themselves. Everything had been ready except the pigeons.

Raskin was taken to the castlelike fortress of Saint-Gilles prison. It was a grim new home, crammed with prisoners who lived like troglodytes in bare stone caves surrounded by vaulted tunnels. The stench of cabbage and urine hung everywhere. But even here, resistance was possible for the determined. Raskin was alone, but other prisoners were given the job of bringing soup or bread or cleaning out his cell. "Call me Jan," one young man said as he emptied out a bucket. His next words were careful, since a guard was watching. "Prepare a message," he whispered before he left again.

Jan was able to go in and out of the cells to carry out cleaning duties. Next time he came, Raskin was ready and slipped a message to Jan, who placed it in his pocket. The prison was full of political prisoners who had learned the skills of the clandes-

tine world. A message had to be smuggled out person to person within the confines of the prison before it could reach someone who could take it into the outside world—a tiny replica of the long courier routes used to get messages out of Belgium and into England. One method was to use cigarette papers, onto which a message would be encoded, transcribed and then sent out.

Raskin wrote a series of notes and letters in the coming days that made it out through different routes. One was for the missionaries of Scheut and to Father Verhaeghe, who had known of his clandestine work. "I am sure about my death sentence," wrote Raskin. "Without grace or a miracle, my days are numbered. But God decides those days and I accept it completely." But, ever the spy as well as the priest, he was not going to give up without doing his best to survive and to save others. He had a vital message: They must destroy the compromising documents he had hidden, which the Germans had not found despite their search. The message was met with alarm by the Scheut leadership, who feared what would happen if their headquarters came to be seen as a den of espionage rather than a place of prayer. So they decided to burn not only those documents but all Raskin's papers. A case was found in the attic full of his notebooks, Chinese papers, drawings and watercolors, a life's mementos of a cultured man. One father with an artistic eye saved some of the pictures and photos, but everything else was consigned to the flames.

Another note outlined the need to protect the broader Leopold Vindictive network. Raskin knew that some in his network had not been arrested, and he wanted to warn his friends. There was a list of names and addresses. These were people who had to be told as soon as possible of his arrest. He also wanted to assure people that he would not talk. "I name nobody," he wrote in this note. "But the others?" The risk was that others would speak. "Mr. Joye and Voske [Devos] should disappear immediately," he

wrote. "Mrs. Roberts also. It's too dangerous." The Lichtervelde group should not worry, Raskin added. He would tell the Germans he had caught the pigeon without the Debaillies' knowledge. Since he frequently stayed in their house and had his own room, he would simply claim he had found the pigeon, locked it in the bedroom and then released it. They were to say that it was normal for him to keep the door of his room closed and that they had known nothing about the bird. It was a barely believable story, but it was the best he could manage.

Raskin realized he was not the only one in trouble. He reported he had seen some of those he knew in the prison—including Van Hooff—and had heard the name Michelli. These names had to be passed on to others, especially Madame Roberts, he explained. Someone had to go to a shop called the Little Doll in Antwerp and ask a series of women to pass her a message. The messenger must take care not to be followed, but the message was urgent. "They will all do this voluntarily but it has to be done in one day if possible as the hours are precious and the life of some of them depends on it."

For some, Raskin's warnings came too late. Madame Roberts was arrested on May 6, at the same time as Thonus and Van Hooff. Her ten-year-old son was smart enough to put out a warning signal to others she knew, and he also burned her papers and hid money linked to Raskin.

At a family party in Wallonia, Clément Macq had injured his knee while dancing. He had been out of town for an operation but came home to his family hoping perhaps that no one had made the connection to him. The Germans rang his doorbell on the morning of August 3. Leaning on a crutch after the operation, even if he had wanted to run he could not have managed to do so.

Fritz Devos fled after the May 6 arrests. He saw a car come to pick up another associate, Julian Praet, who had been helping to

move the parachutists around Brussels. In the car, Devos thought he had seen Marcel Thonus. He believed the agent sent by MI6 was now talking to the Germans. Devos went into hiding, living under a series of false identities.

Hector Joye lay low and stayed with a friend for a month, but he felt uneasy rather than safe. An aunt had tried to persuade him to hide in her convent. But Joye was a family man and he knew this was his vulnerability. If they could not catch him, he knew the Germans would take his wife or children. He felt he had no choice. He went home to Bruges on June 10. Nine days later one of his sons was walking home when neighbors stopped him, telling him he should not go on, as the Germans were there. He went anyway and arrived home to find that his parents had been taken away and the house was being searched. His father's office was sealed. His mother was released after a few days. Her small red diary records the transition of her life from worrying about matters to do with the school she ran to visits to Saint-Gilles and from the Gestapo. Appearing many times in the diary over the following weeks is a line saying simply that the Gestapo had come to the house to talk to her. The drawings of the Belgian coast carefully hidden by Joye in the frames of his kitchen door were not found, but the Germans did discover some military maps he had marked.

For the Debaillie family in Lichtervelde, those months as spring turned to summer were bleak. First Raskin, then Joye had been arrested. The pigeon had flown from their house. Arseen had been on the road with Joye. Every day was spent waiting for the knock on the door or the hand on the shoulder. The family feared those around them as well as the Germans. The village remained deeply divided between the blacks and the whites, the pro- and anti-Nazis, and suddenly the siblings could almost feel the atmosphere becoming more oppressive, as though they were being watched and their activities were known. Rumors began to

abound and whispers spread that the family was involved in some kind of resistance work, perhaps to do with the secret army that was said to be stockpiling weapons ready for the Allies to return. Denunciations spread and arrests began. The fear took its toll.

Michel—the fancier who had released the pigeon from the roof a year earlier—had always suffered from a weak heart, and on August 4, 1942, the gentlest of the brothers was found dead early in the morning next to his bed. Overcome by the anxiety over German arrests, he had suffered a heart attack.

On Saturday morning August 8, the family gathered at eleven o'clock in the cemetery near the center of Lichtervelde to bury him. The plot lies in the middle of the small cemetery, straight down a path from the single entrance by the road. Grief was mixed with fear for Arseen and Gabriel. The two surviving brothers had worried about the risks of being there that day. But to miss their brother's funeral would confirm any suspicions the Germans might have. And they wanted to say goodbye.

Mourners waited in line by the grave to sprinkle holy water onto the coffin. Two men in civilian clothes strode down past the dark headstones that lined the avenue. They were neither friends nor family. They walked up to the black-clad Arseen and pulled him out of line by the sleeve of his shirt. They were not Germans but Flemish collaborators. Without saying anything, he stepped away with them. Gabriel, standing beside him, was left alone. Young Rosa stood and watched as Arseen was led away to a waiting car, only dimly aware of what the others in the family knew: that they had come to bury one brother that day and now had lost another.

Soon afterward, the Germans came to the house to look for Gabriel. Marie and Margaret said they did not know where he was. He had scurried into a hayloft and hid under the sloping roof of the house until morning, when he was sure they had left. He

then stayed for a while with a friendly farmer. Word went around the village that he was dead; a letter from Gabriel to his family said he was going to drown himself. Instead, the family had come up with an ingenious hiding place. In a downstairs room was a table for ironing, with a cloth across it. The family dug down beneath the floor and created a hatch, which opened up to a space only a meter or so square. Just enough for a man to curl up. Gabriel never left the house for the rest of the war, retreating into this space at the first sign of unexpected visitors or trouble. He never slept in his own bed for fear the Germans would come in the night. Even if he heard them coming and had time to hide, he was afraid they would notice that his bed was warm.

The question on everyone's mind was the one that haunted all resistance networks. Had there been a traitor? Or had people just been sloppy? And had anyone talked under duress after they were captured? A bleak and depressing blame game began.

Some in the network were suspicious that Muylaert had talked after he was picked up in October 1941. Macq seemed to think Muylaert's pride meant he was too boastful and not careful enough about whom he told of his work with them. Being a spy was not about showing off and vanity, Macq complained. He said he had always warned Raskin and Joye to be careful of him.

Certainly the Germans had interrogated Muylaert. We do not know what they did to him. Any fragments they may have obtained—perhaps over time, perhaps with torture—might have been used to complete the jigsaw puzzle of their investigation into who was in touch with the British. But there is no real evidence that he talked, and the time between his arrest and Raskin's was too long—seven months—to account for it.

Some of Raskin's Brussels helpers who worked with Michelli claimed Thonus had denounced the whole group after he was arrested, and perhaps his treachery had begun even earlier. The

Belgian Sûreté's investigation shows no proof of that, although it does raise the possibility that Thonus was under surveillance, perhaps owing to his highly visible and reckless behavior and general sloppiness after he arrived with Van Hooff. Thonus denied betraying anyone. He argued that many people with whom he worked were not arrested, meaning he could not have talked. But, according to German police files, Thonus does appear to have given a partial confession, although exactly how it was extracted is unclear. He, like Michelli, may have been badly mistreated by the GFP. This led to further discoveries in the basement of an insurance agent, probably Devos. Van Hooff's last residence in Liège was turned over and his radio set found in working order. Slowly the Germans worked their way through the Brussels network and its wider connections across the country. Belgians and British airmen in hiding were found. At least forty people were initially picked up for interrogation. By November 1942, the number had risen to 225, according to German police reports.

Raskin was linked in the view of German investigators to the Dehennin group, which had been rolled up in October 1941. Since Raskin was arrested only in May 1942, and since Thonus and Van Hooff—the two agents sent in to contact him—were taken five days after his arrest, it may appear that all the May arrests were connected. But the same German team under Plate seems to have been following parallel tracks and only later realized there were connections between the priest and the others taken on May 6.

The networks had been badly compromised. And because they were not compartmentalized, one compromise quickly spread to another. Large networks like Zero and Luc/Marc overlapped with smaller ones like Leopold Vindictive. They were all being rolled up too easily.

Raskin himself knew many people, which was his strength but

also his weakness. That and his impatience. And as the hoped-for second pigeon failed to materialize, his desperation had driven him to try more and more routes. He had tried so many channels to get the map of the Belgian coast back to England that all it took was for one to be compromised, and the authorities would be able to find him. In the end, it looked as if more than one route was uncovered.

After the Church and his friends, Raskin's smuggled messages also sought to protect the other pillar of his life—the royal family. Raskin warned that the Germans would have found two letters from the comte de Grunne in his room. These were danger-ous, as they revealed a potential connection between the royal court and someone now accused of being an MI6 spy. He told Father Verhaeghe to send a message to de Grunne saying that, if asked, they had only talked about family matters and the king's marriage—and nothing else. In order to reassure them, he told Father Verhaeghe to let the others know that he had promised: "I will never tell what connects me closely to the king."

The danger of being linked to the royal family did, however, offer one hope for clemency. "The king (who knows me well) should ask the Führer to treat me mercifully," he said. De Grunne had been alerted to his arrest by Raskin's sister on May 3, two days after it had taken place. On May 11 he wrote to her saying he had been away for a few days and had only just seen her letter. He said he would show it to the queen mother, Elizabeth, who knew Raskin. He added that he was sure she would try to intervene as far as she could, while warning that "in the present circum-stances" there could be no assurances as to what the result of such an intervention would be. Raskin still hoped that, despite all the incriminating evidence, his connections might get him out of the worst trouble. One thing he would never lose was hope.

But the royal route was slow. The queen mother was out of

the country. It was only on May 30 that the royal court made a request to the authorities for the release of Raskin. By then it was already too late. He and his friends had been subjected to what was known forebodingly as *Nacht und Nebel*—night and fog. Hitler had signed a decree six months earlier ordering that those found to be involved in resistance work in occupied territories were to be secretly transferred and taken beyond the reach of normal criminal proceedings. Their families and friends would know nothing about their fate. On May 11 Raskin left Saint-Gilles. His destination was Germany. To his family, he had simply disappeared.

Word reached London on May 5 that something had gone wrong. A three-word telegram arrived at MI6. "Leopold Vindictive arrested," it read. It was from Van Hooff. The next day he too would be arrested. What had happened to them all, and why, was a mystery. On July 1 a message came in about the arrest of a radio operator; alongside it was another strange message saying that "Vindictive is safe and has money." A mistake? Or a German deception message?

ALL THIS TIME MI14(d) and the Columba team had been in the dark. And that had been deliberate. Melland and Sanderson, who had so carefully unfurled those pages of rice paper in July the previous year, had no idea that MI6 had managed to establish contact with their precious source, let alone that they had gone so far as to parachute in agents to establish a connection. The MI6 files are closed, but one letter in the Columba archives points to what happened. The letter is dated May 30, 1942, and is from MI14 in response to a letter sent by MI6 two days previously. There seemed to have been a complaint from MI6 about an MI14 broadcast to Leopold Vindictive made on the BBC. MI14 confirmed that it had sent acknowledgments to Leopold Vindictive in July and on September 25, 1941, via BBC radio but

had made no further broadcast until one that seems to have been transmitted just before the letter in May 1942: "I quite agree that in general it is perhaps inadvisable for messages to be broadcast to organizations on the continent with whom you may possibly be in touch, and I have instructed Melland to advise APS [Army Pigeon Service] not to arrange for broadcasts in these cases until we have discussed the matter with you."

Then comes the damning sentence: "Had we known that you were in touch with Leopold Vindictive we would have spoken to you about him before." This makes it clear that MI6 had established contact with Leopold Vindictive but had not told MI14—the organization whose pigeons had been the reason the network came into existence. "I very much hope that the broadcasts were not the main cause of his capture by the Boche. As he was, I understand, picked up by them early this month i.e. some eight months since the last broadcast using his nom-de-guerre, I feel this is on the whole unlikely," the letter concludes.

MI14 had been trying to reestablish contact via BBC messages without knowing that agents and radio operators had been sent out to meet Leopold Vindictive. It was only when MI6 heard those broadcasts that it suddenly felt the need to tell MI14 what it had been up to in order to get them to stop broadcasting. But by then it was too late. Word had already been received that Raskin had been arrested and the network rolled up. And poor MI14 was left in the position of having to argue that it was unlikely that its earlier broadcasts were to blame for the recent arrest. It is a damning indictment of either the secrecy of British intelligence or its lack of competence and coordination that two branches of the intelligence service could not keep each other informed about their links with the same resistance network. As SOE also found, such travails were a particular problem when it came to MI6, since it so jealously guarded its sources. That might be for

the understandable reason of wanting to protect them against compromise by word getting out too widely, but it might also be simply for the bureaucratic reason of wanting to claim the credit for a successful source. In this case, the mistake seems particularly hard to forgive. It was MI14 that had first been in contact with Leopold Vindictive via the pigeons, and so it could hardly be blamed for trying to continue that relationship. And it was MI14 and Columba's pigeons that Leopold Vindictive kept asking for.

For Brian Melland at MI14(d) there seems to have been something deeply personal about the connection with the bearded chaplain, whom he never actually met but whose words he deciphered with a magnifying glass. Melland was anxious to solve the mystery of his fate. On August 27, 1942, he received a letter saying two people in England had arrived from a church in Flanders and knew about the evacuation of certain priests. "I give you this as of probably interest in connection with the famous Number 37," he was told. Not just at the time but for years afterward, members of Columba and MI14 would fear that their messages, broadcast on the BBC, had been the cause of the Belgian priest's arrest. MI6 never seems to have told them the truth and put them out of their misery by explaining that the rot went much deeper.

THE INTELLIGENCE NETWORKS of both MI6 and SOE in Belgium were falling apart in the spring of 1942. And the problems were compounded because both organizations were so slow to realize it. Parachuted radio operators like Jacques Van Horen had been captured and their radio sets used by the Germans to send false messages, but it took far too long for London to become aware of this. Van Horen was not an isolated case. British operations in Belgium were badly penetrated by German intelligence (although not quite as catastrophically as in the Netherlands, where every single agent dropped was captured). The story of

operations makes for a grim account of arrests, betrayals, failures and denials.

There is often a kind of denial within intelligence services when things start to go wrong, an unwillingness to admit that this is due to more than chance and that an operation has been compromised. SOE slowly realized something looked wrong with an operation called Manfriday/Intersection in the middle of 1942, but as late as September senior figures thought it was still running smoothly. Only as they examined the record more closely did it begin to dawn on SOE that things had gone badly wrong.

MI5 began an investigation. The verdict was dire. Almost every Belgian radio set was being run by the Germans. By autumn 1942, German successes in Belgium meant—according to the official SOE history—that the agency's "organization in the field was no more than a mirage created by the Gestapo." The year had been "operationally disastrous," SOE's own files record. By October 1942, Hardy Amies's Belgian section had dispatched forty-five agents to Belgium; thirty-two were in enemy hands.

Van Horen, who had been in touch with Michelli, was a prime example of the failure to accept what was happening. An MI6 agent had reported on April 28—before the Leopold Vindictive arrests—that *"Van Horen arreté et parlé"*—that he had been arrested and had talked. This was passed on to SOE, since he was primarily their agent. But London remained in denial that he might have been captured, let alone that he may have worked with the Germans. In late July another message came out through the Zero network to Page at MI6 suggesting there had been arrests. But the truth only began to sink in in mid-October when Van Horen managed to have a letter smuggled out through Sweden. It bore three words: *"Suis en prison"*—"I am in prison." By November, SOE staff realized that Van Horen and another agent, Weasel (who had been reporting successful sabotage operations on generators and bridges), were

both detained by the enemy. It still took until December for British intelligence to realize that Van Horen might have been cooperating with the Germans for months before the September message, but no one knew for sure when the collaboration had begun.

MI5's investigating officer complained about the terrible state of SOE files on Belgium. The organization was often lauded for its daring, but it was also sloppy. Agents were of poor quality. The codes they used were weak. In some cases, the identity check an agent was supposed to send at the start of a radio message was wrong, and yet such errors were ignored by SOE because they happened so frequently, making the whole exercise worthless as an indication of whether an agent was under German control. Some SOE agents betrayed everyone: One turned on his brother, sister-in-law, niece and even the doctor who had set his ankle, which he had broken on his drop.

The damning MI5 investigation also raised concerns over the sending of pigeons for agents. The Van Horen compromise was an example of the dangers involved.

Columba itself had been the route for a German deception operation. Containers of money and weapons for the "secret army" were dropped by SOE for Van Horen at the end of May; further consignments were sent in the following months. Their receipt was confirmed by pigeon messages signed "Jean of the Reception Committee." "A thousand thanks for the money and good food," Jean wrote on June 29. Another message congratulating the RAF pilots for their skill ends: "Long Live the freedom of the United Democracies." These messages came through Columba and are written on the standard pink sheets used by the team. "This time we had to wait quite a bit," reads one message from September, which also asks for confirmation that the last pigeons had arrived in London. "Please do not forget to send us some more Sten guns for which all the boys are asking." The last message, in November, sends

particular thanks for some letters dropped to pass on to the "Chief," who is said to be still in France, and also asks for two bottles of whiskey. All of these messages had been sent by Abwehr IIIF. One can only think that the German intelligence officers who had been running the network enjoyed their drink very much.

MI5 noted in its investigation that the pigeons carrying these messages sometimes returned with the acknowledgment a month after the containers had been dropped. And "Jean of the Reception Committee" was not a prearranged form of signature. The MI5 investigator assumed that SOE did not have a clue who this person actually was. The use of pigeons in Van Horen's mission and that of another compromised agent was "thoroughly unreliable" and "highly undesirable," the MI5 officer thought. "It appears to me to amount to little more than presenting the Germans with a channel of communication to this country by which they can send any message they like."

The MI5 investigation also noted that as well as SOE's problems with the Belgian Sûreté (which broke off relations for a while), MI6's secrecy did not help. MI5 knew about the operations of its sister service in Belgium. "SIS have also got some finger in the pie, but exactly how they operate is not known," the MI5 officer notes, adding that communications from SOE agents, including some letters, were often received through MI6. This was the confusion in the field that had caused such a problem with Michelli's network. Some of the SOE agents who came into contact with agents run by MI6 and the Sûreté in Belgium and asked for help were refused, MI5 noted. This was on MI6 instructions, the order being given on the grounds of security because MI6 feared further compromise. The bad blood between the two services was thereby increased.

MI6's secret—one that it kept from MI5, SOE and others in London—was that it, as much as its rival service, was struggling

in Belgium. Thonus and Van Hooff were among a number of trained wireless operators sent into Belgium by MI6 in the spring of 1942, and the supply of intelligence had initially appeared to improve. By June the unit seemed to be receiving comprehensive railway and troop information. But it too was losing agents. Many were being captured almost immediately upon arrival—far more than would be expected assuming the normal level of risk.

In March 1942, following a wave of arrests linked to the Zero, Beaver and Brave networks in Belgium, Claude Dansey had begun to worry. In the same month that Page and MI6 sent Van Hooff and Thonus to contact Leopold Vindictive, he told Page that "unless some drastic steps are taken with or without the consent of Lepage you will soon be without any agents left in Belgium." In light of the SOE experience, Dansey wanted to check if any wireless operators in the field were compromised. Then they could "devise some steps to save what is left." The knowledge of compromise did not, it seems, stop more agents being sent in, including the men sent to meet Raskin.

Urgent meetings with MI5 would be held in late 1942 and early 1943 to try to establish what was going wrong. MI5 wondered if the problem was due to compromised wireless sets or if something more serious was going on. Could there be a traitor, not in Belgium but in London? Remarkably, some even wondered if Lepage himself—the head of the Belgian Sûreté—could be the traitor. As agents paid the price in the field, the war between SOE and Lepage became even more vicious. Starting in spring 1942, SOE had drawn up a dossier of accusations against the head of the Sûreté. Too many agents were burned. There were too many "coincidences": One agent, for instance, was arrested a few days after Lepage complained about a Frenchman being used as a saboteur in Belgium. A whole network of people linked to the case appeared to have been arrested in quick succession. Together this had all

"cost the lives of several men." "It is a remarkable coincidence that in every case of an independent agent becoming known to the Sûreté he has immediately become under suspicion and has subsequently been arrested," SOE pointed out. The charge could not be more serious—that Lepage was selling out SOE operations to the Germans, resulting in the arrest and death of agents. A senior officer at SOE jotted a footnote on a report from Amies saying there was a rumor that the Sûreté sent over to Belgium photos and descriptions of SOE men so that they could be caught.

The extremes to which SOE was willing to go are surprising. There was discussion as to whether the unit could use a contact who had gone to work in the Sûreté to steal any incriminating documents from a safe. It even wondered if someone "would be able to get something just or unjust" on Lepage and perhaps plant an incriminating letter from the Germans in the diplomatic bag to frame him. SOE's anger had blinded it to its own faults. Lepage was difficult and was playing his own game, but there was never any evidence he had deliberately blown operations. It was all too easy to look for someone else to blame.

MI6 also received warnings of possible treachery in London. A CX report—the term given to an item of raw intelligence—of June 13, 1942, came from a courier. It was passed on to SOE, although with reservations that it had not been confirmed. It read: "Germans have full knowledge of projected parachute landings in Belgium." A few months later, another man who arrived in Britain as a refugee passed on a verbal message he had been given: "Mme Sauvage of Liège wishes to inform the British Intelligence Service that Parachutists destined for or released over Belgium are betrayed by someone in London, and there are frequent arrests soon after their landing. The capture of such men has taken place after the arrest in London of the paymaster of the Parachutists Corps here. Mme. Sauvage insists on the fact that it is quite

impossible for the Germans to find out in Belgium the exact place and date of such landings and she is quite sure the leakage must be looked for on this side of the Channel."

Could a traitor inside British intelligence be responsible? There were fears of treachery everywhere, but the MI5 verdict was that the source of the problem were agents in the UK, who after their training were often loose-lipped about their work, sometimes in London's bars and nightclubs. Such was the worry that a person was planted at the instruction school to keep an eye on whether operations were being compromised there.

But if there had been a compromise—perhaps the man who had approached Van Hooff at his hotel—there is no sign it was discovered. There were some traitors within MI6 during the war, notably one named Hooper who had become an agent of the Germans in the late 1930s and ended up working for MI5 and then MI6 on Dutch operations. But no one has ever been discovered dealing with operations in Belgium at the time. Treachery was too easy an excuse. The truth was that SOE and MI6 were in a mess in Belgium, poorly organized, their teams overlapping and easily penetrated, and they were struggling against an effective enemy.

For some in London, the knowledge that agents were being sent into terrible danger was a source of real pain. Hardy Amies struggled over whether the lives lost were worth it—especially because he felt the gains from SOE's sabotage activity in Belgium were relatively meager. "There were many moments—and I still have a guilt complex about it—when I felt once or twice I ought to resign because I thought my heart was not in the thing," he reflected after the war. "I thought this is lunacy—we are just sending people to their death." His only reason for staying was that, even if the successes were few, they kept up morale; and if he quit, someone would just take his place.

Claude Dansey at MI6 had a different view. When his man in MI9, Jimmy Langley, wanted to do more to help agents working on the evasion line who had been captured and condemned to death, Dansey lashed out. "One of your failings is that you are too damned weak," he said. "Your trouble is, Jimmy, that you love your agents."

And as the members of the group that represented its greatest triumph lay in a Brussels prison, Columba itself was about to go through its own darkest hour amid accusations of betrayal. The two founders would depart, and pigeon politics, with its bizarre personalities—including an occult-obsessed viscount—would nearly consume Columba's work.

14

The Viscount

A T HALF PAST ten in the morning of April 19, 1943, a secret court-martial was convened at the duke of York's headquarters in Chelsea. In the dock was one of the most bizarre characters to grace the story of Columba. Evan Morgan—the last Viscount Tredegar—was an aesthete, occultist and animal lover in charge of the army's Columba work. He was almost fifty but looked younger, with an aristocratically long face, his receding hair swept back from his forehead. He stood accused of breaching the Official Secrets Act and revealing the innermost workings of MI14(d). But this was no spy story involving subversion and betrayal by Nazi or Communist agents. Instead, the viscount was accused of revealing these secrets to a group of Ipswich pigeon fanciers, a major in the army who loved animals and—almost beyond parody—a pair of Girl Guide leaders.

It is tempting to see the world of pigeons through rose-tinted spectacles as a wonderfully British story of eccentrics who all somehow managed to get on and pull together in the war effort. Tempting but not true. The reality is that the pigeon world was filled with the kind of petty bureaucratic and personal rivalries that festered even at a time of national crisis. And Morgan's court-martial reveals that the flight path of Columba's pigeons was not

always without turbulence and dangers, at home as well as over European skies.

Evan Morgan was—quite literally—a character out of the novels of the 1930s. He was the epitome of the pleasure-seeking, bright young things of the era, and he was such a flamboyant figure that characters based on him can be found in novels written by his literary friends, including Aldous Huxley, who described him as a "unique fairy prince of modern life."

He was born in Chelsea in 1893 to a family whose seat was a grand house near Newport in South Wales. A vast estate had been in the family since the fourteenth century, and their wealth had been enhanced by the industrial revolution. Military men and politicians populated the family tree. It was, however, a family in decline. Morgan's father had only limited success in both career paths—becoming a captain in the navy in return for donating a boat during the First World War and then failing to make his way in Parliament. Evan never looked likely to follow the family line. From his childhood the boy, surrounded by servants, was physically sickly and foppish. He took the classic aristocratic path of Eton and then Christ Church, Oxford, and never even came close to getting a degree. His friends would later say they did not even know what subject he was supposed to be studying. He inhabited the world depicted in Evelyn Waugh's *Brideshead Revisited*, his rooms at Oxford hung with Chinese silks and rugs from Persia and Russia. After Oxford, he traveled through North Africa and Spain, writing flowery poetry and confirming his reputation as a gay aesthete before he returned to hang out with the Bloomsbury group. He was rich, and this brought hangers-on whom he would often indulge with booze and cocaine after drinks at the Café Royal or dinner at the Savoy.

Thanks to Morgan's sickliness he did not see much service in the First World War. He had then tried to get a job at 10 Downing

Street, where it was decided he was clever but "degenerate." In the 1920s he briefly converted to Catholicism and took off to Rome to study for the priesthood. His valet—whom he had brought with him in his Rolls-Royce—attended all his classes before Morgan himself had to leave after falling for an Italian "youth." In 1932, Morgan had been visiting Germany and attended a private dinner just outside Munich. Among the other guests were Rudolf Hess, Hitler's deputy, and the then head of the SA, Ernst Rohm.

Morgan had been adopted as a Conservative parliamentary candidate in East London in the twenties but never stood a chance. He did, however, still make it into Parliament. In 1934, his father—who knew a thing or two himself about living the high life—died at the Ritz, where he had been with his mistress. As a result Morgan became Viscount Tredegar and a member of the House of Lords. Around this time, his first wife—an actress—had petitioned for divorce on grounds of sodomy.

As well as art, drugs, men and booze, Morgan also became obsessed with the occult. Black magic had gripped a sliver of the British elite in an era when Christianity was losing its hold and when dark rituals offered a justification for the more extreme forms of hedonism and individualism. Morgan became friends with the dark master of the times—Aleister Crowley. A man obsessed with excess and devil worship, Crowley took immense pleasure in building a reputation as the "wickedest man in the world" for his depravity.

Morgan's other primary interest was animals. He traveled with a menagerie of birds, monkeys and even a rat. Invited to lunch at a house, he brought a crow that would peck the guests' ankles and once laid an egg on a dressing table. In the grounds of his stately home, he created a private zoo filled with baboons, venomous spiders, vultures and a boxing kangaroo, asking people if they wanted to fight it. The Conservative MP Henry "Chips" Channon

described it in his diary as a "glorious house," but he noted "the feel and even smell of decay, of aristocracy in extremis, the sinister and the trivial, crucifixes and crocodiles." Morgan was said to have never once visited the ordinary people who worked at the family estate he inherited, even as he threw dissolute parties and as men like Crowley and H. G. Wells came to stay, some of them witnessing black magic rites with owls swooping around them in the house. By 1939, as war approached, Morgan had remarried. This time his wife was a Russian princess named Olga who was terrifyingly beautiful and had once appeared on the cover of *Tatler*.

What use could be made of such a bizarre character as Morgan during the war? *I know,* someone from the army thought, *he likes animals. So let's put him in charge of pigeons.*

Morgan succeeded Rex Pearson in early November 1942 as the officer in command of the Special Section of the Army's Carrier Pigeon Service. The precise reasons for Pearson's departure from a service he had helped create are not recorded, but it does not appear to have been by choice; a reference on Christmas Eve of 1942 to his "removal" seems to confirm as much, as do other references to it being "at short notice." Perhaps the demon drink that had destroyed his time in Switzerland with MI6 had once again undermined his ability to carry out a job he loved.

Whatever the reason, the man who had first persuaded the doubters that Columba might work was now sidelined. On his final day, Pearson wrote to his contact at the BBC that he was having to "relinquish command of this unit today and am being relegated to a unit in the country." He finished his note by explaining that "One Lord Tredegar will take over but your side will all be done by Captain Kleyn to whom I beg you to extend the same good help you have always given me . . . he is very keen."

In the type of bureaucratic tangle that frequently visits itself on the British state, MI14(d) was at the heart of pigeon operations—

deciding where to drop the birds and analyzing the intelligence that returned. But the Special Section (Carrier Pigeons) of the Army's Royal Corps of Signals, which Pearson and now Morgan ran, was in charge of supplying the birds for MI14 to use. This meant that Morgan, from his office in Wing House, was nominally in charge of the critical element of Columba—making sure there was a steady supply of pigeons—but without being involved in the secret side of MI14.

Morgan immediately clashed with the man who had just been appointed to the Army Pigeon Service by MI14 to liaise with Columba and was running its day-to-day operational work. Pearson, before he left, had complained that he did not have enough support and that the army had been unwilling to provide more men. In July, MI14 asked its own teams how much value it derived from Columba. Only MI14(a) said it got nothing. Sanderson said that while the value of the operation with respect to invasion plans had obviously declined, if that possibility arose again it would be "invaluable." Melland pointed out that it was a valuable source "over which *we* have a fair measure of control." MI14(b) said it was of "considerable value, both in itself and as a check on CX reports" (that is, those produced by MI6). A major challenge was the identification of new German divisions and their locations. One message showed that an SS division was still in northern France and had not moved to Italy as other sources suggested. And the great advantage of Columba was speed. The time lag at the start of 1943 for a courier getting a message to Military Intelligence was at least a month; Columba could get the information in a day. It was described as "amazingly current."

The verdict helped justify the arrival of a new intelligence officer with the rank of captain attached to the Army Pigeon Service. JoŸ Leonard Kleyn had been born Johannes Leonardes Kleijn in the Netherlands in 1893. He had come to Britain after

his family's plans to build a shipping line had been dashed by the outbreak of the First World War. Kleyn worked for Royal Dutch Shell and traveled around Europe, becoming fluent in Dutch, English, French and German. That was one qualification for the job. Another was a love of animals. In the 1930s he had given up the Shell job to breed Dalmatians in the south of France, returning to Britain just before the war. His final qualification was his motivation. When war broke out, his father was taken by the Germans from Rotterdam—perhaps because of some suspicion that the family was Jewish (they were not). He died on his way to the concentration camp. That left Joÿ Kleyn with a lifelong hatred for Germans. When war started, he had first joined the Pioneer Corps, where he was given manual labor tasks. But his fluency in languages was recognized, and he was sent over to the Military Intelligence and quickly promoted to captain.

Kleyn would occasionally travel abroad on secret missions, writing reports on his return. On one occasion he wrote in Dutch to speed up the process. He discovered that the report had been translated from Dutch by an Englishwoman at MI6. Twenty years his junior, Diana later became his (fourth) wife. Now in his late forties, he was broad-shouldered and had been a good footballer. He liked a challenge and had a direct manner, capable of charm but also unafraid of confrontation. It is fair to say that he and Evan Morgan were likely to never be close.

Kleyn was the link between Melland's MI14(d) and Morgan at the army. Each month different departments would submit to Melland priority lists of where they wanted pigeons dropped, and Melland would pass them on to Kleyn. Kleyn would collect the pigeons that Morgan had organized via the National Pigeon Service and escort them to the RAF teams at Tempsford, discussing with the team there how many birds could be carried and when. Between two and three hundred birds might be dropped

in a single night. Kleyn reported to Melland and not to Morgan. All Morgan was supposed to do was ensure there was a supply of pigeons.

Morgan's arrival could not have come at a worse moment. In the autumn of 1942, rumors had started to surface that Columba was to be terminated. Brian Melland of MI14 was the first to hear of it—not via official channels but in watercooler talk. The push came from the lieutenant colonel responsible for the pigeons on the army side, who claimed the whole service was overvalued. He wanted the Special Service to be folded back into regular army pigeon operations. On October 9, Melland wrote a memo over his head to a colonel in Military Intelligence, defending the team. The lieutenant colonel was in no position to judge its effectiveness, he wrote, since he did not see the intelligence, pointing out that his adversary had not even asked other departments if they valued the intelligence they received. If the army were tired of this service, then MI14 itself should take it over directly. It was at this moment that Morgan took office on the army side and the alarm bells started to ring in MI14(d). They soon noted that changes were being made that "may not prove wholly beneficial."

One of Morgan's first moves was to stop the payment of cash bonuses to loft owners for birds that returned with a message. For poorer pigeon owners, the money was a lifeline. In the first week of January 1943, it was warned that this could be calamitous, since it might mean pigeon fanciers would no longer provide their best birds. "We may send a thousand out and none of them fit to get back with a message," it was warned. A real commitment was needed to train birds for Columba when only one in ten made it back alive. The point about breeding pigeons was that one invested heavily in trying to develop a strain that would be successful. Ensuring a strain or family of birds that had been carefully built up was not destroyed through the excessive demands made

on it was important. So there was a tension between the racing interest and the national interest. Fanciers did not want to be at a disadvantage compared to fellow racers. From 1942, Columba was organized so that local pigeon supply officers would keep records and make sure the burden was shared equally in each area. Morgan was now dispensing with the services of certain pigeon loft owners who had specialized in training long-distance pigeons and had returned some of the best birds. Fanciers like Bert Woodman referred to the Channel as the "moat," for they knew "it was the graveyard-to-be for hundreds of our best pigeons."

In November, Kleyn was told that some of the equipment used for transporting pigeon baskets to the airfields was no longer available, since his "alleged operations" were less important than some others for which it was required. On November 30 Melland complained to the head of MI14 that army officers were "belittling the value of the Special Service." There was also a complaint that—without MI14 being consulted—operations over Christmas were canceled, leading to the loss of four possible flying days.

Morgan's lifestyle would have jarred with Melland, Kleyn and others. The viscount would frequently stroll from Wing House down Piccadilly for tea at the Ritz, and he would invite young men to the best restaurants in London and back afterward to his Mayfair house. Kleyn and Morgan—who had neighboring rooms in Wing House—began to clash more and more. Kleyn was no longer getting support from the army to visit pilots in the airfields before they took off. "It seems the Columba service is suffering as a result of the departure of Major Pearson and the 'new order' established by his successor Major Viscount Tredegar," reads a note from Melland in December 1942. MI14 may have started to wonder if Morgan was inept or if he had been ordered to deliberately undermine their work.

Kleyn and Morgan were moving to a war footing. Both knew

that in the battle of the bureaucracy only one would survive. In the intelligence world, the best way to get rid of someone is to suggest they may be unreliable or leaky. Both sides soon began to whisper. SOE was one place to start. The viscount and his allies seem to have suggested Kleyn was untrustworthy—particularly because he was Dutch. Since agents would often visit Kleyn at Wing House for training and he would often go to the airfield, he knew a lot about the timing of drops and details of the agents involved. He should be moved or investigated, it was said.

MI5 and SOE began an investigation but realized they were caught in a cross fire. On New Year's Eve, 1942, Major Frost of MI5 told SOE that Melland had approached him in order to express doubts about the discretion and efficiency of Morgan, Viscount Tredegar. For SOE this was all a bit bewildering. The leadership asked Hardy Amies's Belgian section, the main users of pigeons, what was going on. They were told "there is a war in progress between Kleyn and Tredegar factions," with MI14 backing the former. An SOE officer went to see Kleyn on January 6, 1943. Kleyn said the newly established hierarchy was endeavoring "to get rid of him on the grounds that he has not enough work to do." But this was clearly "a political move," since there was in fact plenty to do supporting MI14 and SOE. One problem was that the army hierarchy knew little about Kleyn's work for SOE, since he was instructed to keep secret his visits to the airfield on their behalf. Kleyn asked SOE to put in a good word, and this it did, writing to Frost at MI5 the next day to say that Kleyn had always been helpful and that security would actually be endangered by his removal: "It seems a pity that a man who knows our side of the business so intimately should be removed and another put in his place." A letter to Frost later in the month further emphasized the point: "Our people say that they have been very satisfied with the discretion and services rendered by

Captain Kleyn. With regards to Morgan, I am afraid I cannot help." The attempt to use MI5 to remove Kleyn had been foiled.

By late January, the situation had reached a crisis point and a meeting was called in MI14 to discuss the problems. Morgan's brief tenure was so calamitous that it was decided to get rid of him. The only question was how.

THREE MONTHS LATER, on the morning of April 19, Morgan listened as three charges against him were read out at his court-martial. The first was that at Ipswich on February 4, 1943, he had unlawfully communicated information about pigeon operations to a group of civilians. The second was that on February 3 he had improperly informed a major from the Army Medical Corps about secret aspects of the Columba operation. The third was that he had broken the Official Secrets Act by communicating details of the pigeon operations to two women. To all three charges, he pleaded not guilty.

The prosecution then laid out its case. First—having already stressed that no detail should leave the court—it revealed to those sitting in judgment what Columba was. Next it dealt with the first and most serious charge of breaching the Official Secrets Act, which regarded the viscount's dealings with the pigeon fanciers who supplied their birds through the National Pigeon Service.

Owners in a town would club together around existing local pigeon racing clubs with an agreed leader. Groups like the Folkestone Fanciers or Dover Group had twenty lofts, each with at least thirty birds. For Bert Woodman's Plymouth Group, the day before a drop, members would get a call: "Goods required tonight," they might be told. A van would trundle around the suburban streets and collect the birds. They would be taken to 18 Cecil Street in Plymouth, a large terraced house in which two back rooms had been converted to store up to seven hundred birds. Then the

baskets would be picked up and taken either by van or by rail to Wing House in London, and finally by Kleyn to the airfield. Lofts nearest the target would be picked so the flight path would be as short as possible; Ipswich birds would be sent to the Netherlands, Belgium and Denmark, while south coast birds would be used for France (Denmark was the most distant of Columba's targets, with two birds returning in July 1942). Kleyn was the keeper of logbooks that showed which pigeons were sent out day by day, where they were dropped, which ones returned and what they brought back. This was the sacred record of Columba's work and successes.

At the end of 1942, the court-martial heard that Morgan had gotten hold of the logbooks and told a sergeant to copy out a summary of operations by pigeons belonging to one group of Ipswich breeders. Then, on January 4, he had gone to Ipswich to meet the group, which numbered about two dozen and was led by its pigeon supply officer, Herbie Keys. It is not too hard to imagine what a bunch of largely working-class Ipswich pigeon fanciers made of the aesthete viscount. They were worlds apart socially. But at a hotel, Morgan had read out the summary to the breeders. This was information, the court-martial was told, that could be useful to the enemy. It revealed at which locations birds were being dropped and from where they had returned. Put those together, and the Nazis could potentially work out where agents were operating—like the Belgian team—and then try to find them. "If any hint reached the enemy of those facts the Gestapo would not lose a moment of time in combing the locality in question for persons who had sent any message," the prosecution alleged. That was the first charge.

The second charge involved events a month later. A Major Cassidy had come to the Columba offices on a social visit late in the afternoon. He was a statistician who worked on a different

floor of Wing House and had no reason to know anything about Columba's work. He knew of the viscount's job title but not what the Special Section actually did. He had been brought there by a mutual friend, a Major Carruthers. Cassidy was a bird lover and had been told by Carruthers that the viscount had a rather interesting book about animals from around the world. Inside the office—in which the skeleton of a pigeon was displayed above a bookcase—they looked at an atlas of birds of the world for a while and also talked about whether microgram slides could be enlarged to carry information, since it was something that Cassidy knew about. Then the discussion turned toward pigeons. Cassidy said he had seen plenty of them in Wing House. He said at times he had found it difficult to get into the elevator for all the pigeons.

At that point, Cassidy recalled, one of the men—he could not say whether it was the viscount or Carruthers—said something like "Let's show him the secret stuff." At this, the viscount had a sergeant bring out a live pigeon, a parachute, the instructions and a cylinder and demonstrated how each of these was used. There was also a gesture toward a large map of Europe on the wall behind the viscount's desk. Here locations were marked by pins, which Cassidy surmised were the places where the pigeons were dropped. This amounted, the prosecution said, to conduct to the prejudice of good order and military discipline.

And finally, in the most bizarre of the three alleged transgressions, the prosecution outlined the events of March 15, when the Girl Guides had come to Wing House. This was all part of a publicity push for the Baden-Powell memorial fund—named after the founder of the Scout movement who had died just two years earlier. Arrangements had been made for pigeons with red containers to be dropped in Scotland, who would then fly back to Wing House bearing messages. Photographers would be waiting on the roof to grab a picture that might make the papers. They

had already tried to do this on February 25, but the weather had been terrible. The thick London fog meant the pigeons had no chance of finding Wing House. So, on March 15, they were trying again. It was still foggy, but not as bad, and a few birds had made it. Lady Baden-Powell herself, the widow of the founder, was up on the roof.

The viscount then invited two of the Girl Guide leaders into his office. The show on the roof had been disappointing, and he felt the need to entertain them. Morgan explained how pigeons were brave, dependable birds that could fly through anything—shrapnel, gas, bombs and shells. He once again asked a subaltern to bring in the equipment and then demonstrated—with a live pigeon—how the container and the parachute worked. He explained the different types of cylinder that could be attached and even the secret of their colors. Green, gray and red with a colored disk were linked to the Special Pigeon Service; green meant Columba. Plain red was the normal Army Pigeon Service. Blue was RAF (and with a white patch was an RAF SOS message). Black was civil police and yellow was commercial. He also drew the girls' attention to the map on the wall. Pointing to a spot on the map northwest of the Zuyder Zee in the Netherlands, he told them this had been the site of an enemy radar station the details of which had been brought back by pigeon. This was one of the successes that had so excited R. V. Jones, and the viscount explained that RAF planes had attacked the site.

Captain Kleyn of MI14 was in his office next door. He knew exactly what was going on even though he was not present. The subaltern had come into the office he shared with Kleyn to pick up one of the containers that were kept there for testing to show the Guides. That may well explain what happened next. On Sunday, March 21, Lieutenant Colonel Cullinan told Morgan that he had been reported by the two subalterns for events with the Guide

leaders on March 15. He was told he should plead sickness and resign his appointment.

Two weeks later, Morgan was informed that there was a formal allegation against him. He was apologetic. But it was too late, and two more charges were added relating to the earlier incidents.

At the court-martial, it seemed an open-and-shut case. Plenty of witnesses—not only the sergeants and subalterns but also the Girl Guide leaders and Major Cassidy—produced evidence, if occasionally a bit hazy, about what Morgan had shown and said in their presence.

But Morgan was a well-connected and rich man. And that meant he had a good lawyer. In this case it was Sir Walter Monckton—a man who had served as an adviser to King Edward VIII during the abdication crisis and would later himself become a viscount and Conservative cabinet minister. He offered two lines of defense. The first was the more effective: Why had Morgan gone to see the Ipswich fanciers? Was it off his own bat? Why, no. He had been ordered to go to see them by his superior.

The problem was that the Ipswich breeders—led by Keys—had been very unhappy with the scale of the losses. Too many of their birds were going out and never coming back. The burden may have been shared among them, but they felt that groups in other parts of the country may not have been sacrificing as many birds. So great was the Ipswich group's discontent that there had been a danger they might even withdraw cooperation. So Morgan had been given orders to win them over. He had gone there to appeal for their cooperation to continue under him as they had done under Pearson.

Monckton went over the conversation in Ipswich. Morgan had read out the summary of the two hundred and fifty or so birds that had flown and the number that had come back carrying messages. When he had finished, Keys stood up and said,

"The number is wrong. You have left out two." Morgan had ac-knowledged to them that he had missed two birds that had made it back. Then Monckton made his point: If the information was so secret, then how on earth would Keys know that Morgan had missed two birds? Of course, the answer was that the loft own-ers all knew exactly how many birds had returned because they had come back to their lofts.

Furthermore, Monckton pointed out that Morgan had not told the sergeant to copy the most sensitive parts of the logbook—the details of any message or who had sent it. Under cross-examination, the sergeant revealed that the summary had been prepared not only under the orders of Morgan but also under those of the offi-cer above him, Lieutenant Colonel Cullinan, who was responsible for all pigeon operations and not only those supporting Columba. He had given orders for the summary to be written out to sup-port Morgan's mission to win over the Ipswich team. How had he gotten hold of Kleyn's logbooks? Kleyn had handed them over. Why had he handed them over? Because he knew instructions had come from Cullinan. In other words, the viscount was simply fol-lowing orders. And his mission had worked: Ipswich had contin-ued to supply pigeons.

And when it came to the demonstrations of the pigeon, the parachute and the container to Cassidy and the Girl Guides, was this really a secret? Monckton pointed out that the whole point of the contraptions was that they were dropped over occupied countries. The Germans were surely in possession of hundreds of them already. What further secrets could be exposed? The Ger-mans might not know how, precisely, they were used, or that the green cylinders carried secret Columba messages. But still.

Furthermore, after Morgan's appointment in early November 1942, Monckton asked, was it not the case that Lieutenant Colo-nel Cullinan had himself frequently brought army officers into

Morgan's room and ordered him to carry out a demonstration to them? Morgan in a statement said that his predecessor, Major Pearson, had frequently shown documents such as questionnaires to visitors.

Yes, there was a map of eastern England and the continent on the wall, and it was marked with colored pins. But those on the continent had been affixed by a Dutchman—a Mr. Ray—who had escaped from the Netherlands and placed pins at locations where he thought Allied sympathizers might be prepared to revolt against the enemy in the event of a landing. Plenty of people came through the office but no one had objected to the map before.

Morgan himself did not give evidence in his defense. But a statement he had given previously was read out in which he recalled that the facts of the Zuyder Zee site had been given to him by Lieutenant Colonel Cullinan, "who also told me that he had been congratulated by Guide leaders." It was public knowledge that pigeons were dropped on the continent, since the Girl Guides had to admit they were already aware of it. The vague gesture to the site in the Netherlands was imprecise, Monckton suggested, especially since all the others in the room could not agree whether he had pointed with his finger or a stick, or what precise words he had used.

Brian Melland tried to fight back when he appeared as a witness. He emphasized that the places where pigeons were dropped were secret. He confirmed that the location of the site and the events at the Zuyder Zee were secret. Yes, the enemy was in possession of parachutes, but they would not know the method of release. He even tried to maintain that the difference between red and green canisters was highly significant. He did his best to pile on the pressure, but under the most intensive cross-examination of the entire proceedings, he had to admit that the Germans had probably captured a lot of containers, parachutes and pigeons themselves. It was

becoming clear that the conversations that the viscount had had were either authorized or not that unusual.

Then Monckton made his final plea. Yes, the viscount had made an "error of judgment," but it was important to take into account his personal and medical history. The viscount's childhood, his lawyer explained, had been desperately unhappy. His mother suffered from what was called a "divided personality." By one account she had built herself a large bird's nest in her sitting room and then sat in it wearing a beak. The young Evan Morgan had been a spoiled child, allowed to run riot and live an irregular life. His sister, like his mother, had suffered mental health issues, and the viscount himself was physically sick, having never passed a medical board. From May to November 1942 he had been on continuous sick leave, and frequently after November as well. Monckton brought in Morgan's doctor, who had known him since he was twelve. He had repeatedly warned the viscount of the risk of mental or physical breakdown. Morgan was a man who would have been more at home in fifteenth-century Italy than the War Office of the 1940s, the court was told. The doctor said he was very surprised when he heard Morgan had been accepted for service in the army at all, let alone for secret work. Truth be told, Monckton explained, he was "ill equipped for his station." And at this moment his domestic life was also crashing around him: Princess Olga was seeking a divorce. With all this in mind, Monckton pleaded that the penalty should not be too harsh.

Colonel Prescott, presiding over the court-martial, returned with his verdict: not guilty when it came to the charge regarding Major Cassidy but guilty when it came to Ipswich and the Guides. But the sentence was light. No imprisonment, simply a severe reprimand. Monckton could not have hoped for more. He had done his job. But Morgan was no longer to be part of Columba. In that sense, at least, Melland and others had gotten what they wanted.

That summer Morgan's divorce from Olga came through. The black magic practitioner Aleister Crowley was staying at Tredegar House in Wales once more. Morgan showed him his magic room and they engaged in some occult readings. There were rumors that Morgan had asked Crowley to cast a spell on his former commanding officer to make him sick. But Morgan himself was the one who was sick. In 1949 he died, aged just fifty-five, the last of his line. Four years later Tredegar House was turned into a school.

The viscount's desire to cast a spell on his superior reveals that he well understood what lay behind the court-martial: personal animosity. It is clear from the evidence that not just Kleyn but Melland, Cullinan, the subalterns and sergeants had all taken a deep dislike to their aristocratic colleague almost immediately after his arrival and were determined to get rid of him. They were willing to suggest that he was engaged on trips like Ipswich off his own bat, when in fact he was following orders, or that he was taking a risky step by demonstrating pigeons when others had done the same. That may have been brutal but it was also understandable. Melland, Kleyn and others took their jobs seriously. They were engaged in a secret intelligence operation and there were people whose lives were on the line in France, Belgium and the Netherlands. Careless talk could cost lives. And to have their work compromised by a bizarre, occult-loving viscount would only have made matters worse.

THE VISCOUNT'S BRIEF tenure was only one example of the "pigeon politics" that surrounded Columba. A sad letter arrived at the Air Ministry in early May 1943, just after the court-martial. It was from Rex Pearson. He was now out of a job and writing from his cottage in Hampshire. "The time seems to be ripe for consideration of a separate pigeon Intelligence Service as distinct from Wing House—not to replace it but to augment it," he wrote to the

head of Air Intelligence. This new version of Columba could carry a questionnaire focusing purely on issues that mattered to the Air Ministry, he explained. "I would very much like to organize this service for you," he pleaded, asking for an interview. He was essentially proposing to create another Columba, this time out of the hands of the army.

The letter was dismissed by the director of intelligence operations. A note in the file remarks that "there is something gravely phony about the letter" and that other officers would not touch the proposal either. Poor old Pearson was casting around for some kind of role. After a few months, the one place that would take him was the BBC, where he found work in the European intelligence department. Even here he tried to keep involved in Columba, trying to pull a "fast one" in Kleyn's view by getting questionnaires revised without proper permission.

Pearson's letter was tapping into a deep antipathy between the Air Ministry and the Columba team. The long-running battle between the Army Pigeon Service, which ran Columba, and the Air Ministry, which tecÿically was responsible for all pigeon operations, was intensifying.

William Dex Lea Rayner at the Air Ministry—supposedly Britain's military pigeon supremo—absolutely hated the fact that the army ran its own service. What drove him particularly crazy, sitting in Adastral House in Kingsway, was that the War Office down the road would not even tell him what Columba was up to, perhaps out of a genuine desire to keep intelligence operations secret but perhaps also out of sheer bloody mindedness. The bad blood spilled over into relations with the National Pigeon Service.

At first NPS and Rayner's Air Ministry had been allies against the army and the War Office. In January 1941, an army colonel launched a scathing attack on Rayner and the NPS for excluding

him from meetings. That October, the NPS complained of the same colonel assuming a "dictatorial attitude to the committee."

But as Columba grew, the army began to work directly with the NPS, and it became clear to the fanciers that the army and its Special Section was where the action was. They were the ones who were using birds and supplying food in return. Feathers flew. What really galled Rayner was that the NPS committee (whose work he paid for) knew more than he did about this secret work and kept it from him. The result was "undignified, unnecessary, and even insulting," Rayner complained as he demanded details of the number of birds used, the losses and returns and the value of the information obtained. Rayner became furious when the War Office refused to give answers on grounds of "security"; he subsequently tried to undermine Columba, telling people that his colleagues in the RAF did not consider it useful. "If the whole scheme is a War Office 'racket' then it is not an Air Ministry function to facilitate it," he said.

The most vicious pigeon politics took place within the pigeon fancy itself. There were accusations of favoritism and bullying. Some pigeon fanciers complained to MPs about the "autocratic" approach of the NPS committee, who would turn up and demand pigeons were supplied even from depleted lofts. Owners said they would be threatened with removal from the register and the termination of free food coupons if they did not comply.

But the NPS's most acerbic critic was the man who had helped found it, William Osman. Like Pearson with the army, this founder of pigeon work did not last the course.

Osman had been invited to join the committee in May 1939, but that November he wrote a spectacularly bad-tempered letter to the NPS chair, G. Barrett, saying that the situation was "quite intolerable" and if NPS failed then Barrett "can go on being a subpostmaster and grocer." Osman began by complaining about the NPS secretary, Selby Thomas. "He has never kept any pigeons—

merely budgerigars—and unlike myself has had no experience whatsoever of pigeons in war." He was angry at not being consulted and claimed the NPS was being turned into a "one-man show" that had failed to learn the lessons of the last war. "There is no one on the committee—or for that matter in the country—knowing as much about pigeons for war," he said in a three-page rant. In a fantastically over-the-top comparison he went even further. "I am not prepared to acquiesce in the doings of a Führer." Osman's rivals rebutted his claims, telling the Air Ministry that he had failed to turn up for meetings and do any work. Osman was soon kicked out of the NPS.

He then pushed for a position as a paid consultant to the Air Ministry. In a veiled threat, he suggested that if a suitable role was not found, it might be better "from the point of view of the nation" that he retained his independence so he could "point out mistakes that are made, and perhaps right some injustices." "The number of questions likely to arise upon which I should feel in need of Major Osman's advice are very few," Rayner wrote to his superior, pointing to the problem of his conflicts of interest with his role as editor and proprietor of the *Racing Pigeon* and in the sale of pigeons. This was all despite Rayner originally having been one of Osman's allies. One official claimed that Osman and his relatives and friends had supplied or controlled the supply of pigeons in the First World War, "and judging by the instances I have of prices charged it would appear that he must have made a very good thing of it." His activities were "not in accordance with his professed patriotic motives," an official noted icily.

Osman used his editorship to snipe at his former colleagues. The journal printed extracts from supposedly "restricted" documents relating to Columba. MI14 was called in. Melland despaired. "The main point about this storm-in-a-teacup is that it is purely a quarrel in the pigeon fanciers world," he wrote. MI14 cared only for the

intelligence product—it was up to the Air Ministry and the Royal Corps of Signals to sort out the "private feelings of pigeoneers." Nevertheless, Melland wrote to MI5 and asked it to take a look. "It all sounds a bit hysterical to me, but we certainly don't want any trouble in our particular feathered world." A long list was drawn up of all the disparaging articles in the *Racing Pigeon* that criticized the Army Pigeon Service and the National Pigeon Service.

The fear was that the attacks might undermine the willingness of some fanciers to offer their birds or lead an angry pigeoneer to defend the operation publicly—and do so by revealing Columba's secrets. A scathing report on Osman was written later by the War Office. "Major Osman conducts his paper in an aggressive fashion, encouraging controversy," the report noted, adding that he seemed "slovenly" and drank heavily. But at the end of the day, Richard Walker from MI5 suggested that no action should be taken, partly for fear of publicity.

By the summer of 1943, the court-martial was over and the threats to close down Columba had been seen off by MI14(d). Instead, plans were put in place to increase its staffing because it had been proved to be so successful and to increase the scope of Columba's activities. The pigeon fancy remained committed despite some wobbles. Columba would still have one more important role to play. At its inception, its mission had been to spot German plans to invade Britain. Now it would be needed to prepare the way as Britain and its allies planned to invade Europe; it would play a role in deceiving the enemy and hunting its most dangerous weapons.

Trials and Tribulations

JOSEPH RASKIN ARRIVED in Germany in May 1942, as the country was slowly realizing that the war would not be over as soon as Hitler had promised. In the east, the invasion of the Soviet Union had stalled and was turning into a brutal war of attrition. Allied bombers were beginning to pierce German defenses, thanks to the work of R. V. Jones and others. But the German hold on western Europe remained firm and the Nazi secret police were determined to maintain their grip, by means that included enforcing their version of justice on enemy spies. Raskin and his friends were first taken to the Brauweiler prison in Cologne, which had begun life as a Benedictine abbey in the middle ages but now belonged to the Gestapo, a place where social and political "undesirables" were kept. It was one of the strange ironies of the priest's journey through Nazi Germany that so many of the places he visited had been built for Christian worship, a grim reminder of the subversion of faith in that country.

Hector Joye was able to get a letter home from Brauweiler that July—the only one his wife, Louise, received after his arrest. There was no high drama in it, just hope and domesticity. "I am well. I hope to see you all in a few months. Would you send a good shirt and a new warm jacket," he wrote, adding, as an afterthought, a

request for a large piece of soap. In August, Arseen Debaillie was taken to Brauweiler and reunited with his friends. He sent a letter back to the family saying they should pay money to try to get him released, something the Germans sometimes suggested would work. "I'm doing well, thank God. Life is very monotonous, but there is also nothing to be done," he added. When the Gestapo delivered the letter to Lichtervelde, the agent demanded twenty thousand francs.

Spying had been expensive for the family. They had already tried paying out once for Arseen and had given money to help Devos escape. The family pulled together the money and handed it over. Nothing happened. Then came a demand for more money. Again a sum was handed over, and again nothing came of it.

There were no letters from Raskin. He had a red note attached to his identity card, unlike the other men, which may have been why. All of them were allowed sometimes to walk on a small patch of grass but never to talk to those they knew.

Brauweiler was where the interrogations began. The Germans wanted confessions. For all the arbitrary exercise of power and violence inherent in the Nazi system, they still wanted to put es-pionage cases through a formal legal process. Otherwise, the risk was that spies would be seen as martyrs. And if it was going to go to court, then the most effective way of securing a conviction was through confession. The Germans began the kind of patient work in which their best interrogators excelled. They were trying to draw out as much as they could by playing the men off against each other. They would reveal details of what they learned from one man to the others in order to make it sound as if they knew more than they did, bluffing that others had already told all.

Leopold Vindictive's interrogation was revealing about what the Germans did and did not know. Bodicker from Abwehr IIIF in Brussels forwarded details of what his team had been able to

gather. Everything revolved around the first pigeon and the contact with the group around Joseph Dehennin, whom Raskin had first tried to use to ask Britain for more birds. Clément Macq's account provides the only insight into how the Gestapo tried to break the men. Macq was transferred to Brauweiler on August 5 and interrogated for the first time on August 17. He was read a declaration that contained details regarding his own role and what he and others had discussed with Joye and Raskin. The Germans also seemed to know the times and places of meetings with René Dufrasne, the man to whom Macq had passed Raskin's message to Britain. Macq denied everything and said it was all untrue. After a few hours he was back in his cell. He was never tortured apart from receiving one blow with a stick.

Joye was brought into the room with Macq for another session and a declaration supposedly from him was read aloud. The interrogators spoke about a specific document Joye had given Macq. Joye made a tiny signal with his finger to indicate he had admitted only to giving Macq one document. Joye was asked if he maintained his previous statements, and he said he did. Macq at this point continued to deny everything.

Next Raskin was brought into the room. The Germans asked Macq if he knew who Raskin was. Macq said they had been in contact regarding a cinema projector for the priest's lectures. This was true and provided an alibi. Fortunately, Raskin had said the same thing. Both men then said they had never discussed espionage.

Then Dufrasne was brought in. He was unrecognizable to Macq. He had lost weight, and his eyes were dead. There were no overt signs of torture, but Macq could see that this was a man who had been broken. The interrogators read to Macq a statement by Dufrasne that seemed to contain precise details of their relationship and meetings with regard to Leopold Vindictive. They

asked Dufrasne to confirm this verbally. He did so. Then emotion seemed to overwhelm him. He said something about how Macq had to think of his children and the consequences. Macq later insisted that he had continued to deny everything. Before being taken away, Dufrasne asked the interrogators to tell Macq that he was not the one who had denounced Macq. The interrogators confirmed this.

The interrogators now spoke to Macq alone. They said it was no use denying everything any longer. He had now heard the confessions of Joye and Dufrasne. Macq knew he was in a corner and played for time to think up a story that would correlate with their statements without incriminating him too much. It was lunchtime, and he asked for something to eat. His interrogators consented. But when they came back they insisted on a confession. He said he needed a few moments to digest his food. He was taken back to his cell and offered a pencil and paper, but he refused them, saying that what he had to say could be summed up in a few words and that it was not necessary to write them down. The Germans must have realized he was stalling, and he was left alone again.

A few weeks later, on September 15, Macq was brought back to see the Gestapo. By now he had had time to think up a story. He said that Joye had told him about an organization called Leopold Vindictive, in which Joye and Raskin were involved. Its aim, he had been told, was to help ordinary people under occupation—a kind of underground charity. Joye had asked if he knew about getting some kind of contact with England for the work—perhaps requesting food and supplies from the United States—and this is what he had passed on to Dufrasne.

In his declaration, Dufrasne had talked about a pigeon. Macq denied ever hearing anything about pigeons and said Dufrasne must have been mistaken; perhaps he had heard about it from

Raskin, if anyone. The interrogator insisted that he only needed enlightenment about the pigeon in order to liberate Macq.

A translation of his "confession" was then given to Macq. There was a sentence that Macq thought was ambiguous, so he refused to sign it. The interrogator became indignant and said something about German justice being more correct than Belgian justice and they did not want him to sign anything false. The declaration was duly altered, and Macq agreed to sign.

The Germans had hard evidence. When they started to round up the Dehennin group back in October 1941, at least two hundred documents were found during the search of Dehennin's father's house. His interrogator put them in front of him and asked him to clarify the source of every single one. There were other details that only someone close to Dehennin and whom he met almost every day could have known. Dehennin could not hide his astonishment at all the details and feared that a friend or member of his family had betrayed him. He still did not know that it had been his brother-in-law, Pieren.

There was little he could do to deny he had been the leader of a network. Among the documents unearthed were copies of the telegrams and messages that Leopold Vindictive had given Muylaert to try to get to London.

Faced with the growing stack of evidence accumulated by the Germans, some of the men must have felt they had to confess to certain details. Joye's defense when he was faced with documentary evidence would be that he was only passing to England details of factories and installations where ordinary Belgian people worked so the RAF could avoid bombing them. Raskin had to confess to some activity, but he deliberately hid the role of some of his contacts in Brussels who had passed on information and claimed much of the material that had been collected had been destroyed in April 1942. The advice among the resistance members was to

only confess to what you absolutely could not deny, while trying to find some reason for it that did not implicate others. But the Germans were still able to use those details with other prisoners. Slowly, painstakingly, the Gestapo built its case. It seems easy now to ask who talked and who did not. Perhaps Dufrasne had. Perhaps others made partial confessions. But under what duress and what manipulation? And perhaps they sometimes confessed when confronted with incontrovertible evidence but tried to hide other facts or the role of other people. The recollections of some of the men are full of confusion and fear over who might have talked, often based on a fragmentary picture, since they were unaware of the full extent of German penetration and knowledge. Without knowing who the real traitors were or how evidence had been collected, the men went through their own grim, painful internal interrogation and mental torture, wondering which of their friends might have betrayed them, either before the arrest or by talking afterward. Macq came to believe that Raskin had offered himself up as a sacrifice, taking all the blame on his shoulders and saying he was the sole person behind Leopold Vindictive.

At the end of October 1942 the initial interrogation was over and the men were moved by car to Bochum. As in Brauweiler, the prisoners in Bochum wore their own clothes. It was winter now, and Arseen had to cut a deal with a French cellmate to borrow a green pullover, a khaki shirt, a maroon wool scarf, several blue handkerchiefs and a pair of shoes that did not quite fit.

Next they were transferred to Wuppertal. The days began at a quarter past five in the morning, when they were awoken in their cells. (This was a good fifteen minutes of additional sleep for Raskin compared to his days as a missionary. But now he was on his knees scrubbing floors rather than praying.) Breakfast was either a slice of bread and half a liter of watery porridge or two slices with jam. Days would be spent sewing leather clothes

for the German soldiers who occupied their country. Lunch was cabbage soup, dinner three slices of bread, perhaps with cottage cheese. Raskin wrote some notes but never managed to get them out. One letter survives:

> Arseen, Hector and I are now in the prison of Wuppertal. We are all very healthy: please do not be concerned. Our crime is not dangerous. Only after the war will they allow us to go back home. We are monitored very strictly and receive no letters or parcels. We cannot go to Mass, nor receive Holy Communion, or see a priest. There is not the slightest difference between our guards and real pagans . . . We rarely see each other and there is no way to talk to each other . . . The Lord is among us and the Blessed Mother blesses us, how could we be afraid? The Belgians are about 300 in number . . . we will undoubtedly return to our country so our families can rest assured.

Hope was still alive.

The prisoners may not have been allowed to go to Mass, but on Sundays Raskin held his own service from within his cell. He would break the dark prison bread, bless it and pray. As this happened, a knock would go from cell to cell allowing those who so desired to kneel in their cells as if they were back in church at home and not in a German jail. Some would hear the prayers, while those who could not would at least know they were being said. For a few moments in their cells they were not alone. Macq and Dufrasne had cells next to each other and could talk through the walls. Raskin communicated with Macq and others by hiding messages in a hollow stick that he would drop to the ground during walks, signaling to the person the message was meant for. He tried to send notes to Joye, worried over the man's health and the careworn expression he could see on him when they passed.

A week later, on his fifty-first birthday, Raskin scribbled a prayer card with the addresses of four families back in Belgium whose relatives were in jail with him. He wanted them to be informed that there was no danger and they would return after the war. "There is absolutely no risk," he assured them. He even asked his family to make sure that moths were kept out of his clothes. It was another indication that he was sure he would be home eventually. Raskin felt optimistic that the war would be over soon. "The Germans have long lost all hope," he said. He could see that shortages, especially of food, were beginning to take their toll. The German war machine was starting to shudder under the strain. "The victory is near: Long live our homeland." The message never made it out.

On June 24, 1943, the Allies bombed the city of Wuppertal. Two weeks later, the planes were back again, and this time the prison caught fire. One hundred and sixty-nine men, including the members of Leopold Vindictive, were taken from Wuppertal to Esterwegen on July 7. Now it was prison clothes—black trousers and jacket, hardly brightened by the yellow lines that marked out a political prisoner. Their heads were shaved, although Raskin presented a strange sight since he was still allowed to keep his full beard on top of the bald scalp. Those who knew him there say he also retained his optimism. He was held in a barracks occupied by fellow Belgians and, exempted from certain tasks because he was a priest, continued to some extent to hold to the life of religious ritual that had governed his years before captivity.

In another barracks, Macq worked some of his old engineering magic and somehow managed to construct a radio, from which prisoners could occasionally grab a muffled BBC broadcast that told of progress against the Nazis in the war. They might hear the coded *messages personnels* and wonder what men and women had now taken their place. Raskin was held in a different block, but during one of his walks, the priest told Macq he had written

to the German Ministry of Justice about their case and had mentioned that in the campaign of May 1940 he had saved the lives of two German officers who lay wounded in a burning building. He hoped that might help them. He was already planning for his return.

The priest also found time to go back to his old First World War pastime and sketched out some scenes from camp life. In small print he recorded in a notebook a few lines of a diary during his days there. Three days after his arrival he noted that there was nearly one death every night, usually from dysentery. Arseen Debaillie was among those who were ill but just about made it through. Muylaert and Joye were also hospitalized for long periods with fever. A month after arriving, he recorded a bitter warning of the other way death haunted the cells. "Saturday 7th August. This night suddenly twelve of the sixteen sentenced to death taken away."

By May 1943, the Germans had written up their indictment and the men were told they would stand trial. On Wednesday, August 25, Raskin noted in his diary that the trial had now been scheduled to begin at nine o'clock on the morning of August 31.

In Belgium, no one knew what was happening. The friends had simply disappeared. Hector Joye's wife, Louise, heard nothing of her husband: "What can I answer my sons when they ask for their father again and again?" she wrote to the Red Cross. Rumors swirled around. One was that Raskin had been condemned to death but was pardoned after the intervention of the queen mother of Belgium.

When the morning of the trial came, the men's prison clothes were taken away and replaced with their well-ironed civilian clothes. Raskin unfurled his priestly garments. But the Germans objected, saying the robes were akin to a uniform, which was banned. Instead, he was given a blue suit. His friends' sense of

humor had not been diminished by their confinement, as they joked that it made him look like a car mechanic. Those left in the barracks also promised they would pray. Then came a thirty-kilometer drive through a beautiful sunny landscape.

Normally the court—grandly titled a Tribunal of the People—would sit in Berlin, but it was temporarily sitting in the Ursuline convent of Papenburg. The People's Tribunal had special juris-diction over political crimes—it was a component of the system of terror within Germany and occupied lands. The president of the court was to sit in judgment on Leopold Vindictive. He was dressed in a blood-red robe, giving him, in the eyes of the accused, a satanic appearance. The eyes themselves above an angular nose were also demonic, the Belgians thought. He had the look of a man who seemed to relish his work.

That impression was accurate. Roland Freisler was not a law-yer who had reluctantly collaborated with the Nazi system, he was an intrinsic part of its evil who had been instrumental in taking National Socialist ideology and expressing it in the form of law and decrees. He had authored a legal decree against "na-tional parasites" and attended the Wannsee Conference in 1942 to provide legal advice on the plans for the "Final Solution," which would eliminate the Jews. His trials always began with a Nazi sa-lute, and he brooked no disobedience in his courtroom. Theatrics were important to him—he had learned as much from attending Soviet show trials as an observer before the war. The outward façade was of a normal legal process—a judge, lawyers, dossiers of evidence—translated to the dining room of a convent for girls with a large cross hanging on the wall.

After the salute, the accusations against the group were read aloud. The accused sat on two benches, a line of bald heads except for one woman: a nurse, Hélène Dufour, who had passed mes-sages in sealed envelopes for Dehennin. Two linked groups were

on trial. One, around Dehennin, included the others who had worked with him; the other, around Raskin, included Joye, Macq, Dufrasne and Arseen Debaillie. All were accused of secretly collecting information about the German army and passing it to the enemy or others. Additionally, some were charged with smuggling people out of the country, listening to non-German radio transmissions and being in possession of anti-German material.

It was explained to the court that they were two independent circles of espionage: one, under Dehennin, under the influence of the French Deuxième Bureau and occasionally the English intelligence service; the other, under Raskin, working only with the English. Muylaert was the only common point that brought them together.

The evidence the Germans had accumulated and now presented to the court was weighty. The meetings between Dehennin and his French contact were described in detail, as was the specific intelligence that had been handed over. There were names, code names, dates and details of the money that had passed between him and the French, as well as their work helping people escape the country. There were the lines of contact between Muylaert and MI6 and the attempt to pass telegrams, including those from Raskin.

Next they came to Leopold Vindictive. It had begun, the Germans said correctly, when the "racing" pigeon descended by parachute with its questionnaire—although they had the timing wrong, saying it had been in May 1941. The German allegations described the way the three accused friends—Raskin, Joye and Arseen Debaillie—had met in Lichtervelde and then divided up the intelligence gathering among them and forwarded the collected material to Britain attached to the pigeon. They knew Raskin had been the one to write the final report. There were precise details of what the pigeon had carried back and of what each man had contributed—

for instance, that Arseen had reported about copper wires on the Bruges–Ghent railway line while Joye had reported on what he had seen around Bruges. The pigeon had not been intercepted, so had someone talked under duress? Or had the notes and drafts the men used for their first dispatch been found somewhere? It was noted that Raskin had taken a photograph of the pigeon and that Arseen had developed the picture. The code name Leopold Vindictive 200 and its origins were explained, including the meeting with Keys. Here was their story, of which they were so proud, now turned into an accusation.

No one else was alleged to have collected any of the material—so at least the names of some of the others who provided details to Raskin in Brussels had been protected. Raskin himself was singled out as the central figure, having given orders to spy on military buildings in Ostend after the first pigeon was sent home. The group's desperate desire for further pigeons was noted. The friends' travels in August and September after the sending of the first pigeon were also cited, including Michel's and Arseen's drive along the coast with Joye to make observations that could be transferred to drawings. Painful as it must have been, the group realized that some of them had talked. The Germans also produced the text of telegrams that had been passed to Muylaert to try to get to England, found during the October raids, as well as details of further intelligence that Muylaert had given Raskin.

The telegrams bore the general name Leopold Vindictive, not the names of the members, so they would not have provided enough information to catch the individuals involved straightaway. The mystery of the gap between the October 1941 arrests and those of May 1942 remained. A few details were revealed about the meeting with Thonus in April 1942, and the telegram he had been given asking for another pigeon was produced—the Germans had found that. But there was far less about the second Brussels group, with

which Raskin had actually become far more entangled; the Germans did not, for instance, know the real name of Devos. None of those arrested in May 1942 at Michelli's house—including Thonus and Van Hooff—were put on trial with Leopold Vindictive. There were limits to the Germans' knowledge. The telegrams—the ones given to both groups to send to London—were the most damning written evidence. They were the bitter legacy of the group's failure to establish a reliable channel to London.

The Germans had also managed to intercept a message Raskin had tried to send Joye soon after his arrest. "The very strong anti-German feeling by the accused Raskin is very prominent in a secret message to Joye. He tried to influence Joye to give false information to the officers of the German departments who were interrogating them," the German indictment reads.

The defense lawyer for Raskin and Arseen Debaillie was a sixty-four-year-old who received the indictment only a few days before the trial and was able to speak to his clients for just half an hour before it began, but Raskin still felt he was doing his best. After the accusation had been read aloud, the defendants had to leave and then return one by one. The judge asked them how they pleaded. If they did not plead guilty, he said he would give them a minute more to speak the truth.

Macq denied everything. Dufrasne said he had acted as a Belgian officer and done what such an officer had to do—his duty. Arseen said his brother, now deceased, had been the one responsible. (At this the judge laughed.) Joye suggested that some material had been passed to Raskin but it had all been destroyed and not sent anywhere. At four o'clock on the afternoon of the first day, the court broke up. Raskin's mood was dark. Only now, it seems, was the promise of release disappearing from view. The next day, the defense lawyers made their case—some saying the evidence was hearsay or lacking, or that the

men were former soldiers who were doing their duty. Only two offered up neither denials nor excuses, apologies or mitigating circumstances for their actions. They were Hélène Dufour and Raskin.

Dufour spoke in French of her pride in her country and her actions. Raskin spoke in German, the language of those who sought to judge him. His tone was confident and dignified. No official record remains of what he said; a German began noting it down but when he heard what was being said he stopped taking notes. Raskin was then silenced. "I will never forget his attitude in front of his judges," Macq later recalled. "He said he had done what he had to do as a Belgian. He took all responsibility for the group as its leader." Raskin said he felt no regret in the service he had given his country: "In conscience and before my God, I have done my duty." The judge responded harshly, describing him as an enemy of Germany.

There was plenty of evidence but no full confession from the central players. The chances that they would all be found innocent were slim. But they hoped one or two might be. And the penalty for those found guilty still lay in the balance. A prison sentence would only hold them until the day that was surely coming soon, when the Allies would fight their way to Germany. Under the cross in a convent dining room, they awaited their fate.

Deception

I N MAY 1943, a pigeon on Special Section duty returned to its loft in Oxfordshire. Home was not the suburban terrace of most working-class pigeon fanciers but a creeper-covered Victorian house on the village green in Tackley. The pigeon had originally been bred by a Barnsley fancier, but its home was now with Mary Manningham-Buller. Tending to a secret loft was not solely the province of men, nor even of the working class, although the sport had traditionally been a male-dominated environment. "I suspect that many a man found peace and quiet with his pigeons away from the woman's world of kitchen and scullery," wrote a member of the Osman family. But during the war, women often ended up looking after lofts and collecting messages if the men were away. In Manningham-Buller's case, her husband, Reginald, was elected to Parliament (he would become attorney general, while his daughter Eliza would later become the head of MI5). During the war Mary was largely alone in the picturesque village with her pigeons.

As well as the presence of the pigeons and a strange corporal, the neighbors may have wondered about the motorbikes roaring up to the house to collect messages. The same pigeon that arrived in May 1943 would make a number of journeys from behind enemy lines, a performance that would win it the Dickin Medal.

Manningham-Buller's pigeons—which returned from France twenty times—were particularly valued since some brought back news relevant to an urgent priority for British intelligence, the hunt for Germany's most advanced weapons.

It was one sign of Columba's shift of gears in the midwar period and its move toward a more focused role rather than the random appeals for information with which it had begun. The first attempt to target intelligence gathering had come in August 1942 when a batch of Columba pigeons was specially dispatched to establish enemy responses to the Dieppe raid. Allied troops, mainly Canadian, had been trying to probe German coastal defenses (the kind of attack on the Belgian coast for which Leopold Vindictive's maps would have provided invaluable assistance had they reached London). The losses proved terrible. News of the raid was brought back by a pigeon called Beach Comber, but MI14 and Columba had been tasked with gauging German reactions. A special questionnaire was drawn up to ask about the nature and extent of any damage, the effect on enemy morale and the effectiveness of a warning for locals broadcast on the BBC. "There was an extraordinary wave of hope on the day of Dieppe," one Columba return said.

In the wake of the Dieppe raid, a particularly lengthy message arrived from someone who signed themselves with the intriguing code name "The Father Christmas of Normandy." "Your disembarkation at Dieppe made the French people very happy," wrote Father Christmas on August 27. Truck drivers were told at gunpoint to transport reinforcements, but he explained that he and friends had managed to stop some troops being captured. There was plenty of useful information about German positions and listening posts, but also some interesting personal appeals. These included a request for a message to be sent over the BBC that a particular gendarme in the area would do well to lie awake and think of his future after the war ended. The author promised that

there was a "strong nucleus" of men ready for action who just needed support in terms of weapons and radios (as well as, ideally, some coffee, chocolate, canned food and cigarettes). If the material could be dropped, then a message should be sent out on the BBC saying: "Father Christmas of Normandy will see his children tonight."

Dieppe was the first of four occasions on which aircraft were specifically sent to carry out Columba pigeon drops. The other three specific missions were carried out in support of Operation Crossbow—the hunt for intelligence on V-1 and V-2 rockets.

By December 1942, messages tallying with earlier rumors started to reach R. V. Jones from human sources about the possibility that Germany was developing rockets to hit Britain. Finding out about these rockets became a top priority for Jones and his colleagues, who were desperate for information while the weapons were at the research stage and before they were put to deadly use. At first there was little more to go on, but from March 1943 transcripts were made of the conversations of captured German officers held in Britain. In a highly productive intelligence operation, the interrogation center in which the prisoners were held was bugged. This provided real gems, including a conversation between two generals about progress on the "rocket business." "They've got those huge things which they've brought up here," one said to another. "They've always said they would go fifteen kilometers into the stratosphere and then . . . You only aim at an area." Turf wars complicated the hunt, as Jones had to play second fiddle to a team led by the Conservative politician Edwin Duncan Sandys (who was married to Churchill's daughter).

The pigeons that returned to the loft in Mary Manningham-Buller's Oxfordshire garden in the summer of 1943 brought more details, supplied by an agent. Work was taking place at Peenemünde on the Baltic coast, where previous reports had already

suggested the rockets were being designed. The weapons had not yet struck at Britain but Jones and others knew they were being prepared. Finding any launch sites already constructed in western Europe was a priority. On Christmas Day in 1943, MI14(d) received a specific request from MI14(h) for "Crossbow: Pigeon Intelligence." They were told to organize drops at precise spots in northern France. Cherbourg and Pas-de-Calais had been identified by Jones as possible locations. The race was on to find what were called "ski sites," because the launch pads had been identified as looking like ski boards. The search involved both aerial reconnaissance and pigeons; indeed, these were the largest ever drops for Columba. Brian Melland sent over to Kleyn three specific drop points on the French coast to be passed on to the teams at Tempsford. The plan was to drop eight hundred birds in all. Two hundred pigeons were dropped from each Halifax bomber, which meant it took the dispatchers twenty minutes to release them all from the hatch. This, everyone knew, was risky for the crews.

R. V. Jones may have come to appreciate the role of pigeons, but his colleagues at MI6 were only just realizing the birds could carry back useful intelligence. MI6 gradually began to appreciate the value of pigeons carrying microfilms on which maps and drawings could be sent. Some of the most advanced work on this was carried out by the Middle East pigeon section in Palestine. But it was the Dutch section of MI6 that eventually made most use of the techʏique. "On one occasion a most valuable packet of microfilms of enemy operations was brought back at a critical moment by this means," MI6 noted. It was carried by a bird named Scotch Lass, trained at RAF Felixstowe, which was dropped with an agent in the Netherlands in 1944. Even though the bird was injured, hitting telegraph wires in the semidarkness when it was released at early dawn, it managed to carry back on

the same day—over a distance of 200 miles—thirty-eight micro-photographs "of the utmost value."

MI6 had finally cottoned on to the value of pigeons. But it was late to the game—too late for Joseph Raskin and Leopold Vindictive. Raskin had his microfilms of the German coastal defenses ready for a pigeon three years before Scotch Lass made her flight.

AS RASKIN AND his friends languished in prison, Columba was entering its final, critical phase preparing for the liberation of Europe. The Leopold Vindictive conspirators were waiting—hoping—that this might come in time to save them from whatever fate Nazi Germany had in store. At the very moment they awaited their trial, hundreds of extra Columba pigeons were being dropped in specific locations in northern France, suggesting invasion was imminent. The purpose, though, was not liberation but deception.

At 3:15 p.m. on July 9, 1943, a major "Pigeon Conference" was held in Room 254 of the War Office. Around the table sat representatives from the senior military commands, as well as Brian Melland from MI14. Brigadier Kirkman, deputy director of Military Intelligence, gave an overview of Columba. It was still proving its worth. "It is desired to state how highly this source is appreciated," GHQ Home Forces had written the previous month. "It will become increasingly valuable as the time for operations approaches. It is very much to be hoped that Columba's range and resources will be continually increased." German divisional movements and locations had been supplied, as had the sites of more of the radar stations that R. V. Jones was after. The RAF Special Duties Squadron had honed its dropping skills into a "fine art," and operations took place every month in an arc from Denmark in the north to Bordeaux in southern France. A "go slow"

policy had recently been pursued in order to build up a sufficient stock of birds—which now numbered fifteen thousand—and also to avoid making the enemy too "pigeon conscious" before the final push. Kleyn had written a detailed paper outlining the ways in which the Germans watched Columba. But was there now a way to take advantage of the enemy's pigeon-mindedness?

The Columba team had been aware from the start that their pigeons could be used to trap locals as their opponent became pigeon-minded. They had also heard that the Germans sometimes put their own pigeons in Columba baskets so that a pigeon would fly to a German loft with its message. One woman observed a fat German placing a basket in her garden. She subsequently took the pigeon out and attached to its leg a rude message to the Gestapo. "She was arrested," MI5 reported.

Sometimes the fear of planted German birds was enough to put locals off. At one point the returns from Columba in the Netherlands dropped to zero. The reason, the team learned, was that word had gone around the resistance that the pigeons falling from the sky were German rather than British. "How do they know that these pigeons actually fly to England? *We know better. They are German pigeons. Gestapo pigeons*," a clandestine Dutch newspaper reported on November 2, 1942. Reports claimed that pigeons that arrived asking for shelter for a British pilot, or connections with resistance organizations, or help for Jews were all from the Gestapo. This caused consternation at Columba HQ. The team had been enjoying a fair degree of success in the Netherlands. But in the six months following the newspaper article, there were no returns whatsoever. A report passed on from the French Secret Service in London likewise raised the concern that Gestapo pigeons were posing as British birds. A source said the pigeons were being dropped with a packet of English cigarettes to prove their authenticity and asked for the name of local patriots who could help

in the event of the imminent invasion by the Allies. The French resistance had developed a slogan to raise the alarm: *"Fumez les cigarettes—mangez les pigeons"* ("Smoke the cigarettes—eat the pigeons"). The MI14 team debated whether to advertise the differences between the real pigeons and the German impostors. But the fear was that a warning could confuse people. "It might result in the less intelligent leaving both kinds alone," Melland wrote, pointing out that asking people to avoid mentioning their locality would make nine out of ten messages useless.

MI14 had also understood that the Germans might be using pigeons to feed back false information to London as part of a deception operation—the type of operation they had run using radios and pigeons with the SOE agent Van Horen. An MI6 report from Chimay in Belgium on October 18, 1942, claimed that some Columba pigeons had been delivered to Germans, who sent them back with false information. From the very start, Melland had been skeptical about some of the returns. The fourteenth message received by the team came from a pigeon that had been dropped on May 13, 1941; but it took twenty-five days to come back, looking "fat and in good condition." The writer, near Cherbourg, asked to be put in touch with local agents and made a request to drop messages at a particular crossroads. MI14 deemed that suspicious.

By the following May, the Columba team thought it had seen half a dozen messages planted by Germans. One 1942 message actually came back written in German by two "old soldiers" and was described as having "contained only abjurations written in the purest Goebbelese."

Because a high number of birds were known to fall into enemy hands, MI14(d) decided to treat all messages as possible plants. Basic counterintelligence checks were carried out, looking for corroboration. The Germans typically added extraneous military detail that a civilian would not know. "They are apt to give too

much false information instead of inserting one important but false item between a lot of correct stuff which they do not mind our knowing or which they think we know already," it was noted. Typically, a German message would claim the sender was about to get some new, vital piece of information and needed to be put in touch with a local resistance agent. "Such requests are naturally suspect." But if the Germans had used Columba for deception, could London do the same?

At MI5, the tartan trouser–wearing T. A. Robertson (known as TAR) had been mulling over the possibilities of pigeon deception. Since many of the Columba pigeons were captured by the Germans, the service could be used as a feint. "It occurs to me that this is a possible means of putting deception over to the enemy by the careful framing of the questionnaires, as presumably the Germans must, if they capture some of these birds, take notice of the type of question which is being asked," he wrote to Major Petavel at the War Office on June 24.

Columba was being drawn into a new operation, known as Cockade. The decision had been made that an invasion of Europe could not take place until early in the summer of 1944. But, just as the Germans had tried to keep Britain on edge in 1941–42 regarding their plans, so now the favor would be returned. The idea of Cockade was to draw German forces away from Italy and the Eastern Front by feigning an attack on France and Norway in late 1943. This was to be accomplished using tools like commando raids and agents. Columba's role was to drop extra pigeons in very specific places. The original questionnaire had already been changed to ask not about preparations for an invasion of England but German preparations to defend Europe against Allied invasion. But with these new drops it would be tweaked again to focus on very specific areas, like coastal defenses and locations that might be suitable for the landing of airborne troops. The idea was that the

Germans would notice the different questions and the extra pigeons in certain locations, and this would make them think the Allies were preparing to land at those places in the near future.

In August 1943, the total number of pigeons to be dropped was increased from 750 to 1,000, the extra 250 being dropped in the area of Pas-de-Calais. The RAF teams at Tempsford were given unusually specific instructions to release the birds at a rate of thirty per village, down a particular road. Others from the existing allocation were dropped in Brest, which formed another part of the feint (as did Norway, where the possibility of employing Columba had been investigated, although it had been deemed too risky for the RAF to fly so far for it). This all had to be done carefully, Melland explained, to prevent it being too obvious.

But one intelligence officer raised a concern overlooked by others. What would the dropping of extra Columba pigeons mean for the villagers on the ground? Or for the patriots who picked up those birds? It would create additional anticipation of an invasion. That was unfortunate but not too serious. The much greater risk was that the Germans, if they saw more pigeons coming down and bought the idea that this was to generate more intelligence for an invasion, would increase their vigilance and hunt for members of the resistance in those places. That might lead to disaster for anyone brave enough to respond to the pigeons they found. Deception in this instance was not simply a clever wheeze but something that risked civilian lives. Ordinary people would potentially gather intelligence and risk their lives by sending it back when it was all simply part of a trick. Did the benefit of deception outweigh the risk to those finding pigeons in the areas where nothing was actually going to happen?

These were the moral choices of intelligence work. Only a few in London seemed to worry about such consequences, and there is no evidence that their concerns had any effect on the decision to

go ahead. But nor does it appear that Cockade itself had a significant effect on German thinking. There were some signs of German agitation and increased intelligence activity, but Cockade as a whole and the pigeon drops may simply have been too subtle for a German war machine that was now under increasing strain.

At MI5, Richard Walker came up with an even more complex deception operation as winter took hold. This one he called the "contamination plan." It was based on the knowledge that a stray or lost pigeon would find its way to a nearby loft rather than stay in the wild. His idea was that if some "second rate" British pigeons could be disguised by putting German rings on them and then released by plane over Europe, they would eventually find their way to German-controlled lofts. The pigeon might then be given to a German agent sent to Britain; the bird—back in its home country—would fly to a British loft instead of delivering the intelligence. But the more likely outcome was that the Germans would eventually spot that something was amiss, perhaps by seeing two pigeons with identical ring numbers. They would then realize that their pigeon stock had been contaminated by impostor British birds and wonder how many more of their birds were phony. The only thing they could do would be to recall all their birds, undermining their trust in their own pigeons. And by the time they had checked them and identified any fakes, Walker would have delivered more. It was a cunning plan, Guy Liddell agreed—the avian version of the double-cross.

The contamination plan might throw the Germans off balance at just the right time. But it needed plenty of assistance. Replacing the rings was the hard part, since they were put on when a pigeon was less than a week old and the claw was still flexible. Walker tracked down a Professor Briscoe, as well as two captains (Swann and Hope), to help. Briscoe discovered that the British Aluminium Company had developed a new type of solder, which had not

yet been patented but which they offered to MI5 so long as it was secret. The solder allowed the fabricators to make an invisible joint in the rings. Walker took the German pigeons that had been found on the east coast and used their Wehrmacht rings as the basis to make copies. The last challenge was to drop them. They must not materialize in a British container or parachute, so instead British parachute experts at Henlow came up with a special weighted burlap sack that could carry six or seven birds at a time. When it was pushed through the floor of an aircraft, the weight forced it down, and an elastic band fixed to the aircraft pulled the bag open and turned it upside down, depositing the poor pigeons into the air. In all, three hundred and fifty phony pigeons were released over Belgium and the Netherlands.

A Wehrmacht soldier who looked after pigeons was captured and interrogated later in the war. It was reported back to Guy Liddell at MI5 that one of Walker's "double-cross" pigeons had been picked up dead in Belgium or the Netherlands. The German said it was impossible to put a new ring on the bird without the soldering being spotted. This was excellent news for Walker and Liddell. "He is wrong of course because this is precisely what we have done." It meant the Germans were unaware of the possibility of deception. But in the end, "contamination," like Cockade, was a dud. When the German military officer in charge of the pigeon service was interrogated after the war, he said his lofts could never have been infiltrated since it was impossible to attach a new ring to a pigeon. No one had noticed the phony birds.

Along with all the deception, decoys and feints, plans for the real invasion—including the role of Columba in it—were now gathering pace. And that meant some new arrivals in the pigeon world.

17

———— ·•·•· ————

The Americans Are Coming

WHEN THE 2ND Platoon 280th Signal Company disembarked from USS *Audacious* on September 12, 1942, in Glasgow, "audacious" is probably not the word they would have chosen to reflect how they felt. Their pigeons, which had been brought from America, were in a sorry state from the long journey. About a fifth were sick with colds, "rattles" and lameness. And it did not help that some of the company's specialist equipment had been mistakenly shipped to Iceland. The officer who greeted the platoon informed the men they would have to wait a month in a Glasgow transit camp while their birds were quarantined before finally heading south.

Eventually the men and their bedraggled birds made it to Tidworth. The company was headed by two leading pigeon officers, Lieutenant Thomas H. Spencer, previously a partner in a lumber business from North Carolina; and Lieutenant Irwin F. Salz, a New Yorker and a long-time member of the Sandy Hook pigeon racing company. In Tidworth they settled down to work with the British Army Pigeon Service, sharing birds and advice on an experimental basis. The young American birds struggled at first with the British climate even though they, like the troops, looked stronger thanks to a better diet. "The dampness of the

English climate seemed to cause an undue amount of respiratory troubles in the American pigeons," it was noted. But the American pigeons—like some of their soldiers—soon began cross-breeding with the local population, often quite successfully. The goal was to take the birds into Europe.

America had a pedigree when it came to pigeons. When the U.S. military arrived in Europe during the First World War, it had quickly seen their value and had established its own service in 1917. This began with two officers and twelve men, but by the end of that war more than 330 men were involved. British owners gave 600 young pigeons to the U.S. Army in addition to 10,000 purchased from American fanciers. During the interwar period, homing pigeons found a use with bootleggers during Prohibition as the carriers of messages between ships and land. By 1938, the U.S. Army had built twenty new lofts for a breeding and training center at Fort Monmouth, New Jersey, and in June 1941 the 280th Signal Pigeon Company—out of which other units would be hived off—was organized. A month after Pearl Harbor in December 1941, things really moved up a gear when the War Department made a call to the American fancy for help. It asked for champion racing pigeons that had flown two hundred miles to be loaned, gifted or bought at the price of five dollars apiece. Support flooded in from American owners, who donated thousands of birds and volunteered to work in the Signal Corps. Around 40,000 birds from domestic fanciers were shipped out to tactical units in the field. U.S. Army pigeons were incorporated into twelve special signal pigeon companies, each of which had three combat platoons using 1,500 pigeons apiece. At its peak, the U.S. pigeon corps had 3,000 men, 150 officers and 54,000 pigeons. "Cheer up, Men, Birds May Also Be Drafted," read one newspaper report. There were even the same fears of German pigeon spies as those that haunted Britain's MI5. In January 1941,

America's top code breakers were asked for their help in dealing with an exhausted carrier pigeon found on Long Island carrying a message with some kind of coded coordinates and emblazoned with a Nazi swastika.

America's pigeons soon saw action. A "North African Pigeon Platoon" arrived in Casablanca in November 1942 and moved to the front, where pigeons were trained to home to a Tunisian loft. Their value was apparent when radio silence was required or to convey requests for ammunition and supply, as well as to carry important or secret messages. On March 17, 1943, a pigeon named Yank brought in the first news of the American advance on Gafsa, Tunisia. In early April, during the battle of El Guettar, four messages were carried by a single bird. Two of those were from General Patton, marked secret and urgent.

The North Africa–based pigeon unit moved on to Italy after the invasion of that country began in September 1943. Pigeons were given to partisans around Bologna and as far north as Modena. They would sew birds into their coat pockets or use a special jacket devised by the Americans. The birds could then carry back messages and maps regarding gun positions and troop movements. They were also used when troops were physically so close to the enemy that using a radio would have risked them being overheard or spotted.

Units isolated in mountainous terrain in Italy found pigeons invaluable. One patrol deep in enemy territory, under heavy fire and running out of food, blankets and medical supplies for its wounded, sent back an urgent request for help by pigeon, which led to a parachute drop of supplies within a few hours. American pigeons even saved British lives in Italy. The U.S. 56th Infantry Division was trying to break the German lines at the heavily fortified village of Colvi Vecchia on the morning of October 18, 1943. Bombers were called in to help. What the Americans did not

know was that earlier that morning the Germans had retreated and the British 169th Infantry Brigade had moved into the village. Attempts to cancel the bombings by sending radio messages failed. The only hope was six-month-old G.I. Joe, who had been hatched in Algeria. He flew twenty miles from the 10th Corps HQ in twenty minutes and arrived as the planes were preparing to take off to bomb the village. If he had arrived five minutes later, a hundred British soldiers might have been killed, as well as civilians. G.I. Joe would be the first non-British bird to be awarded the Dickin Medal for gallantry by animals, an honor he enjoyed until 1961, when he died at the ripe old pigeon age of eighteen.

The Office of Strategic Services (OSS)—the forerunner of the Central Intelligence Agency, or CIA—also found pigeons "very beneficial," dropping them with teams behind enemy lines in Europe and with agents in Asia. The United States developed a strange-looking contraption called the pigeon bra, which made it easier for agents to carry the birds on their person. In the fight for Papua New Guinea, U.S. marines sent a patrol to the village of Drabito. The patrol's radio was damaged during a firefight, so they released two pigeons to warn headquarters of a Japanese counterattack. These pigeons were shot down by the Japanese. One pigeon was left, trained by the 7th Australian pigeon section but attached to the U.S. 6th Army. It was released during a short lull in the fighting and came under heavy fire straightaway, but it covered the thirty miles back in forty-six minutes. The Japanese positions were then bombed and the patrol saved.

Some of the most impressive OSS results came in Burma. A four-month-old pigeon named Jungle Joe was parachuted behind enemy lines to Allied scouts gathering intelligence on nearby Japanese troop and gun positions. He was their only means of communication, and he flew back some 225 miles through bad weather and over steep mountains with his information, which

was said to have helped capture what was described as a large chunk of Burma. Another team from the OSS and Office of Naval Intelligence took thirty birds on an epic journey by rail, ship and air from Florida to China so they could train Chinese guerrillas in the event of a possible invasion of the Chinese coast.

The war was global, and so was the deployment of pigeons. Britain's pigeon service extended across the Mediterranean, the Middle East and West Africa from Alexandria to Bahrain, the Seychelles to Dar es Salaam. The Middle East Pigeon Service, with its headquarters at Cairo, carried out operations from Turkey through Syria to Lebanon and down to Jerusalem. The Indian Pigeon Service had operated in the North West Frontier Province in the 1930s. British pigeons sent there as reinforcements must have been bewildered by the change of climate, but they worked successfully behind enemy lines in Burma.

In Europe, the Americans were integrated into pigeon services from late 1943. The United States had already been in on the secret of the Columba operation. In August 1942, the Americans had actually looked at developing their own version of Columba. After discussions with Rex Pearson, the Office of War Information created a mock-up of an American questionnaire. What is noticeable about the American version is that it featured pictures—small cartoons of marching soldiers, ships and gun emplacements—to illustrate the kinds of information people should send back. There was also a focus on which American radio broadcasts could be heard in Europe. But now that they had arrived, the Americans were to be part of Columba itself. Once they had settled after their long journey, Lieutenants Spencer and Salz and the other pigeoneers from 280th Company were assigned Columba lofts for their use. Their mission was to prepare for D-Day. Spencer worked on plans for pigeons to be used for gathering intelligence from behind enemy lines and as a means

of contact for advancing Allied forces when the use of radios was not possible.

Early in December 1943, Bert Woodman in Plymouth received orders to report to Wing House one Saturday morning. His pigeons had been shifted from RAF rescue duty to Special Section work on Columba, and there was a show and lunch that day for fanciers who were contributing pigeons to the war effort. Woodman was met by Lieutenant Colonel Montgomery, who ran army pigeon operations including Special Section. He explained that Woodman was going to be introduced to an American officer. "You will say nothing to anyone," Montgomery told Woodman, specifically saying this meant Rayner at the Air Ministry.

Having agreed, Woodman headed off in the colonel's small van that wintry morning to a Holborn restaurant. In the Venetian room, the fanciers ate a rather tasty Viennese steak. The Special Section officers explained to them that more pigeons would be needed in the coming months. In the drill hall at Buckingham Gate, the fanciers then toured an exhibition of a thousand pigeons. As Woodman was walking around, he was introduced to a young American army officer. "Bert, meet Lieutenant Irwin Salz of the United States Army 280th Pigeon Company," he was told. "Take the lieutenant outside, find a pub and buy him a drink, he has something to ask you."

Neither of them was a local, but eventually they found a pub. Salz explained that he had been sent to ask Bert if he would help supply the Americans with a pigeon service for the return to Europe. Bert quietly answered yes, and the New York and the Plymouth fancier shook hands. A special relationship had been born in the pub.

Just after Christmas, a U.S. staff sergeant arrived by jeep at Woodman's Plymouth Pigeon Supply Group headquarters at 18 Cecil Street, to collect pigeons for Exercise Duck, designed to

test how quickly messages could be distributed after the birds' arrival at a local loft. Woodman and his colleagues showed the American around the locality and its lofts as they sketched out their locations on a big sheet of greaseproof paper spread out on his floor. By February 1944, Lieutenants Spencer and Salz were among the few indoctrinated into the plans for the invasion in Normandy, so that they could work on pigeon communications. They began training birds from Plymouth lofts by tossing them first from the coast and then from U.S. Navy ships in the Channel as far as twenty miles offshore. Some days they were taken out on landing craft, and guns would be fired to simulate the conditions they might expect to meet.

There had been the inevitable battle between the army and the RAF once Rayner at the Air Ministry eventually learned of the plans. Rayner even proposed a test to prove his RAF birds would perform better over longer distances. But in the end, the U.S. First Army was largely supplied by Columba's civilian lofts in Portsmouth and Plymouth, which were well used to cross-Channel work. In all, British pigeon fanciers supplied 46,532 birds to the Americans during the war.

AS THE ALLIED armies gathered for the decisive moment, Columba continued to collect intelligence to prepare the way. Nearly four and a half thousand birds were dropped in the first six months of 1944 from the thousand lofts supplying them. A total of 202 messages made it back despite some terrible weather. The priority lists stating where Columba pigeons should be dropped were now provided by SHAEF, the Supreme Headquarters Allied Expeditionary Force (which also now coordinated SOE). The importance of up-to-date intelligence had never been greater. "It is considered essential to approach the question of Columba targets entirely afresh at this critical stage. Now if ever is the time for the

old lady to show her paces," the team wrote on May 26. A set of priority targets was drawn up, consisting of inland areas of France and Belgium, which were to be covered by a far greater concentration of birds.

The intelligence the pigeons brought back was richer than at Columba's inception three years earlier, and it was filled with the useful minutiae that only a local could provide. A small tunnel in one place was full of mines. A train filled with ammunition passed through a specific station at the same time every day. Mines had been placed in a particular harbor. Information on the German order of battle was especially prized, pointing as it did to the movement of armor belonging to 1st Panzer Korps from Belgium to the Beauvais area.

There were frequent comments on the fragility of German morale. One writer noted that many Germans possessed civilian clothes, which they intended to put on as soon as the Allies arrived. There were now more details of collaborators and a renewed push to go after them; the information was sent to Rear Echelon SHAEF "at their special request." At Sequedin, near Lille, a certain grocer was said to be an informer of the Gestapo, who entertained the officers at his home. Meanwhile at La Basse, on the Rue de Lille, a certain woman was said to be a tenant of a small restaurant reserved for the Germans who denounced patriots to the Gestapo. "It would be a good thing to warn the inhabitants of these localities over the radio," the message writer said.

The intelligence had become more detailed in part because more people were now more willing and able to help. Resistance had evolved since the summer of 1941 from the small, amateurish groups of friends like Leopold Vindictive. Birds were now falling into the hands of organized and semi-organized resistance groups that were growing in number, strength and confidence. In France, the Maquis operated in the countryside—young, armed men in

hiding who carried out sabotage and prepared for war. The messages were now much longer and more precise in terms of intelligence. They show a far greater understanding of the value of tactical military intelligence than the early crop.

At MI5, the priority was to keep Allied plans for D-Day secret from any German spies in Britain. As a result, catching enemy pigeons mattered more than ever. The needs of espionage and counterespionage collided around the cliffs of Britain. The falconry unit—with its hawks trained to go after German pigeons carrying secrets—could cover only a few miles of coastline, but the desire was to expand operations to stop enemy birds. The original plan was to put the unit into action around Colchester, but the hawks' abysmal failure to tell the difference between friend and foe led to concerns that friendly pigeons—including those from SOE, MI6 and Columba, as well as those the army was planning to use for D-Day—would be more likely than Nazi spy pigeons to fall victim to their talons. The plan was blocked. So Richard Walker at MI5 cooked up another idea.

Homing pigeons are dedicated but sociable creatures. If they spot a flock of friendly pigeons, they will often decide to hang out with them in the hope of food or rest. Not long before D-Day, all the fanciers living within ten miles of the coast, from Cornwall to Norfolk, were approached through the NPS and asked to come to a local meeting. Walker turned up and asked them to assist in a scheme to lure into their lofts any single enemy birds that might be flying out of Britain. They were asked to arrange the times at which they let their birds out for their daily flight so that there were always pigeons in the air to attract exhausted enemy birds. This "screen" of friendly birds was the pigeon equivalent of the chaff of R. V. Jones's Window operation, so effective at confusing German radar. However, no enemy birds were caught, as there were no active German agents sending back information. "Had

they done so it is fairly certain that the loft screen would have bagged a fair proportion of them," explained Walker, ever the optimist about his plans.

The Germans also began to prepare on the pigeon front for an Allied invasion. On March 1, the military commander for Belgium and northern France decreed that it would be forbidden to keep pigeons in a number of districts. The rings of all pigeons killed had to be surrendered as confirmation. Forty-five thousand pigeons were moved from coastal towns to Brussels to prevent their use by the enemy. There had been some hopes in Britain that the Germans might leave existing pigeon lofts intact, but it was now clear that a stock of young English birds would have to be brought over.

As D-Day approached, the weather was bad. Cold winds, heavy rain and poor visibility made it hard for the RAF Special Duties team to drop Columba birds. Seven aircraft were lost on the nine operational nights that month (all but two before D-Day itself). On the night of June 5, the BBC crackled with *messages personnels* instructing agents to carry out special sabotage operations against railways and other targets. Bert Woodman took a walk on the promenade in Plymouth with his wife that evening. Out on Plymouth Sound, he could see row after row of invasion craft, arrayed in straight lines like a company of soldiers, with a cloud of barrage balloons hovering above them.

On June 6, Allied troops landed on the heavily fortified Normandy beaches under unimaginably ferocious and brutal bombardment. Amid the gunfire and the chaos and the blood, pigeons flew free above the men's heads back over the Channel to bear news of the unfolding events. The pigeons had been issued from Portsmouth and Plymouth to formations in marshaling areas just before they embarked for France.

In Britain, the fanciers waited by their lofts. The wind was picking up to a gale, and no one was sure a single bird would get

through. Gustav was the first pigeon to arrive back, in five and a quarter hours. He carried a message from a Reuters correspondent dispatched from the beach as the first landings took place. (Gustav later died when someone cleaning his loft accidentally stepped on him.) Paddy, bred in Northern Ireland, was the fastest pigeon—flying 230 miles in four hours and fifty minutes. In Plymouth, alarm bells began to ring as pigeons returned to their lofts and American jeeps raced to collect the cylinders.

Not all the arrivals bore messages. Some of the saddest pigeons that returned to Plymouth were covered in human blood. Their handlers had been carrying pigeon drum containers when they landed. They had been struck by gunfire that had ripped through the drums, freeing the birds to fly home but leaving the men who had carried the pigeons to die on the beaches.

The U.S. First Army used hundreds of birds on D-Day, about half of whom made it back. These carried ammunition status reports and emergency messages. In the end, radios worked reasonably well on the day of the invasion, so the need for pigeons was not quite so great as anticipated. As well as messages from troops, a select group of elite birds had been trained to wear a harness that could carry a container of 35mm film. But these never returned with their historic cargo. The combination of the weight of the container, the hostile conditions and rough handling meant they flew inland to perch and rest rather than heading home, and so went straight into the German lines, where they were shot down or captured.

Many of the pigeons that made it back from D-Day were more exhausted than they should have been. The Army Pigeon Service surmised that this was because they did not take the straightest route. Due to the smoke and noise of battle, rather than fly in a straight line for 125 miles, they took a more circuitous route up the French coast to Dunkirk and then across the Channel before

homing, tripling the distance. Afterward, the APS and Rayner of the RAF inevitably battled as to whose birds had been more effective and disputed details in each other's reports.

The Special Air Service (SAS), established as a commando unit earlier in the war, proved avid pigeon users, taking 330 birds from army lofts around D-Day. Around one in twelve of the birds they were given had already flown Columba missions. One bird sent with SAS troops on June 7, 1944, returned from near the Swiss border on June 29 after spending twenty days in a small container. Long confinement was one reason many birds did not make it home. Another problem for the SAS was that their need for security meant they could not tell loft owners where they were going, so they could not pick the most suitable birds for the mission.

The American pigeoneers slowly accompanied their troops into Europe through shattered French villages, past the wreckage of planes and vehicles and dead horses. The friendly offer of cider and Calvados eased their path. In combat, their pigeons had to fly through heavy fire, still having to evade hawks, sometimes dazed and suffering shell shock. The bond between men and birds remained strong: American soldiers' reports tell of the sadness when disease meant hundreds of pigeons had to be destroyed, or of their pride when a bird was awarded his own "purple heart" for returning back wounded to one of their mobile lofts (which were usually tugged around by a jeep).

The news from the front was not always good. The first word of landings by the 1st British Airborne at Arnhem in September came from pigeons. They reported that the British paratroopers held the northern end of Arnhem Bridge and were waiting for the 2nd Army to arrive to support them. But the reinforcements were delayed and German resistance was much heavier than they expected. On September 19 at ten thirty in the morning, a pigeon named William of Orange was released to fly from Arnhem to

London. Traveling 260 miles, 135 of them over sea, in a speedy four hours and twenty-five minutes, it carried a message that the situation in Arnhem was desperate. The troops urgently needed resupply. Thanks to the pigeon's message, an effort was made to do just that. The aircraft had to take off from the Midlands, as the south was covered in a blanket of fog. By the time it arrived, the drop site to which it sent the supplies was in the hands of the Germans. By the next day things were even worse; the British troops were nearly out of food and ammunition and under heavy fire. Eventually they would have to withdraw from what had indeed been a bridge too far.

As the Allies began to push through France, messages flooded in to Columba as if a dam had burst. Extra drops were organized behind enemy lines to gather intelligence, and people were now willing to take more risks. "We await you impatiently and hope to see you soon to get rid of the dirty Boches who have poisoned our country for four years now," wrote a pair of twenty-two-year-old Frenchmen who signed themselves Lulu and Riri and riskily identified the small locality thirty miles from Chartres where they lived. "Come and liberate us soon and bring cigarettes, tea, sweets, etc. Kick the Boches out of here," read another message. Some, excited by D-Day, started to fight too soon and would die as the German grip took longer to loosen than they had anticipated. Columba carried messages that described members of the resistance being killed and one girl being tied to a wheelbarrow and beaten for having a radio transmission set.

The French resistance shifted from sabotage to more organized warfare. They provided updates through Columba on supplies sent by parachute, with references to which containers were the most useful—they said they now needed less explosives and more equipment that would be useful for guerrilla warfare, rather than the sabotage of the past. They also pleaded for battery-powered radio

sets to be used in the field and even for bicycle tires for messengers, since this was the only means of getting around. One group said a German motor car had been fired on by the resistance, killing a colonel and wounding a general. In reprisal, the Germans hanged eleven young people whose bodies were left exposed for days in the streets of Carhaix. A pigeon with a message from Julien and Jacques dated July 4, 1944, provided detailed intelligence. "Do not worry, dear Allies. We have been standing firm for 4 years now and we know all the defeatists, collaborators and especially the turncoats. We shake you by the hand. Together we shall win." It warned that one group of Maquis had been discovered by the enemy; thirteen were killed, despite an "energetic defense." They also warned: "Your supplies by parachute on the night of 29th–30th June fell into the hands of the enemy."

One of the more startling messages came on July 13 from an organized resistance group in Brittany who wrongly thought they were being deceived. "As we suspect that this is a German pigeon, we are sending you some news which you will find interesting," the group wrote, explaining that they were now well supplied by the Allies and were making preparations to "teach you the lesson which you deserve." They claimed that there were deserters from a German army that consisted mainly of teenagers. "In the end you will pay your debts to the prisoners, the families you have shot and those you have tortured." It offered a warning as well to the Germans. "For us, as from today, 10 Boches for one Frenchman, Suffering for suffering, an eye for an eye, a tooth for a tooth. Remember that we FFI [the French Forces of the Interior, as de Gaulle christened the resistance] will go and occupy Germany and make you pay. Already we have done in many Boches and know that we have the arms we need you will learn very shortly." It was signed Marag—a chief of section of a group of Bretons—and ended with the phrase "*Mort aux Boches.*"

This message was noted to be sent to MI6, no doubt interested in who this highly motivated group of partisans might be.

Out of the blue, the Columba team at MI14 received a letter from their old colleague Rex Pearson soon after D-Day. He had not given up. On June 16, Pearson wrote a personal letter to Brian Melland from the BBC, where he was still working. "Forgive me for being so importunate—I think that's the right word," he began. "This is a chance of a lifetime and more and if you can get me sent over I'll guarantee good results within eight weeks." His suggestion was to avoid the Channel crossing by having pigeons return with messages to a base in Normandy. They could be delivered by plane or even, he suggested, by balloon, as he had done in the First World War, as this would provide independence from the RAF. The rates of return for Columba would be improved enormously, he was sure. "Will you have lunch with me on Monday or Tuesday," he ended pleadingly. Melland replied on June 19 with thanks and explained that the idea of using Normandy as a base was already being discussed. "I'm afraid I'm booked for lunch tomorrow Tuesday, but may I give you a ring when the position is firmer?" he wrote.

Pearson was no longer in the loop and so could not know that the idea of basing Columba in France had indeed already been looked at. The plan had been to open a base in France in August so flights could start in October. But that proved difficult because of the initially uneven rate of the Allied advance, followed by a rapid German retreat once the Allies broke out of Normandy. Instead, Columba continued to operate out of Britain, with Kleyn sending lists of priority areas to match the locations where the Allies were preparing to fight their way through.

A WEEK AFTER D-Day, residents of Britain heard a new, terrifying sound: the buzz of an engine overhead that suddenly spluttered out. Next came silence. Then an explosion. In response to

the arrival of the Allies on the Normandy beaches, the Germans first unleashed their V-1; one of the earliest just missed MI6 HQ at Broadway. A few months later came the V-2 rockets. In London, Churchill grew deeply concerned about the possible impact. Did the city need to be evacuated?

Columba offered help in minimizing the deadly toll of the rockets. The challenge was to find their launch pads. In July, eighty-nine returning Columba messages gave information that helped identify ten flying bomb emplacements. One message lists two "flying torpedo" emplacements in their area, another lists four. As with night-fighter radar, the strangeness of the new tecŸology made the launch sites distinctive enough to be spotted by locals.

The Columba returns helped provide targets for the RAF and American bombers to strike as they desperately sought to stem the tide of rockets. At the start of August, a message from Tôtes in Normandy from a local Frenchman who signed himself Le Favue provided some of the richest information. He detailed targets for railway lines used by the Germans but also specified emplacements for what the author called "robots," with their runways in the sports grounds of a college.

Tôtes was one of the sites targeted by Allied planes as the location of German V-1 positions, and as the French writer then explained, there was an addendum in English from "your captain" and some of his colleagues who "reached us from the sky." The crashed airmen—from the Royal Australian and Canadian Air Forces as well as the U.S. Air Force—went on to use the pigeon message to pass on their own detailed wealth of intelligence about German anti-aircraft positions and infantry movements as well as V-1 sites, knowing enough to explain what type of catapult was being used for takeoff. They explained how Germans had originally said London would be "kaput" in ninety-six hours after the launches began but after a week recognized that many

were failing. They also explained that the V-1 flying bombs were proving only partially successful. Of the first four fired from one position, two fell within two hundred yards and another not much farther off. Only one successful shot per installation per day seemed to be the average.

The airmen even critiqued their own side's bombing tactics:

> The use of heavy bombers at high levels on "No Ball" [V-1 launch sites] and other pin-point targets is to be deplored as they very, very seldom hit any military targets, but do a great deal of damage to French property and make many enemies. As instance on the afternoon of 14th July, many Lancs. [Lancaster bombers] came over and bombed above cloud. The markers went down near the little factory but the heavies let go up to five miles off and bombs fell uselessly in the fields and villages and caused much damage. I saw at least ten sticks fall that did no military good whatever . . . On the roads, the fighters are hitting a lot of French civilian traffic, but are doing good work keeping the Hun quiet.

The team went on to ask for more pigeons to be dropped in specified nearby fields where locals would be helpful. "We are told to wait here for 'Monty,'" the message concluded, a reference to General Montgomery, then pushing through France.

The bleakest messages are those that detail civilian casualties from Allied bombing raids. "I would ask you, my friends," wrote a French farmer who found the pigeon in his beet-root field in Mayenne, "to warn the population a few minutes before the bombing because you kill many civilians who are your friends. Very few Germans get killed. It is nearly always the civilians who suffer from your aircraft. If you circle before dropping your bombs, the population would have time to withdraw from the town, thus avoiding many French victims. You must spare your friends and

kill the Germans." The farmer ended with a plea for liberation as soon as possible, since all his friends had been taken by the Gestapo. "Please send us arms, rifles, revolvers and ammunition by parachute," he wrote, signing himself Jean du Coin Larue. Numerous messages contained pleas to respect the white flags that civilians sometimes flew (despite the risk of a fine), since they were being hit.

Others too warned of the dangers of Allied aircraft hitting civilian targets. In some messages, anger comes through. "Aviators should be very, very, very careful," one author who called himself the Refugee Boar from Parthenay, Deux-Sèvres, wrote in a long message in July 1944, explaining how four fighter bombers targeting a viaduct failed to hit it or kill a single German but did kill a mother of four children. The author provided extensive details of which bombing raids over the previous two months had missed and instead killed civilians. A dairy truck had been hit, and soon afterward a father of seven was killed by fire from an aircraft. "The military results obtained have not warranted the losses and destruction suffered by the French population. Among those who are wildly anti-Boches many complain bitterly of poorly aimed Allied attacks." The writer provided detailed suggestions on how to be more effective—for instance, that trains should be attacked between stations and from the side, so the driver and his fireman (who were always French) were not hit. One message from the Netherlands said, "I implore you not to shoot on trains and vehicles with innocent people. Last week about 250 people were killed or wounded in Holland. You cannot call this fair play and the war cannot be won that way. It is not an act of heroism to shoot on trains with civilians by low-flying aircraft."

In Belgium, Joseph Raskin's family witnessed the power of Allied bombs. On the morning of May 9, the air raid siren sounded in the town of Aarschot where they lived. Heavy bombers flew

over the town but no bombs fell. But two and a half hours later, more U.S. Air Force planes came, and this time they targeted the town's important railway station and depot, close to the Raskin family house. Buildings were reduced to rubble and fires raged. The bridges over the river were destroyed.

As troops moved through Europe, the worry for Allied pigeon experts was increasingly about the presence of enemy pigeons, and about the Germans developing their own version of Columba. An observant military policeman at the harbor of Le Havre spotted birds flying suspiciously away from a hillside not long after it had been captured. A search party was sent and found a camouflaged tunnel entrance. Inside was a team of Germans who had been spying on Allied shipping in the harbor below and releasing the details via pigeon to maintain radio silence. The Germans also enlisted other locals and pigeons to spy in stay-behind networks.

André, a thirty-three-year-old Belgian hotel proprietor from near Ostend, had returned in March from sick leave after being forced to work on the Russian front. In a café, he fell into conversation with a man who said there might be a way for him to avoid going back to the front. All André had to do was work for the man by sending messages via pigeon. A few days later he was given pigeons and forms and told to practice, using the cover name Sabot. His job was to provide details of Allied troop movements if they arrived in the town. André had been recruited into the German "stay-behind" pigeon network.

Intelligence had reached Allied command in late 1944 giving precise details of how the Germans had established these networks to provide intelligence or help organize resistance in Belgium, France, the Netherlands and Germany itself as the Wehrmacht was pushed back. Captured enemy agents said there were twice as many agents using pigeons as there were those using radio

sets. In a mirror image of Columba, they had been given instructions to supply details of Allied troop movements by means of pigeons that would fly back to German-controlled lofts. In Belgium the agents were located mainly near the coast. Some, Richard Walker of MI5 explained in a note, operated clandestinely out of houses with birds hidden in attics, while others used birds from larger military-run lofts such as one in Brussels. "Personally, I consider this constitutes a very real danger," T. A. Robertson at MI5 wrote as he forwarded the paper to Dick White, the intelligence liaison for SHAEF (and a future head of MI5 and MI6). Troops were ordered to report any lofts they found and to wait for the Army Pigeon Signal Company to come and literally clip the birds' wings so they could not carry messages. Riflemen were sometimes ordered to shoot down any birds suspected of carrying messages. Detailed interrogation questionnaires were drawn up for any captured Germans who might have knowledge of pigeon activities.

Captain G. F. Swann was in charge of pigeon counterespionage for the 21st Army Group and found evidence to support Robertson's fears as the troops advanced. This included a coded message from an agent who had since been captured, which his interrogators used in questioning him as they tried to gain useful intelligence on the cipher system German intelligence was using to encode their messages. Details were sent back to MI5, and Walker tried to crack the codes of the various messages received.

André the hotel owner was arrested the day Canadian troops entered his town—local patriots had suspected him all along. He tried to bluff his way out by claiming he was working for the Allied underground movement, but a message from an agent working with him was found on the roof of a building in Ostend. Similarly, Bertrand, an agent in Yquelon in France, was given four thousand francs a month to release pigeons, but at the first

sign of an American tank he got on his bicycle and made off. He was later arrested in Paris. Pigeons were used extensively by the German army before D-Day, but in practice they found it harder to keep using them afterward, so rapidly were they forced to retreat.

As the Allies prepared to make the final push into Germany, intelligence mounted relating to extensive pigeon preparations by the enemy in their homeland. Orders were given to Allied units that one of their first missions on entering German towns was to identify pigeon fanciers and their lofts and then interrogate them. SHAEF even made plans to bomb a particular German loft thought to be supplying Nazi networks.

Allied forces had entered Belgium at the start of September 1944. For the second time, the towns of Belgium felt the full force of war, but now the Germans were retreating rather than advancing. Hitler counterattacked in the Ardennes in December, and it would not be until February that the whole of the country was liberated, but the pace of the Allied advance in the early days surprised even those who were part of it. "Every time we halted, we had fruit and wine showered on us. We looked like flying greengrocer's shops," one British soldier remembered. Joseph Raskin's brothers and sisters and their children watched the Allies pass out chocolate as they made their way through. Crowds lined the streets to welcome the troops with cheers and V for Victory signs. Flags and banners were retrieved from cellars to be flown from houses.

The Germans fell back from Brussels quickly, and by September 3 the Allied convoys were struggling to get through the crowds that thronged the street to welcome them. The cafés blazed with light that night. Champagne stored by the Germans in the cellars of the Palace of Justice was brought out. Brussels "fairly swam in wine," soldiers recalled.

There was a bitter harvest in the following days. Wives and mothers in Brussels had to be restrained from taking out their fury on captured Germans. Some Belgian men grabbed weapons and went hunting for Nazis and collaborators.

That included the men who had betrayed Leopold Vindictive. Pieren, the brother-in-law of Dehennin, is thought to have been shot in Brussels on the day of liberation. Leduc, the man who had arrived at the mission house of Scheut to facilitate Raskin's arrest, was reported to have been killed by the resistance near Lille, although there were later reports that this was a case of mistaken identity and that he might still be at large.

Major Page from MI6 and Lepage from the Belgian Sûreté landed in Arromanches in Normandy on September 11 and arrived in Brussels two days later. In the Hotel Metropole, Page continued his work gathering intelligence, his primary targets being the identification of V-2 weapons sites and an effort to run agents into Germany. Hardy Amies headed to liberated Brussels to work with the Sûreté running agents into Germany and got himself into typically Amies-style trouble. As an old friend of the editor of *Vogue* magazine, while in Brussels he helped one of the magazine's star writers with a story on female members of the Belgian resistance. Amies took the writer—Lee Miller, a muse to Man Ray in Paris and herself the subject of investigation by MI5—to meet the "baby-faced" Countess Thérèse.

The countess had carried millions of francs in her handbag for arms, bribery and sabotage, the journalist's resulting copy read breathlessly. Miller recounted in the story how Amies offered to take her to "a reception." Fearing it would be a boring "handshaking" event, the *Vogue* writer was delighted to find that it actually involved acting as the reception committee in a field for a parachute drop containing weapons. By the time the military got on to the matter, most of Miller's article—including pictures of

Amies, described as a "famous couturier"—had already gone to the printers. As an investigating officer noted, it seemed extraordinary "that a serving officer should lend his secret service background in the interests of his private affairs" through a "gaudy publicity stunt" that "will cause a flutter in many feminine hearts when they realize that their handsome couturier is, after all, the 'Scarlet Pimpernel' of this war." The editor reluctantly agreed to delete a "spicy titbit" about Amies's work for SOE.

Pigeons were among the spoils of war that soldiers were given explicit instructions to seize. As they pushed into Belgium, the Americans were ordered to commandeer German lofts. The 282nd Signal Pigeon Company established its headquarters in Verviers on September 12 and captured from the Germans over a thousand birds, who were then trained for the Americans' own use. Just as crack teams were sent to capture Nazi scientists, so there was a concerted effort to capture the best German pigeons to harness their skills. The 285th Signal Pigeon Company managed to commandeer one of the most famous German racing pigeons, a bird named Meister, who was then made a "naturalized American" so he could be used for breeding.

When one German headquarters building in Belgium was seized, Allied soldiers made a surprising find. In the adjoining loft buildings and storage rooms were a huge number of containers from Columba. And in the lofts were birds with British rings dating from 1940 and 1941. These seem to have been local birds who had British rings resoldered onto them in an attempt to trap locals who thought they were using Columba since the birds would fly to German lofts. This was final proof of just how pigeon-minded the Germans had become. They had taken the threat of Columba seriously enough to try to organize their own large-scale deception operations.

In April 1945, Britain's own deception expert, Richard Walker

from MI5, went to Brussels and Paris to work with the security services of liberated countries on pigeon spies. This included sharing details of "double-cross pigeon agents" and of how to enlist civilian fanciers to spot enemy birds, as well as the tecŸique of using a screen of friendly birds to draw enemy pigeons away from their destination. He even offered the use of the MI5 falcon team to the French, who were worried about pro-Vichy groups who had gone into hiding in remote areas and might be communicating by means of pigeons. In Brussels, he found that pigeon fanciers were desperate to resume their sport, and their 350,000 members formed an impressive political lobby that pressed for the ban to be lifted. The war was nearly over and they wanted things to get back to normal.

By then, Columba had done its work. The operation had been scaled back in late 1944 and was halted when Allied armies reached Germany. It was formally closed on February 14, 1945.

BUT WHAT OF the authors of Columba's most famous missive? Lichtervelde was liberated on September 8, 1944. Gabriel Debaillie finally came out of hiding in the house—although he would struggle for many years to be comfortable in other people's company, never talking much. There was no sign of his brother Arseen. And for the families of Leopold Vindictive in Belgium, even the ending of the war brought them no answers as to the fate of their loved ones who had disappeared. For that, they would have to wait still longer.

18

<center>⋅•⋅</center>

Fates

> Fear and trembling have beset me;
> horror has overwhelmed me.
> I said, "Oh, that I had the wings of a dove!
> I would fly away and be at rest."
>
> <div align="right">PSALM 55:5–6</div>

THE WAR IN Europe came to its end in May 1945. But for the family of Joseph Raskin—like so many others—the waiting did not. They had no inkling at the time that he was involved in espionage and knew nothing about why he had been taken, or where.

Day after day passed without word from the priest and his friends. Some prisoners who had been detained in Nazi camps began to trickle back, but there was no sign of the three men from Lichtervelde. That allowed just a glimmer of hope.

One or two former prisoners who had known them wrote letters to Raskin's family saying that they had seen him in Esterwegen and other prisons along the way and passed on what they knew. Letters full of rumors went back and forth among members of the family—one rumor was that he was alive and might be swapped for some Dutch prisoners. Slowly as the weeks passed a picture emerged of his path through Germany.

On May 26, one of Raskin's sisters received a letter from Jean Starck, who had worked within Leopold Vindictive's Brussels

network and helped shelter Marcel Thonus. He had just re-
turned from Germany. He did not know for sure what had hap-
pened to their relative but the message was bleak. "Regarding
Father Raskin, you have to prepare yourself for bad news," he
wrote. "All the signs are that he was executed in Germany in
1943." Another letter received on the last day of May was from a
Benedictine monk who had heard Raskin's Confession at Ester-
wegen and knew he had been taken from there. "My personal
impression—my belief—is that your brother is no longer of this
world . . . That's all I know about a man who was a hero and
who—if he is dead—had the satisfaction that he can say he had
caused grave damage to the Germans."

As May turned to June, the last vestiges of hope were fading
but still the full story of the men's fates was unclear. For two
months the families asked, searched, questioned. By August the
family learned the truth. The answers finally came in the form
of letters and court documents that revealed the story of Leopold
Vindictive's final days.

On the second day of the trial in August 1943, at the stroke of
midday, Raskin, Joye, Debaillie and most of the others had been sen-
tenced to death. Only Dufour, Dufrasne and Macq had been given
prison sentences, since they were judged simply to have passed
on information rather than collecting it themselves. Despite all
his hopes of freedom being dashed, Raskin accepted the sentence
against him calmly as he was taken back to the prison camp. Each
night as he waited for his fate he would say the rosary and give
sermons.

His demeanor was sterner than before, Clément Macq wrote
to the family, but there had still been joy. In the following few
weeks he had participated in what Macq called musical soirées
at bedtime. On one particularly memorable night he performed
a mix of folk songs, Chinese tunes and religious hymns. But the

hour was getting late. One day the Germans came and announced that all those condemned to death were to be taken away the next morning. That night Raskin blessed the other prisoners one last time. Macq never saw him again.

The next morning, September 15, the condemned were loaded into a truck. They included Raskin, Joye and Debaillie along with Muylaert, Dehennin and one of Dehennin's fellow spies, Marcel van Caester. They were handcuffed in pairs, Raskin with van Caester. Their destination was Dortmund.

At least three hundred people met their end in Dortmund, one of the killing grounds for Nazi Germany. More than a third were political opponents of the Reich and resistance fighters. Almost two-thirds were German, often criminals. But foreign resistance workers and agents were also held there—even one young Australian who had been living in Paris when the war broke out and was caught working for an escape line. The largest group of foreigners were Belgians, the youngest of whom was eighteen years old, the oldest fifty-five.

Even after arrival, punishment was not swiftly delivered. There would be more waiting. Paperwork still had to be filled out.

The most detailed account of Joseph Raskin's final days came from a man who was among the last to see him alive. The man's role seems disconcerting and may have been perplexing to Raskin himself. His name was Steinhoff and he, like Raskin, was a Catholic priest. But his job was to serve as chaplain for those facing death in Dortmund. It was Steinhoff who passed details of Raskin's last moments to his sister after the war.

"Your brother [after his arrival at Dortmund] . . . was under strict guard, and I was not allowed to speak to him," Steinhoff wrote. The cells for condemned men were full, so Raskin was held on another floor. It was only in the final three hours that Steinhoff was allowed to speak to Raskin properly. The Belgian had received

that strange offer of a final meal—consisting in this case, perhaps, only of better-quality soup or cheese. Most prisoners found the extra ration of cigarettes the greater comfort. Raskin was calm and dignified as he gave his Confession and took Communion. Afterward, Steinhoff returned to bring him a cigarette, which Raskin declined because he said he wanted to spend the next moments praying. Steinhoff told Raskin's family that he had written some hymns and also—on his last days—drawn a sketch of a chapel he wanted to have built.

The type of bureaucracy that suffused Nazi Germany remained in evidence. In the afternoon, each of those facing death had to appear before a prosecutor, a registrar and the director. The judgment and sentence were read out. The refusal of clemency was noted. A man was asked if he had any final statements. There would have been no contact with families prior to this, and final letters could now be handed over. These were never forwarded.

The execution took place in a purpose-built annex. Steinhoff saw Raskin again as he and two guards accompanied the priest down the corridor. As Raskin walked he recited the Magnificat, so loudly that everyone within earshot could clearly hear him. Steinhoff spoke the words he said to all the Belgian and French prisoners he saw on that same walk: "This evening, you will be in paradise." Raskin responded by saying, "I hope so, Father."

Most men were calm as they faced their fate. Steinhoff found it difficult when those facing death were overemotional. One condemned man tried to embrace him and asked him to pass the accompanying kiss on to his family. Steinhoff recoiled. Signs of sympathy carried risk for him, since the guards were watching and might report him to the Gestapo. He told the resistance prisoners that one day there would be a plaque in their honor back in their home countries to remember their patriotic sacrifice. Steinhoff kept

a list of those killed. He had to keep it secret from the Gestapo, who would have seen the act as disloyal.

It is hard to know what to think of Steinhoff. Was he a man offering final support for fellow believers at their darkest moment, or was he somehow complicit in the murderous Nazi machine? Steinhoff perhaps understood the ambiguities of his position. He would encourage the condemned men to pray for him when they reached the other side. Where Raskin's faith had called him to challenge what he saw as the abuse of power in the world around him, Steinhoff's focused on the afterlife. The German priest wrote to the Raskin family soon after the war ended. "Sister, perhaps my message helps to strengthen you in the belief of the sacred death of your brother," he said. "I am firmly convinced that his death is an atoning sacrifice before God for the sins of men. I am convinced that by his death more grace will be upon us all than through any work he could have carried out here on this earth."

Steinhoff waited outside as they arrived at the room. He was only allowed through the final door when it was a German prisoner.

The room was divided by a thick curtain of dark brown wool. One half, which Raskin entered, served as an office. He was asked by an official to confirm his name. Once this was done, the curtain was swiftly pulled back. The executioner and two assistants stood waiting. Two men seized Raskin. His shirt and jacket were removed so that his torso was bare. His hands were tied behind his back. His shaved head—he still wore the beard that his brothers and sister had found so amusing when it first appeared—was placed by the two guards in a frame. His neck was secured in place with a bolt. Then, with one swift move, the blade of a guillotine did its work. Joseph Raskin was beheaded. His head fell into a container, blood flowed onto the floor.

The whole process from walking down the corridor to affirming

his name to death took forty-five seconds. This was a murder machine. Not on the scale of the concentration camps, but still efficient and mechanical in its own way. Two jets of water cleaned the blood away to make ready for the next prisoner. That day would be one of the busiest Dortmund would see. Seventeen were killed in all.

On Monday, October 18, 1943, the blade struck Raskin at 6:43 p.m. The three friends who had met that day in July 1941 in Lichtervelde died within minutes of each other: Raskin one minute after Arseen, Joye two minutes after the priest. Three friends who had lived, spied and finally died together.

After they were beheaded, the bodies of Raskin, Joye and Debaillie were taken to Dortmund's main cemetery and cremated. Their ashes were placed in an urn. Everything had been done in secret. The Nazis wanted no martyrs' graves. When the war was over, the Red Cross confirmed the death and Raskin's brother Justin asked for help from a British military officer he knew. On September 4, 1945, Major Shepherd, attached to the Allied occupation in Dortmund, went to the cemetery to collect the ashes. He brought the urn—a simple, closed earthen pot—and a few personal belongings back to Belgium and to the family. Raskin's final letters had gone missing.

The ashes were delivered to the family wrapped in a ribbon in the colors of the Belgian flag. Among the flowers and wreaths around it was a photo of Raskin in Lichtervelde, a smile on his face. No one wanted to talk about the way in which he and the others had actually been killed. Discussing the method of their murder seemed just too brutal. Raskin's remains were then laid to rest in the family grave in Stevoort. The ashes of Hector Joye and Arseen Debaillie also came back from Dortmund.

Arseen's family had found out what little they could of his time in prison from a strange source—the Frenchman who had lent

him clothes in Bochum. After the war, not knowing that Arseen had died, the Frenchman wrote asking if the clothes could be returned. Marie and Margaret wrote back to inform him that their brother had died but that they would of course pay him back for his kindness. He gave them an account of Arseen's last days. The two of them had made plans for life after the war, he explained. He assured them that Arseen would have faced death with all the courage that he witnessed during their brief time together. "He was a true Belgian," he said.

The fate of the others involved in their story was mixed. Joseph Dehennin, Maurice Muylaert and Marcel van Caester were killed in Dortmund the same day as Raskin. Madame Roberts spent fourteen months in prison in Belgium before being released. René Dufrasne died in prison from illness. Clément Macq made it out alive. Henri Michelli was sent to Germany in August 1943 along with Andrée de Jonge of the Comet line, but their death sentence was never carried out. When Dachau was liberated on April 29, 1945, by the U.S. Army, they were freed. Marcel Thonus had been held in Belgium for fifteen months before being taken to Dachau, like Jef Van Hooff. Both parachutists survived to be liberated. (The Belgian authorities still had a file open on Thonus for desertion, but the case was dropped.)

The Belgian Sûreté opened a file on Leopold Vindictive at the end of the war in an effort to understand who had been a part of it, in order to acknowledge their service. The result was a messy picture. The investigator struggled to understand who had done what; the three central participants were all now deceased and could no longer tell their story, and the few more marginal figures who did survive exaggerated their own roles.

Fate dealt its hand to the judge who had presided over the death sentences handed to Raskin and the other men. On the morning of February 3, 1945, Roland Freisler had been holding a session of

the People's Tribunal when Allied bombers struck Berlin. The tribunal took a direct hit and Freisler was crushed to death by a column in his own courtroom.

AS WAR ENDED, men who had fought their way through Europe began to return to their pigeon lofts in gardens across the country. In many cases, wives or mothers had been cleaning, feeding and caring for the birds in their absence. About half the seventy thousand lofts from prewar days were still running. "It was good while it lasted. One by one we are handing over to the men," wrote one woman, a Mrs. Lawson. She had been uninterested in the hobby before the war, but that had changed as she played her part, forced to learn the difference between a squab and a squeaker. "Try not to judge us too harshly if you feel our work lacked the perfection of your master touch," she added wryly. Many women welcomed the return of their men—of course—but also experienced a faint sense of regret at being relegated to the traditional role of making cups of tea while the men tended to the birds. But for other women, their men would never come back and the lofts were theirs now, perhaps to tend in the memory of a husband or son or brother, perhaps instead simply to be boarded up. "There are empty chairs as well as empty perches in the loft," Mrs. Lawson wrote.

What recognition should there be for the birds and their owners who played their part? Should they receive medals? This became the subject of a surreal debate within the Air Ministry after it was pointed out that guard dogs were being rewarded. "I don't want to be unduly hard on the pigeon," one officer began, before going on to say it was unfair to guard dogs to compare the two since dogs had been taught to use their brains while pigeons were just following a homing instinct and so could not be considered brave. "Do pigeons have brains? . . . please comment," he wrote.

Rayner responded with a long missive. Two pigeons might have had the same training, but one would push itself harder to make it home—in other words it was not blind instinct but "voluntary determination." The pigeon had to overcome its fear of drowning and take huge risks despite being more naturally timid and nervous than a dog. In the end, the pigeons would get their recognition. Those deemed the bravest would be among the animals to receive the Dickin Medal. Broadcasts were also made on the BBC to those in Europe who had passed messages through Columba, asking that they identify themselves so they could be acknowledged.

As Columba's work was coming to an end, the army's director of signals offered some acknowledgment to pigeon owners, partly to encourage those who felt the losses were high and little knew the value of the work in which they had been involved. A competition was held with more than a thousand birds, one from each loft that had supplied Columba, including one from the king. "In the past, the work of the Special Section has for obvious reasons been kept surrounded in mystery," the general told the fanciers, "but today I am in a position, partially at any rate, to lift the veil and help you appreciate more fully the valuable contribution you have made to the service." He recognized that many present must have wondered what was inside those cylinders that they had not been allowed to open. He revealed that the information had included details of flying bomb sites and of troop movements. In one case, he said, a message had given such detailed information with regard to a particular headquarters, including the time when officers were present, that a subsequent bombing raid had what he called "excellent results." In one case a writer had told a German who was keen to get out of the war to go to a road where he knew the resistance was waiting. Another message, he explained, had included a short note from

a grounded airman telling his wife he was safe and well. "This pigeon, it is felt, certainly delivered the goods." At the Air Ministry, Rayner was incandescent with rage when he learned that the director had used statistics about Columba and its success rate—roughly a thousand messages from seventeen thousand birds—which Rayner himself had never been told. The dreary farce of pigeon politics continued. The next battle was to work out what kind of pigeon force would be needed in the postwar period.

What role might pigeons play in a future war? And what kind of capability—military, intelligence or civilian—should be maintained in peacetime in preparation? The surreally titled Sub-Committee on Pigeons, Joint Intelligence Committee was created to probe those questions. Captain James Caiger, the man running the Army Pigeon Service including Columba at the end of the war, was appointed civilian representative. He also worked as an unofficial adviser to MI5. The committee decided it was "most undesirable" that it should become known he was acting on behalf of the intelligence services. That meant Caiger was asked to operate undercover on behalf of MI5 in the civilian pigeon world—one of the more unusual assignments for operatives from the security service.

Caiger and Rayner clashed over future plans. The RAF had discontinued the use of pigeons for search and rescue in 1944, and Rayner's best hope of becoming a postwar pigeon coordinator was to set out an ambitious agenda. He wrote a paper outlining the way in which a government establishment under the Air Ministry could drive innovation. It might be possible to develop pigeons that could home to a particular object—they might be taught to home to a searchlight carrying an explosive charge, or even deliver bacteria for biological warfare to a specific target. This might even be possible at long range—in which case, who needed bomber planes? "A thousand pigeons each with a two

ounce explosive capsule, landing at intervals on a specific target, might be a seriously inconvenient surprise," wrote Rayner. Could pigeons dropped by rocket or balloons drift silently into heavily defended areas? Could they be equipped with metallic foil to interfere with radar? Could agents develop a self-destroying microgram message ("This pigeon will self-destruct . . .")? If the right release mechanism could be found, might they be sent back with messages from submarines on intelligence-gathering work and unable to radio home (would the birds be launched out of a torpedo tube, one wonders)? There was no end to the possibilities.

Others were skeptical. Rayner was described by one MI5 officer as "the nearest thing to a pigeon that anybody had seen and that he was clearly trying to make a job for himself."

MI6's belated view was that the risks of being pigeon-blind were real—"the past error of dropping all official interest in pigeons as soon as the war is over should not again be repeated," was their view. The accuracy achieved in dropping by night had enormously increased the value of pigeons for communication from enemy territories. To take advantage of this required practicing the use of pigeons in air travel, air release and parachuting. "Otherwise, when war comes again, there will be (as it was in this war) the best part of two years before satisfactory results can be obtained." MI6 wanted high-level research and training and a government loft but did not want to pay for it.

Captured documents and interrogations were revealing that the Germans had been ahead of the Allies. During the war, the British and Americans had worked on two-way pigeon flights, in which a bird could be trained to go back and forth from a moving location rather than just back home to a static home loft—an operation called Boomerang. Now they were learning that the Germany Army Pigeon Manual of 1925 already included Boomerang as standard practice.

R. V. Jones too wanted to maintain pigeon research. The man of science who had fought the high-tech Battle of the Beams would visit the Air Ministry as the war ended to try to fathom the mystery of how pigeons navigated. (At the same time, he was also trying to work out how male moths homed on female moths from miles away, in order to find out if the ability to sniff chemical compounds could be used to detect a submarine's diesel exhaust or even sniff for traces of nuclear material from a distance.) For a while it seemed as if pigeons would still have a role.

The verdict of MI14 and the War Office was that they might want a renewed Operation Columba behind the Iron Curtain in the next war. But the army said it could see no further role for it. Walker at MI5 explained that the interest was defensive. Even in the absence of all-out war, Britain might be involved in keeping the peace in "wilder countries" where pigeons might be used by "underground forces and local partisans"—such as in southern Europe, the Balkans and the Far East. It would be good for officers out there to have someone to whom they could refer for advice, but all that was needed was a pigeon expert with their own loft rather than a permanent establishment. Money was the final determinant for cash-strapped Britain as the dead-locked subcommittee defaulted to the civilian option, at a tenth of the price of a new research establishment. Caiger would use his hundred pigeons and keep the committee in touch with the latest developments among the fancy at home and abroad.

The pigeon subcommittee approached the Americans. There was no formal U.S. intelligence research team, although the army continued work at Fort Monmouth. Caiger visited the United States with a list of questions, drawn from British spies, regarding research on areas like dropping pigeons from faster planes, night flying, two-way services, the effect of radio transmissions and new tecȲiques in concealing secret messages. There was also interest

as to whether radioactivity affected the flight of homing pigeons. In a post-apocalyptic future, would pigeons still be able to fly over the wastelands left by an atomic bomb? Might a tiny gadget tied to a pigeon's leg indicate if it had passed near an atomic plant? Britain carried out tests, flying pigeons past an atomic source on a boat that emitted a radioactive plume (Caiger himself coming rather too close).

In the House of Commons in February 1948, Reginald Manningham-Buller raised the subject of pigeons, no doubt thanks to his wife's experience. He questioned the secretary of state for air about an Air Ministry letter suggesting there would be no future role for pigeons in war. The secretary of state promised to look into the issue. But interest was waning. MI5's worries shrank to fears that Communist British pigeon fanciers might use their birds in the event of war. MI6 went cold. As clashes with Rayner intensified, Caiger threatened to resign. T. A. Robertson at MI5 responded that "Rayner has always been a menace in pigeon affairs" and lobbied for his removal. Rayner was offered the chance to write a handbook on wartime pigeon use. Caiger himself wrote a short pigeon book, *The Secrets of the Eye*, which was distributed to committee members. ("I would pay ten shillings NOT to have to read this," one air commodore wrote to Robertson at MI5.) The pigeon subcommittee was closed up in March 1950. Pigeon breeding returned to being a matter of competitive pleasure rather than secret intelligence and national service.

But was it really the end for the spy pigeon? A note of the Joint Intelligence Committee in 1948 asked MI5 to inform the London representative of the CIA that "an attempt was being made to probe behind the Iron Curtain." No details of what British spies were trying to do have been released. But it sounds as if a spy somewhere had released a bird, or that pigeons had been dropped to test the population's reaction. And the CIA did go on

to use pigeons for intelligence gathering in the Cold War. In the 1970s, the agency's Directorate of Science and Tecɣology developed a camera small and light enough to be carried by a pigeon. On release it would fly over the target on its way home and take photos at set intervals. A battery-powered motor wound the film, advanced the spool and cocked the shutter. "Details of missions by pigeons are still classified," is all the CIA says about where its spy pigeons flew.

Even today spy pigeons have not entirely disappeared—or, at least, the fear of their stealing secrets is still apparent. In 2008, Iran seized what it said were spy pigeons near its nuclear plant in Natanz, and a few years later, Indian police paraded what they claimed was a Pakistani bird employed in espionage. If anything, the demand for pigeons may return in our tecɣological age. In 2011, Chinese state media announced that a special unit of the People's Liberation Army was training pigeons to conduct "special military missions." "In modern warfare, the pigeon is indispensable," an officer said, especially if an advanced cyber or electromagnetic attack knocked out electronic communications. Perhaps somewhere the successors to Rex Pearson and Brian Melland are also thinking about how to train pigeons for such a post-apocalyptic future.

AT THE END of the Second World War, Brian Melland, by then recognized as the leading expert on captured enemy military material, traveled to occupied Germany. He visited the bunker where Hitler had given orders to his once mighty army, whose movements Melland had previously tried to piece together using all the sources of intelligence at his disposal. Melland left the army soon after the end of the war. He considered returning to the theater and to acting but decided he was too old. Instead, he went to work in the Cabinet Office helping to organize its war archives.

In the early 1960s, nearly twenty years after the war had ended and just a few years before he died, Melland was working through the files of Columba, an operation that had once been his own. The file was still classified, but he was making sure the historical record that would eventually emerge was accurate. The file was bound in one of the standard manila folders used by the government. But on the cover was a cartoon of a pigeon, with Hitler splayed underneath. It was a sign of the humor the team at MI14(d) had always enjoyed despite the life-and-death nature of the struggle in which it was engaged. Checking some of the facts about Columba, Melland exchanged letters with his old colleague Sandy Sanderson. The two men remained close and their letters, still with the odd German phrase thrown in, included references to a plan to meet up for breakfast one day. Melland was trying to ensure that eventually—when the file was declassified—people would have a real understanding of this most unusual of intelligence operations. Columba certainly justified high praise for the birds' owners and those in enemy territory who ran such grave risks, he and Sanderson agreed. The thoughts of the two men were also drawn to Message 37, which they had opened up together in July 1941 with such surprise. Both agreed that this one message had been different from all the others. It had been the "outstanding achievement," Melland wrote as he left a note in the file for others, one day, to find. The fate of Leopold Vindictive—whose members were still not named inside the folder as Melland closed it one last time—preyed on his mind, though, as he considered the sacrifice they had made for the small sheets of rice paper tucked into a canister.

What did Columba achieve? Pigeons did not win the war. People did. And that included the hungry, half-starved people who chose not to dine on the pigeons they found in French, Belgian and Dutch fields or, out of fear, to hand them over to their occupiers, but who instead chose to risk their lives dispatching a

bird to Britain with the hope that they might thereby have played some small part in aiding their deliverance. Soldiers and sailors and airmen also won the war. They relied on intelligence to guide them, and Columba's messages played their part—whether in understanding the disposition of Nazi forces, the location of defenses that were shooting down RAF planes, or of rockets striking Britain. It is rare for one single item of intelligence to be transformative. The picture is a mosaic made up of many pieces and fragments, and while other sources no doubt played a much larger role than Columba, those pink slips often provided a missing piece or confirmation that was crucial for the likes of MI14 and R. V. Jones.

Columba was a unique intelligence operation that provided something that no other source could: intelligence from ordinary people in enemy territory, almost in real time. It offered a direct, emotional bond as well as an intelligence link between those in occupied Europe and the pigeon owners, spies and most senior figures in Britain. That was why Churchill himself was shown Message 37 from Leopold Vindictive. It was not simply the intelligence—it was what that message signified. It offered hope in both Britain and occupied Europe that the two parties, connected only by a pigeon, could reach out to each other and, despite the potential risks, would not give up in the face of appalling odds.

The costs were heavy. Certainly for the birds—of the more than sixteen thousand pigeons sent out, only one in ten made it back alive. But the costs were heavy for people too. How are we to judge the terrible cost for those three friends from Lichtervelde who paid such a price for their decision to make use of an Ipswich bird found in a farmer's field on a July morning? The team at MI14(d) may have been stunned by the intelligence haul that Joseph Raskin, Hector Joye and Arseen Debaillie provided them, but was it truly worth their lives? One answer is that these were

three men who heard a call, bound in patriotic love for their country and underpinned by their own faith. And their decision to heed that call provides an inspiration for others who may one day face their own choice. A choice, when confronted with tyranny, to not submit but instead to resist.

ACKNOWLEDGMENTS

THE STORY OF Columba and of those who used the Secret Pigeon Service has been pieced together over many years and with the help of many people. I would like to thank the following archives, institutions and their staff for access to material: Britain's National Archives at Kew; the Belgian Security Service archives at the Centre for Historical Research and Documentation on War and Society (CEGESOMA) in Brussels; the U.S. National Archives at College Park, Maryland; the British Library; the trustees of the Liddell Hart Centre for Military Archives at King's College, London; the Imperial War Museum archive; the Churchill Archives at Churchill College, Cambridge; the BBC Written Archives at Caversham; the Royal Signals Museum; the British Archives of Falconry; and the British Falconers' Club.

Vital pieces of the puzzle were found in British and Belgian archives, but it would not have been possible to understand the whole picture—and especially the story of Leopold Vindictive— without the assistance of a number of individuals who guided me through the various archives, or who provided advice and, in some cases, their own material. They include Colin Hill (who welcomed me into his loft when I first began looking at the subject), Joÿ Clinch, Martin Skipworth, Mark Seaman, Robin Libert, Eliza Manningham-Buller, Philippe Connart, Andrew Riley, Mark Upton, Tony James, David Horobin, Louise North, Jo Peeters, Martyn

Cox, Geoffrey Pidgeon, Emmanuel Debruyne, Nicolas Livingstone, Anna and David Melland, Peter Kleyn and Michael Shepherd. I'd also like to thank Gisela Corera for her help with translations and Steve Gove for his comments and help with the text. My agent, Georgina Capel, has provided the kind of encouragement and support every writer needs (even when I told her my plan was to write about pigeons). And my editor, Arabella Pike at HarperCollins, has adeptly guided me in bringing the story together with her astute suggestions. My wife and sons have also shown great patience as I wrestled with my pigeons, and they will always have my thanks for their support and encouragement.

I owe a particular debt to the families of the Leopold Vindictive network. The Debaillie and Joye families provided me with memories and papers that were vital in telling this story. This book would not have been possible without the help of Brigitte Raskin, the niece of Joseph Raskin. Her own research into her uncle's life proved an invaluable guide. And her advice, hospitality and friendship have, I hope, resulted in a British–Belgian cooperation that is in some tiny way a reflection of what her uncle sought to achieve during the war.

NOTES

---◆·◆---

A NOTE ON SOURCES

References are to the National Archives at Kew unless otherwise specified. The full set of Columba messages has not been preserved in a single place. The first ninety-one messages are in WO 208/3560, with more in WO 208/3561 and WO 208/3555. A photostat copy of Message 37 is in CAB 208/3564, the central Columba file. A further set of messages that were of use to the Admiralty are preserved in ADM 199/2475.

The R. V. Jones papers are held at Churchill College, Cambridge.

The Belgian Security Service files are at the CEGESOMA archive in Brussels.

Admiral Keyes's papers are at the British Library.

L. H. F. Sanderson's papers are at the Liddell Hart Archive, King's College, London.

U.S. National Archives are at College Park, Maryland.

BBC documents are held in the BBC Written Archives Centre, Caversham.

Documents on Joseph Raskin and the Scheut mission are in the KADOC archive in Louvain, Belgium.

INTRODUCTION

8 sent to distant towns: The general historical background is drawn from
 Andrew D. Belchman, *Pigeons* (New York: Grove Press, 2006); Wendell
 Levi, *The Pigeon* (1969); Courtney Humphries, *Superdove* (New York:
 HarperCollins, 2008); Jean Hansell, *The Pigeon in the Wider World* (Bath:
 Millstream Books, 2010).

9 one in nine families had a pigeon: Belchman, *Pigeons*, p. 199.

11 the humble pigeon's flight: Steven Joÿston, "Animals in War: Commem-
 oration, Patriotism, Death," *Political Research Quarterly* vol. 65, no. 2 (June
 2012), pp. 359–71.

I: BIRTH

13 handed over by its owner: The most likely bird is listed as coming from
 Margetts/Routh on Lattice Avenue, judging by the Meritorious Perfor-
 mance List in William Osman's *Pigeons in World War II* (1950). According
 to a 1935 telephone directory, William Henry James Routh lived at num-
 ber 60 and at number 58 was Albert James Margetts, so this may have
 been a loft shared by the two families.

13 behind enemy lines: Details of flights are drawn from a combination
 of sources, including Freddie Clark, *Agents by Moonlight* (Stroud: Tem-
 pus, 1999); the website http://beforetempsford.org.uk; Ron Hockey's
 papers and flight logs, which are held at the Imperial War Museum;
 Gibb McCall, *Flight Most Secret* (William Kimber, 1981); Hugh Verity, *We
 Landed by Moonlight* (Manchester: Crecy, 1998); and files at the National
 Archives.

14 parachuting two agents into Belgium: Ron Hockey's papers, Imperial War
 Museum; http://www.cegesoma.be/docs/Invent/AA_1098_AA_1100.pdf;
 www.beforetempsford.org.uk, "7 July 1941." There is some confusion
 among different logs and files as to which operations were flown on
 this and surrounding nights. One was Operation Marble—parachuting
 an agent named Paul Jacquemin into Belgium to work with MI6's sole
 network, code-named Clarence. Another was Moonshine/Opinion. Nicolas
 Livingstone, who produced the Before Tempsford site, believes the most
 likely flight on which our pigeon was dropped was the Moonshine/
 Opinion mission.

14 "give them a good drop": See Frank Cromwell Griffith's testimony at
 the Imperial War Museum, Reel 2, http://www.iwm.org.uk/collections
 /item/object/80012005.

14 the next night: www.beforetempsford.org.uk, "3 Oct 1941."

15 *Racing Pigeon* in 1898: Lt. Col. A. H. Osman, *Pigeons in the Great War* (1929);
 Garry McCafferty, *They Had No Choice* (Stroud: Tempus, 2002), ch. 20.

16 expanded across all the services: Osman, *Pigeons in the Great War*.

16 "When the battle rages": Quoted in Levi, *The Pigeon*, p. 7.

16 trapped behind enemy lines: Osman, *Pigeons in the Great War*.

16 disbanded not long after the war: A small loft was kept in Egypt, with the plan that it would be used for internal security. But by 1928, that loft was closed, leaving only a small facility in Singapore.

17 newspaper he edited: AIR 2/2211.

17 concentrated in working-class areas: WO 32/10681; Osman's estimate. There were two unions, the larger being the National Homing Union; and two journals—the more prominent being the *Racing Pigeon*, owned and edited by Osman in London, the second *British Homing World*, edited by F. W. Marriott and published in Birmingham.

18 "There was a terrible slaughter": H. C. Woodman, "War of Little Wings," *Racing Pigeon Pictorial*, 1975–6. All references to Woodman are taken from these articles.

18 hard-up dance band manager: Osman, *Pigeons in the Great War*; WO 208/3565.

20 Z's man in Zurich: Anthony Read and David Fisher, *Colonel Z* (London: Hodder and Stoughton, 1984), p. 231.

20 adverse impact on his work: Keith Jeffery, *MI6* (London: Bloomsbury, 2010), p. 379 refers to the drinking problem without naming Pearson, but the identity is clear when cross-referenced with the account in Read and Fisher, *Colonel Z*, p. 231.

21 taken across the front lines: Read and Fisher, *Colonel Z*, p. 139.

21 Animals were another possibility: One intelligence officer persuaded a farmer's wife to bribe a German soldier to deliver a hen to her sister on the other side of the wire. The hen would then have a message tied to its leg and be released at night to waddle home. Sigismund Payne-Best, Imperial War Museum Sound Archive interview 4520.

22 carrying important military information: WO 208/3561.

22 end of the First World War: WO 208/3564.

22 refused to cooperate: HS 8/854.

23 a source of abiding tension: The first demand for pigeons for intelligence work was made in October 1940, when a mission was successfully carried out by two birds selected from a civilian loft by the Air Ministry.

24 "They may be picked up": AIR 2/4969.

24 "In our jaundiced opinion": McCall, *Flight Most Secret*, pp. 46–7.

2: THE SPECIAL PIGEON SERVICE

28 more talented younger men: Noel Annan, *Changing Enemies* (London: HarperCollins, 1995), p. 3.

28 passing on their secrets: Guy Liddell, diary entry, May 11, 1945.

29 just landed in Britain: Biographical details of Brian Melland are from his son, David Melland.

30 New Year's Day in 1941: Annan, *Changing Enemies*, p. 2.

30 invasion was considered imminent: Leo McKinstry, *Operation Sealion* (London: JoŸ Murray, 2014), p. 87.

31 if nothing had been heard: Sanderson papers, Liddell Hart Archives.

32 German navy had been considering the challenge: German Plans for the Invasion of England, U.S. National Archives NR 910.

32 coastal defenses between Dover and Brighton: German Plans for the Invasion of England, U.S. National Archives NR 910.

34 many were likely to be rubbish: Annan, *Changing Enemies*, p. 26.

34 "least reliable of our whole body of sources": WO 190/893. Keith Jeffery in *MI6* makes clear that it was only by the end of 1941 that the Cleveland (then Clarence) network under Walthère Dewe was establishing contacts. Dewe had been involved in the Dame Blanche network during the First World War and had continued working between the wars. His team had been given one-way radio transmitters so his subagents could send back reports, but it was proving hard to train people to use the sets and get the networks up and running in the early days of occupation.

35 it had failed to deliver: WO 198/893.

36 nearly a third of a year: Jeffery, *MI6*, p. 520.

36 floodlight the whole of southern England: R. V. Jones, *Most Secret War* (London: Coronet, 1978), p. 65.

38 ears heard an unusual noise: Jones, *Most Secret War*, p. 426.

39 intensive manufacture of gas: WO 198/893.

40 Columba Message 1: http://beforetempsford.org.uk.

42 "striking down anyone who betrays": Columba Message 51.

42 eat them before they were ripe: Columba Message 62.

43 taken off with his airplane and fled: Columba Message 62, August 1941.

43 replace all his own pigeons: Columba Message 75.

3: LEOPOLD VINDICTIVE

49 what being a patriot really meant: Many biographical details of the Raskin, Joye and Debaillie families have been provided by the families themselves; others are from Brigitte Raskin, *De eeuw van de ekster. Een Belgisch levensverhaal* (Amsterdam: Meulenhoff, 1994).

52 Belgium's war quickly became Britain's: JoŸ Horne and Alan Kramer, *German Atrocities 1914* (New Haven and London: Yale University Press, 2001), pp. 26–30.

59 Columba birds were dropped: WO 208/3562.

59 "have to kill all mine": Columba Message 506, August 28, 1943.

61 details of what they observed: The Belgian Security Service Archive file on Leopold Vindictive contains details of some of those who provided information, although the precise dates and contacts remain confusing.

4: ARRIVAL

68 "I well remember the fascination": CAB 146/431.

68 distribute the information to other departments: Later in the war, these functions would be taken over by Captain Kleyn's team at Wing House.

71 attempts to send in a radio operator: HS 6/217.

72 day he would never forget: The account of Keyes's visit to Belgium is drawn from the official record, PREM 4/24/4, his own papers, which are held at the British Library, and the account of his son, Roger Keyes, *Outrageous Fortune* (London: Martin Secker and Warburg, 1984).

74 long-barreled Luger pistol: Keyes papers; Philip JoŸs, *Within Two Cloaks* (London: William Kimber, 1979).

78 "assessing the sender's bona fides": WO 208/3556.

79 shown to Churchill himself: The sending of the message personally to Churchill is recorded in the Columba file, CAB 208/3564, in a draft of Kenneth Strong's memoir.

5: LISTENING

82 "listening to the English radio": BBC E2/192/1 File 1a, April–July 1941, p. 24 has detailed reports of Belgian responses to the BBC.

82 permitting her pupils to listen to the BBC: BBC E2/186/4, November 1940–January 1941.

82 "wife would like to kiss": Columba Message 85.

82 they wanted him to know: Columba Message 46.

83 "done it and said nothing": Columba Message 240. See also Lynne Olson, *Last Hope Island* (London: Scribe, 2017), p. 118.

83 had arrived in London: The specific code names are mentioned in a memo of April 30, 1942, BBC E2/90.

84 crossed the Channel with their treasure: The archives are confusing about this message. BBC E2/90 shows that a message may have been broadcast on July 14 after a request the day before to Leopold Vindictive 300 in response to requests from the intelligence services. On July 15 the archives show an acknowledgment being broadcast to Leopold Vindictive 200. There is no sign from the Belgian side that the 300 message was heard.

88 response to JoŸ Victoire: Notes from the papers of Brigitte Raskin.

89 supplied intelligence to the priest: Raskin's circle included the two sisters Yvonne and Louisa Deloge and also Elise Ausseloos.

89 lodging, food, clothes and money: Letter of Mme. Roberts, Belgian Security Service Archives.

89 "Père Raskin and his group": Joseph Raskin file, Belgian Security Service Archives.

90 The message was relayed again: WO 208/3556 includes the message and the timing of broadcasts.

91 At 3:35 a.m. the following day . . . Operation Periwig: Also www.before tempsford.org.uk.

6: BATTLE OF THE SKIES

94 "Germans are fully pigeon-minded": WO 206/3556 Annex, note by Captain Kleyn.

94 "Our defense against the carrier pigeons was vast": Quoted in *War of the Birds*, a 2005 TV documentary.

94 issue a warning: The Channel Islands poster can be seen in the Bletchley Park museum.

94 "impose the death penalty inexorably": Philips Adhemar, Ardoye, Columba Message 30.

94 "The coward!": Columba Message 545, September 1, 1943.

94 booby trap underneath: Columba Message 376, May 1943.

95 "have been arrested": Columba Message 634, November 7, 1943.

95 RAF passing overhead: Columba Message 547, Loudun (Vienne), August 16, 1943.

95 "marksmen on the coast": Columba Message 376, May 1943.

96 work of training one: "How Trained Hawks Were Used in the War," *Falconer* vol. II, no. 1 (July 1948).

97 not worth an exhaustive investigation: WO 32/10681.

98 "fit de-icing apparatus to pigeons": WO 32/10681.

99 killed during their work: There are official accounts in the MI5 files of the Falcon Destruction Unit, but the best details can be found in Woodman, "War of Little Wings."

99 assumed he had liberated it: Basil Thomson in Hugh and Grahame Greene, *The Spy's Bedside Book* (London: Hutchinson, 2008), p. 185.

101 released from London: KV 4/10.

101 destroy all non-NPS birds: WO32/10331; Liddell diary, August 17, 1942, KV 4/190.

102 eight hundred men looking after them: The whole enterprise was controlled by SS Waffen General Ernst Sachs, who was in charge of long-range communications, and beneath him a fancier named Heinrich Voss.

Soldiers would strap on large backpacks, which acted as two-storey pigeon carriers to accommodate as many as twelve birds. *Organization of Military Pigeons in Germany*, report in U.S. National Archives, NR 6111; KV 4/10.

102 on the Eastern Front: Pigeons were used where radio conditions were difficult (for instance, in mountainous regions) and where there was a lack of radio sets and trained operators. In wilder areas like the Balkans, outlying agents could send pigeons with messages to central radio stations.

103 trip that took twelve or thirteen hours: *War of the Birds.*

103 Germans in the First World War: A pigeon has fifty-two main feathers in its wing and tail, and a prearranged system of spots on feathers could make an almost unbreakable code (KV 4/10).

103 would notice anything suspicious: Study by Flt. Lt. Walker of MI5, in WO 208/3556.

103 heighten pigeon-spy fears: KV 4/193. It was feared by MI5 that Germans might land baskets of pigeons by boat or submarine at caves on the British coast, where agents could then pick them up. Or they might be smuggled in via neutral boats or trawlers (especially through Ireland) or dropped by parachute to remote farms. Perhaps, fretted MI5, once taken to Ireland, they might be placed in an overcoat pocket and then put on a trading vessel heading for South Wales.

104 given homes in an English loft: KV 4/10.

105 "ones in the Scilly Isles": KV 4/191.

7: REACHING OUT

107 still in their containers: RAF operations record book of 138 Squadron indicates a flight on September 3, 1941, that took off from Newmarket at 20:15 on a mission code-named Conugal. At Courtrai the weather was clear and fine and the agent was dropped, but then it is recorded that bad weather prevailed and the pigeons were brought back.

108 drop pigeons near Lichtervelde: See www.beforetempsford.org.uk.

108 "kill individual Germans": HS 6/104.

108 seven miles to the west of their target: www.beforetempsford.org.uk.

111 target for enemy action: M. R. D. Foot, *SOE in the Low Countries* (London: St. Ermin's Press, 2009), p. 229.

114 newly created commando units: McKinstry, *Operation Sealion*, p. 151.

114 their intended audience in London: A doctor named Husquin, who also worked with the resistance, provided plans of German emplacements and a map of Ostend on which he had worked during a recent visit.

115 resistance work in 1940: Testimony and interviews of Clément Macq, Belgian Security Service Archives.

116 originally from Hamburg: Belgian Security Service Archives on Abwehr IIIF.

116 spoke both English and French: HS 6/750.

117 combination of patience and boldness: MI5 manual on the Abwehr, July 1944; https://www.cia.gov/library/readingroom/docs/GERMAN%20 INTELLIGENCE%20SERVICE%20(WWII),%20%20VOL.%201_0003 .pdf.

117 contacts to work against them: In Brussels, Dehennin began working with Marcel van Caester, a member of the gendarmerie who had access to sensitive information. Hélène Dufour, a nurse, would carry sealed envelopes for them.

117 through the Iberian peninsula: One telegram was handed over to a contact of the Cleveland network, who had a transmitter.

117 a message would get through: Dehennin was primarily linked to French rather than British intelligence. Raskin himself was not keen to work with the French. He wanted to deal directly with the British rather than go through middlemen whom he did not always entirely trust. But he was desperate enough to use the Dehennin contact to try to reconnect with Britain.

117 policeman named Eric Pieren: Fernand Strubbe, *Geheime Oorlog* (Tielt: Lannoo, 1992), p. 118.

118 Pieren did not know his name: Notes from the papers of Brigitte Raskin; Bodicker report number 35. Also German Secret Police Report of June 4, 1942.

8: RESISTANCE

120 just another regular Columba drop: Devos testimony, Belgian Security Service Archives.

121 message was given to Devos: Papers of Brigitte Raskin.

122 "What are the English waiting for": Columba Message 81.

122 "Frenchmen wait impatiently": Columba Message 91.

122 Columba would halt its operations: Pearson also seems to have been involved in a difficult but unspecified argument with Military Intelligence in December 1941, according to a note in a file dated December 20, 1941 (BBC E2/78).

122 "spotted by the night fighters": Leonard Ratcliff in Sean Rayment, *Tales from the Special Forces Club* (London: William Collins, 2013), p. 172.

123 two hundred bombers a month: AIR 40/3054.

123 discerned from aerial reconnaissance: Columba Message 79.

124 "Help our Jews": Columba Message 236, ADM 199/2475.

124 "questions that the finder could answer": R. V. Jones papers B85, "Pigeons."

125 boring, old fashioned and upright: Details drawn from Strubbe, *Geheime Oorlog*.

126 boss inside the organization: J. M. Langley, *Fight Another Day* (London: Collins, 1974), p. 133.

127 named Jean Vandael: Vandael was linked to MI6. His network was codenamed Alex.

127 make their way to England: Although Vandael was convinced that his messages were reaching England, this was not always the case; perhaps the French were unable or unwilling to get them through. Vandael was now trying to use the Three Musketeers network, which also had links with Zero.

127 taught to see his partner agency: Jones, *Within Two Cloaks*, p. 11.

129 had been a double agent: Verity, *We Landed by Moonlight*, pp. 12–13, 43–4; Foot, *SOE in the Low Countries*, p. 267.

129 pick people up or drop them off: Hugh Verity, Imperial War Museum Sound Archive 32162.

129 reconstruct its contents: It is not clear how London knew a message had gone missing. Possibly Vandael himself told them he had delivered a message, and this was what led London to investigate its disappearance. There is only one note in the Belgian Security Service Archives, and the MI6 files remain closed.

130 attempt to reach out had failed: Letter of February 1942, Leopold Vindictive file, Belgian Security Service Archives.

130 act as a radio operator: Letter from Commander Vandermies, January 23, 1942, Leopold Vindictive file, Belgian Security Service Archives.

9: SECRET AGENTS

133 taking to Europe: The account of Jef Van Hooff's time as an agent is, unless otherwise indicated, drawn from his memoir, *Je Suis Espion* (Mechelen: Imprimerie H. Dessain, undated). Additional details of the dropping of agents are from AIR 27/956.

133 would be Leopold Vindictive: Note from Page of February 27, 1942, in the Leopold Vindictive file, Belgian Security Service Archives.

137 "he made a good impression": HS 9/1506/4; Strubbe, *Geheime Oorlog*, pp. 297–8; Van Hooff memoir.

137 Amies played by his own rules: HS 9/29/2.

137 shot or beaten to death: HS 6/272.

137 "only be described as bitter": HS 7/100.

138 shot as a result: Christopher Murphy, *Security and Special Operations* (London: Palgrave Macmillan, 2006), p. 8.

138 "poor child of northern Europe": Hardy Amies interview, Imperial War Museum Sound Archives 8687.

140 run both organizations: Gill Bennett, *Churchill's Man of Mystery* (Abingdon: Routledge, 2007), p. 267.

140 the agent was actually from MI6: Jones, *Most Secret War*, p. 336.

140 sent out on the BBC: Foot, *SOE in the Low Countries*, p. 37.

141 to MI6 and not to him: Amies of SOE and Arontstein and Nicodeme of the Belgian security service, the Sûreté, had a thunderous argument on March 16, 1942.

141 play off the other side: Initially the Sûreté was based at 27 Eaton Place and then around the corner at 38 Belgrave Square, a stone's throw from the Deuxième Bureau at 34 and then 40 Eaton Place (Emmanuel Debruyne, "Un Service secret en exil, L'administration de la Sûreté de L'Etat a Londres," 2005, http://www.cegesoma.be/docs/media/chtp_beg/chtp_15 /chtp15_025_Debruyne.pdf).

141 Belgians and other foreign services: Foot, *SOE in the Low Countries*, p. 225; see also Olson, *Last Hope Island*, p. 152.

142 basis of close cooperation: Read and Fisher, *Colonel Z*, p. 278.

142 "crypto-fascist regime around the monarch": Jeffery, *MI6*, pp. 387–9.

142 nothing to do with the Sûreté: Foot, *SOE in the Low Countries*, p. 231.

142 "bloody liar": HS 6/300.

143 details about his own background: HS 6/232.

143 England rather than Belgium: Lepage grumbled to MI5 about MI6 not letting him communicate directly with agents in Belgium (KV 4/188). On July 28, 1941, he had lunch with Guy Liddell of MI5. "I gather that he does not much like SIS presumably because they will not allow him to communicate direct with his agents in Belgium. SIS quite rightly feel that they must maintain control of these matters," Liddell noted in his diary.

146 no record of a German spy: HS 6/300, February 6, 1942.

147 "so that he could redeem himself": Nicodeme's 1945 letter at the end of the war is in Thonus's file in the Belgian Security Service Archives.

147 undertaken by the Belgian government: Leopold Vindictive file, Belgian Security Service Archives.

148 parachute to the ground: Osman, *Pigeons in the Great War*, p. 48.

148 fancier vetted by MI5: RAF birds offered more security, it was thought, but they were less well trained than civilian birds at long distances. But by 1942 RAF lofts did most of the agent work.

149 find they were in Scotland: AIR 2/5036 and AIR 2/4129, which correlates closely as to timing with the story in *We Landed by Moonlight*, pp. 34–6, and that of Freddie Dyke, http://www.bbc.co.uk/history/ww2peopleswar /stories/57/a2083457.shtml. The same owner, R. W. Beard, had been supplying pigeons via Rayner for a month for previous attempted secret missions.

149 those of the Air Ministry: HS 8/854.

150 given written instructions: WO 208/3561.

150 HQ at Baker Street: HS 8/854. In 1942, SOE parachuted an agent into Belgium to work with pigeon loft owners to create a news service that would send in propaganda films and send out Belgian newspapers. The idea was that twenty-five pigeons would arrive with food each month at a base near Waterloo, although the results proved mixed (HS 6/92).

151 "saucers of water": Jones, *Most Secret War*, pp. 404–5.

151 "spasmodic and only ancillary": In September 1942, a special exemption certificate was issued for S. J. Bryant, MI6's pigeon expert, whose birds had been working for Columba, to hold pigeons at Broadway where he would work with Wing Commander Sofiano, the man in charge of the logistics of dropping agents (AIR 2/4129; other files list him as Briant). Bryant trained birds that made three flights from France for Special Section, and homed on July 11, September 9, and November 29, 1941.

10: UNDERCOVER

160 why he was there: Burr (alias Thonus) testimony, Belgian Security Service Archives.

160 "constantly drunk": Thonus file, Belgian Security Service Archives. See particularly a note from Marius of December 10, 1942.

160 parachutist had brought for him: Devos's postwar testimony is not altogether accurate and reliable.

161 "did not establish wireless": Letter from Page, January 26, 1945, in the Leopold Vindictive file, Belgian Security Service Archives.

161 buying and selling paintings: Notes on Bodicker, Belgian Security Service Archives.

163 refrain was frequently heard: BBC E2/78, May 11, 1942.

164 after arriving in Belgium: www.beforetempsford.org.uk.

164 information of great importance: Jean Starck, quoted in a postwar letter from Justin Raskin, brother of Joseph. Leopold Vindictive file, Belgian Security Service Archives.

165 "I felt burned": Thonus's brief testimony, Leopold Vindictive file, Belgian Security Service Archives.

166 most important traitor in Europe: Herman Bodson, *Downed Allied Airmen and Evasion of Capture* (Jefferson, NC: McFarland, 2005), ch. 8.

167 women who were captured: Bodson, *Downed Allied Airmen and Evasion of Capture*, ch. 8; Jacques Doneux, *They Arrived by Moonlight* (London: St. Ermin's Press, 2000).

167 come to see Michelli: Albert Mardagar—also known as BAVEY—was dropped on May 1, 1942, to make contact via Michelli with Maurice Vandael, the uncle of Jean Vandael.

11: BATTLE OF THE SKIES 11

169 using a collar-stud compass: Larry Carr's escape report for MI9. Copy provided by Joÿ Clinch.

170 shot down four bombers: Columba Message 988, August 6, 1944.

171 shot down and killed: HS 9/932/8; http://www.conscript-heroes.com /Art48-Lockhart-960.html; http://aircrewremembered.com/william-lock hart.html; Columba Message 214.

172 consider discontinuing the service: "When we have considered washing them out in the past," one officer wrote in January 1942, "the reaction has been well—we've got them, and they may be some moral encouragement to one or two chaps, and you never know, they may save a crew someday, so we may as well hang on to them" (AIR 15/716).

175 ground-based interception system: AIR 40/3054.

175 reports waiting in Lisbon: Jones, *Most Secret War*, p. 341.

176 "Pigeons drew first blood": R. V. Jones papers B85.

177 "Cheerio!!!!! Twee Geuzen": ADM 199/2475.

177 found by pigeon that year: Jones, *Most Secret War*, p. 357.

178 Leopold Vindictive's Message 37: WO 208/3564.

180 "such a profuse message": Jones, *Most Secret War*, p. 390.

180 "so wide a distribution": R. V. Jones papers B85; F. H.

12: CAPTURE

183 used on the escape line: Jean-Leon Charles and Phillipe Dasnoy, *Les Dossiers secrets de la police allemande en Belgique*, pp. 377–8.

184 also known as Flore Dings: Florentine was separated from her husband, Paul Dings.

187 in order to save his parents: HS 6/205, Etienne van Hoyer information; Foot, *SOE in the Low Countries*.

188 sent collaborators to Michelli: The Abwehr had sent a Belgian collaborator to Michelli using the correct recognition phrase: "I am coming from Marcel to know if you are interested in Malaga." The collaborator asked Michelli to help get messages to France. Michelli had provided the name of a priest who could hide documents under his vestments. The Germans had used Van Horen's codes and radio set to send out another message to London on May 4, making it look as if everything was progressing fine.

188 no one watching his back: Foot, *SOE in the Low Countries*, p. 272.

188 fell into the hands of the Germans: HS 6/111. The Beaver network to which Michelli was linked had been penetrated and one of its agents turned. Van Damme—Beaver—had been arrested on January 15.

188 captured by the Gestapo: Carr's escape report, provided by Joÿ Clinch.

13: INTERROGATION AND INFILTRATION

192 stench of cabbage and urine: http://home.clara.net/clinchy/neeb2a3.htm.

194 "done in one day if possible": Letter in Brigitte Raskin's papers.

195 series of false identities: Devos testimony in Leopold Vindictive file, Belgian Security Service Archives.

197 warned Raskin and Joye: Letter from Clément Macq, November 11, 1945, papers of Brigitte Raskin.

197 treachery had begun even earlier: Julian Praet was among those who accused Thonus of possible treachery. Another member of the Brussels group, Jean Starck, in a two-page letter to Justin Raskin written after the war on March 21, 1946 (Brigitte Raskin papers), also pointed the finger at Thonus, with whom he had worked for two months. See also Joseph Raskin file, Belgian Security Service Archives.

198 Thonus denied betraying anyone: Thonus testimony in Leopold Vindictive file, Belgian Security Service Archives. Thonus countered accusations by saying he was suspicious of Marcel Allard, a Brussels contact of Devos with whom he stayed and whom he heard had been arrested on the morning of May 6.

198 probably Devos: Charles and Dasnoy, *Les Dossiers secrets de la police allemande en Belgique.*

200 "Vindictive is safe and has money": Leopold Vindictive file, Belgian Security Service Archives.

201 "I very much hope": A draft of the letter from DO of MI14/G1H is in WO 208/3561.

203 betrayals, failures and denials: Foot, *SOE in the Low Countries.*

203 "no more than a mirage": Quoted in Jeffery, *MI6*, p. 520.

204 detained by the enemy: Foot, *SOE in the Low Countries*, p. 277.

204 it was also sloppy: KV 6/10.

204 such errors were ignored: HS 7/100.

204 broken on his drop: Foot, *SOE in the Low Countries.*

205 enjoyed their drink very much: HS 6/205.

206 "unless some drastic steps are taken": Jeffery, *MI6*, pp. 520–1.

206 arrested in quick succession: HS 6/300.

207 photos and descriptions of SOE men: Foot, *SOE in the Low Countries*, p. 287.

207 plant an incriminating letter: HS 6/300/1.

207 "Germans have full knowledge": HS 6/231. The MI6 note to SOE alongside it commented: "We have no information as to precisely where this report came from or whether it is supposed to apply to individual landings or some combined operation. However, it is forwarded to you under strong reserve."

207 "Mme. Sauvage insists on the fact": KV 6/10.

208 in Belgium at the time: Hooper was an agent of the SS by March 1939. Twice that spring and summer he met Giskes of the Abwehr at Cologne (Liddell diary, July 27).

208 For some in London: Hardy Amies, Imperial War Museum Sound Archive.

209 "Your trouble is": Langley, *Fight Another Day*, p. 202.

14: THE VISCOUNT

211 Girl Guide leaders: The transcript and details of the court-martial are in WO 71/1078.

212 "unique fairy prince of modern life": Biographical details of Evan Morgan drawn from Monty Dart and William Cross, *Aspects of Evan* (William Cross, 2012); and William Cross, *Not Behind Lace Curtains* (William Cross, 2013).

212 enhanced by the industrial revolution: Christopher Wilson, "The devil worshipping viscount and his very naughty party trick with a parrot," *Daily Mail*, June 18, 2013.

213 head of the SA, Ernst Rohm: http://www.bbc.co.uk/blogs/waleshis tory/2010/12/evan_morgan_of_tredegar_house.html; http://www.bbc .co.uk/blogs/wales/entries/58b3be05-87b7-3fca-b511-2c9c24bc61a8.

214 "glorious house": Dart and Cross, *Aspects of Evan*, p. 96.

214 a job he loved: WO 208/3556.

214 "One Lord Tredegar": BBC E2/78, November 11, 1942.

215 "check on CX reports": WO 208/3561.

217 supply of pigeons: Foot, *SOE in the Low Countries*, p. 62.

217 take it over directly: The next day a senior officer wrote to the deputy director of Military Intelligence backing Melland, saying that he viewed the material as of real value. And he stressed that its value would increase when the time came to send troops over the Channel and back into Europe. "Then, and not till then, will be the time to consider its abolition," the lieutenant colonel (Hirsch) wrote. WO 208/3561 has details of the plans to abolish the service and of the impact of Tredegar's arrival.

218 some of the best birds: Columba Summary 7, MI14(d), December 21, 1942, WO 208/3556.

219 details of the agents involved: SOE had already expressed some security concerns, dating back to the summer. Columba pigeons were preferred to Air Ministry birds because they performed better, but SOE wanted to be sure there was no danger that details of operations would leak out. MI5 was asked to keep an eye on Columba's security.

220 reached a crisis point: Columba Summary 8, January 21, 1943, WO 208/3556.

220 at least thirty birds: McCafferty, *They Had No Choice*, p. 17.

229 revised without proper permission: WO 208/3563.

230 value of the information obtained: AIR 2/4969, April 1944.

230 "War Office 'racket'": AIR 2/4969, July 1944.

230 threatened with removal: The NPS was dominated at national and local levels by strong personalities who were accused of using it to serve their own interests. An MI5 report noted that "the personnel appointed held conspicuous peacetime positions within the fancy and the services were thereby brought into political issues affecting the civilian pigeon world" (KV 4/229).

231 conflicts of interest: WO 32/10681.

231 "professed patriotic motives": One version has it that Osman failed to offer up his own birds for NPS work, which then led the committee to withdraw his membership. It was suggested he had a conflict of interest with his editorship of the *Racing Pigeon* and had generally been obstinate (WO 32/10681).

232 scope of Columba's activities: WO 208/3561.

15: TRIALS AND TRIBULATIONS

235 tried to break the men: The account by Macq, who survived and provided testimony to the Belgian Sûreté after the war, is the only one we have. The most detailed account of the specific allegations against the men comes in a series of German court documents. One set is in the Leopold Vindictive file in the Belgian Security Service Archives, with other versions obtained from Berlin on microfilm in the same archive (CEGES AA MIC 136). Another copy obtained from Germany is in the papers of Brigitte Raskin.

237 clarify the source of every single one: Testimony of the German interrogator given after the war, in the Belgian Security Service Archives.

240 message never made it out: Details emerged in a packet of information and belongings released to the family after Raskin's death. Further information from Brigitte Raskin and her papers.

16: DECEPTION

247 win it the Dickin Medal: Dickin Medal Citation 30: Pigeon NPS.42. NS.7524, bred by C. Dyson, Barnsley. Date of Award: October 1945, "For bringing important messages three times from enemy-occupied country, viz: July 1942, May 1943 and July 1943, while serving with the Special Service from the continent." The three flights appear to be: (1) departing July 23, 1942, arrived July 28 from Brittany; this is possibly Columba Message 177, which has details of arrivals of minesweepers at Duistieham from Caen, which was received in MI14 on July 29; (2) from France, May 10,

1943, returned May 17; (3) from France, released by agent July 22, 1943, arrived July 26.

248 Allied troops, mainly Canadian: The Canadian troops involved in Dieppe used their own pigeons, of which four were taken from a loft for the raid. Two were released from the beach at Dieppe with operational messages from the brigadier. The first bird, 4230, returned in less than three hours; the second, 2707, was presumed killed by heavy flak. A third bird was released from a British destroyer in the middle of the Channel with an operational message from Major General J. H. Roberts and returned at five o'clock that afternoon. The last bird was released on return to England.

248 losses proved terrible: MI14 note September 24, 1942, WO 208/3556; Columba Messages 195 and 214 from Pas-de-Calais.

249 "only aim at an area": Jones, *Most Secret War*, p. 425.

250 organize drops at precise spots: AIR 20/8457.

250 risky for the crews: AIR 20/8457.

250 pigeon section in Palestine: Memo of February 1944, https://worldwar2 militaryintelligence.blogspot.co.uk/2016/10/microgram-pigeon-service-1944 .html.

250 "valuable packet of microfilms": KV 4/229, 3a.

251 Bordeaux in southern France: In 1943, 5,814 birds were dropped, of which 634 came back, 378 with messages. Messages of support continued to come in. By 1943 the team had also moved to cardboard message containers, which were less likely to be lost. It also started to drop the birds in pairs to improve the chances of return. No compensation was initially offered to the owners of intelligence pigeons, but in late 1943 pressure from NPS and the Air Ministry led the War Office to adopt a less direct method of selecting civilian fanciers. In 1944 the selection of lofts was no longer permitted to be the sole responsibility of the Special Section, although the War Office thought this a retrograde step.

252 "She was arrested": Liddell diary, July 16, 1944, KV 4/194.

252 no returns whatsoever: MI14(d) looked at what it might do—for instance, asking the Dutch underground to advise contacts through a whispering campaign that pigeons were genuine, perhaps with the addition of a sign—such as if the last two numbers of the pigeon ring added up to 4, 7 or 11. The unit also wondered about having the same newspaper publish a retraction that would be dropped along with the pigeons. The last option was to broadcast a message on the BBC.

253 "Smoke the cigarettes": WO 208/3561.

253 nine out of ten messages useless: Melland also wondered whether some references to different types of basket might not relate to the Gestapo but to MI6. "I am just wondering whether the users of the 'petits paniers en osier' are the Gestapo or whether friends [the semi-ironic name often

used to refer to MI6] are running a service as well. Do you remember a CX report [issued by MI6] which rather suggested something of the sort?" he asked. It was clear that MI14 was under no illusions that its sister service might keep it informed as to its activities.

253 messages planted by Germans: WO 208/3556.

253 "too much false information": WO 208/3561.

254 wrote to Major Petavel: CAB 154/35.

255 prevent it being too obvious: Minutes of meeting, WO 208/3561.

255 worry about such consequences: https://worldwar2militaryintelligence .blogspot.co.uk/2015/09/1943-british-correspondence-reveals-use.html; CAB 154/61.

257 released over Belgium and the Netherlands: See also Liddell diary, KV 4/193. In November 1944 (November 29, according to KV 4/195), Walker said that a pigeon dropped in Belgium with phony rings and markings had been picked up by the resistance and seemed to have been used by the Germans, as it had another mark on its wing that had not been put there by the British, although there was no message attached. Bert Woodman in Plymouth claimed that the Germans did something similar by putting fake British rings on their own pigeons and sent them to infiltrate British lofts by throwing them out of planes over the south of the country.

257 possibility of deception: KV 4/195. Information on U.S. pigeon operations is drawn largely from the U.S. National Archives. The primary set of files are RG111 National Archives Identifier 6924019, which are on the U.S. Army Pigeon Service. These boxes also contain significant amounts of information about the German pigeon services, activities in Belgium and also correspondence with the British Army and other services, including a significant amount of MI5 material on stay-behind networks and countering German pigeon operations toward the end of the war. The files also include histories written by some of the U.S. Army Pigeon Signal companies such as the 280th. Within the NSA records at the National Archives, NR 4660 (National Archives Identifier 2765793) has a useful file on pigeon messages. Another set of useful files is RG 498 (National Archives Identifier 5896574), with a box on British organization records including the role of pigeons.

17: THE AMERICANS ARE COMING

259 mistakenly shipped to Iceland: 280th Signal Pigeon Company Report, U.S. National Archives, Records Relating to Army Pigeons R 611.

260 purchased from American fanciers: Levi, The Pigeon.

260 "Birds May Also Be Drafted": Joe Razes, "Pigeons of War," American Pigeon Museum website.

261 emblazoned with a Nazi swastika: U.S. National Archives, Historic Cryp-
 tographic Records RG 457.

261 marked secret and urgent: On May 9, 1943, a pigeon brought through
 the very first news of the surrender of the German 10th and 15th Pan-
 zer Divisions (WO 204/2930; http://www.arcre.com/archive/pigeons
 /pigeonstunis).

262 as well as civilians: WO 204/2930, cited at http://www.arcre.com/archive
 /pigeons/pigeonsgijoe.

262 age of eighteen: MI14 had considered trying to use Columba in southern
 Italy but found it was relatively easy to get agents through on foot in both
 directions, while it was thought that the Italian population would not be
 sympathetic enough to provide reliable intelligence. A service for Greece
 was also considered, but the distances were too far from the nearest base
 (WO 208/3561).

263 invasion of the Chinese coast: Levi, The Pigeon, pp. 21–2.

263 extended across the Mediterranean: KV 4/299. On April 14, 1943, a six-
 month-old pigeon named Princess was liberated from Crete at five thirty
 in the morning and arrived at the Middle Eastern pigeon loft in Alexan-
 dria at four thirty that afternoon, 285 miles away, but died of exhaustion
 from the flight. It received the Dickin Medal. MI5 officers in the Middle
 East caught the odd pigeon with a message in Arabic, but when translated
 found they were invocations and prayers, since some locals thought that
 a message would fly straight to God.

263 heard in Europe: The only correspondence and references to the U.S.
 questionnaire are in BBC E2/78, August–October 1942. There is a 1993
 article—now declassified—in the CIA's classified journal, Studies in
 Intelligence, about the United States and Columba. However, many of
 the details appear to be wrong and based on a partial understanding
 of the operation dating from when the U.S. joined the operation in
 1944. The article fails to appreciate that the operation had already been
 going on for a number of years. The article is at https://www.cia.gov
 /library/center-for-the-study-of-intelligence/kent-csi/vol5no2/html
 /v05i2a11p_0001.htm.

264 born in the pub: Woodman, "War of Little Wings."

267 fall victim to their talons: HS 8/85.

267 attract exhausted enemy birds: WO 208/3565.

269 accidentally stepped on him: Another bird was deemed slightly less
 useful on D-Day. A message made its way back to HQ from a keeper
 the day after D-Day: "Pigeon released owing to unsuitable accommo-
 dation. Having laid 2 eggs I think she deserves some compassionate
 leave."

271 a bridge too far: McCafferty, They Had No Choice.

273 group of partisans might be: One short message picked up in West Cork,

Ireland, even though the pigeon was sent from Cambridge, was telephoned to MI5. It asked for the bombing of targets in Côtes du Nord with the promise that a battalion of Free French would attack the moment the bombing started. Another pigeon alighted exhausted on a British ship, the HMCS *Kootenay*, on August 2, 1944, and in a reverse of the usual flow, the message was passed from Naval Intelligence to MI14(d). It was filled with useful intelligence about a German naval base and a fortified island (ADM 199/2475). There was also extensive reporting of battle damage—for instance, how twenty American aircraft had bombed trains and railway depots at Bertrix-Libramont, with the result that twelve trains were put out of order, although there were no casualties.

274 sports grounds of a college: Columba Message 987, August 1944. "The following are safe and well and awaiting developments under cover: F/ Lt. DM Shanks—RAAF, W/O Capusdin, A., RCAF, Lts V. Dingman— Pensinger, Clements, Bishop, Hansen, McDonald B.—USAAF."

276 "Please send us arms": Columba Message 938.

276 trains should be attacked: Columba Message 935.

276 "I implore you": Columba Message 978, August 15, 1944.

277 maintain radio silence: Woodman, "War of Little Wings."

278 tried to crack the codes: Note from T. A. Robertson, October 6, 1944; note from Paris, November 9, 1944; Counter-measures enemy pigeon service, December 25, 1944; Walker note, January 23, 1945, U.S. National Archives British Organization Records RG 498.

279 forced to retreat: Prisoner of War Interrogation Report, U.S. National Archives Records Relating to Army Pigeons RG 111.

279 then interrogate them: Memo of April 30, 1945, U.S. National Archives British Organization Records RG 498.

279 supplying Nazi networks: KV 4/10.

279 "flying greengrocer's shops": Frank William Clarke, WW2 People's War, http://www.bbc.co.uk/history/ww2peopleswar/stories/79/a4801079 .shtml.

280 run agents into Germany: Jeffery, *MI6*, p. 544.

281 "spicy titbit": HS 9/29/2.

281 fly to German lofts: *Special Section 1940–1945, Royal Signals* (The War Office).

18: FATES

284 say the rosary and give sermons: Macq letters, Belgian Security Service Archives.

285 caught working for an escape line: The Australian was Bruce Dowding (WO 311/296).

288 Seventeen were killed in all: http://herinneringmemoire.be/documenten

/Knippschild/Rede-Knippschild/index.htm; http://herinneringmemoire
.be/documenten/Knippschild/Willkuerjustiz/index.htm.

289 the same day as Raskin: Their times of death can be found at http://
www.herinneringmemoire.be/lijsten/Gexecuteerden/Dortmund
/Dortmund-Hinrichtungen-NN-Belgier.htm.

290 "There are empty chairs": "Women, Wartime and the Fancy," in McCaf-
ferty, *They Had No Choice.*

291 more naturally timid and nervous than a dog: AIR 2/5036.

292 "delivered the goods": The director of signals then presented three med-
als, bearing the signals emblem, to Herbie Keys of Ipswich, as the pi-
geon supply officer who had presented the greatest number of recorded
service returns; to Mr. Bryant, whose pigeon NURP38BPC6 had homed
three times; and to J. H. Catchpole from Ipswich, owner of a bird that
had homed 480 miles from northern Denmark, the most outstanding
single performance.

292 on behalf of the intelligence services: KV 4/299, minutes of first meeting
held on April 2, 1946.

292 home to a particular object: Rayner paper, AIR 15/716.

293 "nearest thing to a pigeon": KV 4/466(1).

293 "when war comes again": KV 4/229, 3a.

293 did not want to pay for it: KV 4/229, 25a.

293 included Boomerang as standard practice: KV 4/229.

294 nuclear material from a distance: Jones, *Most Secret War*, pp. 636–7.

294 all that was needed: KV 4/229, 14a.

294 army continued work at Fort Monmouth: KV 4/230.

295 lobbied for his removal: KV 4/299.

296 "the pigeon is indispensable": http://www.telegraph.co.uk/news/world
news/asia/china/8356921/China-trains-army-of-messenger-pigeons.html.

296 organize its war archives: KV 4/196.

297 he and Sanderson agreed: WO 208/3564.

INDEX

Aerial reconnaissance, 34–35, 38, 79, 87, 123–124, 175, 178

Air Ministry. *See* Royal Air Force

Albert I (king of Belgium), 75, 164

Allard, Marcel, 315n198

Allied invasion of Europe (Operation Overlord)
 German defenses, 111, 113, 265
 Normandy landings, 268–269
 Operation Columba role, 253–257, 263–270
 results of bombing campaign, 275–277

Allied invasion of Italy, 261–262

Allied invasion of N. Africa (Operation Torch), 261

Amies, Hardy, 137–138, 140–143, 152, 203, 207–208, 219, 280–281

Annan, Noel, 29–30

Arvor 114 (code name), 45

Astrid (queen of Belgium), 164

Atlantic Wall, 111, 113

Australian Pigeon Service, 262

Baden-Powell, Robert S., 222

Baldwin, Stanley, 36

Barrett, G., 230

Battle of Britain, 36, 38, 169

Battle of El Guettar, 261

Battle of the Beams, 37, 122–123, 294

Battle of the Birds, 95–99, 104–106, 282

Battle of the Somme, 16

Beach Comber (pigeon), 248

Beard, R. W., 312n149

Beaver (network code name), 158, 206, 314n188

Belgian Sûreté, 141–142, 146–147, 151, 198, 205–207, 280, 289, 312n141

Belgium
 blacks/blackshirts (collaborators), 2, 49, 62, 70
 civilian casualties, 69, 275–277
 German attack and occupation, 30, 33, 73–74
 German capture of agents, 202–203
 German defense against pigeons, 93–96
 German use of pigeons, 277–278
 government in exile, 76–77, 118, 141, 143–144, 146–147, 163, 191
 liberation from Nazi occupation, 279
 life under Nazi occupation, 6–7, 11, 41–42, 62
 messages personnels, BBC, 83
 restrictions on pigeon keeping, 59
 WWI invasion and occupation, 51–56

Berrier, Louis, 93

Billy (pigeon), 173

Bletchley Park, 33, 38, 80, 100, 150

The Blitz, 36

Blunt, Anthony, 28
Bodicker (Boedecker), Georg,
116–118, 131, 161, 166, 189, 191,
234–235
Boyle, David, 100
Brave (network code name), 206
Brideshead Revisited (Waugh), 212
Briscoe (Professor), 256
British Army Pigeon Service, 15–16,
22–23, 99, 104, 201, 215, 223, 229,
232, 269–270, 292. *See also*
National Pigeon Service
British Broadcasting Corporation
(BBC)
audience reception clarity, 24, 82
communications to Leopold
Vindictive, 81, 84, 88, 90,
107–109, 116, 120, 159, 200–202,
307n84
communications to resistance
networks, 131, 167, 177–179,
318n252
Dad's Army (radio series), 31
German attempts at jamming,
81–82
messages personnels broadcasts,
83–84, 140, 148, 240, 248–249, 268
post-war broadcasts, 291
V for Victory campaign, 6, 64,
82–83, 279
Written Archives Centre at
Caversham, 301, 303
British Homing World, 305n17
British National Archives, 5, 301, 303,
319n257
British Special Air Service (SAS), 270
Brodmeier, Walter, 183
Bryant, S. J., 313n152, 322n292

Caesar, Julius, 9
Caiger, James, 292–295
Canada/Canadian forces, 166, 248,
274, 278, 318n248

Carr, Larry, 168–170, 182, 188
Carruthers (Major), 222
Cassart, Jean (aka Hireling), 108,
127–129, 147
Cassidy (Major), 221–222, 224, 227
Chamberlain, Neville, 73
Channon, Henry ("Chips"), 213–214
China
falconry as sport, 104
Keyes service in, 78
missionary service of Raskin, 3, 50,
56–57, 112, 189, 191
pigeon use in WWII, 263
training for future warfare, 296
Churchill, Winston
becoming prime minister, 73
dealing with invasion fears, 30–31,
113–114
dealing with rocket attacks, 274
maintaining Belgian monarchy,
76–77
Operation Columba and, 6, 15, 131
privy to Message 37, 79–80, 298
supporting the resistance, 136, 140
V for Victory campaign, 6, 82–83
CICM (Scheut Missionaries), 51
Clarence (code name, aka
Cleveland), 304n14, 306n34,
310n117
Cold War, pigeon intelligence
gathering, 294–296
Collaboration/collaborators. *See also*
Traitor(s)
accepting/embracing Nazi
ideology, 196, 242
attitude of patriots toward, 40, 272
blacks/blackshirts, 2, 49, 62, 70
as a choice, 41
double-crossed agents, 314n188
identifying/punishing, 11, 46, 137,
178–179, 180, 266, 272, 280
infiltration of the resistance, 184,
187–188, 203–204, 314n188

Vichy regime of France, 45
women as, 184
Comet (code name). *See* Escape and
evasion networks
Concentration camps, 288
Countess Thérèse, 280–281
Crowley, Aleister, 213–214, 228
Cullinan (Lt. Colonel), 223, 225–228

Dad's Army (radio series), 31
Dame Blanche (network), 306n34
Dancey, Claude ("Uncle Claude"),
19–20, 33–35, 79, 125–126, 131,
139–142, 152, 206, 209
Darlan, Jean Louise, 45
Debaillie, Arseen
disappearance following
liberation, 282–283
entry into secret of the pigeon, 49
establishing communications
channels, 119
German arrest, interrogation
and trial, 195–196, 234–246,
283–285
German execution, 284, 288–289
intelligence gathering, 58, 112
looking for dropped pigeons, 86
recognition as patriot, 298–299
Debaillie family. *See also* Leopold
Vindictive 200
entry into secret of the pigeon,
2–3, 49–50
falling under German suspicion,
194–196
intelligence gathering, 57–58, 61
paying for Arseen's release, 234
preserving historical record,
306n49
release of first pigeon, 64–65
resistance activities, 81–82
supporting the spying operation,
109, 158–159
waiting for pigeons, 85–87

Debaillie, Gabriel
entry into secret of the pigeon, 49
going into hiding, 196–197
intelligence gathering, 61
struggles following liberation,
282
Debaillie, Margaret and Marie
learning about Arseen's death, 289
monitoring BBC radio, 81, 84, 90,
107, 160
role in spying operation, 59, 62, 64
Debaillie, Michel
as pigeon fancier, 2
death and burial, 196
entry into secret of the pigeon, 49
intelligence gathering, 112
release of first pigeon, 64–65, 67, 84
role in spying operation, 59
De Gaulle, Charles, 141, 171–172
De Grunne (Count, chamberlain),
75–76, 87–88, 164, 199
Dehennin, Joseph, 117–118, 124, 198,
235, 237, 242–243, 285, 289,
310n116
De Jonge, Andrée ("Dedee") (aka
"Little Cyclone"), 125–126, 129,
289
De Jonge, Frederick, 165
Denmark, 10, 59, 221, 251
Deuxième Bureau, 141–142, 243
Devos, Fritz, 119–121, 124–125, 127,
158, 160, 193–195, 198, 234, 245
Dewe, Walthère, 306n34
De Zitter, Prosper, 166–167, 184
Dieppe Raid, 114, 171, 248–249,
318n248
Double-Cross system, 187, 256–257,
282
Doves. *See* Pigeons (*Columba livia*)
Dufour, Hélène, 242, 246, 284,
310n117
Dufrasne, René, 115, 235–236, 238–239,
243, 245, 284, 289

Dunkirk, British evacuation, 14, 74–75, 77, 89, 113

Eckardt, Reinhold, 169
Edward VIII (king of England), 224
Elizabeth (queen of Belgium), 75–76, 199, 241
Elizabeth II (queen of England), 10
Enigma, 33, 90, 123, 180. See also Bletchley Park
Escape and evasion networks. See also MI9
 Comet network, 165–169, 182, 188
 German penetration, 125–128, 166–168, 184–185
 German search to identify, 116–118, 131
 MI9 role in, 27, 209
 recovery/hiding downed pilots, 89, 168–171
 trials and executions, 243, 285

Ferrant, Julien, 94
"Final Solution" (Holocaust), 242
Fowler, Charles Astley, 16
France
 civilian casualties, 275–276
 collapse and occupation, 30, 33
 D-Day preparations, 251–252
 Dieppe Raid, 114
 German pigeon defense/deception operations, 93–96
 German use of pigeons, 277–278
 life under Nazi occupation, 11
 restrictions on pigeon keeping, 59
 siege of Paris, 9, 102
Franco-Prussian War (1870–1871), 9
Free French Army, 321n273
Freisler, Roland, 242
French resistance (French Forces of the Interior), 24, 140–141, 151, 179, 253, 271–272

Freya (German radar code name), 123, 175
Frost (Major), 101, 219

George VI (king of England), 76
German invasion of England. See Operation Sea Lion
German Pigeon Service
 British defense against, 104–106, 267
 British spy-pigeon fears, 99–101, 103
 deception operations, 252–254, 257, 272, 282
 requisitioning Belgian birds and lofts, 102–103
 U.S. capture and use for birds and lofts, 281
 U.S. spy-pigeon fears, 260–261
G.I. Joe (pigeon), 262
Giralt, Florentine (aka Flore Dings), 184–185
Girl Guides, 222–224, 225–226
Goering Hermann, 96
Government Communications Headquarters (GCHQ), 5
Gustav (pigeon), 269

Henton, George, 170
Hess, Rudolph, 29, 213
Himmler, Heinrich, 102
Hitler, Adolph, 6, 30, 32, 74, 76, 111, 163, 200, 233, 296–297
HMCS Kootenay, 321n273
HMS Vindictive, 78
Hockey, Ron, 14, 91
Holocaust ("Final Solution"), 242
Homosexuality, 137, 212–213, 218
Hope (Captain), 256
Huxley, Aldous, 212

Indian Pigeon Service, 263
Invasion of England. See Operation Sea Lion

Invasion of Italy, 261
Invasion of the Soviet Union. *See*
 Operation Barbarossa
Iran, 296
Irish Republican Army, 18

Jackson, Ashley, 14
Jacquemin, Paul, 304n14
Jempson, Frederick JoŸ. *See* Page
 (Major)
Jenks, Stan, 170
Jews, German plans for, 102, 124, 176,
 216, 242
JoŸ Victoire (network code name).
 See Leopold Vindictive 200
Jones, Reginald V. ("R. V."), 36–38,
 123–124, 140, 151, 174–180, 223,
 233, 249–251, 267, 294, 298
Jones, Wally, 170
Joye, Hector. *See also* Leopold
 Vindictive 200
 entry into secret of the pigeon, 3,
 50, 58
 German arrest, interrogation and
 trial, 195, 233–246
 German execution, 284, 288
 intelligence gathering, 59–60,
 111–117
 recognition as a patriot, 298–299
Joye, Louise, 241
Jungle Joe (pigeon), 262–263

Keyes, Roger, 72–74, 76–78, 85–86,
 164
Keys, Herbie, 221, 224–225
Kirkman (Brigadier), 251
Kleyn, Diana, 216
Kleyn, JoŸ Leonard (aka Johannes
 Leonardes Kleijn), 214, 215–221,
 223, 225, 228–229, 250, 252, 273

Langley, James M. ("Jimmy"), 126, 209

Lawson (Mrs.), 290
Leduc, Augustin (aka Laurent), 161,
 191
Leopold (king of Belgium), 72–78,
 87–88, 131, 163–164
Leopold Vindictive 200 (network
 code name). *See also* Debaillie
 family; Joye, Hector; Raskin,
 Joseph
 acknowledging importance of,
 289–290, 298–299
 credibility as a source, 77–78
 discovery in forgotten files, 7
 dispatch of first message (Message
 37), 63–65, 67, 81, 84
 establishing communications
 channels, 107, 119–122, 124–130
 German attempts to identify,
 131
 German capture, interrogation
 and trial, 198–200, 234–246
 German execution of members,
 284–289
 intelligence gathering/reports,
 58–65, 90, 114, 178, 248
 maintaining secrecy, 193–194
 MI6 agent contact, 133, 143,
 158–160, 163–166, 206
 MI6/MI4 competition over,
 130–131, 152, 200–203
 name and symbol defined, 78, 113,
 120
 name change, 87–88, 90, 110
 pigeon drops, 85–87, 90–91, 93,
 107–111, 138, 151–152, 159
 preserving historical record,
 297–299
 providing radio to, 109, 130, 152
 radio communications, 198–201
Lepage, Fernand, 141–143, 146–147,
 206–207, 280, 312n143
Le Queux, William, 52

Lichtervelde
 arrival of first pigeon, 49–50
 first pigeon return to England, 67,
 84
 occupation, Belgian support of, 2
 occupation, liberation from, 282
 pigeon drops, 13–15, 85–86, 93–94,
 107–109
 resistance activities, 81–82
 spy ring arrests, 193–196, 243–244
Liddell, Guy, 100, 103, 105
LMN Kommando 6 (resistance
 group), 171
Lockhart, Guy, 171
Long, Leo, 28
Luc (intelligence network), 126, 198

Macq, Clément, 109–111, 114–115, 194,
 197, 235–240, 243–246, 284–285, 289
Manningham-Buller, Eliza, 247
Manningham-Buller, Mary, 247–249
Manningham-Buller, Reginald, 247,
 295
Man Ray (aka Emmanuel
 Radnitzky), 280
Marc (intelligence network), 126, 198
Mardagar, Albert (code name
 BAVEY), 313n167
Marquis (resistance network),
 266–267
Mary (pigeon), 97
Meister (pigeon), 281
Melland, Brian, 28–30, 39–40, 43, 68,
 121–122, 152, 178, 200–202,
 215–219, 226–228, 231–232, 250,
 253–255, 273, 296–297
MI3, 28
MI5
 about the branch, 27
 counterintelligence operations,
 116–117, 146, 203–205, 219–220
 identifying German deception
 operations, 252–257, 282
 investigating German pigeon
 operations, 97–106, 260, 277–279,
 309n103, 319n257
 investigating loss of networks,
 206–208
 investigation of pigeon program,
 231–232, 317n230
 maintaining D-Day secrecy, 267
 post-war pigeon research, 292–295
 relationship with MI6, 205–206
 role in agent recruitment, 137
MI6. See also Dancey, Claude
 about the branch, 27
 agent drops behind enemy lines,
 13–14, 35–36, 86, 133–136, 148,
 304n14
 agent recruitment, 21–22, 139–140,
 143–144, 146–147
 beginning of WWII, status, 33–34,
 74
 creation of Z network, 19–20
 dismissive of pigeon operations,
 22, 36, 79, 162, 250–251
 German penetration into,
 207–208, 318n253
 intelligence gathering/reports,
 36–37, 39, 44, 46, 79, 94, 123, 215,
 280
 loss of Belgian networks, 185–189,
 195–200, 202–203
 post-war pigeon research, 293–295
 relationship with Leopold
 Vindictive, 158–159, 200–202,
 243
 relationship with SOE, 127,
 139–141, 166–168, 204–206,
 315n207
 relationship with the Sûreté,
 141–147, 205
 taking over pigeon operations, 131,
 151–152
MI9, 27, 125–127, 209. See also Escape
 and evasion networks

MI14/MI14(d)
 about the role/importance,
 27–29
 activities/mission, 30–32
 agent recruitment, 28–30
 identifying German deception
 operations, 252–254
 intelligence gathering/reports,
 33–35, 38–39, 176
 investigation of pigeon program,
 217–220, 231–232
 lack of priority of operations,
 121–122, 152
 locating rocket launch pads,
 249–250, 274
 pigeon operations in Italy and
 Greece, 320n262
 post-war pigeon research, 294
 relationship with Leopold
 Vindictive, 77–78, 86–87, 202
 relationship with MI6 and SOE,
 130–131, 149, 152, 200–202,
 319n25, 319n253
 revealing secrets of, 211–215
Michelli, Henri, 125–128, 130,
 159–160, 165–169, 181–185,
 187–189, 194, 197–198, 203, 205,
 245, 289
Middle East Pigeon Service, 263
Miller, Lee, 280–281
Mohring (Major), 116
Monckton, Sir Walter, 224–227
Mongolia, Raskin travels in, 56–57
Montgomery (Lt. Colonel), 264
Mont Saint-Michel, 44–45
Morelle, Charles, 182
Morgan, Evan (aka Viscount
 Tredegar), 211–228, 228
Morgan, Olga (aka Princess Olga),
 214, 227–228
Murphy, Alan ("Sticky"), 128–129
Muylaert, Maurice, 115–118, 197, 237,
 241, 243–244, 285, 289

Nacht und Nebel (Hitler decree, "night
 and fog"), 200
National Pigeon Service. See also
 British Pigeon Service;
 Operation Columba
 Air Ministry role, 18–19, 97,
 229–230, 312n148, 316n219
 bird registration and membership,
 17–18, 318n251
 destruction of falcon predators,
 95–99
 destruction of nonregistered
 birds, 101–102
 numbers of pigeons used, 292
 Osman membership, 17, 231–232,
 317n231
 pigeon losses, 298
 pigeons replacing radios, 96, 120,
 149–151, 172–174, 261–264, 269,
 277, 309n102
 politics and dissension, 19, 209,
 228–231, 292, 317n230
Netherlands
 attack and occupation, 30
 BBC messages personnels, 83
 civilian casualties, 275–276
 collapse and occupation, 33
 German capture of agents,
 202–203
 German pigeon defense/deception
 operations, 93–96, 252, 256–257
 German radar stations, 223, 226
 German use of pigeons, 277–278
 life under Nazi occupation, 11, 30
 pigeon drops, 221
 pigeon releases, 103–104, 124, 172,
 173, 176–177, 250–251
Newmarket, Suffolk, 13, 24, 305n107
Noah (Biblical patriarch), 8
Norway, 32, 34, 59, 111, 254–255

Office of Strategic Services (OSS),
 262–263

Official Secrets Act, 211, 220
Operation Barbarossa, 70, 233
Operation Boomerang, 293
Operation Claribel, 71
Operation Cockade, 254–257
Operation Columba. *See also*
 National Pigeon Service
 about the origins, 15–24
 beginning pigeon drops into
 Belgium, 24–25
 betrayal by Lord Tredegar, 211–228
 deception operations, 251, 254–257,
 281–282
 discovery of forgotten files, 5–7
 German awareness/reprisals,
 93–96, 252
 German deceptions, 252–254
 intelligence questionnaires, 2, 21,
 23–34, 39, 64, 82, 94, 103, 124, 229
 message arrival and handling,
 67–68, 178
 message content and value, 40–42
 Message 1, 40
 Message 2, 40
 Message 18, 44–45
 Message 19, 44–45
 Message 37, 6, 68–72, 78–80, 87, 178,
 297–298, 303
 Message 214, 171
 Message 235, 177
 Message 486, 178
 MI6 takeover, 131, 151–152
 moving operation to France, 273
 numbers of pigeons used, 224,
 250–252, 255, 257, 265, 269
 pigeon losses, 93, 218, 269–270,
 298–299
 pigeon recognition/medals, 247,
 262, 270, 290–291, 317n247,
 320n263, 322n292
 post-war continuation, 292–296
 preserving historical record,
 297–298

 priority for operational support,
 121, 138, 152, 265–266
 role in D-Day planning, 253–257,
 263–266
 termination of program, 217, 282
 U.S. entry into, 263, 320n263
 worth to war effort, 10–12, 82, 180,
 215–218, 251, 298–299
Operation Crossbow (V-1/V-2 rocket
 search), 249–250
Operation Intersection, 198, 203
Operation Lena (German agent
 operation), 100
Operation Manfriday, 203
Operation Marble, 304n14
Operation Moonshine/Opinion,
 304n14
Operation Overlord. *See* Allied
 invasion of Europe
Operation Periwig, 91
Operation Sea Lion (German
 invasion of Britain), 24, 30–34,
 37–40, 43–45, 70–71, 80, 100–101,
 111–114, 122, 215
Operation Torch, 261
Osman, Alfred Henry, 15–17
Osman, William, 16–19, 230–232,
 305n17, 317n231

Paddy (pigeon), 269
Page (Major, aka Frederick Joy
 Jempson), 139, 142–143, 145–146,
 158, 168, 174–175, 203, 206, 280
Pakistan, 296
Patton, George S., 261
Pearson, Rex, 19–23, 39, 78, 121–122,
 149, 177, 214–215, 218, 224,
 228–230, 263, 273, 305n20,
 310n122
Philby, Kim, 74
Pieren, Eric, 117–118, 237, 280
Pigeon racing, 9, 15–17, 218, 220,
 259–260

Pigeons (*Columba livia*)
about the naming and perception of, 7–8
as a sport, 17
care and feeding, 150
communicating with, history of, 8–9
contribution to war effort, 10–12
endurance and homing instincts, 8
falcons as predators, 95–99, 104–106, 267, 282
fancy/fanciers (keeping/breeding), 9–10
German use of, 102–104, 252–257, 267–268, 319n257
religious symbolism, 62–63
use in WWI, 15–17, 21–22, 95, 99, 102, 103, 231, 260
women as keepers/fanciers, 18, 247–248, 290
Plate (Peeters), Willy, 161, 166, 189, 198
Praet, Julian, 194–195, 315n197
Prescott (Colonel), 227

Racing Pigeon, 15, 17, 231–232, 305n17, 317n231
Radar
Battle of Britain, 95
British development, 38
German use of, 122–123
intelligence gathering on German facilities, 123–124, 175, 177, 223, 251, 274
intercept guidance systems, 178–179
jamming techniques, 179–180, 267, 293
Radios
agent operations, 35–36, 88, 108–110, 115, 130, 144, 148–149, 155–168, 185–187, 253, 306n34
BBC broadcasts, 24, 81–84, 90, 116, 160, 240

deception/double-cross operations, 32, 187–188
direction-finding, 161, 162
German capture of, 198–200, 202–204, 314n188
German facilities, 71, 124
intercept guidance systems, 37–38
jamming techniques, 293
maintaining secrecy, 159–160
pigeons as replacement, 96, 120, 149–151, 172–174, 261–264, 269, 277, 309n102
post-war pigeon research, 294–295
resistance operations, 71, 271
Ralston, Bill, 188
Raskin, Albert, 109
Raskin, Brigitte, 302, 306n49
Raskin, Joseph. *See also* Leopold Vindictive 200
childhood and ordination as priest, 50–51
China missionary service, 56–57
early resistance activities, 57–58
entry into secret of the pigeon, 3, 50, 58
German arrest, interrogation and trial, 191–193, 198–202, 233–246
German execution, 283–290
German suspicions of, 119–120, 131
intelligence gathering, 58–61, 111–117, 119–121
preparing and sending first report, 61–65
recognition as a patriot, 298–299
relationship with King Leopold, 163–164
spying during WWI, 52–56
Raskin, Justin, 315n197
Rayner, William Dex Lea, 18–19, 148–149, 229–231, 264–265, 270, 291–293

Resistance networks/activity. *See also*
 Collaboration/collaborators;
 Spying/spy networks
 about the formation of, 41–42, 50,
 57–58, 89, 109, 125
 as choice/facing risk of, 2, 11, 41,
 80, 182
 BBC broadcasts, 91–92, 131, 167,
 177–179, 318n252
 British agent drops into Belgium,
 13–15
 British intelligence links to, 137,
 139–143, 201–202
 Debailies family entry into, 49–50,
 58–59, 195–196
 determining source credibility,
 45–46
 German activity/reprisal against,
 52, 179, 200, 237–238, 252–255,
 271, 280
 German executions, 285–290
 German penetration into, 116–119,
 197
 MI6 undercover agents in, 133–135
 Nacht und Nebel decree, 200
 newspapers, 2, 24, 64, 252
 organization and coordination,
 165–168
 pigeon drops, 43, 84–85, 133
 role in D-Day planning/
 operations, 253–257, 266–267,
 271–272
 sabotage operations, 71, 108, 136,
 166, 168, 267–268
 shift to organized warfare, 271–272
 women in, 11, 18, 61, 87, 89,
 125–126, 159, 165, 182, 184–185,
 194, 247, 280
Reuter, Julius, 9
Roberts, Anna de Bruycher
 (Madame), 87, 89, 115, 125, 159,
 165, 182, 184–185, 194, 289
Roberts, Jesse, 89

Roberts, J. H., 318n248
Rohm, Ernst, 213
Royal Air Force
 agent and pigeon drops, 13–15,
 24–25, 46–47, 86–87, 91, 95,
 107–108, 121–122, 133–135, 147–148,
 155, 216–217, 251, 255, 268,
 309n107
 agent retrieval, 128–129
 bombing of Germany, 123, 233
 crew recovery operations, 172–174,
 264, 292
 estimate of need for pigeons, 17
 German interception system,
 175–177, 179
 information from Columba
 pigeons, 11, 84, 123, 177–178, 223,
 237, 274
 jamming tecŸiques, 178–179, 267
 loss of planes, 123, 151, 174–175,
 179–180
 pigeon keeping, 5, 101, 148, 312n148
 relationship with British Army
 Pigeon Service, 265, 269–270
 return of downed airmen, 168–171,
 182
 role in Operation Columba, 18–19,
 23, 228–230
Russia. *See* Soviet Union

Sabotage operations
 agent recruitment/insertion, 108,
 137–147
 efforts in Belgium, 89, 125, 166
 efforts in France, 266–267, 271
 German penetration into, 166–168,
 203–204
 planning for German invasion, 71
 preparing for D-Day, 268
 shift to organized warfare, 271–272
 as SOE mission, 136–137, 142–143,
 168, 208
Salz, Irwin F., 259, 263–265

Sanderson, L. H. F. ("Sandy"), 29–34, 39–40, 43–45, 68–70, 87, 152, 200, 215, 297

Sandys, Edwin Duncan, 249

Scheut Missionaries, 51, 193

ScŸeidau, Philip (aka Agent Felix), 148–149

Scotch Lass (pigeon), 250–251

Scottish Society for the Protection of Wild Birds, 98

The Secrets of the Eye (Caiger), 295

Shepherd (Major), 288

Shoebridge, Ron, 182, 188

Siege of Paris (1870–1871), 9, 102

Sofiano (Wing Commander), 313n152

Soviet Union, 28, 70, 233, 242, 294

Special Operations Executive (SOE)
 about the formation and mission, 34, 133, 136
 agent recruitment, 136–139, 143
 beginning use of pigeons, 149–150
 relationship with MI6, 127, 139–142
 relationship with the Sûreté, 142–146
 role in resistance operations, 139–141

Spencer, Thomas H., 259, 263, 265

Spying/spy networks. *See also* Resistance networks/activity
 agent insertion, 133–135, 146–148, 155–157
 agent operations, 157–161
 agent recruitment and training, 135–146
 Debaillie family role in, 1–3, 234
 early MI6 capabilities, 33–34
 German hunt/arrests, 116–118, 161, 179, 183–184, 191–200
 German penetration, 100–101, 146, 184–188, 202–204
 German stay-behind activities, 277
 intelligence gathering/reports, 87

Leopold Vindictive activities, 49–50, 59–65, 78, 112
 pigeons use in, 99–106, 152, 295–296
 Raskin arrest in WWI, 51–53
 Raskin training/preparations for, 54–58, 89, 115–116
 women in, 242, 246, 284, 310n117

Starck, Jean, 189, 283, 315n197

Steinhoff (priest), 285–287

Studies in Intelligence (CIA journal), 320n263

Swann, G. F., 256, 278

Tatler (magazine), 214

Thomas, Selby, 230–231

Thonus, Marcel (alias Burr), 133–134, 140, 146, 152–153, 156–160, 163, 165, 168, 182, 187–189, 194–198, 206, 244–245, 284, 289, 315n197–198

Three Musketeers (network), 311n127

Tommy (pigeon), 176–177

Tower, Cyril, 177

Traitors. *See also* Collaboration/collaborators; Traitors

Traitor(s)
 de Zitter as, 166
 Eric Pieren as, 117–118, 237, 280
 identification of Raskin by, 118
 susceptibility of networks to, 157, 184, 197, 206–208
 uncovering Leopold Vindictive, 237–238

U.S. Army Pigeon Service
 action during WWI, 16, 260
 arrival in Britain, 259–260
 capture and use of German pigeons, 281
 Exercise Duck, 264–265
 incorporation into Operation Columba, 263–264

U.S. Army Pigeon Service (*continued*)
numbers of pigeons used, 260
service in N. Africa and Italy,
261–262
service in New Guinea and
Burma, 262–263
unit histories from WWII, 319n257
U.S. 280th Signal Pigeon Company,
259–261, 319n257
U.S. 282nd Signal Pigeon Company,
281
U.S. 285th Signal Pigeon Company,
281
U.S. Central Intelligence Agency
(CIA), 262, 295–296, 320n263
USS *Audacious*, 259

V-1/V-2 rockets, 249–250, 273–275,
280, 298
Van Caester, Marcel, 285, 289, 310n117
Vandael, Jean (code name Alex),
127–130, 133, 152, 158, 167, 311n127
Vandael, Maurice, 313n167
Van Hooff, Jef, 133–147, 151–153,
155–159, 161–165, 168, 181–184,
187–189, 194, 198, 200, 206, 208,
245, 289, 311n133
Van Horen, Jacques (aka Terrier,
code name), 167, 185–188,
202–205, 253, 314n188
Van Roey (Cardinal), 181
Verhaeghe, Remi (Fr.), 114, 193, 199
V for Victory campaign, 6, 64, 82–83,
279
Viscount Tredegar. *See* Morgan,
Evan
Vogue (magazine), 280–281

Walker, Richard Melville, 101, 104,
106, 256–257
Wauquez, Gérard, 182
Weasel (sabotage agent), 203

Wells, H. G., 214
William of Orange (pigeon), 270–271
Window (radar jamming operation),
178–180, 267
Winkie (pigeon), 173
Women. *See also* Resistance
networks/activity; Spying/spy
networks
arrest and imprisonment, 167, 194,
242, 246, 289
as intelligence sources/operatives,
11, 61, 119, 247
distracting agents, 138, 144, 145,
160–161, 220
operating clandestine network,
125–126
pigeon keeping, 18, 247, 290
victimization/reprisals against, 52,
167
Woodman, Bert, 17–18, 36, 68, 98,
100–101, 172–173, 218, 220,
264–265, 268, 319n257
World War I
agent operations, 147–148
Belgian monarchy during, 72, 76
intelligence gathering, 20, 273
intelligence operatives, 28, 306n34
Joye experiences during, 59–60
pigeon use during, 15–17, 21–22, 95,
99, 102, 103, 231, 260
Raskin experiences during, 52–56,
61, 75, 241
U.S. Army pigeon service, 260
Wurzburgs (German radar code
name), 175

Yank (pigeon), 261

Zero (network code name), 118, 126,
198, 203, 206, 311n127
Zimmerman, Hauptman, 102
Z (intelligence network), 19–20